THINKING ABOUT EXHIBITIONS

Exhibitions have become *the* medium through which most art becomes
known. Constantly reshaped by artists and curators, the exhibition has
become a prominent and diverse part of contemporary culture. *Thinking
About Exhibitions* presents a multi-disciplinary anthology of writings on
current exhibition practices by curators, critics, artists, sociologists and
historians from Australia, Europe and North America. It marks out the
emergence of new discourses surrounding the exhibition and illustrates the
urgency of the debates centred on and fostered by exhibitions today.

Texts have been grouped – or installed – in sections which focus on the
history of the exhibition, forms of staging and spectacle, and questions of
curatorship, spectatorship and narrative. These writings (including case
studies and polemical interviews) investigate exhibitions in settings outside
of the traditional gallery as well as innovative work in extending cultural
debates within the museum.

Thinking About Exhibitions is fully illustrated with over ninety
black-and-white photographs and includes a bibliography on the subject of
art exhibitions. It is essential reading for anyone involved in exhibitions or
their study.

Reesa Greenberg is Associate Professor of Art History at Concordia
University, Montréal. **Bruce W. Ferguson** is a writer and independent
curator based in New York. **Sandy Nairne** is Director of Public and
Regional Services at the Tate Gallery, London.

THINKING ABOUT EXHIBITIONS

Edited by Reesa Greenberg, Bruce W. Ferguson and Sandy Nairne

London and New York

First published 1996
by Routledge
11 New Fetter Lane, London EC4P 4EE

Simultaneously published in the USA and Canada
by Routledge
29 West 35th Street, New York, NY 10001

Reprinted 1999, 2000

Routledge is an imprint of the Taylor & Francis Group

Collection as a whole © 1996 Reesa Greenberg, Bruce W. Ferguson and
Sandy Nairne
Individual chapters © respective authors

Text design: Secondary Modern/Keenan
Typeset in Monotype Granjon and Univers by
Solidus (Bristol) Limited
Printed and bound in Great Britain by TJ International Ltd, Padstow, Cornwall

British Library Cataloguing in Publication Data
A catalogue record for this book is available from the British Library

Library of Congress Cataloguing in Publication Data
A catalogue record for this book has been requested

ISBN 0-415-11589-2 (hbk)
ISBN 0-415-11590-6 (pbk)

Contents

List of plates

NOTES ON CONTRIBUTORS

LAWRENCE ALLOWAY (1926–90) was a British critic and curator who worked first in London and was associated with the ICA. From the later 1960s he was based in New York and worked for a period as Curator at the Solomon R. Guggenheim Museum. His principal essays were collected under the title *Network: Art and the Complex Present* (Ann Arbor, Michigan, UMI Research Press, 1984).

MIEKE BAL is Professor of the Theory of Literature and director of the Amsterdam School of Cultural Analysis (asca) at the University of Amsterdam. Her recent publications include *Reading Rembrandt: Beyond the Word/Image Opposition* (1991) and *Double Exposures: The Subject of Cultural Analysis* (1996).

JUDITH BARRY is an artist and writer living in New York. Her art practice is often research-based, combining media with installation. Recent projects with publications include 'The Work of the Forest', 'Rouen: intermittent futures/touring machines', 'whole potatoes from mashed' and 'Hardcell'. A collection of her works and writing, *Public Fantasy*, was published by the

ICA, London, in 1991. She is represented by Nicole Klagsbrun in New York, Rena Bransten in San Francisco and Xavier Hufkens in Belgium.

TONY BENNETT is Professor of Cultural Studies at Griffith University, Brisbane, and Director of the Key Centre for Culture and Media Policy. His collected essays on museums, entitled *The Birth of the Museum, history, theory, politics*, are published by Routledge (1995).

DANIEL BUREN is an artist born in Paris who lives and works 'in situ'. His major publications include *Five Texts* (John Weber Gallery, New York, and Jack Wendler Gallery, 1973); *Les Couleurs: sculptures, Les Formes: peintures* (The Press of the Nova Scotia College of Art and Design, Halifax, 1981); *De La Couverture* (42nd Venice Biennale, Association française d'action artistique, Paris, 1986); *Photo Souvenirs 1965–1988* (Artédition and Alemandi, Torino, 1987). He is represented in New York by the John Weber Gallery.

GERMANO CELANT is currently Curator of Contemporary Art at the Solomon R. Guggenheim Museum, New York. He is a widely published critic and writer on contemporary art and a contributing editor to *Artforum* and *Interview* magazines in New York. His recent books include monographs on Mario Merz, Robert Mapplethorpe and Keith Haring. He is currently organizing the first major retrospective of Claes Oldenburg's work.

CLÉMENTINE DELISS is a curator and writer who lives in London. She is currently Artistic Director of *africa95* and devised and co-curated 'Seven Stories about Modern Art in Africa' at the Whitechapel Art Gallery (1995).

BRUCE W. FERGUSON is a curator and writer based in New York. He was Director of SITE *Santa Fe*, a biennial international exhibition of contemporary art inaugurated in 1995 in New Mexico.

ANDREA FRASER is an artist who lives and works in New York. Her work was included as part of the Austrian contribution to the 1993 Venice Biennale. Recent exhibitions and projects have explored the concept of *Services* as offered by artists.

WALTER GRASSKAMP is a writer and professor of art history at the Akademie der Bildenden Künste in Munich. He has written extensively about the relations between art and its institutions and his most recent publication is *Der lange Marsch durch die Illusionen. Uber Kunst und Politik* (1995).

REESA GREENBERG is an art historian and writer. She is Associate Professor of Art History at Concordia University, Montréal.

PETER S. HAWKINS is Professor of Religion and Literature at Yale Divinity School where he directs a program in religion and the arts. He has published a further essay on the NAMES Project Quilt, 'Stitches in Time', in the *Yale Review*, Summer 1995.

NATHALIE HEINICH is a researcher in sociology at the Centre national de la recherche scientifique, and belongs to the Groupe de sociologie politique et morale (Ecole des hautes etudes en sciences sociale, Paris). Her recent publications include *Du peintre à l'artiste. Artisans et académiciens à l'âge classique* (Paris, Editions de Minuit, 1993), *Harold Szeeman, un cas singulier. Entretien* (Caen, L'schoppe, 1995) and *The Glory of Van Gogh. An Anthropology of Admiration* (Princeton University Press, 1996).

IVAN KARP was formerly a curator of African ethnology in the Department of Anthropology, National Museum of Natural History, Smithsonian Institution. He is currently National Endowment for the Humanities Professor of Liberal Arts at Emory University, Atlanta. He co-edited *Exhibiting Cultures* with Steven D. Lavine, published by the Smithsonian Institution Press (Washington, D.C., 1991).

XVII

ROSALIND E. KRAUSS is Meyer Schapiro Professor of Modern Art and Theory at Columbia University, New York. She is a founding editor of *October* magazine. Her most recent book is *The Optical Unconscious* (MIT Press, 1993).

JOHANNE LAMOUREUX is Associate Professor of Art History at l'Université de Montréal. Her recent work has focused on the sequels of site specificity and the rhetoric of contemporary exhibitions. In 1995 she curated *Seeing in Tongues: Le bout de la langue* at the Morris and Helen Belkin Gallery, University of British Columbia.

JEAN-FRANÇOIS LYOTARD is a philosopher and French scholar, currently a visiting Professor at Emory University, Atlanta. His most recent publication is *Moralités Postmodernes* (Galilée, 1994; Minnesota Press, 1996).

GERALD McMASTER is an artist and Curator of Contemporary Indian Art at the Canadian Museum of Civilisation, Hull, Québec. He curated *Indigena: Contemporary Native Perspectives* with Lee Ann Martin there in 1992 and was the Canadian Commissioner to the Venice Biennale in 1995.

University of Amsterdam. She has worked on several topics relating to the history of the museum and published *Kunst als natur. De Habsburgse schildenijengalerij in Wenen omstreeks 1780* (Amsterdam, 1991).

JOHN MILLER is an artist and writer. He teaches drawing at the School of Visual Arts, New York, and is the senior editor of *Acme Journal*. He is represented by Metro Pictures, New York, Jablonka Galerie, Cologne and Richard Telles Fine Art, Los Angeles.

SANDY NAIRNE is Director of Public and Regional Services at the Tate Gallery, London. He is the author of *State of the Art* (London, Chatto & Windus, 1987).

DIANA NEMIROFF is Curator of Canadian Art at the National Gallery of Canada, Ottawa. She has written extensively on contemporary art in Canada and has curated *Songs of Experience* (with Jessica Bradley) and *Land Spirit Power* (with Charlotte Townsend-Gault and Robert Houle).

BRIAN O'DOHERTY is an artist (Patrick Ireland) and writer who lives in New York. His essay in this collection appears in his forthcoming book *"Inside the White Cube"* (Merve Verlag, Berlin, 1996). He is represented in New York by the Charles Cowles Gallery.

JEAN-MARC POINSOT is a professor at the Université Rennes 2, where he teaches applied museology and has written extensively on contemporary exhibitions. His most recent publication is *Quand l'oeuvre a lieu*, published by Artédition (Paris, 1995).

MICHAEL POLLAK (1948–92) was a researcher at the Centre national de la recherche scientifique, and belonged to the Institut d'histoire du temps present and to the Groupe de sociologie politique et morale, Ecole des hautes etudes en sciences sociales in Paris. A selection of his main works has been published under the title *Une identité blessée: études de sociologie et d'histoire* (Paris, Métailié, 1993).

MARI CARMEN RAMÍREZ is curator of Latin American Art at the Archer M. Huntington Art Gallery, and adjunct lecturer at the Department of Art at the University of Texas, Austin. She was the editor of *The School of the South: El Taller Torres Garcia and its Legacy* (Archer M. Huntington Art Gallery and the University of Texas Press, Austin, 1992).

VALERY PETROVICH SAZONOV is an art historian who graduated from the Leningrad Institute of Art. He is the Director of the Penza Regional Art Gallery (the Savitsky Gallery) and a member of the National Presidium of ICOM.

MARTHA WARD is Associate Professor at the University of Chicago. Her recent publications include *Pissarro, Neo-Impressionism, and the Spaces of the Avant-Garde* (University of Chicago Press, 1996).

FRED WILSON is an artist based in New York. His exhibition *Mining the Museum* at the Maryland Historical Society in Baltimore received the American Association of Museums' Curators' Committee award for Exhibition of the Year in 1993.

ACKNOWLEDGEMENTS XXI

Thinking about Exhibitions originated in and is based on the seminars on
exhibitions taught by Reesa Greenberg at Concordia University, Montréal,
in the 1980s. It is also informed by the two-part symposium organized by
Bruce Ferguson and Sandy Nairne entitled *The Politics of Images* held at
the Tate Gallery, London and the DIA Foundation, New York in the
autumn of 1990. The anthology was formulated as a specific project during
the Getty Grant Program Senior Research Fellowship which we held
jointly in 1993.

 We are immensely grateful to all the contributors who responded so
positively to the idea of this anthology. We should like to thank all those
who have encouraged and supported our investigations into the changing
nature of exhibitions of contemporary art. First thanks go to the Getty
Grant Program, and Deborah Marrow and Gwen Walden in particular, for
their generous support to our research work. We should also like to thank
the following institutions and individuals for their help: Vassif Kortun,
Norton Batkin and the Center for Curatorial Studies at Bard College; Meg
Duff and the Library Staff of the Tate Gallery; The Canada Council for the
Arts; Claudia Büttner; Laura Down; Kristina Huneault; Miani Johnson;

Johanne Lamoureux; Hélène Lipstadt; Martine Moinot; Alissa Schoenfeld; Kitty Scott; Sylvia Sleigh; Barbara Steinman; Sarah Thornton; Lisa Tickner; Richard Wentworth (for the title of Part IV); Robert McGee, Rebecca Pates and Benjamin Caplan for their work on translation. We should also like to thank those at Routledge who have worked on the book including Cathcrine Turnbull, Sophie Powell and Tamsin Meddings, and especially Rebecca Barden, our commissioning editor.

RG, BF, SN.

INTRODUCTION

There is an intellectual and structural correspondence between the subject of this book and its form. Art exhibitions and anthologies are primary vehicles for the production and dissemination of knowledge today. Both are collections of discrete entities compiled for purposes of validation and distribution. Both usually consist of extant work, although in recent years many more works are commissioned or made specially for the event. With art exhibitions and anthologies, objects and texts are always assembled and arranged according to an arbitrary schema intended to construct and convey meaning. In their mega forms – the blockbuster, the retrospective: collections of complete works or compilations which inaugurate or consolidate a discipline – they lay claim to being exhaustive when they are always incomplete (and often only exhausting). Exhibitions and anthologies are, by definition, selective and exclusive due to the biases of the organizers and the actual or perceived constraints of space, finance and availability of works. The totality which many art exhibitions and anthologies seem to claim to embody is a fiction and even a fantasy.

Art exhibitions and anthologies have become the epitome of recent intellectual and cultural manifestations. They are virtually synonymous

with postmodernism's tropes of built-in obsolescence, fragmentation and inherent contradiction. But however piecemeal, and however provocative, there is always an attempt, acknowledged or not, at some form of synthesis and narrative closure. For this reason, art exhibitions and anthologies are frequently used as introductions to specific phenomena. Both have a tendency to be self-referential and didactic and, until recently, relatively unselfconscious and uncritical.

Thinking about Exhibitions adopts the form of the anthology to highlight the emergence and consolidation of a new discourse on art exhibitions as well as to bring into debate a range of issues at play in their formation and reception. We hope to draw attention to the structured elements of an enterprise, the anthology, designed to feature and focus. By way of preventing predictability and forestalling foreclosure, our introductory remarks are brief and deliberately tangential.

Exhibitions have become *the* medium through which most art becomes known. Not only have the number and range of exhibitions increased dramatically in recent years but museums and art galleries such as the Tate in London and the Whitney in New York now display their permanent collections as a series of temporary exhibitions. Exhibitions are the primary site of exchange in the political economy of art, where signification is constructed, maintained and occasionally deconstructed. Part spectacle, part socio-historical event, part structuring device, exhibitions – especially exhibitions of contemporary art – establish and administer the cultural meanings of art. Yet, despite the growing importance of exhibitions, their histories, their structures and their socio-political implications are only now beginning to be written about and theorized. What work has been done is partial, in both senses of the word, and surprisingly random. While certain lines of enquiry are becoming entrenched (the implications of spectatorship, the deployment of artworks, or the curatorship of international exhibitions), it is too early to deem these definitive.

We have chosen texts which predominantly relate to exhibitions *per se*, in an effort to delineate a difference between thinking about exhibitions and thinking about what Daniel Sherman and Irit Rogoff refer to as 'museum culture'. Issues in the two spheres overlap but they are not always the same. The literature relating to museums tends to minimize instances of protest or scandal and often isolates the implications of the architectural or spatial surround. The discourse also ignores the increasingly varied sites and forms for constructing, experiencing and understanding exhibitions outside museums. A tendency to stress the seemingly fixed characteristics of permanent displays has deflected attention from the ever growing number and diversity of temporary exhibitions and the structural and historical relationships of these more ephemeral events to long-term displays.

2

Thinking about Exhibitions can be compared to an international group exhibition of North American and European contributors. This geographic parameter is a response to the strong and active discourse on exhibitions now occurring in several countries. Notwithstanding parallel developments and mutual influences, the desire for reform in the purpose, staging or documentation of exhibitions takes distinct forms in different places. Anglo-American writing has focused on the politics of exclusion and questions of alterity. Discussions of exhibitions in France and Québec have been marked by semiotics, post-structuralism and sociology. German commentators seem preoccupied with documenting histories of avant-garde exhibitions. The Dutch concentrate on the hypothetical and the historical. We have attempted to assemble a variety of approaches both to underscore the specificity of time and place in writing on exhibitions and to emphasize that the questions posed and the alternatives proposed in one place, in one discipline or at one point in time may not be relevant elsewhere. At the same time, we would caution against too simplistic a reading of the texts in nationalistic terms and have made our choices both to conform to and subvert the 'national' characteristics so casually proposed above.

The texts have been grouped, or installed, in sections designed to focus on exhibition history and histories, curatorship, exhibition sites and forms of installation, narratology and spectatorship. But, as will quickly be evident, most texts relate to several sections. By way of allusion to the impossibility of confining each essay to a particular category, the titles of several of the sections are intentionally oblique. The choice of texts is designed to create an eclectic mix: exhibition proposals, dialogues, diatribes, position papers, case studies, theoretical analyses, catalogue essays, long and short texts. Together, they are representative of the range of writing on art exhibitions. A number of texts from the 1970s and 1980s have been included either because the issues they raise remain pertinent or because they provide a sense of how the discussion of exhibitions has changed. The majority are recent, an indication that the topic is of increasing interest and that the debates have become more varied and more pointed. While earlier essays were written by curators, artists or critics, more of the recent contributions are by academics and arts administrators.

Writing about exhibitions rather than the works of art within them can be seen as a crisis in criticism and its languages. This tactic may either be a compensatory device, a politicized attempt to consider works of art as interrelated rather than as individual entities, or a textual response to changes in the artworld itself. Just as the growing number of exhibitions increases the respectability of the phenomenon, so also the increase in writing about exhibitions reinforces the respectability of the topic as worthy of study. That more and more writers from an ever greater variety of disciplines focus on art exhibitions is also indicative of the political and

3

cultural urgency of so many of the debates centred on and fostered by exhibitions.

Each essay in this anthology can be seen as part of a continuing dialogue with the existing literature or a critique of established curatorial positions. As the exhibition phenomenon itself comes under closer scrutiny, its failures and fissures become more apparent.

In perusing this anthology those conversant with the literature on exhibitions and museums will be aware that certain important commentators appear only in the Bibliography and not in this selection of readings. Essays such as those by Carol Duncan and Allan Wallach or Douglas Crimp or Hans Haacke, already well known through reprints or other anthologies, have become building blocks for further work that has followed, including material here. In our desire to introduce unfamiliar figures to an English-speaking or young readership and to provide an interdisciplinary selection of texts, we were unable to include all that we might have wished.

The Bibliography does not attempt to be comprehensive. It is a multilingual selection indicative of the literature generated in the artworld. Limiting the listings to art references resulted in excluding the many theoretical texts from other disciplines that continue to have a profound effect on writing about exhibitions. It is our hope that the listings in the Select Bibliography and the essays included here will stimulate further thinking about exhibitions and will encourage more radical shifts in their making, siting and reception.

RG, BF, SN, April 1995.

PART I

THE FUTURE OF HISTORY

I

THE MUSEUM
AND THE 'AHISTORICAL' EXHIBITION
The latest gimmick by the arbiters of taste, or an important
cultural phenomenon?

Debora J. Meijers

INTRODUCTION

'The museum is a house for art', according to Harald Szeemann, the independent
Swiss exhibition designer, well known for such events as *documenta 5* (Kassel, 1972),
Junggesellenmaschinen (Bern, 1975) and *Der Hang zum Gesamtkunstwerk* (Zürich,
1985). Art is fragile, Szeemann continues, an alternative to everything in our society
that is geared to consumption and reproduction. That is why, according to him, it
needs to be protected, and the museum is the proper place for this.[1]

 This is quite a change from the open museum of the seventies, of which

Szeemann himself was an ardent proponent, when attempts were made to make social contradictions visible in the museum, on the one hand, and to free art from being sentenced to the museum, on the other hand, by connecting it once more with the world outside.

After this 'museum revolution' of the seventies, Szeemann's statement sums up in a nutshell the notion which has dominated the eighties. The recent museum boom can be directly connected with it: never have so many museums been built or expanded as in the last decennium.

The museum is an institution which plays a decisive part in determining the significance of works of art. It is impossible, however, to say anything about this in general. A more specific question is required. I have therefore decided not to assume the position of an artist who tries to imagine the future significance of her work – after all, I am not an artist. Instead, I shall proceed to a kind of art-historical self-reflection by examining what a number of exhibition designers have done. If the significance of an individual work is determined anywhere, then it is by the place that it is assigned among other works. It is precisely in this field – art in its setting – that an interesting recent development can be detected.

8

➡ **1.1 Harald Szeemann, *A-Historische Klanken*, view of exhibition curated by Harald Szeemann, Museum Boymans–van Beuningen, Rotterdam, 1988. Photograph by Jannes Linders, courtesy of the Museum Boymans–van Beuningen, Rotterdam.**

This development is the trend toward the 'ahistorical' exhibition. In spite of all their differences, these exhibitions have in common the fact that they abandon the traditional chronological arrangement. The aim is to reveal correspondences between works from what may be very distant periods and cultures. These affinities cut across chronological boundaries as well as the conventional stylistic categories implemented in art history. The classical classification in terms of material is abandoned too, so that *Einfühling* (empathy) finally makes it possible to connect a fifteenth-century chair with a female portrait by Picasso and an installation by Joseph Beuys. This combination was part of the exhibition which Harald Szeemann designed at the Boymans–van Beuningen Museum in Rotterdam in 1988, entitled *A-Historische Klanken* ('Ahistorical Sounds').

Another example is provided by the activities of Rudi Fuchs, from his *documenta 7* in 1982 to the reorganization of the Haags Gemeentemuseum, where he was appointed as director some years later. The Boymans Museum recently gave another guest curator a free hand with the entire collection of the museum: the film director Peter Greenaway.

Szeemann's exhibition is an exceptionally lucid example of this style of design.

The first striking feature is the amount of light and space. The general impression is balanced and carefully considered, despite the fact that upon closer inspection the objects prove to be extremely diverse. Is this visual balance just a matter of good taste, just as antique furniture can fit into a well-designed modern interior, or is there more to it than that?

There is, according to Szeemann's explanatory comments.[2] I want to discuss his ideas on the utopian potential of art, which should find expression in the space between the works, but I shall start with the visual aspect of the rooms, and in particular the way in which he made use of their existing triple division.

A sculpture occupied the central position in each area: Joseph Beuys's *Grond* in the middle, Imi Knoebel's *Buffet* to the right, and Bruce Nauman's *Studio Piece* to the left. Szeemann then proceeded to allow these sculptures to resonate in other works of art to produce a spatial dialogue. In this way he wanted ahistorical sounds to resonate, and so convey today's verdict on yesterday.

But beside this timeless, aesthetic atmosphere, he gave form to three neo-Breughelian parables:

The main room – and I am still quoting Szeemann here – is the site of spiritual

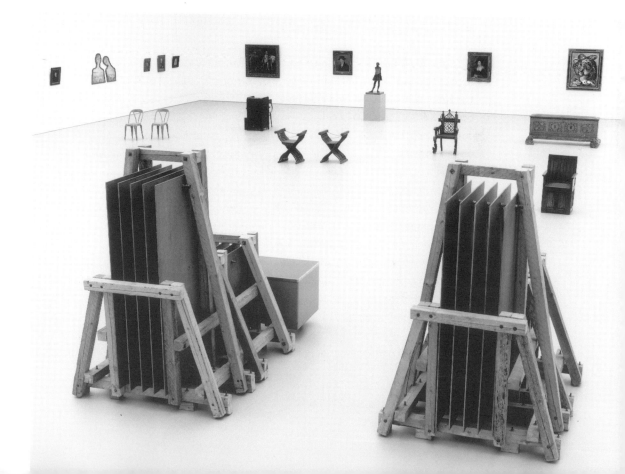

confusion, a vigorous appeal to human creativity, and suffering and death: Breughel's *Tower of Babel* (confusion), Beuys's batteries and office furniture combined with older pieces of furniture (creativity), and Rubens' *Three Crosses* (suffering).

The right-hand room is dominated by 'the cryptic silence of emptiness and monochrome': Knoebel juxtaposed with *The Adoration of Mary* by Geertgen tot Sint Jans, a silver urn from 1918, Morandi, Broodthaers and van Elk.

Finally, to the left we find 'the sacral elevation of the apparently trivial': Nauman in combination with Rothko, Hieronymus Bosch, Saenredam, Mondriaan and a Venetian glass dish from the sixteenth century.

Kandinsky's *Lyrisches* hangs in a central position, as if to accentuate the leitmotiv of this visual composition: the painting refers to the same 'urge toward the *Gesamtkunstwerk*' which Szeemann always finds in himself, his tendency to seek constantly for the essential link between the different arts, as a reaction to the penchant for classification which dominates the practice of museums.

Is this all obvious to the visitor? I do not think so, except for the initiated. Perhaps you should surrender to the direct visual impact of the exhibition, which was powerful enough and full of surprises. But then we run up against the following issue.

Various critics have drawn attention to the emergence of a new type of arbiter of taste coincident with this type of ahistorical exhibition. Particularly in the world of modern and contemporary art, museum directors and some freelance exhibition designers have sometimes acquired an unassailable, guru-like status. This phenomenon recently came in for some sharp criticism from the Belgian art critic Frans Boenders in his *kunst zonder kader, museum zonder hoed* (*Art without a Boundary, Museum without a Hat*),[3] a booklet whose title pokes fun at Jan Hoet, the Ghent museum director and *documenta* designer. According to Boenders, arbiters of taste are only interested in an egotistical show: they are not really interested in the art that they display. The artists they select form their coterie; and there is absolutely no form of scrutiny of the criteria for the choice of items collected and put on display in this way. Arbiters of taste like to justify their choices as intuitive, and this, Boenders says, guarantees their omnipotence.

Are these critics right? And to what extent can the genre of the ahistorical exhibition be considered as an instrument in this power game? Or is there more to it than that, and is this an important cultural phenomenon?[4] I would like to set these questions against the background of a number of moments in the history of the art museum, for the present trend has its roots in this history. It harks back, for instance, to the impregnability of the aristocratic maecenas; to the classical Academy as the site of untrammelled artistic exchange; and to the 'mixed' eighteenth-century gallery. We can also note the affinities with the sacralization of the museum room as a 'white

cube' in the twenties; nor should we forget a type of exhibition that appeared in the first decennia of this century, in which non-Western, 'primitive' art was combined with abstract Western art. What kind of new phenomenon is being created from these fragments of museum history?

MUSEUM HISTORY AS TOOL-SHED

If we are to understand the end product better, we have to scrutinize the ingredients more closely. First of all, there is the ideal of the aristocratic maecenas. In the early eighties Douglas Crimp published an article entitled 'The art of exhibition', in which Rudi Fuchs's 1982 *documenta* came in for heavy criticism.[5] The points made by Crimp resemble Boenders' objections to the arbiter of taste, but they are more specific. For instance, Crimp draws attention to the official postcard of *documenta 7* showing the Neo-Classical statute of Landgrave Friedrich the Second of Hessen-Kassel. The statue of the man who commissioned the museum around 1770 stands in the square in front of the building. Here, however, he is portrayed in all his power and isolation. It is as if Fuchs wanted to rehabilitate this isolated figure silhouetted against the sky, turning him into a mascot for his own enterprise.

There are more levels at which Fuchs referred to an aristocratic past. In his own words, he wanted to see his *documenta* as an academy, that is 'not as a school, but as one of the magnificent institutions which existed in the seventeenth and eighteenth centuries, before they became stupid and doctrinaire. They were the meeting place for great minds, with distinct characters and traditions; they joined in the search for overlappings and differences, and in this way they endeavoured to define their cultural moment'.[6]

Following the example of an academy of this kind, Fuchs wanted to make what he called the different dialects of 1982 confront one another. That is why he did not opt for an arrangement according to styles, which was the usual practice. He stuck to the year 1982 and combined hardly any works from different periods. It is a small step, however, from the combination of different styles to the combination of different periods. This is the step that he took soon afterwards in Eindhoven, as we shall shortly see.

Szeemann too harks back to the period before the nineteenth century. He too refers to the Academy in connection with his Rotterdam exhibition, and he follows Fuchs in viewing this traditional institution as a place where styles can be combined without being reduced to one another. His arguments are more complex, however, and are of a strongly utopian kind, as I have already mentioned. He is searching for the essence of the work of art, that is its timeless dimension, which can be traced in the visible form. That is why he displays the works in such a spacious and balanced

11

way, so that 'a genuinely free zone is created between them, and in each individual work as well'. This is his way of approaching the utopia of art, that is revealing art's utopian potential: art whose dream of total freedom offers a counterweight to the unfree nationalistic state.[7] In his quest for the ideal, inner distance from the other works and from the whole, he explores the autonomy of the work, which is where he locates the utopian force of art. This is the zone where the utopia of an ideal society can acquire form, in the form of an academy where things are combined without being reduced to one another. That is how Szeemann sees it.

In terms of art theory, this association has its interesting points. After all, the seventeenth-century Academy was originally conceived to facilitate a confrontation among different artistic characters and traditions, and it is thus no coincidence that there is renewed interest in this eclectic theory of art in a postmodern era. All the same, when *eklogè*, a positive kind of eclecticism, is propagated in the academies of the seventeenth and eighteenth centuries, this selection of the best features of the various schools takes place within a well-defined context: there was a fixed range of variants which could be portrayed in art, and the only innovation lay in perfecting existing forms. In this sense the Academy was already doctrinaire and totalitarian from the seventeenth century on, despite the claims of Fuchs and Szeemann. Their nostalgia is selective, since a fixed artistic order is precisely what they do *not* want.

These considerations bring me to a second source of inspiration, the 'mixed' gallery of the seventeenth and eighteenth centuries. Although Fuchs and Szeemann do not refer explicitly to the arrangement of this traditional gallery of paintings, it still constitutes one of the sources of their ahistorical approach. The aristocratic maecenas and the classical Academy stood for a kind of art collection in which the works were not yet arranged geographically and chronologically. There was certainly an awareness of the possibility of such classifications in terms of schools, but no one felt the need to put them on show in exhibition rooms or galleries. On the contrary, the schools were mixed to facilitate comparisons between the various paintings and to enable art to appear in all its diversity.

A distant echo of this principle can be heard in Fuchs's 1983 arrangement of the collection of the van Abbemuseum in Eindhoven in groups which enables the works 'to engage in mutual dialogue'. For instance, he confronts Chagall's *Homage to Apollinaire* (1912) with Luciano Fabro's *The Judgement of Paris* (1979). Through this confrontation of works which differ considerably in terms of material, style and period, their characteristics become clearer, and affinities can even be detected. For example, Fuchs sees the same fragility and vulnerability in the skin of the painting and of the terracotta sculpture. He also detects a thematic affinity: 'Fabro gives prominence to an item of Greek mythology which has continued to operate over the

12

centuries. Chagall has a Russian background, but that is connected with a basic story too. They are both concerned with essential things in life, the charged nature of history'.[8]

Such 'essential things' transcend art-historical classifications in terms of style and period. While Fuchs *no longer* uses that classification here, in the galleries of the seventeenth and eighteenth centuries it did *not yet* exist. At the same time, however, he considers it important that works like those by Chagall and Fabro, with their enormous differences in terms of material, style and period, retain their self-sufficiency. This is the same aim as that of the Academy and the mixed gallery, namely the combination of styles without reducing them to one another. But that is as far as the parallel goes.

In the last resort, the modern ahistorical comparisons have a different aim from their precursors of the seventeenth and eighteenth centuries. In those days the comparative mode of perception was part and parcel of the vital, practical function which art collections had for the artists of their day. As I have already mentioned, artists were expected to implement the *eklogè* – the selection of the best aspects propagated by the Academy – in the mixed gallery. Through inspection and comparison on the spot they were expected to determine to what extent each work approached the highest form of beauty. The norms for such an evaluation were still the Italian Renaissance masters and, fundamentally, classical antiquity. The mixed arrangement of the collections served a fixed canon of beauty, just as was the case with the confrontations between representatives of different 'styles' within the Academy. These galleries enabled visitors to see that Raphael and Rubens were both near-perfect, but that they had achieved this end using very different painterly resources. The spectator could then examine how his own contemporary Mengs had best approached the qualities of Raphael (linearity, for example), or a painter like Dietrich had successfully appropriated Rubens' use of colour. The gallery was the immediate training ground for the artist, which is why no one hit upon the idea of arranging the paintings by school or period before the end of the eighteenth century.

Neither our contemporary, 'postmodern' arrangement of art nor the eighteenth-century arrangement exhibits the works in terms of stylistic evolution. In the eighteenth century it is *not yet* done; in the contemporary exhibitions it is *no longer* done. The eagerness to abandon an evolutionary view of art history evidenced by Fuchs and Szeemann has its interesting aspects, and I shall return to them in my concluding remarks, but they cannot simply relive the vital function of *ekologè*: observation, comparison and emulation. Neither the Academy nor the museum can still fulfil Fuchs's dream of a meeting place for great minds. This function disappeared along with the fixed canon of beauty. Since the Romantic era artists are no longer expected to submit to tradition, they are no longer modest enough to

13

consider the work of their great predecessors as necessary exemplary material. They
have to be original – and I think this is still the case with postmodernism, in spite of
its recycling of historical forms. They consider it more important to express their
originality in their work than to mark a place for themselves in the existing artistic
family tree. As a result a tension developed between traditional art and modern or
contemporary art, which the conventional classification of museums directly and
tangibly shows.

So when Fuchs and Szeemann re-establish contact between these areas, they are
doing something different from what was going on in the eighteenth-century
museum. Here too their nostalgia is selective. They are not concerned with showing
that 'modern' artists have learned from 'past masters' how to make the best use of the
timeless resources of art. This eighteenth-century, more technique-minded approach
has given way to the romantic, Baudelairean themes of affinity, correspondence and
resonance. Thus Szeemann sees an affinity between Imi Knoebel's *Buffet* (1984/5)
and Geertgen tot Sint Jan's *Adoration of Mary* (late fifteenth century). He detects a
correspondence in the intimacy and restraint of both religious sensibilities: he sees an
affinity between the miniaturist, private altar piece and the modern buffet which
could also be a domestic altar. Those who share this subjectivity can share exciting
and new visual experiences. Those who do not may well be annoyed.

Fuchs does something similar when he lets the works by Chagall and Fabro
reflect one another, as we saw. Although Fuchs's enterprise is more down-to-earth
than Szeemann's and follows the perceptible qualities of the works more closely, they
are both characterized by a romantic form of the quest for the essence. The works
acquire a role in the communication of a message. Szeemann calls it 'the victory over
materialism,' while Fuchs situates it in his general struggle 'against modern decay'
(advertising, low-quality pop music, etc.). The centre of these exhibitions is occupied
by the exhibition designer himself; in fact, he has now turned artist.

We have just seen that this ahistorical approach is unable to breathe new life into the
artistic theory of the premodern period, but inevitably remains trapped in the
modern concept of art inspired by Romanticism. However, besides the romantic
notions of 'affinity', 'correspondence' and 'resonance', we can refer to a specific type
of exhibition which prepared the way for the ahistorical approach. This style of
exhibition, applied to a particular field, emerged during the first decennia of this
century. The growth of interest in non-European art on the part of artists themselves
coincided with the first experiments by a few progressive collectors and museum
directors to arrange parts of their collections in a 'mixed' way. They did so to
demonstrate the parallels between (expressionist) modern art and the sculptures of
so-called primitive peoples. Ethnographers and art historians gradually came to

regard these artefacts as works of art. This cleared the way for the ad lib
establishment of connections between visual representations from the most diverse
places and periods. The aim was to show that expression and instinct were
characteristic of genuine, that is non-bourgeois, art in all times and places. This
disregard for time and place presupposes that the objects are treated as fully
autonomous works of aesthetic value, a process recorded by André Malraux in his
Musée imaginaire (1947).[9] Malraux provides a convincing description of the instances
which have played a major role in this process: the actual museum and the imaginary
museum, that is the unlimited archive of images which could be compiled once
photography had made it possible to reproduce everything.

As well as being a description of this process, Malraux's book is itself its
hyperbole, as Douglas Crimp calls it.[10] Malraux confirms the tendency and takes it to
extremes, because he sees this international visual archive of art as a liberating force.
According to him, it enables us to bypass the material properties of the objects in
order to arrive at what he regards as genuine, non-bourgeois art: Rouault's *Old King*
finds its echo in the ancient mask of Agamemnon, the movement of a Degas horse is
related to a primitive plaque, to say nothing of the timeless, pure image of woman,
whether created by the artists who decorated the Greek temples or by Vermeer. This
is not a question of mutual influence: the works are filled with the same spirit,
independently of one another.

The mobility which 'world art' had gained when it lost its materiality through
photography, however, had consequences for the treatment of the objects themselves.
Various exhibitions were held from the beginning of this century reflecting
Malraux's principles. Max Sauerlandt juxtaposed Expressionist woodcuts and
linocuts with Greek red-figure and black-figure vases in the Hamburg Kunsthalle.
A better-known example is that of Karl Ernst Osthaux, who was already combining
European and non-European art in the Folkwang Museum in 1912. This approach
was continued in the arrangement of the new premises in Essen (1929), where
paintings by Emil Nolde, African masks and figures of ancestors from the South Sea
islands were put on display in the same room. In the Netherlands this thread was
picked up by Willem Sandberg. He organized the controversial exhibition *Modern
Art Old and New* in the Stedelijk Museum in Amsterdam in 1955, where Cobra
paintings alternated with African masks and sculptures by Lipchitz and others.

These exhibitions were all designed to display obvious formal affinities. Robert
Goldwater, the author of *Primitivism and Modern Art*, went a step further by using
the principle of 'affinities' in a similar way to its use in the ahistorical exhibitions of
the eighties. In 1957 he designed the interior of the Museum of Primitive Art in New
York in a novel way. A correspondent of the Swiss periodical *Du* referred to an
'assoziatives Zusammenklingen der Formen und Farben im Sinne von *l'art pour l'art*

15

(an associative symphony of forms and colours in the sense of art for art's sake).[11] It sounds like Szeemann. Indeed, the writer anticipates Szeemann in evoking an extra sense to describe the new experience: hearing. Goldwater, the correspondent of *Du* continues, takes no notice of the persistent and often highly restrictive ethnographic usage of the term 'culture area', but he dares to combine a pre-Columbian deity with an Easter Island sculpture.

Besides associations with the enterprises of Fuchs and Szeemann, one might also consider the more recent form of 'global village', as expressed in *Les Magiciens de la Terre*, the large-scale exhibition held in Paris in 1989. But while the fifties quest was for a basic language of forms which was assumed to be universal, it is now the formal *differences* which are stressed. Artists from different cultures could do what they liked in Paris, and the results were extremely diversified. However, the very idea of organizing an exhibition of this kind must be based on the supposition that there is some connecting thread, despite all the differences.

Fuchs and Szeemann, too, want to break through the boundaries of space and time without eliminating the visual differences. The kind of museum space that they

➡ **1.2 Peter Greenaway, *The Physical Self*, view of exhibition curated by Peter Greenaway, Museum Boymans–van Beuningen, Rotterdam, 1991–2. Photograph by Peter Cox, courtesy of the Museum Boymans–van Beuningen, Rotterdam.**

choose for the purpose is the sacral, white cube designed in the twenties. This is the last fragment of museum history that I will mention here. Since then this cube has functioned as a neutral area which can thus be filled subjectively, and where the works of art can be constantly rearranged to form new ensembles.

Ahistorical exhibitions of this kind need such a space in order to do justice to the individual works. At the same time, however, the opposite process takes place. The use of white, which has become a traditional feature of the museum by now, acts in the same way as all museum resources: it levels out everything within its preserve, and in a totalitarian way it erases differences to form a single entity.

This white cube has experienced a strong revival over the past few years, along with the other revivals I mentioned: the notion of the archetypal style of the fifties, and the system of aristocratic patronage with the corresponding representations of the classical academy and the courtly art collection where artists of various persuasions could communicate with one another in noble style – a top-heavy utopia!

By comparison, Peter Greenaway's *The Physical Self* is a relief. He too has assumed a perspective within which the traditional classification in terms of periods and kinds of objects is disregarded, but his motives are far more down-to-earth.[12]

While Szeemann's exhibition focuses on the spirituality of art, Greenaway is concerned with its materiality. His theme is the mortal, physical condition of the human body, as evidenced in works of art and functional articles from the Boymans Museum: nudity, the male and female body (not necessarily seen in sexual terms), the stages of youth, adulthood and old age, and the forms of functional articles designed to match the body, such as bicycle saddles, handles and cutlery. These are the categories by which the exhibition is organized. But the most important item is not from the museum collection: the four 'classical' nudes behind glass which serve as markers for the whole exhibition.

Greenaway's exhibition can be seen as the opposite of Szeemann's in every way: while Szeemann's area is spacious, light and meditative, Greenaway's is articulated, it uses light/dark contrasts, and it induces activity. While Szeemann's parabolic arrangement is static, Greenaway's chapter-by-chapter arrangement is narrative. While for Szeemann art is utopia, for Greenaway it is reality. The nudes form a bridge between our own physicality and that of the models used for the works on display.

Finally, Szeemann is searching for the essence of art and of the art exhibition,

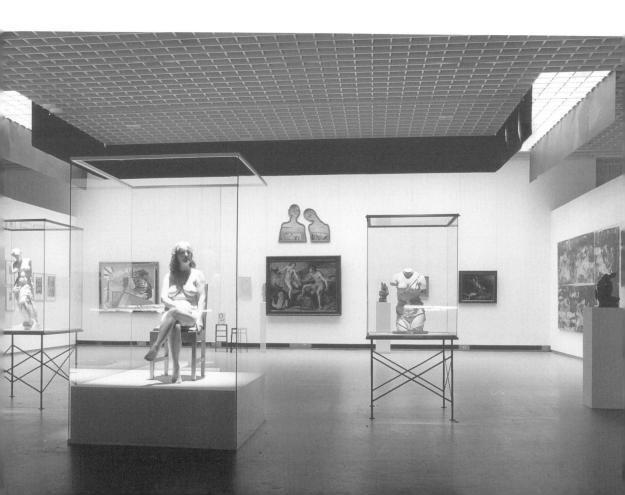

while Greenaway recognizes and appreciates the artificiality of both. He dares to make an exhibition somewhat contrived, for instance by shining spotlights on paintings to suggest fire and rippling water (Cornelis Corneliszn of Haarlem, Rubens). Though both designers break with the taxonomy of the museum, Szeemann does so in order to attain a higher truth, while Greenaway 'recycles' the taxonomy to parody it.

CONCLUSION

To return to the question with which we began: to what extent can the phenomenon of the ahistorical exhibition be considered as an instrument in the power game played by exhibition designers and museum directors? Is this highly subjective manner of arrangement mainly due to a need felt by the new arbiters of taste to make themselves inscrutable and thus guarantee their position of power? That would be an overtendentious conclusion, ignoring the fact that this kind of arrangement is connected with much more general trends. This is already evident in the considerable differences between the practitioners of this 'genre': while the attitude of Fuchs and Szeemann recalls that of the guru, this cannot be said of Greenaway. So there must be something else going on.

18 There are more general indications today that traditional notions of chronological development and separate styles are no longer acceptable. There are doubts regarding history as an evolutionary process. Who still dares to state that humanity progresses, and that each stage evolves irreversibly from the previous one? This feeling of a lack of direction runs parallel to doubts about the possibility of describing this process in a scientific way. These doubts find expression in the 'linguistic turn', a blurring of the boundary between the discipline of history and literature. The same goes for art history. An exhibition designer who regards his activity as art is not essentially different from the historian who becomes increasingly aware of the literary dimension of his historical account.

In some art-historical circles, this growing disbelief in the nineteenth-century view of history as an evolutionary process is combined with the simultaneous erosion of the notion of style. Fuchs is right to state that an arrangement by style is no longer relevant: 'style' can no longer be regarded as an indication of the content and position of the work of art. Style used to be regarded in art history as the key to a work, as its expressive idiom, but nowadays every form, material and medium is allowed. The range of possibilities is unlimited and strongly personal. An exhibition based on the assumption of separate lines of development, that is of separate styles, does violence to this diversity.[13]

What Fuchs and Szeemann want to show, on the other hand, is precisely the

simultaneity of extremely diverse artistic expressions. It is also immaterial to them whether the objects are derived from different periods. What they are doing is to project the contemporary erosion of the concept of style on to an era when there was no question of such an erosion at all, that is, the era from Romanticism to the 1960s, the grand era of 'isms' and styles. This projection seems disturbing, but is it such an unusual strategy? Were art historians in the nineteenth century not doing the same when they *introduced* the concept of style and then proceeded to view the entire history of art from that angle?[14] These ahistorical exhibitions force us to face up to the fact that the apparently unassailable notions which art historians employ are constructs. But at the same time they try to 'repair' the erosion of the concept of style and the collapse of the notion of evolution by resorting to means of creating a new unity: the 'correspondences' and the idea of an original, universal style, as well as the sacral white area. The works of art are arranged on the basis of new truths which are presented as universals, despite their strong personal colouring. Regrettably, this essentialism closes the door which these exhibitions had seemed to open.

Translated from the Dutch by Peter Mason.

NOTES

This paper was originally published in *Place, Position, Presentation, Public*, ed. Ine Gevers, Jan van Eyck Akademie, Maastricht, pp. 28–40, a collection of papers presented at a symposium held at the Jan van Eyck Akademie, 7–9 April 1992.

1 Rob de Graaf, Antje von Graevenitz, 'De overwinning op het materialisme: Vraaggesprek met Harald Szeeman', *Archis*, 3 (1988), p. 9.

2 Harald Szeemann, *A-Historische Klanken* ('Ahistorical Sounds'), Museum Boymans–van Beuningen, Rotterdam, 1988.

3 Frans Boenders, *Kunst zonder Kader, Museum zonder Hoed*, Louvain, 1991.

4 See also Marga van Mechelen, 'Van de Geschiedenis los', in *Kunst en Museumjournal*, 2:4 (1991), pp. 1–8; Riet de Leeuw, 'De tentoonstellingsmaker als verteller', in *Metropolis M*, 6 (1989), pp. 94–9; Riet de Leeuw and Evelyn Beer, *L'Exposition imaginaire. De Kunst van het Tentoonstellen in de Jaren Tachtig*, The Hague, 1989.

5 Douglas Crimp, 'The art of exhibition', in *October: The First Decade*, Cambridge, Mass. and London, 1987, pp. 223–55.

6 Rudi Fuchs, 'Brief aan onbekend kunstenaar, Kassel 1981', unpublished paper, 1981, p. 4.

7 Harald Szeemann, 'Vorbereitungen', and Bazon Brock, 'Der Hang zum Gesamtkunstwerk', in *Der Hang zum Gesamtkunstwerk: Europäishe Utopien seit 1800*, ed. Suzanne Haeni, Aarau and Frankfurt am Main, 1983, pp. 16–19 and 22–4 respectively.

8 Fuchs: 'Wij hebben veel werken die niemand wil: Interview met Rudi Fuchs, directeur van het Van Abbemuseum in Eindhoven', in *Openbaar Kunstbezit*, 4 (1983), p. 133.

9 André Malraux, *Psychologie de l'art*, part 2: *Le Musée imaginaire*, Paris, 1947.

10 Douglas Crimp, 'On the museum's ruins', in *Postmodern Culture*, ed. Hal Foster, London and Concord, Mass., 1990 (1st edn 1980), p. 50.

11 Jean Gabus, 'Das "imaginäre museum" wird Wirklichkeit. The Museum of Primitive Art in New York', *Du*, 7 (July 1958), p. 32.

12 Peter Greenaway, *The Physical Self*, Rotterdam, Museum Boymans–van Beunignen, 1991.

13 Rudi Fuchs, 'Rede tijdens de voorbereiding van *documenta 7*', unpublished paper, 1982, pp. 4–5.

14 See, e.g., Carl Friedrich von Rumohr, *Italienische Forschungen*, 3 vols, Berlin, 1827–31; Gustav Friedrich Waagen, *Handbuch der Deutschen und Niederländischen Malerschulen*, Berlin, 1862; Sir Joseph Archer Crowe and Giovanni Battista Cavalcaselle, *A New History of Painting in Italy, from the Second to the Sixteenth Century*, 3 vols, London, 1884.

2

BROKERING IDENTITIES
Art curators and the politics of cultural representation

Mari Carmen Ramírez

ARTISTIC ARBITERS OR CULTURAL BROKERS?
The issue of the representation of Latin American art – meaning the arts of Mexico, South and Central America, and the Caribbean – in the United States has been at the core of debates which have been transforming curatorial practices over the last ten years. Since the mid-eighties, we have seen a steady rise in the number of exhibitions setting forth particular notions of identity for Latin American art, as well as a proliferation of exhibition catalogues and critical articles both validating or contesting the various discourses in which these identities have been inscribed. The debates encompassing these exhibitions mark the transformation of the curator of contemporary art from behind-the-scenes aesthetic arbiter to central player in the

broader stage of global cultural politics. In this essay, I will consider how the dynamics of identity politics,[1] at both the transnational (global) and the local (multicultural) levels, have impacted on curatorial practices. The case of Latin American art in the United States presents an ideal starting point from which to chart this significant transformation of curatorial agency.

First, however, it is important to situate the function and position of the professional curator in the sphere of contemporary culture. Curators are, above all, the institutionally recognized experts of the artworld establishment, whether they operate inside an institution or independently. More than art critics or gallery dealers, they establish the meaning and status of contemporary art through its acquisition, exhibition, and intepretation. The highly commodified status of contemporary art and the institutions that suppport it in both First and Third World societies, in turn, have placed the curator at the service of elite audiences or specialized groups. To a greater extent than other artworld professionals, curators additionally depend on an established infrastructure to support their efforts. This infrastructure includes institutional networks, such as those provided by museums, galleries, or alternative spaces; financial sponsors, whether public, private, or corporate; and teams of technical or professional experts. Curators are the sanctioned intermediaries of these institutional and professional networks, on one hand; artists and audiences, on the other. Curatorial function is, thus, inherently restricted by the interests of larger or more powerful groups and constituencies. To pretend that any type of alternative field of action exists outside of the web of market or institutionally dominated interests is a fallacy.

In this elite context, curators have traditionally functioned as arbiters of taste and quality. The authority of this arbiter role derives from an absolute – ultimately ideological – set of criteria grounded in the restrictive parameters of the canon of Western (i.e. First World) Modernism/Post-Modernism. Until recently, for instance, the task of contemporary art curators consisted of judging the quality of one picture against another, or of one artist versus another, according to the conventions of rupture and formal experimentation established by the European and North American avant-garde movements. The results, as we know, often resembled a league championship of winners and losers.[2] The winners usually being artists who readily fit into this tradition; the losers being the art producers of cultures and civilizations outside, or marginal, to it.

With the international surge of exhibitions and collections based on notions of group or collective identity, however, we have seen the gradual displacement of the art curator's role of arbiter and its substitution with that of cultural mediator. This new role, for which I will use the term "broker," implies exchanging the authority of curatorial arbitrage for the purportedly more neutral standard of group ethnicity or

identity. Curators who act as cultural brokers are not limited to discriminating artistic excellence. Their function, instead, is to uncover and explicate how the artistic practices of traditionally subordinate or peripheral groups or emerging communities convey notions of identity.[3] In contrast to the elite role of arbiter, the widespread assumption of the cultural-broker function *appears* to have radically shifted the focus and field of action of contemporary-art curators. By selecting, framing, and interpreting peripheral art in exhibitions and exhibition catalogues, for instance, art curators can claim to be shaping a more democratic space where specific cultural groups can recognize themselves. This shift of curatorial function, in turn, seems to have opened up new venues for the distribution, acceptance, and appreciation of previously marginalized art.

Before weighing further the benefits or shortcomings of this new curatorial role, it is important to elucidate how such an institutionally oriented figure was catapulted from his/her elite niche to the para-institutional centerfield of the global or multicultural arena. The explanation goes hand in hand with the transformations which peripheral art markets – exemplified by Latin American art – have undergone in recent years as a result of transnational economic trends. As Ulf Hannerz has established in the case of West African cultures, the only way this type of market structure can succeed is through specialists with a strong base in the global centers who can move and disseminate meanings in exchange for material or other forms of compensation.[4] When the art originates in peripheral regions, the rewards can be expected to be greater. Curators who champion artists from these marginal areas can thus claim to have pushed the borders of contemporary art, reorganized cultural frontiers, and charted out new identities for previously marginalized groups.

When linked to this type of market scenario, the role of cultural broker, rather than effectively expanding the parameters for the evaluation and presentation of contemporary artistic practices, further complicates them. As the debates of recent years have shown, "identity" is not an "essence" that can be translated into a particular set of conceptual or visual traits. It is, rather, a negotiated *construct* that results from the multiple positions of the subject vis-à-vis the social, cultural, and political conditions which contain it. How, then, can exhibitions or collections attempt to *represent* the social, ethnic, or political complexities of groups without reducing their subjects to essentialist stereotypes? In either one of these contexts, the criterion for dealing with issues of identity reveals itself as even more autocratic than the "trained eye" or "taste" which originally guided the artistic arbiter.

This situation places the cultural broker at the very core of a contradiction: on one hand, she/he can be credited for helping to tear down artworld hierarchies, seemingly democratizing the space for cultural action; on the other hand, in a market scenario where "identity" can only be a reductive *construct*, the framing and

23

packaging of images of the collective self can only result in a highly delusionary enterprise. The tensions of this contradiction confront art curators with a dilemma: where should they position themselves vis-à-vis the identities of the groups they claim to represent? The type of market scenario that holds the representation of Latin American and Latino art in place offers a specific instance to fully engage this question.

THE CULTURAL-IDENTITIES MARKET: LATIN AMERICAN OR LATINO?

Approaching the issue of how Latin American art has been represented in the United States, and the role which curators have played in this process, requires recognizing that whatever is upheld as Latin American art *inside* the United States is invariably a reductive *trope*: that is, a meaningless expression having only minimal relation to the artistic development of the specific countries that make up our continent.[5] The history of the representation of this art in the United States since the forties, and the role which New York has played as center for its validation and distribution,[6] illustrate how the Latin American art trope has traditionally served to legitimate the cultural, political, and/or economic agendas of both North American and Latin American groups.

24

Whose interests does this construct serve in the nineties? Part of the difficulty of answering this question has to do with the way in which the ideology and politics of multiculturalism have subsumed the complexities of this phenomenon. The majority of the debates surrounding the representation of Latin American art in mainstream exhibitions have been articulated from the perspective of identity politics and the struggle for enfranchisement of Latino groups based in the United States. While according a place to Latin American artists inside North American museums and cultural institutions this situation has, in turn, produced a new *construct* in the form of a "melted" identity for Latin American and Latino artists. The common identity, promoted by both alternative and mainstream curators, is predicated on a shared legacy of Spanish colonialism, geographic displacement, racial discrimination, and marginalization within the hegemonic center represented by the United States.[7] The long-term impact of this process suggests a new form of cultural exchange between the United States and Latin America: one which originates from inside the US-based Latino community and its pressures upon the center of power itself.

In order to understand the forces at play in the representation of Latin American art in the United States, we must therefore distinguish between the pragmatic and ideological demands of the US-based Latino political project, and the specific conditions posed by the phenomenon of Latin American art *inside* the United States.

In the first case, the issues center on the struggle of Latino artists for equal access to art markets and institutions; in the second, what is at stake are the workings of an expanding transnational market of Latin American art. Despite the commonalities of language and culture between both groups, the divergent interests that guide them do not necessarily make for a natural alliance. I will thus approach "Latin American" and "Latino" as separate categories in order to understand how and why they differ, and if a common ground exists. To be effective, this task must be undertaken from the simultaneous perspective of "inside–outside"; that is to say, a perspective that takes into account the Latin American point of view inside and outside the United States, inside and outside the contested ground of multiculturalism.

From this bifocal perspective, the surge of Latin American art exhibitions and market activity since the mid-eighties can be seen as the result of tensions generated by two seemingly separate and contradictory processes: on one hand, the dynamics of global integration that are altering relationships between Latin America and the United States (as well as Latin America and the rest of the world); on the other, the politics of identity and multiculturalism that are transforming the United States itself. Despite their apparent contradiction, these processes are interdependent. Their interdependence is part of the way in which the demands of global market capitalism are impacting old and new concepts of identities. Contrary to a generalized fallacy, late consumer capitalism does not operate through cultural homogenization, but through the marketing of the appearance of "difference" and particularity. This consumer-capitalist logic is responsible for new notions of identities which result from an alternating process of adaptation/resistance to the complex demands for cultural symbols of consumer markets.[8]

The key to this process is the notion of a transnational market driven by nationalist or ethnically grounded images and symbols in the form of artistic commodities that disseminate meanings. For instance, the efforts undertaken in the last decade to integrate Latin American countries into the dynamics of a new world order have necessitated the exchange of cultural capital for access to financial and economic privileges.[9] One of the unacknowledged forms in which this exchange has taken place has been through art exhibitions, which under the semblance of collective representation have functioned to mask the complex process of validation of Latin American countries in global financial centers represented by New York. Further complementing this flow of identities from Latin America into the United States has been the presence of a post-civil-rights Latino political and artistic movement acting within the broader parameters of multiculturalism. As George Yúdice has established in his investigations of the US multicultural phenomenon, the emergence of the Latino movement, as well as of other multicultural groups, both

coincided with and was assisted by the rapid expansion of a consumer-oriented market of cultural symbols.[10] It was precisely the mainstream's omnivorous demands for symbols of Latin culture to placate the more radical demands of Latino groups that paved the way for the acceptance of Latin American art and identity in the United States. This fact suggests that the conflation of identities between Latin American and Latino artists registered by the recent exhibition boom, instead of presenting an alternative to the transnational flow of identities, is an expression of the same demand for easily marketable and consumable cultural symbols. As a result, curators who serve to broker the exchange between transnational and multicultural interest groups will not only have to confront the reality of competing notions of identity but will eventually be forced to choose between them. As evident in the case of Latin American versus Latino representation, what is gained by one group is lost by the other.

MAINSTREAMING IDENTITIES

The characteristics of the cultural-identities market, which supports current curatorial practices, further reassert that what is at stake in the representation of Latin American and Latino identity is a fallacious *construct* – a *mise en scène* of identity – at the service of specific interest groups. These groups include Latin American political or cultural elites, mainstream museums, specialized art markets, Latino activists, and consumer-oriented markets. The impact of these manifold groups on the transformation of curatorial roles will be outlined here by reference to key points in the history of the representation of Latin American and Latino art in the United States. Such a sketch will provide a historical perspective – thus far absent from considerations of this topic – which should serve to clarify the particularities of the present period. In doing so, however, a further distinction needs to be drawn. This involves separating the representation of Mexican art from that of South and Central America.

A series of special factors distinguish the Mexican case from that of its Latin American neighbors. The first, of course, is its strategic 2,000-mile border position. Next-door-neighbor status has produced a long uneasy history of conflict tempered by the fascination of Mexico's exotic culture to the North American imagination (a fascination that – incidentally – has been absent in the case of Canada, if we compare its relative invisibility in North American cultural circles). A second factor can be traced to the dynamics of cultural nationalism in Mexico. The 1910 Revolution forged an alliance between artists and the state which translated into an aggressive promotion of the arts on the part of the Mexican government. The combination of these two factors accounts for the long history of representation and self-

representation of Mexico in the United States.[11] A third factor is the active legacy –
whether recognized or not – of the Mexican Muralists and their school to at least two
generations of North American artists. This legacy resulted from both the physical
presence of *Los Tres Grandes* in the United States in the 1930s as well as from the
active embracement of their political and artistic model by the Chicano movement in
the 1970s and 1980s. Lastly, with the flurry of cultural exchange that preceded the
approval of NAFTA, we have seen a new surge of exhibitions of Mexican art and
artists which have once again repackaged the Mexican image for North American
audiences. In the present climate of multiculturalism, however, the new image of
Mexico has shed most of its exoticism in order to become the expression of a hybrid
border culture, a culture that owes as much to the Mexican nationalist past as to the
interface with North American, Chicano, and Latino art.

The case of South American art is different. Until the recent end of the Cold War
era, North American interest in the arts and culture of the southern continent was
dictated almost exclusively by the demands of "Big Stick" foreign policy. We can cite
at least two waves of exhibitions and collecting activity that establish important
precedents for the eighties boom. The first wave took place between 1940 and 1945,
at the peak of World War II. It was directly related to the United States' concerns
about Latin American sympathy for German, Italian, and Spanish fascism and their
potential infiltration of the Western Hemisphere.[12] In its role as the "latest and
strangest recruit in Uncle Sam's defense line-up" the Museum of Modern Art
organized eight exhibitions of Latin American art and began collecting efforts
during this five-year period.[13] Similar concerns over Latin America's potentially
subversive role surrounded the founding of the Pan American Union's exhibition
program in Washington, D.C. in the mid-forties. The establishment of this program,
which Eva Cockcroft characterized as "the beginning of the 'ghettoization' of Latin
American art" functioned as the major gateway of Latin American art into the
United States, until well into the eighties.[14]

Curatorial involvement with Latin American art during the war period was
predicated on open acknowledgment of the state of emergency and the ensuing
necessity of strengthening relations with neighbors to the South. Alfred H. Barr, the
influential chief curator of the Museum of Modern Art, observed how this political
bias mediated any discussion or appreciation of Latin American art in North
American circles.[15] Barr himself, describing his own curatorial efforts on behalf of
Latin American art, referred to them as "minor interventions," consisting of "a brief
visit, some genuine interest, and few purchases for little money."[16] As a result, the
representation of Latin American art that ensued from this interventionist policy was
a mixed bag which attempted cautiously to reconcile artistic products that were
"*international* in style or character" – that is, whose quality could be measured

according to the standards of European and North American Modernism – with the more problematic art based on "national or local values," generally thought to be conveyed in forms of "provincial realism."[17]

The second boom of Latin American art exhibitions took place between 1959 and 1970. This period establishes a closer precedent for the representation of Latin American art in the United States today. With the escalation of the Cold War, the upsurge created by the Cuban Revolution, and the emergence of the United States as economic and political superpower, Latin America's strategic importance intensified. Throughout most of the sixties, the amount of US investment in Latin American countries grew to unparalleled levels. Significantly, a larger portion of it went to cultural projects, including the private support, through the Ford and Rockefeller Foundations, of important institutions dedicated to the promotion of avant-garde art in Buenos Aires (i.e. the Instituto Torcuato di Tella) and Santiago de Chile.[18]

Latin American art and artists were once again brought to the attention of the North American public. More than thirty exhibitions of Latin American art took place in the United States in places as far ranging as Boston, New York, New Haven, Minneapolis, Dallas, Houston, Austin, and Lincoln (Nebraska).[19] Artists from all over Latin America (but mostly South America) were awarded Guggenheim Fellowships to spend time in the United States. A number of South American artists moved to New York, signalling the first of several subsequent artistic migrations. At the same time, important collections were initiated, such as the University of Texas at Austin Collection, complemented by important acquisitions on the part of mainstream institutions, namely the Guggenheim Museum. An international circuit was set in place, very similar to the one we have today, which facilitated artistic exchange.

These circumstances also signal the emergence of the curator as the central figure of an international network dominated by the growing power of private foundations, corporations, and elite business sectors. Lawrence Alloway, Thomas Messer, Stanton Catlin, Sam Hunter, José Gómez Sicre, and the Buenos Aires-based Jorge Romero Brest – assisted by occasional curious forays on the part of Clement Greenberg – shuttled back and forth between New York and the leading South American capitals *charting* the "internationalization" of Latin American art. Couched in the "'modernity' versus 'roots'" debate, the representation of Latin American art that resulted from this newly established artistic network was predicated on the absorption of the particular traits of Latin American identity into the homogenizing standard of Euro-American modernism, understood then as Abstract Expressionism and its variants. A regional version of identity was exchanged for access into the "universal" community of modern art.[20] In a similar way, Latin American attempts to gain equal access to the exhibition and market structures that supported this type

of artistic exchange soon faltered, due to its strongly biased and artificial nature. An exemplary instance of this failure was Jorge Romero Brest's unsuccessful attempts to stimulate an international market for Argentinean art through the promotional activities of the Instituto di Tella in Buenos Aires.[21]

In most Latin American countries, efforts towards internationalization, simultaneously met with strong resistance from the local intelligentsia who supported alternative models of political and cultural development. In this context, the first attempts to elaborate a critical curatorial practice that would take into account the Latin American point of view began to take shape. During the sixties, critics Marta Traba and Raquel Tibol, in the absence of the "professional" curator role, straddled the terrain of both.[22] Traba's assertion that "Today no Latin American exhibition is charged with meaning of its own. It is, or is not important to the extent of its relation to, and derivation, from, artistic forms alien to the continent,"[23] is indicative of the heated debates which sought to establish art and culture as the site of resistance to US imperialism. As a result of this critical legacy, and until very recently, the United States was not a focal point of cultural interest for Latin American artists.

By the early seventies, the conditions that facilitated this type of artistic exchange between Latin American countries and the United States disappeared as a result of political dictatorships that sealed off a number of the most important South American countries from the rest of the world. It was not until the mid-eighties, when the third wave of exhibitions and market activity surprised the North American artworld, that Latin American art again captured the attention of North American cultural circles. What is unprecedented about this third period, however, is that by this time, the economic and political factors that had made Latin America attractive to the United States appeared to have considerably diminished. That is to say, with the thawing of the Cold War, the dissolution of authoritarian regimes, and the huge foreign debt, Latin America does not hold the same strategic appeal for the United States. Therefore, the parameters of foreign policy alone do not dictate cultural interaction.

Thus, we are back to the question posed at the beginning of this essay: how can we explain whose interests the Latin American art *construct* served in the eighties and nineties? The usual explanation points to the unpredictable whims of an art market overinflated with European art and attracted to the cheap prices of Latin American art.[24] While there is an element of truth in this explanation, it leaves aside important developments that were already in place. It is important to understand that, by the mid-eighties, the most important countries underwent a series of political and economic transformations associated with the re-establishment of democracies and the coming to power of neo-liberal governments. The neo-liberal emphasis on

29

privatization, free markets, and regional trade agreements, in particular, led to the substitution of traditional subsidies for art and artists with a more active market structure that significantly opened up the cultural spheres of these countries to the dynamics of transnational, global exchange.

Neo-liberalism has accorded an important, if not yet fully recognized, function to the visual arts. This new function has, in turn, created a very complex space for their production and distribution. I dare to characterize this new domain in terms of three interrelated factors. First, contrary to the fixed locale of the nation-state, this space is no longer circumscribed or determined by national or regional borders. Instead, it consists of a fluid transit of artists, exhibitions, curators, private sponsorship, and a novel breed of entrepreneurial collectors who circulate between the international art centers and the Latin American capitals. Here, it is important to stress that while some of these transformations have been taking place since the sixties, the intensity with which they are unfolding today is unprecedented. The second characteristic of this flexible space is that it is largely controlled by the promotional and financial interests of neo-liberal private sectors which, since the late seventies have increasingly taken over the role of art patronage previously held by national governments. Thus, whereas, in the past, the visual arts functioned as banners of prestige for nationalist states, today they can be seen to embody a type of marketing tool for Latin American neo-liberal economic elites.[25]

A third factor is one that I think has gone largely unnoticed. It refers to the active role which Latin American financial interests have played in promoting the third exhibition and market "boom" of Latin American art. It is time to recognize that this boom was not so much an imperialist plot to co-opt Latin American art – as it is too fondly portrayed – but a phenomenon directly or indirectly associated with the self-promotion of Latin American economic interests (particularly Mexican, Colombian, Venezuelan and Cuban–American economic elites) in the United States and Western Europe. It is not by chance that the most sought after Latin American artists in the auctions held by Sotheby's or Christie's are all indigenous to these countries, where the strongest accumulation of Latin American capital is located. The nature of the boom itself serves to support this point. Unlike the phenomenon of the sixties, which concentrated on contemporary art, the exhibition and market boom of the eighties was strongly focused on the work of established "masters" active largely during the decades of 1920–40. This period, as we know, saw the consolidation of the national state throughout most of Latin America, and therefore represents the point of origin for Latin America's modernizing elite. The erasure of the conflict-ridden sixties and seventies from the ensuing mainstream account of Latin American art can only suggest two things: first, the neo-liberal elites' search for legitimation of their origins in an essentialist, ultimately reductive, account of the

30

cultural achievements of the twenties and thirties; second, the recognition of the
positive achievements of their modernization project.

A further example of the above trend is that, for the first time ever, we have seen
the presentation in the United States and Europe of a number of monumental and
very influential exhibitions organized by Latin American curators or US–Latin
American curatorial teams, and underwritten by Latin American financial
investment groups. The first of these exhibitions, entitled *Myth and Magic in America:
The Eighties*, was organized in 1991 by Mexico's Museo de Arte Contemporáneo de
Monterrey with monies provided by the Monterrey-based Alpha group. It was
followed by the Metropolitan Museum's *Mexico: Splendors of Thirty Centuries*, an
exhibition financed by the television conglomerate of Televisa and a consortium of
private interests.[26] Both exhibitions were organized and presented during the hype
that accompanied the early negotiation of the North American Free Trade
Agreement.

The notion of Mexican and Latin American identity set forth in these exhibitions
illustrates the logic of adaptation to the demands of the new economic order. Based
on the same model of "de-territorialization" and elimination of borders predicated
by the recently enacted regional trade agreement, *Myth and Magic* presented a
mammoth review of eighties painting from Canada, the United States, and Latin
America. *Splendors of Mexico*, on the other hand, reverted to the homogenizing
survey format in order to present the univocal, linear narrative of Mexico's thirty
centuries of artistic history, a history which stopped with the figures of Diego Rivera
and Frida Kahlo, well-known and appreciated celebrities of the art market. In both
cases an attractive model of Latin American identity was exchanged for the promise
of political and economic privileges. A third instance was MOMA's *Latin American
Artists of the Twentieth Century*, a blockbuster endorsed by the Latin American
contingent of the museum's International Council and financed with monies from
Venezuela and the United States. This showbiz was the final step in the
consolidation and legitimation of what could be considered the bilateral
master-framework of the modern art of this region taking shape since the
mid-eighties.[27]

The complexities of the present scenario of United States/Latin American
relations have had a definite impact on the role of curatorial practices vis-à-vis the
representation of Latin American art. The organic vacuum produced by the crisis of
oppositional movements in Latin America, the disappearance of the bi-polar
framework that articulated practices of resistance, and their substitution by the
neo-liberal market framework, has all but displaced artists and intellectuals from
their traditional roles in the public spheres of these countries.[28] In their stead, the
curator has emerged as the primary agent of a large network of privatized interests.

31

The new conditions have dictated that the curator transform him or herself into "a transnational citizen, responsible for a cartography of the dissolution of cultural frontiers."[29] This has implied exchanging the ethical position of the "resistant critic" for the neutral role of "cultural broker."

The history of the representation of Latino groups in the United States contrasts sharply with that of Latin American art, outlined so far. It is important to remember that like other ethnic minorities, Latinos had been systematically excluded from the North American artworld until well into the eighties, when the Houston Museum of Fine Arts' *Hispanic Art in the United States: Thirty Contemporary Painters and Sculptors* first accorded them an official, if highly reductive and distorted place, in North American art history.[30] In other words, at the time when North American curators were championing the "internationalization" of Latin American art, Latino art was all but ignored by North American institutions. As a result of this extremely biased situation, the representation of Latino art was largely undertaken by Latinos themselves in the contestatary ground of public walls, community art centers, and culturally specific museums. This strategy gave rise to a highly successful model of *self-representation* which went hand in hand with the role played by the art of Latino groups – particularly that of Chicanos and Puerto Ricans – in the civil-rights movement. The existence of this model accounts for the different way in which Latinos have been represented. In contrast to Latin Americans, who have been the facile prey of mainstream curators, the majority of exhibitions organized by Latinos have been organized by artist-activists or educators with strong ties to their communities. Only recently have we seen the emergence of professional curators amongst this group. The results of the present merging of transnational and multicultural agendas, however, has significantly altered the parameters of action of Latino groups. With the increase in demand for Latino art, many artists from these previously marginalized communities have been entering the mainstream. To the extent that this process has implied their appropriation by mainstream institutions, the parameters of the self-representation model have been eroded. This takeover has forced the acceptance of Latino art on the basis of an essentialist "difference" or desirable "otherness," categories which have come to define and institute a new standard of conformity to the parameters of the global system.

The representation of Latin American art encouraged by multiculturalism and exemplified by *The Decade Show*, organized in 1990 by three New York-based alternative museums, is an equally problematic one. Under the category of "Latino/Latin American," *The Decade Show* presented a broad spectrum of works by artists from Central and South America, comparing them as a homogenous block to those of African-, Asian-, Native-, and Anglo-American artists. This type of representational strategy – which pitted Latin American and Latinos in a common

32

front against the dominant white Anglo society – was aimed at legitimizing the art of these groups within the struggle for enfranchisement of US minorities.[31] In doing so, it only succeeded in masking the fragile and uneasy alliance between the extremely diverse groups embodied in the Latin American/Latino category. This uneasiness originates in the vast differences of class, ethnicity, political, and artistic perspectives that separate these groups of artists. For instance, while the majority of South American artists are of upper- or middle-class origins, Chicano and Puerto Rican artists trace their origins to the immigrant rural or urban working class. Finding a common ground amongst these groups could only imply recognizing their diverging positions and the impossibility of effecting a smooth alignment between them.

One ironic offshoot of this situation has been the "mainstreaming" of Latin American art as "marginal," a term that could only be used formerly to describe Latino art's position with respect to the institutions that exercise power in US society. Such a status, however, is more difficult to sustain with respect to Latin American artists who "make it" in the United States, as they are already positioned in one way or another within the transnational art circuit. (This has, incidentally, given rise to the category of "marginal-international.") The mainstreaming of Latin American art as "marginal" has further complicated the tensions between these groups of artists. For, while Latino art has served to broker the acceptance of Latin American identity in US institutions, it has not gained equal access to them. Mainstream public museums, under pressure to represent Latino artists, invariably manage to displace their responsibility by buying Latin American art, whose value is well established in the market.[32] As a result, attempts to create a real market for Latino art have been slow to materialize. The controversies that accompanied the organization of a number of recent shows – such as the Whitney's 1993 Biennial, MOMA's Latin American blockbuster, and the Huntington Art Gallery's *Encounters/Displacements* – led mostly by Chicano artists, indicate a similar process at work with regard to exhibitions.

For Latin Americans, a further consequence of this contradictory dynamic has also implied their forced acceptance into the US artworld on the basis of "difference." This tendency was clearly illustrated in *The Decade Show*, where the artistic production of each group was presented in terms of exotic cultural attributes and symbols which served as a point of contrast with Anglo culture. The implications for Mexican, South American, Central American, and Puerto Rican artists who do not conform to the new rules, whose art cannot be formally differentiated in any significant way to that of North American artists, are the same as twenty years ago. If, in the past, their work was rejected because it was not in line with international trends, today it is rejected because it does not reflect the new type

33

of "multicultural" art. The new exaltation of difference and particularity that prevails is, in essence, another form of cultural colonialism.

The representation of Latin American art in the United States is the result of contradictory tensions between the drive towards *integration* represented by transnational interests and the democratic aperture exemplified by *multiculturalism*. The exchange between these two interest groups is being brokered through notions of identity, a fact which has created a demand for exhibitions focused on setting up ready-made frameworks of identity for these artistic groups. The dynamics of this phenomenon have placed the curator of contemporary art in the role of cultural broker. Yet curators who choose to act as brokers of this exchange face a no-exit situation, as opting for either model of identity will ultimately contradict or exclude others. Instead of offering alternatives, this situation has only continued to reiterate already institutionalized exclusionary practices. It has also blocked the acceptance of the intrinsic heterogeneity that constitutes the ethnic and cultural experience of each group of artists and the multiple ways in which each group is negotiating its identity with the powers that be. Recognizing this pluralism also implies acknowledging that the differences and antagonisms within each group of artists cannot be easily aligned under one particular representation of group identity.[33]

34

CONCLUSIONS: FOR A RENEWAL OF CURATORIAL PRACTICES

To accept the contradictions posed by conditions which contain the practice of contemporary-art curators today implies an open recognition of the workings of the cultural-identities market as well as of the intermediate function played by the curator in this type of scenario. From this point of view, curators must be able to recognize that what holds an individual or group together cannot be reduced to a particular set of traits or to a specific essence embodied in art. Neither can it be apprehended in a single exhibition or collection. The particular notions of identity promoted by transnational markets, in any case, result from the position of a particular artist, group, or practice vis-à-vis the transnational market structure in which it is inscribed. Therefore, it is to the diversity of each group's experience, in its contradictory stances and multiplicity of approaches towards art, that curators must turn their attention. This approach should ultimately pave the way for new exhibition models and a more authentic renewal of curatorial practices.

In conclusion, however, I would like to raise two series of questions that should further clarify why such a renewal is impossible at the present time. The first question concerns the role of curators with respect to the artistic production of marginal or peripheral groups. By marginal, I mean marginal, not "marginal-international." To what extent, for instance, is the artistic production of a

Bolivian or Nicaraguan artist – to take two examples far removed from the circuit – capable of generating exhibition interest outside of the parameters dictated by the transnational circuit of "cultural identities"? Where should curators position themselves vis-à-vis the self-serving interests that regulate the function of this network? The second question concerns the potential of art curators for articulating a critical practice in the type of scenario described here. Given the reductive dynamic of transnational markets and their questionable impact on curatorial practices, is it worthwhile even to raise the question of a critical curatorial practice? To what extent is this attempt "overdetermined" by the nature of the distribution, validation, and legitimation of art in a world increasingly driven by the marketing and consumption of false difference? Or, to pose the question in another way, to what extent is such an attempt defeated from the start by the bonds that directly or indirectly link our practice to the self-serving interests of privatized markets? Any attempt to envision the future of a critical curatorial practice in the present conditions inevitably leads into a blind alley.

NOTES

This essay is a revised version of a talk given at a working seminar at the Center for Curatorial Studies, Bard College, 15–17 April 1994. The author is grateful to the Center for Curatorial Studies for having allowed its reproduction in this volume.

1 The term "identity politics" refers to the movement for democratic rights undertaken in recent years by groups that until now have been on the fringes of the centers of power. This includes the so-called "new social movements" (women, ethnic groups, gays and lesbians, and other marginal or peripheral constituencies). All of these movements have relied strongly on the symbolic discourse of culture to convey their messages, hence the importance of art for each of them.

2 For a discussion of curators vis-à-vis issues of power, see Susan M. Pearce, *Museums, Objects, and Collections: A Cultural Study*, Leicester, Leicester University Press, 1992; repr. Washington, D.C., Smithsonian Institution Press, 1993, pp. 232–5.

3 Gerardo Mosquera has incisively analyzed this phenomenon in his text, "Power and the intercultural circulation of art," paper delivered at a Getty-sponsored conference on *Art and Power* in 1994.

4 See Ulf Hannerz, "Scenarios for peripheral cultures," in *Culture, Globalization, and the World System: Contemporary Conditions for the Representation of Identity*, ed. Anthony D. King, Current Debates in Art History 3, Binghampton, New York, Department of Art and Art History, State University of New York, 1991, pp. 107–28.

5 The term Latin America itself, as we know, is homogenizing and ultimately useless. Unlike the racially or ethnically defined terms African or Native American, "Latin American" does not refer to a specific race or etnia. It is, rather, a term denotative of a cultural and geographic region which encompasses more than twenty nation-states of broad socio-economic, racial, and ethnic diversity; a diversity that manifests itself not

only between the individual countries, but within each country itself. Behind an unevenly shared legacy of European colonialism, language, and religion, are highly mixed societies whose dynamic of transculturation has produced not one, but many hybrid cultures. This distinction, I must add, applies also to the Latino population of the United States, which comprises the Mexican–American, Puerto Rican, and Cuban–American communities, as well as Central and South American groups. Despite the North American tendency to reduce culture exclusively to race, Latinos do not constitute a "race" or "etnia" by themselves; they are rather an amalgam of races, classes, and nationalities that resist easy classification or categorization. For the uses of the Latin American art trope in recent exhibitions, see my "Beyond the 'fantastic': framing identity in U.S. exhibitions of Latin American art," *Art Journal*, 51:4 (1994), pp. 60–8.

6 Further distinguishing the Latin American case in the United States is a relatively strong and stable art market complemented by a budding professional and institutional infrastructure. Latin American art enjoys a category in and of itself in the regular auction programs of Sotheby's and Christie's. Separate status has generated a highly specialized group of buyers and gallery dealers concentrated in New York and, most recently, Miami. It has also created a need for specialized curators of Latin American art. Indeed, since the late eighties, several museums across the nation have added curators of Latin American art to their body of staff while simultaneously initiating collecting efforts in this area. Latinos (as well as other US-based ethnic groups), not only lack similar mainstream institutional or market structures, but, as I hope to illustrate later on, have for the most part been denied access to them.

7 I have elaborated on the problems posed by this "melted" identity in my "Between two waters: image and identity in Latino-American art," in *American Visions/Visiones de las Américas: Artistic and Cultural Identity in the Western Hemisphere*, ed. Noreen Tomassi, Mary Jane Jacob, and Ivo Mesquita, New York, ACA Books/Allworth Press, 1994, pp. 8–18.

8 For the full implications of this process, see George Yúdice, "Globalización e intermediación cultural," in *Identidades, políticas e integración regional*, ed. Hugo Achugar, Montevideo, FESUR, 1994, n. p.

9 For the impact of these economic transformations on Latin American culture, see Néstor García Canclini, *Culturas Híbridas: Estrategias para entrar y salir de la modernidad*, Mexico, Grijalbo, 1990, pp. 81–93; and "Cultural reconversion," in *On Edge: The Crisis of Contemporary Latin American Culture*, ed. George Yúdice, Jean Franco, and Juan Flores, Minneapolis, University of Minnesota Press, 1992, pp. 35–6.

10 See Yúdice, "Globalización e intermediación cultural," n.p.

11 The representation of Mexican art in the United States between 1920 and 1950 is discussed by Eva Cockcroft, "The United States and socially concerned Latin American art," in *The Latin American Spirit: Art and Artists in the United States, 1920–1970*, ed. Luis Carcel, New York, Bronx Museum of the Arts, 1988, pp. 184–91.

12 A partial discussion of exhibitions of Latin American art organized before the 1980s can be found in ibid., pp. 191–212.

13 Ibid., pp. 192 and 194.

14 Ibid., p. 194. The establishment of the Pan-American Union's exhibition program (today the Organization of Latin American States-sponsored Museum of Modern Art of Latin America) was followed by the activities of the Center for Inter-American Relations (now the Americas Society) established in 1970. Both served as entry points to

depoliticize Latin American art and relieve mainstream institutions of having to exhibit it.

15 Alfred H. Barr, "Problems of research and documentation in contemporary Latin American art," in *Studies in Latin American Art: Proceedings of a Conference Held at the Museum of Modern Art New York, 28–31 May 1945*, ed. Elizabeth Wilder, New York, American Council of Learned Societies, 1949, pp. 38–9.

16 Ibid., p. 41.

17 Ibid., p. 39 (emphasis in original).

18 See John King, *El di Tella y el desarrollo cultural argentino en la década del sesenta*, Buenos Aires, Ediciones de Arte Gaglianone, 1985, pp. 18–19 and 35–42; and Néstor García Canclini, *La producción simbólica: Teoría y método en sociología del arte*, Mexico, Siglo Veintiuno Editores, 1979, 1988, pp. 100–8.

19 The most influential exhibitions of the period were *The Emergent Decade: Latin American Painting in the 1960s*, organized by Thomas Messer at the Solomon R. Guggenheim Museum in New York in 1966, and *Art of Latin America since Independence*, organized that same year by Stanton Catlin and Terence Grieder at the Yale University Art Gallery in New Haven, Connecticut.

20 Lawrence Alloway, "Latin America and international art," *Art in America*, 53 (1965), pp. 66–7. For an overview of the issues being debated in exhibitions of the period, see Cockroft, "The United States and socially concerned Latin American art," pp. 201–12.

21 Lawrence Alloway, interviewed in King, *El di Tella*, pp. 255–7.

22 See Marta Traba, *Dos décadas vulnerables en las artes plásticas latinoamericanas 1950–1970*, Mexico, Siglo Veintiuno Editores, 1973; Raquel Tibol, *Confrontaciones. Crónica y recuento*, Mexico, Ediciones Sámara, 1992.

23 Cited in Alloway, "Latin America and international art," p. 66.

24 Early considerations of this question were Shifra Goldman's articles, "Latin American arts U.S. explosion: looking a gift horse in the mouth," *New Art Examiner*, 17 (Dec. 1989), pp. 25–9; and "Latin visions and revisions," *Art in America*, May 1988, pp. 138–49. More recently, George Yúdice has cited the low prices of Latin American works as one of the reasons for the recent explosion of Latin American art in the US mainstream. See "Globalización e intermediación cultural," p. 8.

25 See García Canclini, *Cúlturas híbridas*, pp. 81–93.

26 *Mito y magia en América: Los Ochenta*, ed. Guillermina Olmedo, Monterrey, Museo de Arte Contemporáneo de Monterrey, 1991; and, *Mexico: Splendors of Thirty Centuries*, New York, Metropolitan Museum of Art, 1990.

27 *Latin American Artists of the Twentieth Century*, ed. Waldo Rasmussen, New York, Museum of Modern Art, 1993.

28 See Yúdice, "Globalización e intermediación cultural," n.p.

29 Ivo Mesquita, *Cartographies*, Winnipeg, Winnipeg Art Gallery, 1993, pp. 13–62.

30 See, for instance, Jacinto Quirarte, "Exhibitions of Chicano art: 1965 to the present," in *CARA. Chicano Art: Resistance and Affirmation*, Los Angeles, Wight Art Gallery, University of California, Los Angeles, 1991, pp. 163–7.

31 *The Decade Show: Frameworks of Identity in the 1980's*, New York, Museum of Contemporary Hispanic Art, The New Museum of Contemporary Art and The Studio Museum in Harlem, 1990.

32 Chon Noriega has argued a similar point in "Installed in America," in Noriega and José Piedra, eds, *Revelaciones: Hispanic Art of Evanescence*, Ithaca, New York, Herbert F. Johnson Museum of Art, Cornell University, 1993, n.p.

33 As Stuart Hall has observed with respect to African-American artists, "[The point is] ... that these antagonisms refuse to be neatly aligned; they are simply not reducible to one another; they refuse to coalesce around a single axis of differentiation. We are always in negotiation, not with a single set of oppositions that place us in the same relation to others, but with a series of different positionalities ... [which] are often dislocating in relation to one another" (*Black Popular Culture: A Project by Michelle Wallace*, ed. Gina Dent, Seattle, Bay Press, 1992, pp. 30–1).

3

LARGE EXHIBITIONS
A sketch of a typology

Jean-Marc Poinsot

Contemporary art comes to us through the medium of the exhibition. History has
shown that the other ways it makes itself manifest are fast becoming obsolete and
regressive, no longer mobilizing talent, resources or attention.

It has been quite a while since exhibitions outgrew their original ostentatious
stage, claiming an aesthetic status for artwork independent of the constraints
imposed by a commission. For artists, these constraints now permanently form an
integral part of their aesthetic project (even for those who produce paintings to be
framed).

Exhibitions are far from being merely a staging of the aesthetic projects of their
participants. Other discourses become embroiled with those of the artists. Certain

among them are manifestly stronger and more evident in exhibitions of larger scope. These affirm, in a scarcely veiled manner, their pretension in thinking of aesthetic models, in constructing history or even in making art a utopia for society.[1]

Such exhibition manifestations often have the amplitude of a museum collection in the number of pieces presented, their quality, chronological extension and the cultural area concerned. More than any museum, exhibitions collect – without suffering the consequences of the obstacles that isolate or disperse works – works of art which, when gathered together, acquire a normative value or a programme of reproduction. By mobilizing material and intellectual means without measures common to permanent exhibitions, they can concretely produce, with a relatively short delay, what has been elaborated for countless years in museums and in books on the history and theory of art. The essential characteristic of these temporary events cannot be reduced to a question of dimension and means; the desire to bring together in thought what have hitherto appeared to be separate, coherent and homogenous entities and to redistribute what seemed preordained is what bestows upon temporary exhibitions a theoretical value and what makes them 'exhibitions'.[2]

This functions to cancel, in a sense, earlier exhibitions and exempts visitors from a relation to reality, situating them within the sole new order proposed. To a greater degree than all others, these exhibitions are animated by a project which can in no way be confused with the aesthetic project of artists.

Somewhere between the degree-zero presentation certain practitioners claimed in the late sixties[3] and the full museum of obsessions, the ideology of presentation has moved from transparency to opacity, from the erasure of aesthetic projects to their over-determination. During the same period, the utopian model of the museum evolved from an ancillary and functional architecture – a metaphor for the museum's non-intervention in the meanings of artworks by a refusal of all specificity – to an architecture reaffirmed by its enclosure, its hierarchic organization of spaces, its permanence and its symbolic value as monument.

The excess of meaning invested in the exhibition and the museum demands an inquiry into the capacity of the exhibition to conduct a truly structured discourse and justifies the enterprise in which this text is a participant. What I would like to come to grips with is as follows: at the time that several exhibition events were inscribed, in what manner was the activity of the presentation distributed around a restricted number of basic notions, types of intervention and models for constructing artistic reality?

40

WRITING HISTORY

Around 1980, certain museums and exhibition organizers demonstrated the need to advance the writing of history, proposing appraisals which would redistribute works and events. The opening of the Centre Pompidou justified the large-scale exhibitions *Paris/New York*, *Paris/Berlin*, *Paris/Moscow* and *Paris/Paris* between 1977 and 1981. Once the series came to a close, Cologne's *Westkunst* proposed its own version of the history of 'occidental' art in one huge sweeping exhibition. To these monumental compilations, Amsterdam's Stedelijk Museum added its own assessment of an admittedly shorter period between 1960 and 1980 and the jury, as it were, is still out. Interest in these exhibitions, particularly *60/80*, *Westkunst* and *Paris/Paris*, centres on the ways in which clearly distinct theses concerning the organization of the temporality of contemporary art were put into practice.[4]

Natural History

> The goal of the exhibition *60/80: attitudes, concepts, images* is not to present a graphic description of the evolution of the visual arts during the period mentioned in the title. It is almost a reflection of an attempt to relive the memory of two decades that are among the most turbulent in 20th Century art. Not only have we tried to align and confront the more relevant ideas and uncommon personalities of the period but, by so doing, we are attempting to evoke an image of future developments.[5]

From the first few phrases of his preface, Eddy de Wilde clearly stated his intention: not to drain recent art of its vitality under the pretext of explaining it. De Wilde refused the position of outside observer, preferring to underline the projective value of the works included. He also wanted, along with Ad Pedersen, who mounted the exhibition, to protect the works from any intervention which would opacify their perception. Each recognized the great amount of activity during the chosen period and the inherent difficulties of analysing it – the critics not having clearly elucidated the period – and they considered that a thorough selection was of more worth than their discourses. The sole important characteristic for Ad Pedersen resided in the fact that art had ruptured its traditional boundaries and extended its domain.

> In order to communicate, an artist can choose the kind of expression, medium and style which is best-suited to his/her ideas. Photography, film, video, music, performance, theatre and dance are all forms which have been integrated into artistic practice.[6]

There would be no point in doubting that the artist remained the only true point of reference. If Ad Pedersen specified that he had selected the most innovative works

and those marking the artist's first contact with the avant-garde, the actual selection was not aimed at reducing the work of each artist to the instance of its encounter with history. Safe from the various machinations of history, the works are concerned only with time.

> I held obstinately to my desire to give the exhibition a more-or-less chronological shape to the extent that this provides an evident basic organization which is not perceived as an importunate structure.
>
> (ibid, p. 1)

The passage of time should thus be the natural background against which a number of aesthetic facts come to light; in and of themselves, the collective events of artistic life (exhibitions or critical categories) have little bearing on those facts. The recourse to the universal chronological model, the notation of the extremely voluminous facts of language and the selection of original works maintains a distance which other 'historical' exhibitions have solved by a juxtaposition, without admixture, between the chronological order of the document and the spatial distribution of the works.

42

➡ **3.1 *Westkunst*, view of 'Nouveau Realiste' room (R. Hains, Y. Klein *et al.*) in *Westkunst* exhibition, Cologne, 1981. Photography courtesy of Kasper König.**

In the arrangement of the *Identité italienne* exhibition,[7] one was faced with the confrontation between a voluntarily nourished sequence of events (panels and windows covered with documents) and a series of works from the same artist's body of work. By accumulating documentation in certain exhibition areas or in the catalogue, one can, in a certain sense, conjure the effect of time on the works. While remaining in real time, such manifestations can organize memory without having to construct a temporality. For this reason they most often remain content with the most 'natural' measurement of time: the calendar.[8]

Historicism and Formalist History
Westkunst: Zeitgenössische Kunst seit 1939 and *Paris/Paris: créations en France 1937–1957* had to resolve – in the same year and general context – the presentation of artistic creation in the mid-twentieth century. Both exhibitions sought to write history and both were closely compared in the art press. In my opinion, nothing characterizes the difference between these two events more than the elaboration of their interior architectures, in so far as they were created by the works themselves.

Paris/Paris offered an itinerary constructed along a circulation corridor whose

walls, covered with artworks, at times opened on to larger and quite frequently fragmented spaces. The relative exiguity of the rooms, the manner in which their interiors were deployed and the large number of exposed objects combined to present the visitor with a very linear, yet labyrinthical, passage.

The organizers of *Westkunst* developed their interior architecture from the standpoint of conventional museological space. They established a celebratory architecture, a series of vast spaces, often flanked by lateral appendages. Pillars and thick walls served to reassure the visitor of the permanence of the frame when the decor was, in fact, very light. Bright walls and diffused lighting combined to make the rooms appear larger. Work from the seventies was housed in a section, partitioned at intervals, which had no enclosed spaces; contemporary work was found in identical parallel rooms, each opening to the next at a common angle but with no corridors. The slow rhythm of separate large bright spaces preceded an open, non-structured space and a uniform grid. What could be a more evident metaphor for the workings of history? The architecture suggested a structure for circulation and the symbolic charge of its emplacement differentiated the ambiance of discovering artworks in terms of their situation in time.[9]

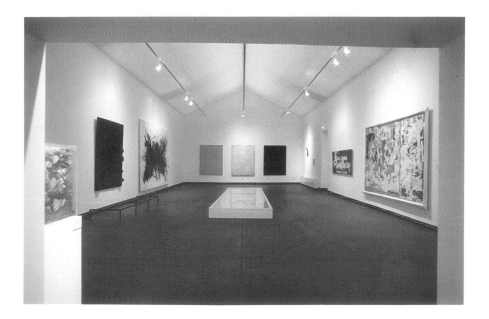

The exhibition *Paris/Paris* underwent difficulties due to the stance it assumed. The desire to treat literature, music, design, the environment and particularities of artistic debate, etc., led to a very fragmented distribution of space. This was articulated on two levels, offering a differentiated treatment to the ensuing objects and the processing accorded them. An oppositional structure, whose shape changed according to zone, dissociated documentation from the major works. Artworks summoned more for their marking of history in general, a respect for the calendar of political events, or as a chronicle of their aesthetic impact, were arranged in tight rows on dark or non-contrasting backgrounds and in the frequent proximity of accompanying documents (drawings, texts, photographs, various documentation, catalogues, etc.). Works selected for their artistic qualities appeared less numerous, grouped in spaces which were more actualized (dark Giacomettis in a white hall, bright Dubuffets on sombre walls) and, finally, protected from the too close presence of the visitor. Fougeron, the evocation of the Picasso who painted *Guernica*, or even Fautrier and his hostages derive from general history while Giacometti, Picasso, Dubuffet or the abstractions clearly derived from art.

The historicist concept which dominated this exhibition explicitly found

44 ➡ **3.2 Claes Oldenburg, *The Store*, 1961, installation view. Photograph by Robert R. McElroy, New York.**

expression in excess, in the transformation of a large portion of the works into historical documents and their insertion into predetermined contexts. There was a levelling tendency, the result of bestowing equivalent value to current events, films, kitchen appliances and works by this or that artist. This conception of art history is accentuated by the Centre Pompidou's institutional multidisciplinarity. It has found in the exhibition rhetoric of museums of ideas and objects, such as the Bibliothèque publique d'information and the Centre de création industrielle, a way to treat 'modern' works of art that allows it to postulate that in art history, history is as, if not more, important than art. Historicism which derives from multidisciplinarity and an historicism anxious not to forget anything leaves open the way for masterpieces. Occupying their position in the temporal sequence, these masterpieces, while perhaps bearing the marks of time, could not participate in structuring it. They were, at best, marginal.

Westkunst, for its part, scaled down any evocation of events external to art; its chronological division included a period when art and artists in particular were severely tested by history. Not once are the works summoned as documentation of a history other than that of art.[10] In this, *Westkunst* was in step with a formalist

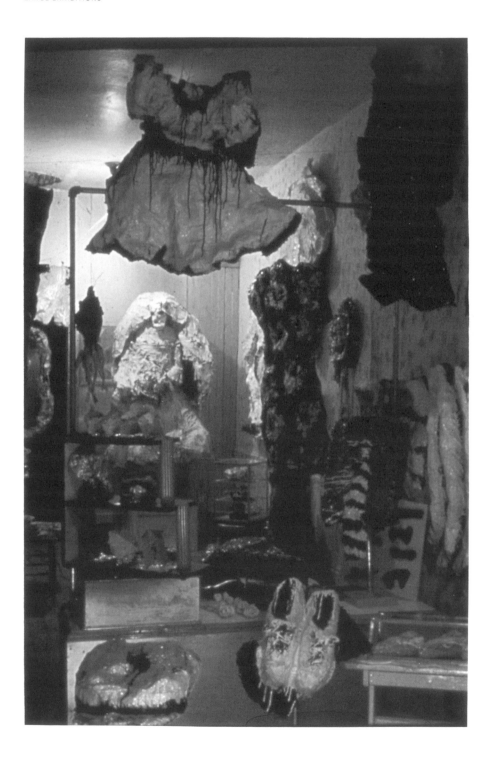

tradition issuing from Wölfflin, a prominent figure in the development of The Museum of Modern Art in New York and the modernist theses which assured its coherence. The works were grouped in coherent series according to a formal, historical (in terms of production) and iconographic framework. When the work was produced as part of a homogenous ensemble, it was reconstituted in its entirety. Not one non-artistic object could be found amidst the works. The exhibition was organized according to an historical progression with its proper temporality; in other words, it had its own particular developments, its own hierarchy based on the relative position of the work of this or that artist.[11]

Westkunst shared a practice with *Paris/Paris* which the Centre Pompidou imposed with the first exhibition of its *Paris/New York* inaugural cycle: the reconstitution of the situations surrounding the works' appearance. This practice offered the very interesting possibility of placing the viewer as close as possible to the initial presentation of a series of works which was often conceived to appear in its entirety, or confronting the viewer with a characteristic artistic debate which raged at the time. From among several examples, I will cite Oldenburg's *The Store* or *L'Exposition internationale du Surréalisme* in 1938.

This practice makes plain the manner in which numerous contemporary artists organize the form and thematics of their production in terms of the fact of exhibitions. It would also explain why exhibitions which punctuate the history of twentieth-century art are not limited to being the first occasion of certain works' public appearance and why they, in and of themselves, constitute a cultural fact. These reconstitutions are capable – to a greater extent than the selection of unique works – of structuring the proposition with evidence. Thus, they compensate for the inevitable dilution of ideas resulting from the expanding scale of exhibitions by offering particularly spectacular claims, but they cannot escape the general organization of meanings imposed by the overall context of the exhibition.[12]

Therefore, the presentation of Fautrier's *Otages* in *Paris/Paris* attracted more attention than did the painter's other works which were shown in a more diffuse manner in other rooms; in this way, the value of historical testimony was privileged in terms of aesthetic content (the redundancy of presenting works by Fautrier in several sites in the exhibition cannot but confirm the separation of the historical and aesthetic roles attributed to the various works).

At *Westkunst*, the same *Otages* took on a different, more formal meaning. The context of the Cologne exhibition made the reconstitution of a room in Paris's *Salon de la jeune peinture* of 1967 all the more problematic in that it did not seek to evince the ideological context in which Buren, Mosset, Parmentier and Toroni developed.

These three principal models for exhibiting the history of art informed the structure and shape of less important or more sector-based events.

'Natural' history favours monographic exhibitions centring on an artist's strong
work (even when they are atypical in terms of art history) and events that group
works with common thematics or problematics while avoiding presenting
ready-made or acknowledged movements.

Historicism compiles monographic exhibitions which include evocations of a
single artist's life, testimonials by privileged witnesses (a critic, a dealer, a collector)
or outlines of cultural movements of limited duration given the totality of their
history.

Historism, historicism's variant, is devoted to researching themes concerning the
dilution of the aesthetic fact, and is extremely sensitive to ideological events.

Formalist history does not neglect the influence of monographic exhibitions on
movements whose historical existence it has established by placing a particular accent
on instances of rupture and innovation. Proceding in the same fashion with the
works of each artist, it focuses attention on a specific, demarcated aspect which is
considered major or striking (Cézanne's later work, Stella's 'Black Paintings').

Formalist art history is largely constructed on masterpieces and star players
whereas historicism tolerates the exceptional category of objects upon which history
has no claim and recognizes that it cannot constitute historical events.

47

ENUNCIATING PROJECTS AND THEIR AESTHETIC VALUES

The exhibition as work of art

Towards the end of the fifties a novel aesthetic experience appeared as a substitute
for an ambulatory contemplation of autonomous objects, severed from any context
and cumulatively mounted: situating the spectator. Faced with Klein's 'void',
Arman's 'fullness' and the environments of Kaprow and Oldenburg, viewers no
longer came to visit; they came to live an experience from which it would be difficult
to maintain a distance.[13]

The work of art as object was gradually erased by the increasing use of the
convention of the exhibition as a form of aesthetic experience. Whether empty or
full, labyrinth or stall, the exhibition site was assimilated by the artist, leaving the
viewer incapable of grasping anything beyond the experience that had been
proposed. The exhibition exhausted itself in contemplation. All that remained was
the memory of a moment lived.

Diverse modalities have characterized the exhibition's transformation into a direct
discourse by the artist to an audience. Several artists considered the exhibition to be a
didactic situation in which sentient facts were arranged in such a way that the viewer
eventually acquired a reading. The works appeared in a series – a testimonial to their

proper development or function – or a succession of exhibitions was staged, delivered like consecutive lessons.[14]

Other artists transformed the exhibition into a spectacle featuring either themselves (mostly short-term events but some, like Joseph Beuys's action 'I like America and America likes me', lasting three days) or the production of works which could be modified (real movement, movement provoked by displacing the spectator, vital processes, audiovisual effects, etc.) to articulate their manifestation in a temporal sequence.

The generalization of these performances led several artists to critically review the function and significance of such exhibitions and to analyse their institutional or intellectual contexts (Buren, Broodthaers, Asher, Graham . . .). The exhibition as support for aesthetic experience tended to transform the gallery or museum into an extension of the studio, establishing communication with an audience which considered a mediator's intervention undesirable if it wasn't at the general production stage.

During the summer of 1969, Seth Siegelaub organized an exhibition of eleven artists whose works were dispersed at various spots around the planet.[15] The very

➡ **3.3 *When Attitudes Become Form*, exhibition curated by Harald Szeemann, Kunsthalle, Bern, 1969. Works by Soinnier, Saret, Kuehn, Artschwager, de Maria. Photograph courtesy of Harald Szeemann.**

factual presentation of the event in the catalogue provided the exhibition with one simple arbitrary rule: to organize the relation of the works to the public such that it would not alter in any way the artists' propositions[16] while enumerating all the rules, conventions and constraints in order to render them transparent. Several exhibitions were organized according to this model, their catalogues assuming the form of meeting minutes (*18 Paris IV 70*, Paris, April 1970 *Information*, The Museum of Modern Art, New York, July–September 1970; *Conceptual Art, Arte Povera, Land Art*, Turin, Galleria Civica d'Arte Moderna, June–July 1970).

One of the first large exhibitions of this type, *When Attitudes become Form*, was held in the Kunsthalle in Berne in March/April 1969. Harald Szeemann had gathered the works of artists which other exhibitions had already consigned to categories such as Minimal Art, Anti-Form, Conceptual Art, Arte Povera and Earth Art. This exhibition's merit sprang from its ignoring of categories and its refusal to arrange and clarify. The catalogue offered an index of artists classified alphabetically in an extensive repertory. The exhibition juxtaposed radically diverse materials on the floors and walls of the various rooms. While a number of artists had themselves installed their contributions or envisaged an integration with the site (Lawrence

Weiner's removal of the walls' roughcast, Heizer's broken sidewalk, Beuys's animal-fat corner), and other works or information were placed by personnel acting on the artists' instructions, nothing remotely resembled a painting or a sculpture. The interaction of works with the site, with each other or with the public seemed to give the exhibition its own life force. Imagination and organizational effort combined to unite certain works under certain conditions to provoke a chain reaction, leaving the impression of the complete autonomy of the work in relation to the person who conceived it.

Harald Szeemann pushed the aspect of event even further by curating *Happening & Fluxus*, featuring cubicles of similar size which accommodated the works of each artist and were deployed around a wall of chronologically filed documents, including those which lasted only for the duration of the 'happening'.[17] An extension of this project was slated for *documenta 5*, but this hundred-day event could not see the light of day in its initial form. It should be noted that, in an event of *documenta*'s scope, the pure and simple extrapolation of the governing rules formulated for specific works clashed with the institutional diversity of large gatherings.

In no time, this strategy of non-involvement towards an artist's action became a

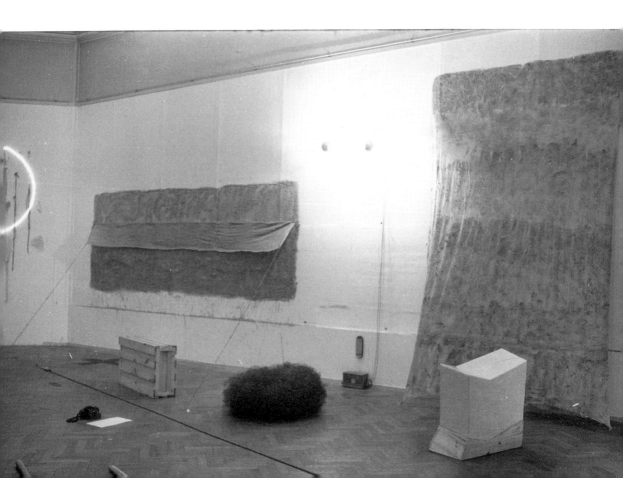

model for collective events;[18] this lasted longer in the case of personal exhibitions and it survived in the type of architecture it advocated and adopted. Siegelaub did not have an exhibition site and Szeemann used a conventional Kunsthalle. Both implied that the ideal site for this new art was some disused warehouse without interior partitions which, while offering all the facilities, could absorb the ravages. Exhibitions subsequently were staged in the salt depots of Venice, the Entrepôt Lainé in Bordeaux was consolidated, and materials were piled onto the floors of rue Beaubourg. The latest factory to be recycled for modern art opened in May 1984 in Schaffhausen to house the Crex collection. The 'Hallen fur Neue Kunst' is a sort of anti-museum for directly experiencing art without the curatorial or educational apparatus – an extension, in a permanent structure, of what was once just enunciated in exhibitions.

Even the most arbitrary guidelines tend, with repetition, to become cumbersome conventions. Their form becomes more of an obstacle to the perception of the works when an informed public anticipates the proposition that the consumption of art lies in its enunciation and performance. The organizer, as well as the visitor, requires a more critical approach to the event in order to preserve a strong relationship to the

50

➡ **3.4 Front façade of the Fridericianum at *documenta* 7, with work by Daniel Buren, Kassel, 1982. Photograph courtesy of the *documenta* archive.**

work. While preparing *documenta* 7,[19] Rudi Fuchs drew from what he'd learned from artists such as Buren, Asher, Judd, Toroni to conceive an exhibition where he would rely on their propositions in order to make manifest the entire institutional apparatus which the large number of conventional paintings and sculptures incited him to evince.

Could he, in effect, juxtapose paintings by Baselitz, Kiefer or Polke with the interventions of Kounellis, Long and Buren without running the risk of the confrontation turning against him? To avoid the kind of situation which Harald Szeemann found himself in during *documenta* 5,[20] Rudi Fuchs endeavoured instead to remuseify the exhibition site in collaboration with those same artists who had originally threatened it. This operation allowed him to provide the paintings and sculptures with the material and symbolic framework they required and to maintain the exhibition's force of impact by preserving *in situ* (*hic et nunc*) events while keeping the necessary critical distance to avoid mystification.

The catalogue, posters and other documents conveyed the clear reminder that the Fridericianum was the first building in Europe to be constructed to house a museum. Diverse interventions (R.P. Lohse developed a colour chart in the Orangerie

medallions, Oldenburg supposed that the monument occupying a spot outside the
city was a gigantic pickaxe hurled by Hercules, Rückriem arranged his hewn stone
into a monumental doorway, Kounellis covered the first wall a visitor sees upon
entering the Fridericianum with gold leaf) directly appropriated one of the site's
historical references or reinforced its celebration while others posited a criticism or
an unveiling (Buren treated the place directly in front of the Fridericianum like a
fairground, Weiner covered the museum and the catalogue with the following
inscription: 'numerous coloured objects placed side by side to form a row of
numerous coloured objects', Michael Asher partially reconstructed the inside walls of
the Haus Esters which serves as an exhibition site for contemporary art in Krefeld,
etc.).

The operation was facilitated by locating the interventions in several sites, a
division which followed the guidelines adopted by Seth Siegelaub or Michel Claura
for their respective exhibitions in 1969 and 1970. I do not believe that this
opportunity given to artists to feature their work under varying conditions (in the
exhibition as in the catalogue) alongside dissimilar works was a ploy to avoid
thematic or stylistic structures; it was a mechanism to preserve the arbitrary nature of

the works' confrontations. Thus Rudi Fuchs could freely arrange groupings that would have appeared too reductive had they represented a single and exclusive reading of the works.

The affirmation of aesthetic values in their extension

The mechanisms of revelation which expose their transparency hinge upon an *a priori* privileging of individual processes of creators and their public. They avoid proceeding with a distanciated analysis in which the result would be proposed on behalf of the works. These mechanisms testify to a rejection of a generalized aesthetic, which is precisely what *documenta 5* (summer 1972) and *Contemporanea* (Rome, November 1973)[21] sought to do. Both exhibitions were conceived in a climate of triumphant but confusing and stimulating avant-gardism. Visual artists appeared to be inventing new art forms with the same facility that they shared ideas and, to a certain extent, practices with creators in the performing arts (film, video, performance, concert, etc.).

In order to account for these developments and to avoid total confusion, *documenta 5* and *Contemporanea*[22] proposed a grid of highly detailed readings. *Documenta* had close to twenty sections housing contemporary artwork alongside all manner of imagery and socially imaginative material. The realms of religion, finance, media, advertising, mental illness and visions of the present and the future suggested a breakthrough into artistic actuality by parallel categories. Which is what in fact was done in the 'everyday mythologies' section. All the visual and communications apparatus of the social sciences was mobilized to mediatize the numerous discourses interfering with aesthetic objects. Harald Szeemann had, in fact, transported the plastic arts to the museum of contemporary civilization for delivery to the semiologists, psychoanalysts and assorted sociologists.

Contemporanea differed little in its general intent, but its organization into sections (art, film, theatre, architecture and design, music, dance, artists' books and recordings, visual and concrete poetry, alternative news) was formally distributed (by media) rather than in the imagination. Both exhibitions had, as a basis, the fundamental idea that the forms and the stakes at play in contemporary aesthetics are disseminated in all directions (daily life, means of acquiring knowledge, other art forms) and are simultaneously based on other activities and images. The proposed extension developed in the fabric of the social material in one synchronic slice (having hypertrophy of the present tense as a value).

Global comprehension of the type of open situation exercised at *documenta 5* and *Contemporanea* was in direct opposition to the model constructed around a uni-disciplinary body of work of the same time-oriented style. The great avant-garde trends had previously engendered events which brought together aesthetically

coherent works. Presented as a slice of history whose virtual continuity was signified by the evolution of an immediate past, these exhibitions were of interest for the apertures which made their projective value comprehensible. By summoning the future, they offer themselves as reproducable models, inducing the production of varying perceptions like so many continuations or realizations of the initial prevision. Thus, *Lumière et Mouvement*, presented at the Kunsthalle in Bern in 1965, initiated a series whose last metamorphosis was *Electra* at the Musée d'art moderne de la Ville de Paris in December 1983.[23] *Art of the Real, USA, 1948–1968*, organized by New York's Museum of Modern Art and presented at the Grand Palais in Paris (14 November–23 December 1968), played a similar role for Formalist painting. Centred entirely on the selection of works and their ordering towards the expansion and recognition of the enunciated aesthetic options, such exhibitions accomplish the modernist ideology of progress in art. The adoption of a chronological structure for the presentation of contemporary works underlines a belief in history as a value and anticipates future recognition by juxtaposing new works with those of past innovators. The exhibition thus interiorizes its working within the constraints of museum authority by preparing for recognition, prefiguring it while translating modernist obsession into a permanent surpassing of itself.[24]

Usage of the past as a cancellation of history, another declension of time as a value,[25] has been the basic argument of postmodern and, simultaneously, traditionalist attitudes. An active advocate for the recovered freedom of artists to legitimately utilize art history as a source of new work, Achille Bonito Oliva, for instance, hardly renewed his conception of the exhibition when he produced *Avanguardia–Transavanguardia* (Rome, Mura Aureliane, April 1982). Only the removal of the mouldings in the Villa Borghese parking-lot near the Aurelian Wall could be seen as having a symbolic value.

Like Bonito Oliva, other exhibition organizers, in an effort to reaffirm the vitality of painting over other developing models of contemporary art, reintegrated the most venerable architectures or institutions (*A New Spirit in Painting* at the Royal Academy of Arts, London, 1981, and *Zeitgeist* at the Martin Gropius Bau, Berlin, 1982) but they moved about more freely across generations and stylistic trends. Thus in *A New Spirit in Painting*, Christos Joachimides, Norman Rosenthal and Nicholas Serota chose to affirm the actuality of painting by selecting from the period considered to be characteristically avant-garde. They demonstrated that true paintings were still being produced and that this art had not lost its values, regardless of affirmations to the contrary by museum curators and art critics.

Picasso, Matta, Balthus, Hélion, Bacon, Baselitz and several others were shown alongside works by non-academic minimalists like Ryman, Marden or Charlton and fewer newcomers than one might expect: Chia, Fetting, Hödicke, Kirkeby, Paladino,

53

etc. The inherent message was that the exhibition did not register any fashionable phenomenon of concern to a new generation of painters but rather conveyed a profound tendency which the artists shared that was beyond their respective ages or individual stylistic approaches. The exhibition appeared to consciously avoid too direct a probing into each work's proper coherence and thereby did not weaken its approach with parasitical data. The selection of one work over another was not explained; only the general quality of the painting and, in most cases, the image were discussed. Beyond individual styles, the iconography was kept to the more conventional and general,[26] suggesting the major tendential sensitivities with a separation of Latins from Norsemen. The catalogue, with its lightened critical and documentary apparatus so non-concurrent with the numerous colour reproductions, referred back to the works without ensuring the reader's knowledge of them.

As sole motivation, the organizers restricted themselves to explaining the title of the event, establishing no filiation or cultural kinship other than the partition of Europe along North–South lines. The principle argument was aimed at rediscovering – in a past which was itself disorganized – artists and ideas long marooned by the simplifying history of modernism.

54

➡ **3.5 Sol LeWitt, *Lignes en quatre directions et toutes leurs combinaisons*, installed at CapcMusée d'art contemporain de Bordeaux, 1983. Photograph courtesy of ISO, CapcMusée d'art contemporain de Bordeaux.**

The renewed interest in painting, which was associated with a willingness to abolish the interdict against borrowings from a non-modernist past, began to spring up in other exhibitions willing to go beyond chronological frameworks to underline affinities and imaginary or plastic coherences. Exhibitions such as *Uit het Noorden* (van Abbemuseum, Eindhoven, 1984), which grouped works by Munch, Jorn and Kirkeby, and *Légendes* (Capc, Musée d'art contemporain de Bordeaux, May 1984) were motivated by an opposition to *A New Spirit in Painting*. They sought, in a kind of imaginary museum of a few artists, to make visible a renewed reading of past works and the common traits these artists shared with artists of past generations. Their particularity consisted in making it appear as though the filiations, stylistic and imaginary continuities and affinities of sensibility do not operate solely in the positivist rationality of a history geared to its own ends and, importantly, that the bequest which past generations have handed down remains susceptible to the most unexpected investments. The framework of *Légendes* justified the confrontations between Fautrier and Baselitz, Dubuffet and Schnabel, Chaissac and Combas. The intentions of *Légendes* also resided in the rejection of any general and unique governing principle regarding temporality.

The diversity of the modalities of the declension of time as a value (linear history, extension of present time, the past as an annihilation of history, multiple temporalities . . .) in the schemata of exhibition organization is aimed at instilling belief in the interdependence of aesthetic values and the concomitant representation of history. What is coherent on an aesthetic level remains a representation that does not resist the test of new events; the history of art owes it to itself to criticize in order to develop a specific construction of its own temporality. Art history must not neglect these representations for they have a structural function, one which describes the extension of the aesthetic data they ordain.

SYMBOLIC FUNCTION

The symbolic function of art is evident in the way society uses it and the various utopias it elaborates for society. Art's production of these utopias integrates certain symbolic and societal exigencies, inventing for them a particular form whose themes have inspired numerous exhibitions. The values which the corpus affirms in defence of artists are equally caught up in a process of mythification of which the exhibition

is one of the more efficient cogs in the mechanism. In an effort to escape this process, artists have attempted to reject art as a mythic system at the risk of depriving it not only of all significance but also of any specific form while it dematerializes. Certain among them have analysed the mythification process to the very core of its functioning but this resistance has often yielded a void which myth immediately refills with significance.

For several years, another attitude has been apparent, consisting of the over-determination of myth, confounding its form with that of a work of art. This attitude, accompanied by the restitution of the art object, encouraged the advent of exhibitions openly aligned on the side of symbolic values. I will address those exhibitions using a cognitive approach to analyse art's capacity to produce symbolic values capable of withstanding a precise example, as well as exhibitions which function as mythifying machines in an attempt to bring the mechanisms up-to-date.

The 'myth' [27]

In 1973, Harald Szeemann formulated the idea for a *Museum of Obsessions* as a proposal for a *documenta* before envisaging the *The Bachelor Machines–La Mamma–Il Sole* trilogy which engendered the exhibitions *The Bachelor Machines* in 1975 and *Monte Verità* in 1978.[28] The year 1983 saw him addressing another European cultural theme with *Der Hang zum Gesamtkunstwerk* ('The quest for the total work of art'). These various themes are all mythic and Szeemann chose them for that reason. This was precisely what was of interest to him for, as he had recognized, total art exists no more than its thematization does. In fact, throughout the development of these different exhibitions, partially suggested to him by the work of contemporary artists he knew, Szeemann adopted a line of thinking which rejected the synchronic divisions effected at the 1972 *documenta* for an immersion in the history of artistic utopias. The history he developed was practically identical to the one Barthes envisaged for literature after having taken Lucien Febvre's theses into account – a history with neither names nor works.

This nameless, workless history was one in which the Facteur Cheval (a postman who built an ideal palace between 1879 and 1912 in a village in south-east France) and Adolphe Wölffli stood alongside Dada or Italian Futurism,[29] a history where, between the paintings and sculptures, one could find documents or objects, maquettes, reduced models of unmoveable works, reconstructions of works or vanished devices (I refer to Gaudí's maquette for the Colonia Güell chapel).[30] While the works were present before our very eyes during the exhibition, they were as sketches or traces of an absent project, one which did not exist save in the imagination which grouped and associated them. While the *Der Hang zum Gesamtkunstwerk* catalogue comprised numerous rubrics and entries, it was not,

strictly speaking, a catalogue of works on exhibition; it, too, instilled a lingering doubt over the status of what was on display.

In this case, everything which was sensitive or concrete – contrary to what I've termed the exhibition's degree-zero presentation where the mechanism of presentation is aimed at erasure – had a tendency to disappear, eclipsed by the overall project but nonetheless bearing witness that the latter was founded in history. Szeeman's mythic (see note 25) consists of the reification of utopia or utopias beyond the limitations of works or objects. He expounded at length on this point in his catalogue preface for *The Bachelor Machines*.

> This catalogue is an invaluable instrument for seizing the various points of view offered by mythology, philosophy, theology, psychology, sociology and sexology, bachelors and their myth, as well as the unit of energy produced by the bachelor machine.
>
> The exhibition can be experienced on several levels: as an attempt to place the exhibition as a means of expression and communication in the service of the visualization of representations and mentally closed circuits – the modalities of refusal and, as such, indirectly subversive. Moreover, the exhibition should show that behavior and intentions are what matter and not the finished product.[31]

In this text, Szeemann insisted on two points. The first concerned the complexity of myth which necessitated recourse to various systems of knowledge, the second elaborating a myth from the standpoint of an idea which aimed at rendering that idea accessible by denying the work and denying the finished product. Szeemann described his constitution of the myth exactly as Barthes analysed it in *Mythologies*:

> A myth is a value. It has no truth for sanction: nothing keeps it from being a perpetual alibi: it needs only that its signifier be two-faced to forever dispose of an elsewhere: the meaning is always there to present the form (which here would be the works and objects exhibited); the form is always there to distance the meaning of the many studies which cannot exhaust the meaning enough.[32]

Therefore, what Szeemann accomplished would be a history of myths and, above all, of values, of European values during a period of symbolic redistribution of cultural boundaries.

The myth

The series of exhibitions,[33] which for several years contributed to the pre-eminence of painting, of which I have given two examples, no doubt tried to take account of an aesthetic sensibility at a given time but also flirted with the ambiguous possibility of a new negotiation – changing the system of aesthetic values for one of symbolic values.

The majority of introductory texts to catalogues[34] demanded a requestioning of

57

existing aesthetic categories and the criteria of values used for adjudicating contemporary art. The common argument consisted of a denial of the notion of the avant-garde and the productions attributed to it; continuities were made to appear more credible than the accident one proposed to forget. Actual values were opposed to the preceding ones on every point. A mediatized art was succeeded by an art of sensibility, presentation by representation, analysis by subjective expression and *bricolage* by technique.

The finality of exhibitions has not always been clearly shown even if the preface writers such as Eddy de Wilde knew what they were refuting. He brushed aside the project of making history or taking up a theme or proposing an idea or advancing a theory.[35] In his text, as in the others, values tend to substitute for concepts; these values are affirmed at the end of a process where the work of art becomes once more identifiable, having refound its aura by reintegrating its form as painting and sculpture. The restoration of the work would be accompanied by a return to the possibility of expressing the individual sensitivity of each artist.

The very function of catalogues has changed, another perceptible modification. From instruments of knowledge, ancillary to comprehending the works, they have become albums. If the texts were abundant, an exception in all but a few, it was in order to conduct a discourse of verity, to restore a belief rather than to communicate knowledge. And it is quite symptomatic to note that philosophers have replaced historians or the cohort of representatives of the human sciences in these texts.

Of these various exhibitions, *Zeitgeist* appears to have been the one whose mythical functioning was the most obvious. Its particularly nurtured emplacement sought to subjugate the visitor. The exhibition was held in a neo-classical building with a museological function capable of ceremoniously celebrating the works. The reintegration of a site to accommodate art cannot be accomplished without particular effort. Not content with resurrecting the usual installations by inevitable artists such as Beuys, Christos Joachimides commissioned four paintings by each of eight artists for the atrium's double row of arcades.[36] With other selections and spectacular staging, Joachimides – in a systematic search for seduction – intensified the decor's effect with his staging. The 'shock of images' was intended to provoke unanimity of the senses.

Whereas Szeemann informed us, in his *Hang zum Gesamtkunstwerk*, that he was interested in writing a myth and, by so doing, designating a distance, a placing into quotation marks which would authorize a knowledgeable approach, Joachimides did not bother to inform either the reader of his catalogue or the exhibition visitor as to the particularity of the art being exhibited. His efforts focused on the arrangement and development of the works; on exhibiting the building and the catalogue.

Seeking to reconstitute, by any means, the aura of the work of art, Joachimides

wanted to rediscover a situation prior to that of 'the work of art in the age of mechanical reproduction', while retaining the advantages of the exhibition's value.

'Zeitgeist : der Ort, *dieser* Ort, *diese* Künstler, in *diesem* Augenblick'[37] wanted to be considered as, simultaneously, an exhibition of unity and immediacy. To reinforce his claims, Joachimides relied on the theses of his friend, aesthetician Karl Heinz Bohrer whose central concept is *Plötzlichkeit*, the 'suddenness' of the aesthetic shock. Instead of reinstituting the cult of the work of art – he criticizes art from the seventies as having exaggerated its claim to autonomy – Joachimides attempted to substitute it with the entire exhibition. To do this, he presented himself as the speaker of a narrative using commissions as a device. He replaced the artists' capacity for utterance with his own aptitude for including their discourses in his own.

Similarly, proceeding with the history of the building, in its past and present situations, he evacuated any possibility of annotating it to its true level. Thus, the commissioned works, including those that touched on politics (Borofsky, Kounellis), served to fuel the mythifying mechanism. The reason why the centre of the mechanism is *Plötzlichkeit* is that immediacy erases all painted subjects and speakers, leaving the exhibition face to face with its sole author. This slippage is of utmost importance because those who reviewed the exhibition situated their arguments both ideologically and stylistically, reproaching the organizer for selecting works which were so ignorant of political facts in such a highly charged context.[38] The selection was practically secondary – he took up a few young Germans who, mostly, had appeared in other large international exhibitions – in relation to the general disposition of the exhibition, a situation which allowed those selected to become cult figures with the organizer as high priest. I would say that in a certain way the historical and political context of Berlin and the Martin Gropius Bau, contrary to what many believed, contributed to nourishing this mythification. *Zeitgeist*, like a small number of large exhibitions, consisted of a symbolic response to a generalized crisis. The exhibition attempted to crystallize the fervour of surrounding admirers deprived of their gods. Here the myth consisted of having us believe that we again were venerating works of art when, in fact, the object of our adoration was the cultural cult itself.

Let us not confuse the various levels involved:
– a stylistic change characterized by a return to painting, the image and, eventually, mythical content,
– the myth, by which painting and the image, rediscovered, would be the only true works of art, thereby justifying a renewed fervour in their veneration,[39]
– and, finally, myth relying on its artistic and symbolic realities to make the cult of contemporary art into an activity of substitution, a means of conjuring the crisis and

resolving, on a symbolic level, what cannot be resolved on the political and economic level.

The credibility of the cultural solution is such that it permits, during a period of grave economic difficulties, financing for the numerous exhibitions of recent years in addition to the completion of ambitious, monumental programmes to renovate and enlarge museums or to create new ones. Should certain polemics persist because of the contradictory exigencies of the political and the cultural, it would not be long before they were absorbed into a mythic construct.

Made-to-Measure Myth

When the city of Düsseldorf, under the aegis of an institution created for the occasion, asked Kasper König to ensure the production of a major exhibition, the theme had yet to be defined. No specific artistic urgency occasioned its approach. Rivalry for cultural supremacy between two great neighbouring metropolitan centres, seeking a symbol for a more general supremacy, was the sole motivating factor for the production of a representation of current German art in *Von hier aus*.[40] The overall symbolic stakes were explicit: to make Düsseldorf shine on the

➡ **3.6** *Von hier aus*, **view of the installation, Düsseldorf, 1984. Photograph courtesy of Kasper König.**

international stage and art market and to bestow upon Germany a representation of its contemporary culture as it had not dared to do since the expiation of Nazi crimes. Hence the curatorial commission, a commission in which König had to acquit himself so that his credit in the aesthetic order would remain unaltered.[41] The solution he arrived at consisted of creating an equilibrium between the respective labours of celebration and knowledge.

The celebration mainly comprised the invention of a novel type of exhibition architecture which could integrate innovations or modifications to the staging of recent contemporary works while taking into account the desire to produce a manifestation of mass. In one exhibition hall, architect Hermann Czech conceived of a doubly articulated architecture. Taking advantage of the freedom a ranked architect enjoys in a space not parcelled out in square metres, he imagined the necessary number of independant constructions by dispersing them according to a random and open topography. The ensuing city was based on a religious capital, given the number of temples or architectural fragments it contained. Hermann Czech, in effect, declined all the variations on the theme of sanctuary or those marks of its architecture which could only be discerned by the colour or moulding of a

cornice under which would have hitherto hung a mounted panel. The entirety was clearly highlighted by an elevated entrance which allowed the visitor to take in the entire hall at a glance. The viewer could also remark on the manner in which the specific installations or constructions slid between architectures like so many monuments, autonomous among the museological ones.

Once it was planned out, this imaginary city of the arts was adapted to the particular exigencies of each group of works. The expressive architectural details were executed to ratify an overall symbolism and the individual requirements of the artists. The mahogony walls behind Rückriem's hewn stones evoked large statuary museums of antiquity – the 'chamber of virgins' borrowed from the Parthenon – permitting Baselitz to appropriate two different halls to house his paintings and sculptures, etc. One could be ironic about the supporting citations, but as stigmata of the myth of art as the only redeeming value a cult is capable of, they satisfied the requirements of the patrons and the egos of the artists while positing a recreational argument for visiting an exhibition which could not have stood on historic (too short a period) or aesthetic (arbitrary criteria) structures alone.

Meanwhile, König did not confront the visitor with only this one proposition.

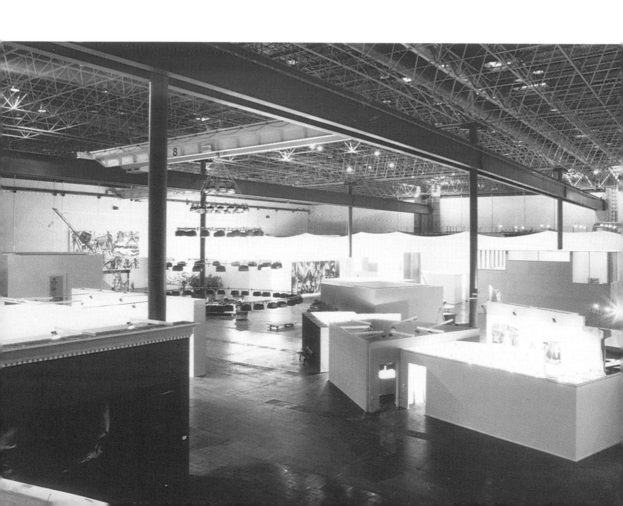

Options were also proffered on aesthetic and historical grounds. Beyond treating painting with great consideration, the exhibition included extremely diversified works (installations, sculptures, environments, films, video, etc.) selected according to a scenario (*Von hier aus*) without narrow temporal or national constraints. The selection was an integration of representative works from the German art scene since 1970; several artists who had disappeared for a number of years (Hesse, Palermo, Broodthaers ...) or were foreigners who had been active in Germany (Filliou, Koepke, Kirkeby, Paik ...). An intensive documentary and analytical effort contributed to produce a catalogue laden with texts and documents which, contrary to other publications, was actually a close accounting of the exhibition itself (the catalogue and reproduction of exhibited works, including specific installations).

This critical rebalancing, due to an augmented selection of works and an approach not rigidly affixed to the moment, allowed for the preservation of the narrow avenue of another reading alongside the mythifying discourse imposed by Düsseldorf.

This division of response supplied by Kaspar König to his colleagues was precisely what Joachimides did not do with *Zeitgeist*. One could explain how the appearance of a return of art to its more admissable forms could again permit a symbolic investment in art, as well as how this investment, in a certain sense, fashioned the economy of the works by situating itself on the general level of the exhibition. It remains to uncover the specific mechanism by which mythification operates. It should be understood that no large event is sheltered by this mythification and that, in a certain sense, the societies in which we live do not stage these events except to the extent that the mythification derives from itself. And this mythification's advent is much more fluent than that which is made manifest in the exhibition of the mythic act of the commission (which, for historical exhibitions, takes the form of a reconstitution).

At first glance, the commission would appear to be an adaptation on the part of the museum to the specific forms of contemporary creation. The curator seeks, from the intelligence culled from the work of artists, to manage, within the confines of his/her programme and spaces, the place and time for an aesthetic experience beyond any constraint other than those which artists impose on themselves. Whether the artist produces paintings or appropriates museum space has little importance in this context. The commission for a site and a time permits the offering of the unique and non-reproducible display of a masterpiece to a public which identifies with the patron and which derives satisfaction from seeing a work by 'X' made to measure for their very own museum. The advantage of the commission derives from this infinite possibility of identification with the patron. In fact, it is at once the museum and the curator, the exhibition and its organizer, city councillors, the minister, the president,

his state and, by delegation, every visitor who effects the commission.

In a sense, through the aegis of the commission, the exhibition and the contemporary art museum equal the ideological efficiency of sports competitions in the particular difficulties inherent in organizing the preservation of an aesthetic and/or historical dimension. Aesthetic and historical proposals must never disappear – not for art's sake, but because they guarantee mythification. Commissions lacking in detail, inadequate productions, or even incoherent productions parachuted in out of nowhere, are all examples of abortive attempts at mythification. Therein lies the difference between *Von hier aus* and *La Nouvelle Biennale de Paris*.

Myth as object of knowledge, active mythification running the risk of occulting the works or with a mechanism of multiple readings governing aesthetic specificity: such are the three alternatives regarding the relationship between the exhibition to non-aesthetic systems of values. Modalities and contents may vary, even in accordance with the dominant symbolic values. The notion that art exists for the sole satisfaction of the intellect or as purveyor of the only aesthetic pleasure is as mythical as the idea that art alone, as a value preserved, will be the solution to the ills which plague our society.

This is the reason, without citing the three dimensions along whose lines I proposed to measure the state of the exhibition, it would seem to me derisory to imagine that any presentation of contemporary works of art could possibly conceive of situating itself as the only one on the inside track of historical knowledge, aesthetic fulfilment or mythical illusion.

None of these fields can be invested but by the management of the other two. Each learning process must proceed through mastery of its own celebration, much as any attempt at mythification cannot accrue without aesthetic content. As a representation which contemporary society bestows on art, the exhibition cannot endure being reduced to specialized finalities; the economy of art sees to it that all organizers negotiate their projects at every level.

Translated from the French by Robert McGee.

NOTES

This essay was originally published as 'Les Grandes Expositions: Esquisse d'une typologie', in *L'Oeuvre et son accrochage*, special number of *Cahiers du Musée national d'art moderne*, 17/18 (1986), pp. 122–45; and republished in Jean-Marc Poinsot, *L'Atelier sans mur*, Villeurbanne, Art édition, 1991.

1 The inherent stakes of art, its consciousness, economy and symbolic value are present in each manifestation whose text is, in a sense, composed of multiple

discourses which cannot be simultaneously understood except with an ideological or mythical reading.

2 Consequent to the expression which served as title for an event on universal exhibitions at the Musée des arts décoratifs in Paris, the exhibition itself, despite its title, did not truly make a concrete case for the enunciated project in a very convincing manner.

3 '. . .', Seth Siegelaub, 'On exhibitions and the world at large', *Studio International*, December 1969, republished in *Idea Art*, a critical anthology edited by Gregory Battcock, New York, Dutton, 1973, p. 166.

4 *Paris/New York (1905–1968)*, 1977; *Paris/Berlin: Rapports et contrastes France–Allemagne (1900–1933)*, 1978; *Paris/Moscou (1900–1930)*, 1979; *Paris/Paris: Créations en France 1937–1957*, 1981 – all Paris, Centre Georges Pompidou; *Westkunst: Zeitgenössische Kunst seit 1939*, Cologne, Rheinhallen, 1981; Ad Pedersen, *60/80: Attitudes, Concepts, Images*, Amsterdam, Stedelijk Museum, 1982.

5 Eddy de Wilde, 'Forward', *60/80*, n. p.

6 Ad Pedersen, *60/80*, p. 2.

7 *Identité italienne: L'Art en Italie depuis 1959*, Musée national d'art moderne, Paris, Centre Georges Pompidou, 1981.

8 Observers of the years 1960–70 have an even greater recourse to a neutral non-elaborated temporality which takes charge of a great number of gestures, events and situations; considering the diversity and multitude of facts characteristic of this period, they refuse to operate a choice which, to their eyes, would mutilate the fabric of artistic debate. Diverse publications and exhibitions take up this attitude: Lucy R. Lippard, *Six Years: The Dematerialization of the Art Object from 1966 to 1972*, New York, Praeger, 1973; Germano Celant, *Precronistoria 1966–69*, Florence, Centro Di, 1976; Barbara Haskell, *Blam ! The Explosion of Pop, Minimalism and Performance 1958–1964*, New York, Whitney Museum of American Art, 1984. As the title of Celant's book suggests, 'natural' history is a treatment of facts and information intended as a prelude to a true historical analysis.

9 For a more precise analysis one must distinguish between historism – which consists of placing works of art on the same level as other objects, documents or historical facts under the pretext of a common appurtenance to history – and historicism which, in a presentation structured by the historical dimension, places all works on the same level and on an equal footing with the others in its concern to provide a complete representation of the artistic situation at a given point in time. Historism imposes the sole historical criteria, confounding facts or objects of varying natures; historicism levels the reciprocal qualities of the works while distinguishing them from non-artistic objects.

10 The themes of later works produced in exile or the Competition for the Monument of the Unknown Political Prisoner (ICA, London, 1953) very marginally evoke the incidences of political or historical events on artistic life and aesthetic production only when the itinerary through the exhibition and the selection of works allows for an exclusively artistic reading of the works.

11 It is not my intention to judge the cogency of the choice of works – something the art press widely debated while the exhibitions were in progress – but it must be noted that the respective positions influenced some selections and exclusions.

12 Despite the presence of original works, as I noted at the beginning of this text, these practices ensure media interest in major exhibitions.

13 As Achille Bonito Oliva remarked in the preface of the catalogue *Contemporanea*, Florence, Centro Di, 1973, pp. 25–32, the public contributes to the complete production of the work. Moreover, he entitled the paragraph dealing with this question: 'The public as work of art'.

14 As examples, let me cite Andy Warhol's first one-man exhibition at the Ferus Gallery in Los Angeles in 1962 which was comprised entirely of images of Campbell's Soup boxes, Robert Morris's December 1964 Green Gallery exhibition in New York where, in simple volumes, he took the measurements of the various dimensions of the interior space, or the group events of Buren, Mosset, Parmentier and Toroni in 1967 where they undertook to de(monstrate)construct the mechanism of their work. These examples have an illustrative value. The history of the integration of exhibition practice into artistic production has yet to be made. It began in the second half of the nineteenth century.

15 *July, August, September 1969*, Andre, Barry, Buren, Dibbets, Huebler, Kosuth, Lewitt, Long, N.E. Thing Co. Ltd, Smithson, Weiner.

16 '. . .' Siegelaub, 'On exhibitions', p. 168.

17 *Happening & Fluxus*, Cologne, Koelnischer Kunstverein, Nov. 1970.

18 Artists and their audiences have invented modalities allowing the transformation of initially ephemeral works into works with an intermittent or potential materiality. This is one result of the development of specific performances.

19 *documenta 7*, Kassel, 19 June–28 Sept. 1982.

20 Buren denounced, in his work and catalogue text, the fact that Szeemann used the works of artists as affects to compose his own work.

21 *documenta 5: Befragung des Realität, Bildwelten heute*, Kassel, Museum Fridericianum, Neue Galerie, 30 June–8 Oct. 1972.

22 *Contemporanea* and *documenta 5* were produced in summarily installed sites with little adaptability to works of art (the Villa Borghese parking-lot) or placed in such a way that the frontal architecture was denied (the Haus Rucker Co. sign on the Fridericianum's facade, the insertion of installations on the exterior of buildings along the interior circuit such as the environments of H.A. Schult or Kienholz) in both its appearance and structure.

23 *Licht und Bewegung, Lumière et mouvement, Luce e Movimento, Light and Movement, Kinetische Kunst, Neue Tendenzen der Architektur*, Bern, Kunsthalle, 3 July–5 Sept. 1965. *Electra, ou l'electricité et l'electronique dans l'art du XXe siècle*, Musée d'art moderne de la ville de Paris, Dec. 1983–Jan. 1984.

24 If the aesthetic which was affirmed during the sixties measured up to the question of modernity, work during the following years, 1968–70, was stigmatized with the frenzy of avant-gardism, offered a surfeit of models of development through too many channels to be plausible. The increasing relations with extra-artistic realities caused the substitution of the prospective exploration of the future – one synchronic with the present and with a linear dimension – for a structural space instead.

25 The declension of time as a value would seem to me to be the oppositional structure most capable of accounting for the principal tendencies which characterize the major exhibitions of the last twenty years; because presence in a museum remains a norm for the persistance of aesthetic values and the latter is measured on an historical scale – the museum remains the marketplace where aesthetic values are negotiated. Another aspect of these values and their symbolic content, the capability of art to propound

utopias for society, is discussed further in the text.

26 The exhibition authors strongly insisted, in their preface to the catalogue and in their choice of works, on conventional categories of the image: human experience evoked through the figure, landscape and the still-life, signalling their refusal to seize an eventual specificity in an iconography which therefore could have been dated.

27 I owe this written form to Harald Szeemann, who employed it in his preface to the catalogue *The Bachelor Machines*, p. 9 (see note 28). 'This exhibition is a response to the need to engage the specific means of the exhibition in the visualization of a myth. The organizer does not, under any circumstances, distinguish between a myth or a 'myth', but he nevertheless finds himself in a desperate position: by means of the exhibition, he must give shape to something incomplete.'

28 *Junggesellenmaschinen–Les Machines célibataires*, Kunsthalle, Bern, July–Aug. 1975 (then Venice, Brussels, Düsseldorf, Paris, Malmö, Amsterdam, Vienna); *Monte Verità, Ascona*, Ascona, July–Sept. 1978 (then Zürich, Berlin, Vienna); *Der Hang zum Gesamtkunstwerk, Europäische Utopien seit 1800*, Kunsthaus, Zürich, Feb.–April 1983 (then Düsseldorf, Vienna, Berlin).

29 I would like to evoke with these few proper names precisely those who are not. The producers of a single work find their identity absorbed by their very production. As for the vocables Dada or Italian Futurism or Bauhaus, or even Die gläserne Kette, they become entities in the dissolution of individualities, subjects, authors – even if what appears in the exhibition is signed.

30 Harald Szeemann explains this point in his preface to the catalogue (translation *Art 83/84*, Chêne, 1984, p. 170).

66

31 Harald Szeemann, Preface to *Junggesellemaschinen–Les Machines Célibataires*, Venice, Alfieri, 1975, pp. 8–9.

32 Roland Barthes, *Mythologies*, Paris, Seuil, 1970, p. 209.

33 *A New Spirit in Painting*, London, Royal Academy of Arts, 1981; *Avanguardia–Transavanguardia*, Rome, 1982; *Zeitgeist: Internationale Kunstausstellung*, Berlin, Martin Gropius Bau, 1982; *La Grande Parade: Highlights in Painting after 1940*, Amsterdam, Stedelijk Museum, 1984.

34 It should be noted that none of the catalogues comprised a rigorous study of the works on exhibit.

35 Eddy de Wilde, 'Introduction', *La Grande Parade*.

36 Joachimides saw his role in the commission as comparable to the Florentine patron in the *quattrocento*.

37 C. Joachimides, 'Achill and Hector vor den Mauern von Troja', *Zeitgeist*, p. 10.

38 See Douglas Crimp, 'The art of exhibition', *October*, 30 (1984).

39 What we have here is a myth that has yet to be defined but comparable to the one which Szeemann was able to isolate under the form of the *Gesamtkunstwerk*.

40 *Von hier aus, zwei Monate neue deutsche Kunst in Düsseldorf*, Düsseldorf, Messegelände, Sept.–Dec. 1984.

41 Kasper König has repeatedly sided with artists critical of the museum system.

4

FOR EXAMPLE, *DOCUMENTA*, OR, HOW IS ART HISTORY PRODUCED?

Walter Grasskamp

In 1978, Wulf Herzogenrath reconstructed an exhibition for the Kölnischer Kunstverein (the Cologne Art Association), that his predecessor Toni Feldenkirchen had organized thirty years earlier in the Cologne exhibition hall. The purpose of the 1949 exhibition, *Deutsche Malerei und Plastik der Gegenwart* ('Contemporary German Painting and Sculpture'), had been to define anew, after the iconoclasm of the National Socialists, what would count as contemporary art in the young West Germany. The original plan to repeat such an overview every four years starting in 1949 never got off the ground. Had a second exhibition on German or even on international art been organized in Cologne in 1953, the Kassel exhibition, *documenta*, would probably never have come into being. This missed opportunity

might have been one reason the exhibition was repeated thirty years later, but it was certainly not the only one. Nor was it a matter of reviewing the decisions then taken. It would have been futile to give in to the critics' favourite game of figuring out which artists might then have been over- or under-represented. This is in any case a moot point because the speaker (or writer) who makes it wins the debate every time, and it would have been even more boring in this case, due to the historical home advantage.

The repetition of the exhibition was meant rather to change perspectives, to present an alternative to the usual art-historical point of view, which after thirty years, as a rule, is only concerned with a few works and meanwhile forgets the artistic context, from which it isolates these works. How many forgotten paintings and sculptures are there for each painting that makes a career for itself in the colour reproductions of the standard works of art history? When do these decisions (which art historians take in order, they think, to separate the chaff from the wheat) start to be taken for granted? How often do these few works remain unchallenged merely because the other works have simply been overlooked, forgotten, or even frittered away by the heirs? 'Kunst ist die Ausdauer der Hinterbliebenen' ('Art is the perseverance of the survivors/dependents') was a motto of the Cologne Dada group *Stupid*, which Wulf Herzogenrath likes to quote. The repetition of the thirty-year-old exhibition was an unorthodox example of this motto: the difficulties that arose in attempts to get hold of works by some artists who have fallen through the sieves of art history are proof of the importance of widows and heirs in the transformation of an artist into one of the few.

Of course, historiography, including art historiography, is only possible if a few events are selected from the chaos and peddled. Historiography pretends to go by the worth of events, as contemporaries supposedly saw it, but uses its own evaluation. Just as general historiography prefers capitals over provinces, times of war over peace, technical improvements over the culture of the skilled trades, so art history has priorities that help to reduce the picture, a product of artistic processes and events, into an art-historical extract. Artists participate in the emergence of priorities and in their propagation, just as much as art dealers do; their agents include collectors, exhibition managers, and the curators of estates. These priorities are extracted from the raw material of casual discussions, recommendations, ambitiously staged exhibitions, rumours, expert judgements, catalogues, auctions, juries, and commissions, and then upgraded. The Kassel exhibition *documenta* is an exemplar of the genesis and propagation of such priorities.

CONSPIRACY THEORY

All who argue in this way are easily suspected of being in the ideological vicinity of a conspiracy theory as it is propagated by opponents of contemporary art to explain its success. The disciples of this popular theory like to attribute the success of contemporary art to a mafia of clever dealers with a clique of corrupt museum staff members and obsequious collectors who have allegedly managed to abuse the greed of the public for novelties to such a degree that charlatans and botchers are installed as important artists at tax-payers' expense. The propagandists of this theory – not infrequently unsuccessful artists or artists who have other conceptions of art, but also museum directors and critics – generally deliver such useless and unfounded polemics that to disprove them is not difficult, and to discuss them in the first place would be superfluous, if the conspiracy theorists did not know how to foster and exploit the reservations of numerous museum-goers about contemporary works of art. But sound and astute critics also like to fall back on the typical elements of a conspiracy theory, so that the altercation remains current.

The arguments of the opponents of the conspiracy theory are no more convincing. In trying to disprove the conspiracy theory, they go to the other extreme and try to minimize, if not altogether deny, the influence of dealers and other agents on the success of a work or a school of art. They act as if the nature of the work of art, its attitude to tradition, or the artistic competence of the artist were sufficient to explain the success of art, as if all other factors of success were accidental and irrelevant concomitant circumstances. But everyone who moves for a few years in cultural circles knows the flowing transition between collegiality and collaboration, between favours and business acumen, between the methods of gentlemen and those of crooks, in which the art business *nolens volens* participates, whether the participants be dealers, critics, collectors, exhibition managers, or artists. Those who simply deny this constant endangering of their own independent definition of their position only manage to raise suspicions – not least that they are naive.

Both views are false in so far as they want to be exclusive. No work of art produces its own success, but it must be possible to judge its quality without reference to the persons who made it successful. One can find a work of art good even if one does not approve of the methods with which it has been brought into circulation, and conversely, not every artist who imagines that he has been cheated of his success by some shady character must therefore be rehabilitated; possibly he really was a bore. So the explicit intention of the organizers of *documenta II* (1959) to propagate abstract art as 'world language' was taken by some critics to be only a sign that realist artists, mainly those of the school of social realism, were to be pushed out of the public's field of vision by the West German postwar capitalist agents of art. If

this was a strategy, it was successful: amends could not be made to the tradition of social realism that National Socialism had eradicated, as it could to abstract art, for instance, in the West German fifties and sixties. The dispersed social realists would have felt that they were held in contempt when *documenta 5* (1972) propagated American Photo-Realism, and when *documenta 6* (1977) borrowed social realism from East Germany. Social realists were indubitably the martyrs of the Kassel *documenta*, but even martyrs can be wrong.

If *documenta* is to be seen as an exemplar of how art history is produced, then that is not so much because it has provided much fuel to the conspiracy theory – especially where the nepotism of galleries was concerned, a matter which could not be swept under the rug with official denials. Gallery owners, as it happens, have their fingers in every pie when art history is produced; this is an old hat and not necessarily a dirty one. The issue only becomes crucial when under the pressure of public opinion, according to which gallery owners have no business meddling with art history, their activities are embellished or denied, because then their contribution to art history cannot be discovered and therefore cannot be criticized. Otherwise ten shrewd art dealers are more beneficial to art history than one People's Commissar of

⬇ **4.1 The Museum Fridericianum during the first *documenta* in 1955. The building, ruined during World War II, had been provisionally reconstructed. Photograph by Günther Becker, courtesy of the *documenta* archive.**

⬆ **4.2 Paintings by Picasso, Gris, Braque and others in a room within a room at *documenta I*. Photograph by Günther Becker, courtesy of the *documenta* archive.**

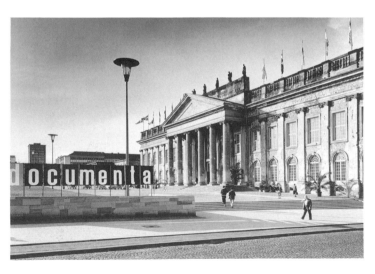

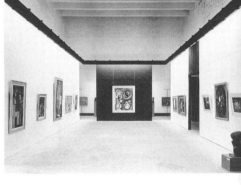

Art; it is less embarrassing to be duped by one fat bluffer than to be forced to believe in the emperor's new clothes. In any case, Abraham Lincoln's formulation of the politics on which conspiracy theory is based is also applicable to art history: 'You can fool all the people some of the time, and some of the people all the time, but you can not fool all the people all of the time.'

SELECTION

Documenta is an exemplar for the production of art history, because it is the most distinguished exhibition venture of the postwar era that has continually survived its own difficulties. The initial intention to counterbalance the pent-up West German demand for modern art led, after a few years, to the organization of an exhibition of international stature, which substantially forms the general consciousness of what counts as contemporary art. *Documenta* does not only play this role for its contemporaries, because it anticipates the production of art history by relieving it of the pains of selection.

Not only the social realists have suffered from this selection; even a Hans

⬇ **4.3 Paintings by German Expressionists in a construction of temporary walls at *documenta I*. Note the view into the next room, exclusively reserved for Marc Chagall. The door, staged as a column, refers tactfully to the classical character of the Museum Fridericianum. Photograph by Günther Becker, courtesy of the *documenta* archive.**

⬆ **4.4 The Anglo-Saxon hall of fame at *documenta I*, bringing together sculpture by Henry Moore, Alexander Calder, Kenneth Armitage, Lynn Chadwick, Reg Butler and Barbara Hepworth, with support from Hans Arp, Julio Gonzalez and others. Photograph by Günther Becker, courtesy of the *documenta* archive.**

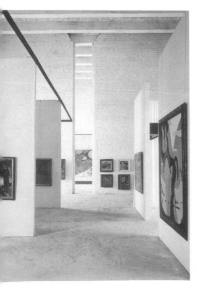 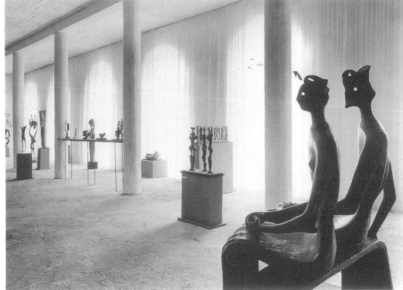

Purrmann, who was represented at the first *documenta* (1955) not only with his own works, but also with a bust by Emy Roeder, was not invited to the second and third exhibitions. In the autumn of 1964, when *documenta III* was still running, he admitted in a letter: 'That the *documenta* disregarded me entirely and did not ask for a single drawing from me has been hurting me all summer and has been the cause of my bad moods, but one must continue to work, even if I have reached the end of my life.' With this terse note of an 84-year-old about a crisis caused by not receiving an invitation to *documenta*, the myth of *documenta* becomes more palpable than all the attacks of its critics, a myth according to which whoever was chosen is thereby accepted into a pantheon for which those who remain outside know no substitute. This dilemma is apparent in Wolf Vostell's and Jörg Immendorff's protest actions on the occasion of *documenta 4* (1968), as well as in the posters inscribed 'Flatz is not participating at the documenta', which were posted on the columns of Fridericianum on the occasion of *documenta 6*: some of the omitted artists made themselves noticed on the spot, and so even the protest reified the myth of the event. For *documenta* – which, with tongue-in-cheek, has been called the Olympiad of the Arts because of its original four-year cycle – a slogan which we have not been able to apply to the Olympiad for a long time now applies: participation is everything. The jury's ritual roll-call of the participants is the precursor of exclusion from art history which the spurned have cause to fear, since they have been eliminated from one of its most important preliminary rounds. The dissemination of such jury decisions into art history grows with the fuss that the jurors sometimes make about their decisions, and this rightly has never been a question of modesty in Kassel. The jurors further the myth of this selection by staving off the impression of fortuitousness, subjectivity and wilfulness, which their decisions nevertheless can never quite deny, however many compelling reasons are listed. After all, no one decides what to do only according to reasons; even Immanuel Kant is said to have had his whims.

STAGING

The inventor of *documenta*, Arnold Bode, was not content with selecting works. His main ambition was to improve the architecture of the exhibition, the staging. The great importance of the question of staging of the first three *documentas* cannot be explained only by Bode's engagement, who also designed the architecture of fairs and pavilions at world exhibitions. In addition, *documenta* was one of the largest experiments of presentation and arrangement undertaken in the history of the art museum, quite comparable to Vivant Denon's presentation of Napoleon's trophies in the Louvre. No museum had ever before worked under similarly favourable and yet challenging conditions as the later so-called *Museum der Hundert Tage* (the

hundred-day museum): works for an entire museum could be chosen by the organizers at whim and taken to Kassel without the paintings having to be bought or captured. But what is especially important is the fact that they could get rid of the paintings afterwards without having to burden themselves with the acquisitions in the long run or even having to manoeuvre the showpieces of yore into storage rooms. But the advantages of such a personal-choice situation were as great as the pressures of the prestige, which weighed on the museum for one hundred days. That was the challenge Bode was capable of taking up.

His early installations with light-weight building boards, cement floors, steel bars, wood constructions, bricks, grey plastic curtains, which filtered the incoming daylight or set dark accents in the rooms, the white-washed walls, with which he rehabilitated the austerity of cultivated living that had been lost with the Bauhaus and buried by the fifties Germany of variegated wall-paper; all these were successful contributions to the way in which art history is produced: shindigs are helpful. He deliberately studied museums and exhibitions in order to find out how art is staged, and the development of the 'environment art' of the sixties must have appeared to him like the logical consequence of his work. An artist such as the late Michael Buthe would have studied with Arnold Bode. Bode's staging produced significance. The ceiling installation of Nay's paintings at *documenta III* (1964) was the final accomplishment of Bodean staging, though not always achieved without opposition. He was accused of overstaging, and *documenta 4* (1968) was organized by Jean Leering. Success happens to be a question of staging for exhibition designers, too.

73

HISTORICIZING

But success is not only a question of staging. The staging and selection of exhibits had to be legitimated in academic terms, precisely because it was a matter of contemporary art for which other strategies of legitimation were not available. For the first three *documentas*, this role was undertaken by Werner Haftmann, whose widely read history of *Painting in the Twentieth Century* was published a year before the first *documenta*, in 1954. Later generations can scarcely comprehend the significance this standard work had in West Germany during the fifties. Uwe M. Schneede, now director of the Kunsthalle, Hamburg, gave a fitting outline of its importance:

> Werner Haftmann's *Painting in the Twentieth Century* of 1954 is still the only art history of modernity written by a single author. It introduced my generation to contemporary art. What was here spread out on 550 pages on Impressionism and Fauvism, Blaue Reiter and Bauhaus, Abstract Espressionism and Realism was studied word for word

and appropriated. Irritated by the other book, Hans Sedlmayrs' *Art in Crisis: The Lost Centre*, it was with Haftmann that one found satisfaction. When it was possible to breathe again after World War II, Werner Haftmann naturally became the apologist of his generation of artists. He meritoriously fought for them and against the continuing feelings of resentment.

As a propagandist of modern art, especially the abstract and informal art that was current in his day, Dr Haftmann was the necessary counterpart of the artist and art professor Bode, precisely because he was scientifically accredited. Against the opponents of *documenta* he used the serious and profound words of the German art historian, a gesture of defence as well as intimidation, which could not fail to find its modest target in a West Germany which was still science-fearing.

Haftmann was for the first three *documentas* what one would, by the time of the fourth, have called a chief ideologist. On the occasion of the fourth, in the troubled year of 1968, Haftmann had already withdrawn from the Kassel council of war, as had Werner Schmalenbach. They left the site, before Pop Art and Photo-Realism could ruin the concept in which Haftmann in particular had invested his reputation: abstract art as world language. A governing ideologist with a master's certificate, he obviously did not want to exchange the sinking ship for the one that was just being launched. He knew how to prevent himself from sinking: immediately after the third *documenta*, the last one for which he was jointly responsible, his art history of 1954 was published as an extended paperback in two volumes, the second volume having been conceived as a book of plates. While Bode's achievement, staging, evaporated on the day on which it was disassembled, Haftmann could take with him what had proved to be enduring: his theoretical outlines and historiographical constructions, the canon of the works selected and, above all, even some of their photographs. The plates in the second volume of his outstanding book overlap with the catalogues of the first three *documentas* and even some colour printing blocks seem to have gone with him, which not only means that some expenses were saved but helps once more to answer the question of how art history is produced. Many artists who were successful at *documenta* now got into the text and colour-plate section of a standard work; what more could they want? This is how art history is produced: more important than the original in the twentieth century is the reproduction, the photo. If it is available to the art historian, he can easily canonize an artist in the holy book and especially through colour plates, for a picture is worth a thousand words and a colour picture still more. Atypically modest for someone in his field, Haftmann seems to have anticipated as much – or was he one of the first postwar students of Walter Benjamin's theory of 'The work of art in the age of mechanical reproduction'? In any case, Haftmann's book was epoch-making in the

74

1965 edition: he historicized contemporary art, not only by word and colour plates, but – unlike most art historians – he was not above dealing with the latest developments. This is to his credit, even if he gave up before Pop Art without recognizing that it confirmed, if not his art-historical predilections, his way of propagating them. His resignation from responsibility for *documenta* and Bode's retreat produced a *documenta* vacuum: two star parts were simultaneously to be filled for the following *documenta*, yet it seemed only a matter of time before they would be filled, since, after all, Kassel meant not only art history but careers in the making.

CHANGING THE HEROES

Appearances were deceptive. As it was to turn out at *documenta* 5 (1972), after the interregnum of the fourth, a dangerous mission was in fact advertised, and Harald Szeemann was the first to be made to fulfil it. None of Bode's and Haftmann's successors has ever managed to convert continuity into power, which the founders have always been able to utilize in support of *documenta* whenever its survival was in question. The more continuity the institution gained, the less sure became the careers of its prominent and changing collaborators. When Manfred Schneckenburger, the director of *documenta* 6, got the unique chance to preside over *documenta* 8 (1987) as well, it was only because the original candidates, Eddy de Wilde and Harald Szeemann, could not agree on the joint concept which the funding committee – which Schneckenburger was part of – had condemned the two *prima donnas* to deliver. With few exceptions (e.g. Bazon Brock, who continued and considerably expanded Haftmann's strategy of legitimation with his 'School for Visitors' from *documenta* 4 (1968) to *documenta* 6 (1977); Klaus Honnef, who was responsible for various sections on the fifth and the sixth *documentas*; Wulf Herzogenrath, who curated sections of *documentas* 6 and 8) nobody returned to the spot and rarely did anyone's career profit from starring as curator. If directing *documenta* became a unique chance with unsure results, it had to be made into a heroic role, and thus a dramatic change of hero took place in Kassel, a decisive prelude to the international revaluation of the *curator*.

Originally *documenta* was eager to promote the artist as hero, and this was all the more possible and necessary as modern artists had been among the victims of National Socialist discrimination. In the catalogue of the first *documenta*, the heroization of the artists found a peculiar and prominent expression in the sixteen-page section of plates, laconically listed in the table of contents as 'Photographs of Artists'. The plates of this section represent, among others, Picasso, Braque, Léger, the Futurists, and Max Beckmann, either at work in their *ateliers* or otherwise posing for the camera. No work of art in this *documenta* can be more

75

suggestive of the manner in which art was then received than this small section of pictures. An aura of solemnity and gravity is the common denominator of these portraits of heroes, which even a photo of a studio party at Ernst Ludwig Kirchner's cannot disturb, for the complete otherness of the life that is represented even here is apparent. The catalogue of *documenta II* (1959) does not include such a concentrated glorification of artists, but the portraits of the artists are littered throughout the catalogue itself such that they scarcely have a less pompous effect; in some instances, it is even increased. The catalogue of *documenta III* (1964) does not include any photographs of artists. It is as if an embarrassing *faux pas* was being set right, and the works alone stand for the names. The same applies for the catalogue of *documenta 4* (1968). Was it really a *faux pas* to include the pictures of the artists, or was it a mnemonic device to assure the audience all the more that everything that a few years earlier they were supposed to consider degenerate art is really the work of people who are not only worthy of respect but should even be honoured? This was the era when newsreels in the cinemas showed the famous painting monkeys, whose miserable concoctions seemed to coincide so much with modern art. Were the portraits meant to remove all doubts and were they dispensable once the fascist trauma began to wane in the sixties?

Documenta 5 (1972) solved the puzzle of the lost photographs of artists. Instead of venerating the producers, behind whom the *documenta* organizers of the first and second hour had retreated, the triumph of the new heroes, the mediators, was heralded. Szeemann was prepared for it, as his first feat, the exhibition *When Attitudes become Form* (1969), had already proved that not only artists but also art mediators can become stars of the art world if they present the right artists at the right time in the right *context*. Fascinated by the way modern artists work without commissions or reservations, Szeemann discovered the artistic sides of his activities as mediator and emphasized them – half-art-historian, half-visionary – in his theoretical concepts also. His contradictory notion of *Individuelle Mythologien* (Individual Mythologies), the slogan of *documenta 5*, is possibly the best password ever invented to lead into modern art's field of force. It gave *documenta 5* the intellectual and artistic features necessary to secure its fame as the most important *documenta* apart from the first.

Incidentally, this notion changed Haftmann's strategy of legitimation, because it did not historicize the artistic material but characterized it by labelling it. Haftmann's strategy had anyway come to an end because the fast changes in avant-gardes and new tendencies made it obsolete. By calling the central section of the fifth *documenta* 'Individual Mythologies', Szeemann had appropriated a different way of producing art history without historical concepts. This way characteristically removes an activity from the artists, which is in any case only occasionally incumbent

upon them nowadays. If the names 'Impressionists' and 'Fauves' were distilled from insults, 'Dadaists' from an attempt at parody, the 'Surrealists' and 'Futurists', like other groups of artists, condensed their intentions programmatically into their group names. Since the sixties, the mediators, among others, competed to name groups first. With 'Individual Mythologies,' Szeemann launched a name comparable to those which other mediators had come up with earlier and later, e.g., Conceptual Art, Earth and Land Art, Arte Povera, and the New Savages, in competition with the artists who named the movements 'Fluxus' or 'Art & Language'. When an audience wants to fall back upon a programme or a surrogate programme in order to understand a work of art, it has come to do so by means of such concepts, and especially through the mediators, whose new heroic role is derived from their achievements, which they prove with their understanding of artists and works on the one hand, and their apt characterizations on the other.

Although Szeemann succeeded in revitalizing the institution of *documenta* by giving it a risky contemporaneity, he was not thanked for his achievements for a long time. The official organizers of *documenta* even considered suing him personally for some deficits in the budget that appear ridiculously tiny today but at that time might have ruined a man who did not have another job to go to. Nor was his immediate successor, Manfred Schneckenberger, the head of the *documenta* 6 and former head of the Cologne exhibition hall, reintegrated into the mediators' career scheme, but worked freelance for a long time after. Rudi Fuchs was clever and did not leave his job to make *documenta* 7 (1982), but returned to his museum in Eindhoven after a year of absence. He had realized that the much envied heroes of the hundred days could turn out to be highly respected un-employees in the following years. Not one of them in fact ever received the official recognition that Haftmann had gained by becoming the director of the West Berlin National Gallery after he left the Kassel exhibition committee. Nevertheless, the example set by Szeemann, with *When Attitudes Become Form*, *documenta* 5 and other subsequent important exhibitions, has influenced and changed the world of art mediating in many ways.

77

POSTSCRIPTUM

This essay was originally published as 'Modell documenta oder wie wird Kunstgeschichte gemacht?' in 1982. It has been revised and partly altered for this translation. It was written to introduce volume 49 of the German art magazine *Kunstforum International*, which I edited and baptized as 'Mythos *documenta*. Ein Bilderbuch zur Kunstgeschichte' ('The myth of *documenta*. An Art historical Picturebook'). The volume assembled hundreds of photographs of the first six *documentas* and short commentaries on its role in West German cultural history. It

was the first time that I had dealt with the history of *documenta*, to which I have returned twice, first in order to analyse its subterranean relationship with another important German exhibition of modern art, *Entartete Kunst* ('Degenerate Art') (1937), and second to reconstruct precisely the hanging and staging of the first *documenta* on the basis of newly discovered photographs. The essay '*Degenerate Art* and *Documenta I*: Modernism ostracized and disarmed', which was published in German in 1987 to commemorate the fiftieth anniversary of the exhibition *Degenerate Art*, was published in English in the book *Museum Culture: Histories, Discourses, Spectacles* which Irit Rogoff and Daniel J. Sherman edited for the University of Minnesota Press in 1994. The second essay, originally a slide show with commentary, '*documenta* – kunst des XX. jahrhunderts. internationale ausstellung im museum fridericianum in kassel', has appeared, with a small selection of plates, in the book *Die Kunst der Ausstellung*, which Bernd Klüser and Katherina Hegewisch have edited for Insel Verlag, Frankfurt am Main in 1991.

Translated from the German by Rebecca Pates.

PART II

STAGING SPECTATORS

5

THE EXHIBITIONARY COMPLEX

Tony Bennett

In reviewing Foucault on the asylum, the clinic, and the prison as institutional articulations of power and knowledge relations, Douglas Crimp suggests that there 'is another such institution of confinement ripe for analysis in Foucault's terms – the museum – and another discipline – art history'.[1] Crimp is no doubt right, although the terms of his proposal are misleadingly restrictive. For the emergence of the art museum was closely related to that of a wider range of institutions – history and natural-science museums, dioramas and panoramas, national and, later, international exhibitions, arcades and department stores – which served as linked sites for the development and circulation of new disciplines (history, biology, art history, anthropology) and their discursive formations (the past, evolution, aesthetics, Man) as well as for the development of new technologies of vision. Furthermore, while

these comprised an intersecting set of institutional and disciplinary relations which might be productively analysed as particular articulations of power and knowledge, the suggestion that they should be construed as institutions of confinement is curious. It seems to imply that works of art had previously wandered through the streets of Europe like the Ships of Fools in Foucault's *Madness and Civilisations*; or that geological and natural-history specimens had been displayed before the world, like the condemned on the scaffold, rather than being withheld from public gaze, secreted in the *studiolo* of princes, or made accessible only to the limited gaze of high society in the *cabinets des curieux* of the aristocracy. Museums may have enclosed objects within walls, but the nineteenth century saw their doors opened to the general public – witnesses whose presence was just as essential to a display of power as had been that of the people before the spectacle of punishment in the eighteenth century.

Institutions, then, not of confinement but of exhibition, forming a complex of disciplinary and power relations whose development might more fruitfully be juxtaposed to, rather than aligned with, the formation of Foucault's 'carceral archipelago'. For the movement Foucault traces in *Discipline and Punish* is one in which objects and bodies – the scaffold and the body of the condemned – which had previously formed a part of the public display of power were withdrawn from the public gaze as punishment increasingly took the form of incarceration. No longer inscribed within a public dramaturgy of power, the body of the condemned comes to be caught up within an inward-looking web of power relations. Subjected to omnipresent forms of surveillance through which the message of power was carried directly to it so as to render it docile, the body no longer served as the surface on which, through the system of retaliatory marks inflicted on it in the name of the sovereign, the lessons of power were written for others to read:

> The scaffold, where the body of the tortured criminal had been exposed to the ritually manifest force of the sovereign, the punitive theatre in which the representation of punishment was permanently available to the social body, was replaced by a great enclosed, complex and hierarchised structure that was integrated into the very body of the state apparatus.[2]

The institutions comprising 'the exhibitionary complex', by contrast, were involved in the transfer of objects and bodies from the enclosed and private domains in which they had previously been displayed (but to a restricted public) into progressively more open and public arenas where, through the representations to which they were subjected, they formed vehicles for inscribing and broadcasting the messages of power (but of a different type) throughout society.

Two different sets of institutions and their accompanying knowledge/power

relations, then, whose histories, in these respects, run in opposing directions. Yet they are also parallel histories. The exhibitionary complex and the carceral archipelago develop over roughly the same period – the late eighteenth to the mid-nineteenth centuries – and achieve developed articulations of the new principles they embodied within a decade or so of one another. Foucault regards the opening of the new prison at Mettray in 1840 as a key moment in the development of the carceral system. Why Mettray? Because, Foucault argues, 'it is the disciplinary form at its most extreme, the model in which are concentrated all the coercive technologies of behaviour previously found in the cloister, prison, school or regiment and which, in being brought together in one place, served as a guide for the future development of carceral institutions', (p. 293). In Britain, the opening of Pentonville Model Prison in 1842 is often viewed in a similar light. Less than a decade later the Great Exhibition of 1851 brought together an ensemble of disciplines and techniques of display that had been developed within the previous histories of museums, panoramas, Mechanics Institute exhibitions, art galleries, and arcades. In doing so, it translated these into exhibitionary forms which, in simultaneously ordering objects for public inspection and ordering the public that inspected, were to have a profound and lasting influence on the subsequent development of museums, art galleries, expositions, and department stores.

Nor are these entirely separate histories. At certain points they overlap, often with a transfer of meanings and effects between them. To understand their interrelations, however, it will be necessary, in borrowing from Foucault, to qualify the terms he proposes for investigating the development of power/knowledge relations during the formation of the modern period. For the set of such relations associated with the development of the exhibitionary complex serves as a check to the generalizing conclusions Foucault derives from his examination of the carceral system. In particular, it calls into question his suggestion that the penitentiary merely perfected the individualizing and normalizing technologies associated with a veritable swarming of forms of surveillance and disciplinary mechanisms which came to suffuse society with a new – and all-pervasive – political economy of power. This is not to suggest that technologies of surveillance had no place in the exhibitionary complex but rather that their intrication with new forms of spectacle produced a more complex and nuanced set of relations through which power was exercised and relayed to – and, in part, through and by – the populace than the Foucauldian account allows.

Foucault's primary concern, of course, is with the problem of order. He conceives the development of new forms of discipline and surveillance, as Jeffrey Minson puts it, as an 'attempt to reduce an ungovernable *populace* to a multiply differentiated *population*', parts of 'an historical movement aimed at transforming highly disruptive

economic conflicts and political forms of disorder into quasi-technical or moral problems for social administration'. These mechanisms assumed, Minson continues, 'that the key to the populace's social and political unruliness and also the means of combating it lies in the "opacity" of the populace to the forces of order'.[3] The exhibitionary complex was also a response to the problem of order, but one which worked differently in seeking to transform that problem into one of culture – a question of winning hearts and minds as well as the disciplining and training of bodies. As such, its constituent institutions reversed the orientations of the disciplinary apparatuses in seeking to render the forces and principles of order visible to the populace – transformed, here, into a people, a citizenry – rather than vice versa. They sought not to map the social body in order to know the populace by rendering it visible to power. Instead, through the provision of object lessons in power – the power to command and arrange things and bodies for public display – they sought to allow the people, and *en masse* rather than individually, to know rather than be known, to become the subjects rather than the objects of knowledge. Yet, ideally, they sought also to allow the people to know and thence to regulate themselves; to become, in seeing themselves from the side of power, both the subjects

84

➡ **5.1 The Great Exhibition, 1851: the Western, or British, Nave, looking east. Photograph by H. Owen and M. Ferrier, reproduced by courtesy of the Board of Trustees of the Victoria and Albert Museum, London.**

and the objects of knowledge, knowing power and what power knows, and knowing themselves as (ideally) known by power, interiorizing its gaze as a principle of self-surveillance and, hence, self-regulation.

It is, then, as a set of cultural technologies concerned to organize a voluntarily self-regulating citizenry that I propose to examine the formation of the exhibitionary complex. In doing so, I shall draw on the Gramscian perspective of the ethical and educative function of the modern state to account for the relations of this complex to the development of the bourgeois democratic polity. Yet, while wishing to resist a tendency in Foucault towards misplaced generalizations, it is to Foucault's work that I shall look to unravel the relations between knowledge and power effected by the technologies of vision embodied in the architectural forms of the exhibitionary complex.

DISCIPLINE, SURVEILLANCE, SPECTACLE

In discussing the proposals of late-eighteenth-century penal reformers, Foucault remarks that punishment, while remaining a 'legible lesson' organized in relation to

the body of the offended, was envisioned as 'a school rather than a festival; an ever-open book rather than a ceremony' (p. 111). Hence, in schemes to use convict labour in public contexts, it was envisaged that the convict would repay society twice: once by the labour he provided, and a second time by the signs he produced, a focus of both profit and signification in serving as an ever present reminder of the connection between crime and punishment:

> Children should be allowed to come to the places where the penalty is being carried out; there they will attend their classes in civics. And grown men will periodically relearn the laws. Let us conceive of places of punishment as a Garden of the Laws that families would visit on Sundays.
>
> (p. 111)

In the event, punishment took a different path with the development of the carceral system. Under both the *ancien régime* and the projects of the late-eighteenth-century reformers, punishment had formed part of a public system of representation. Both regimes obeyed a logic according to which 'secret punishment is a punishment half-wasted' (p. 111). With the development of the

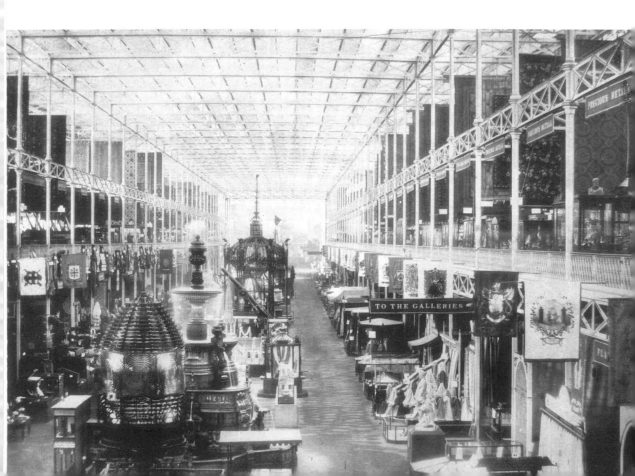

the hearts and minds of their visitors, these also brought their bodies with them creating architectural problems as vexed as any posed by the development of the carceral archipelago. The birth of the latter, Foucault argues, required a new architectural problematic:

> that of an architecture that is no longer built simply to be seen (as with the ostentation of palaces), or to observe the external space (cf. the geometry of fortresses), but to permit an internal, articulated and detailed control – to render visible those who are inside it; in more general terms, an architecture that would operate to transform individuals: to act on those it shelters, to provide a hold on their conduct, to carry the effects of power right to them, to make it possible to know them, to alter them.
>
> (p. 172)

As Davison notes, the development of the exhibitionary complex also posed a new demand: that everyone should see, and not just the ostentation of imposing façades but their contents too. This, too, created a series of architectural problems which were ultimately resolved only through a 'political economy of detail' similar to that applied to the regulation of the relations among bodies, space, and time within the penitentiary. In Britain, France, and Germany, the late eighteenth and early nineteenth centuries witnessed a spate of state-sponsored architectural competitions for the design of museums in which the emphasis shifted progressively away from organizing spaces of display for the private pleasure of the prince or aristocrat and towards an organization of space and vision that would enable museums to function as organs of public instruction.[12] Yet, as I have already suggested, it is misleading to view the architectural problematics of the exhibitionary complex as simply reversing the principles of panopticism. The effect of these principles, Foucault argues, was to abolish the crowd conceived as 'a compact mass, a locus of multiple exchanges, individualities merging together, a collective effect' and to replace it with 'a collection of separated individualities' (p. 201). However, as John MacArthur notes, the Panopticon is simply a technique, not itself a disciplinary regime or essentially a part of one, and like all techniques, its potential effects are not exhausted by its deployment within any of the regimes in which it happens to be used.[13] The peculiarity of the exhibitionary complex is not to be found in its reversal of the principles of the Panopticon. Rather, it consists in its incorporation of aspects of those principles together with those of the panorama, forming a technology of vision which served not to atomize and disperse the crowd but to regulate it, and to do so by rendering it visible to itself, by making the crowd itself the ultimate spectacle.

An instruction from a 'Short Sermon to Sightseers' at the 1901 Pan-American Exposition enjoined: 'Please remember when you get inside the gates you are part of the show.'[14] This was also true of museums and department stores which, like many

of the main exhibition halls of expositions, frequently contained galleries affording a superior vantage point from which the layout of the whole and the activities of other visitors could also be observed.[15] It was, however, the expositions which developed this characteristic furthest in constructing viewing positions from which they could be surveyed as totalities: the function of the Eiffel Tower at the 1889 Paris exposition, for example. To see and be seen, to survey yet always be under surveillance, the object of an unknown but controlling look: in these ways, as micro-worlds rendered constantly visible to themselves, expositions realized some of the ideals of panopticism in transforming the crowd into a constantly surveyed, self-watching, self-regulating, and as the historical record suggests, consistently orderly public – a society watching over itself.

Within the hierarchically organized systems of looks of the penitentiary in which each level of looking is monitored by a higher one, the inmate constitutes the point at which all these looks culminate but he is unable to return a look of his own or move to a higher level of vision. The exhibitionary complex, by contrast, perfected a self-monitoring system of looks in which the subject and object positions can be exchanged, in which the crowd comes to commune with and regulate itself through interiorizing the ideal and ordered view of itself as seen from the controlling vision of power – a site of sight accessible to all. It was in thus democratizing the eye of power that the expositions realized Bentham's aspiration for a system of looks within which the central position would be available to the public at all times, a model lesson in civics in which a society regulated itself through self-observation. But, of course, of self-observation from a certain perspective. As Manfredo Tafuri puts it:

> The arcades and the department stores of Paris, like the great expositions, were certainly the places in which the crowd, itself become a spectacle, found the spatial and visual means for a self-education from the point of view of capital.[16]

However, this was not an achievement of architecture alone. Account must also be taken of the forces which, in shaping the exhibitionary complex, formed both its public and its rhetorics.

SEEING THINGS

It seems unlikely, come the revolution, that it will occur to anyone to storm the British Museum. Perhaps it always was so. Yet, in the early days of its history, the fear that it might incite the vengeance of the mob was real enough. In 1780, in the midst of the Gordon Riots, troops were housed in the gardens and building and, in 1848, when the Chartists marched to present the People's Charter to parliament, the authorities prepared to defend the museum as vigilantly as if it had been a

penitentiary. The museum staff were sworn in as special constables; fortifications were constructed around the perimeter; a garrison of museum staff, regular troops, and Chelsea pensioners, armed with muskets, pikes, and cutlasses, and with provisions for a three-day siege, occupied the buildings; stones were carried to the roof to be hurled down on the Chartists should they succeed in breaching the outer defences.[17]

This fear of the crowd haunted debates on the museum's policy for over a century. Acknowledged as one of the first public museums, its conception of the public was a limited one. Visitors were admitted only in groups of fifteen and were obliged to submit their credentials for inspection prior to admission which was granted only if they were found to be 'not exceptionable'.[18] When changes to this policy were proposed, they were resisted by both the museum's trustees and its curators, apprehensive that the unruliness of the mob would mar the ordered display of culture and knowledge. When, shortly after the museum's establishment, it was proposed that there be public days on which unrestricted access would be allowed, the proposal was scuttled on the grounds, as one trustee put it, that some of the visitors from the streets would inevitably be 'in liquor' and 'will never be kept in

➡ **5.2 The South Kensington Museum (later the Victoria and Albert): interior of the South Court, eastern portion, from the south, *c.* 1876 (drawing by John Watkins). Reproduced by courtesy of the Board of Trustees of the Victoria and Albert Museum, London.**

order'. And if public days should be allowed, Dr Ward continued:

> then it will be necessary for the Trustees to have a presence of a Committee of themselves attending, with at least two Justices of the Peace and the constables of the division of Bloomsbury . . . supported by a guard such as one as usually attends at the Play-House, and even after all this, Accidents must and will happen.[19]

Similar objections were raised when, in 1835, a select committee was appointed to inquire into the management of the museum and suggested that it might be opened over Easter to facilitate attendance by the labouring classes. A few decades later, however, the issue had been finally resolved in favour of the reformers. The most significant shift in the state's attitude towards museums was marked by the opening of the South Kensington Museum in 1857. Administered, eventually, under the auspices of the Board of Education, the museum was officially dedicated to the service of an extended and undifferentiated public with opening hours and an admissions policy designed to maximize its accessibility to the working classes. It proved remarkably successful, too, attracting over 15 million visits between 1857 and 1883, over 6.5 million of which were recorded in the evenings, the most popular time

for working-class visitors who, it seems, remained largely sober. Henry Cole, the first director of the museum and an ardent advocate of the role museums should play in the formation of a rational public culture, pointedly rebutted the conceptions of the unruly mob which had informed earlier objections to open admissions policies. Informing a House of Commons committee in 1860 that only one person had had to be excluded for not being able to walk steadily, he went on to note that the sale of alcohol in the refreshment rooms had averaged out, as Altick summarizes it, at 'two and a half drops of wine, fourteen-fifteenths of a drop of brandy, and ten and half drops of bottled ale per capita'.[20] As the evidence of the orderliness of the newly extended museum public mounted, even the British Museum relented and, in 1883, embarked on a programme of electrification to permit evening opening.

The South Kensington Museum thus marked a significant turning point in the development of British museum policy in clearly enunciating the principles of the modern museum conceived as an instrument of public education. It provided the axis around which London's museum complex was to develop throughout the rest of the century and exerted a strong influence on the development of museums in the provincial cities and towns. These now rapidly took advantage of the Museum Bill of

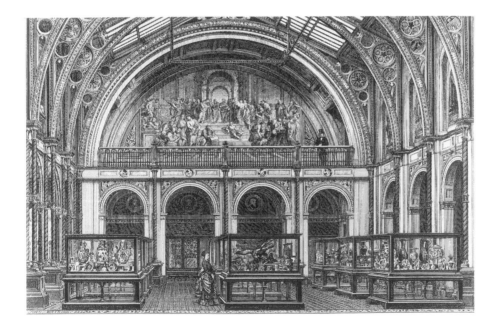

1845 (hitherto used relatively sparingly) which empowered local authorities to establish museums and art galleries: the number of public museums in Britain increased from 50 in 1860 to 200 in 1900.[21] In its turn, however, the South Kensington Museum had derived its primary impetus from the Great Exhibition which, in developing a new pedagogic relation between state and people, had also subdued the spectre of the crowd. This spectre had been raised again in the debates set in motion by the proposal that admission to the exhibition should be free. It could only be expected one correspondent to *The Times* argued, that both the rules of decorum and the rights of property would be violated if entry were made free to 'his majesty the mob'. These fears were exacerbated by the revolutionary upheavals of 1848, occasioning several European monarchs to petition that the public be banned from the opening ceremony (planned for May Day) for fear that this might spark off an insurrection which, in turn, might give rise to a general European conflagration.[22] And then there was the fear of social contagion should the labouring classes be allowed to rub shoulders with the upper classes.

In the event, the Great Exhibition proved a transitional form. While open to all, it also stratified its public in providing different days for different classes of visitors regulated by varying prices of admission. In spite of this limitation, the exhibition proved a major spur to the development of open-door policies. Attracting over 6 million visitors itself, it also vastly stimulated the attendance at London's main historic sites and museums: visits to the British Museum, for example, increased from 720,643 in 1850 to 2,230,242 in 1851.[23] Perhaps more important, though, was the orderliness of the public which in spite of the thousand extra constables and ten thousand troops kept on stand-by, proved duly appreciative, decorous in its bearing and entirely apolitical. More than that, the exhibition transformed the many-headed mob into an ordered crowd, a part of the spectacle and a sight of pleasure in itself. Victoria, in recording her impressions of the opening ceremony, dwelt particularly on her pleasure in seeing so large, so orderly, and so peaceable a crowd assembled in one place:

> The Green Park and Hyde Park were one mass of densely crowded human beings, in the highest good humour and most enthusiastic. I never saw Hyde Park look as it did, being filled with crowds as far as the eye could see.[24]

Nor was this entirely unprepared for. The working-class public the exhibition attracted was one whose conduct had been regulated into appropriate forms in the earlier history of the Mechanics Institute exhibitions. Devoted largely to the display of industrial objects and processes, these exhibitions pioneered policies of low admission prices and late opening hours to encourage working-class attendance long before these were adopted within the official museum complex. In doing so,

moreover, they sought to tutor their visitors on the modes of deportment required if they were to be admitted. Instruction booklets advised working-class visitors how to present themselves, placing particular stress on the need to change out of their working clothes – partly so as not to soil the exhibits, but also so as not to detract from the pleasure of the overall spectacle; indeed, to become parts of it:

> Here is a visitor of another sort; the mechanic has resolved to treat himself with a few hours holiday and recreation; he leaves the 'grimy shop', the dirty bench, and donning his Saturday night suit he appears before us – an honourable and worthy object.[25]

In brief, the Great Exhibition and, subsequently, the public museums developed in its wake found themselves heirs to a public which had already been formed by a set of pedagogic relations which, developed initially by voluntary organizations – in what Gramsci would call the realm of civil society – were henceforward to be more thoroughgoingly promoted within the social body in being subjected to the direction of the state.

Not, then, a history of confinement but one of the opening up of objects to more public contexts of inspection and visibility: this is the direction of movement embodied in the formation of the exhibitionary complex. A movement which simultaneously helped to form a new public and inscribe it in new relations of sight and vision. Of course, the precise trajectory of these developments in Britain was not followed elsewhere in Europe. None the less, the general direction of development was the same. While earlier collections (whether of scientific objects, curiosities, or works of art) had gone under a variety of names (museums, *studioli*, *cabinets des curieux*, *Wunderkammern*, *Kunstkammern*) and fulfilled a variety of functions (the storing and dissemination of knowledge, the display of princely and aristocratic power, the advancement of reputations and careers), they had mostly shared two principles: that of private ownership and that of restricted access.[26] The formation of the exhibitionary complex involved a break with both in effecting the transfer of significant quantities of cultural and scientific property from private into public ownership where they were housed within institutions administered by the state for the benefit of an extended general public.

The significance of the formation of the exhibitionary complex, viewed in this perspective, was that of providing new instruments for the moral and cultural regulation of the working classes. Museums and expositions, in drawing on the techniques and rhetorics of display and pedagogic relations developed in earlier nineteenth-century exhibitionary forms, provided a context in which the working- and middle-class publics could be brought together and the former – having been tutored into forms of behaviour to suit them for the occasion – could be exposed to the improving influence of the latter. A history, then, of the formation of a new

95

public and its inscription in new relations of power and knowledge. But a history
accompanied by a parallel one aimed at the destruction of earlier traditions of
popular exhibition and the publics they implied and produced. In Britain, this took
the form, *inter alia*, of a concerted attack on popular fairs owing to their association
with riot, carnival, and, in their sideshows, the display of monstrosities and
curiosities which, no longer enjoying elite patronage, were now perceived as
impediments to the rationalizing influence of the restructured exhibitionary
complex.

Yet, by the end of the century, fairs were to be actively promoted as an aid rather
than a threat to public order. This was partly because the mechanization of fairs
meant that their entertainments were increasingly brought into line with the values
of industrial civilization, a testimony to the virtues of progress.[27] But it was also a
consequence of changes in the conduct of fairgoers. By the end of the century, Hugh
Cunningham argues, 'fairgoing had become a relatively routine ingredient in the
accepted world of leisure' as 'fairs became tolerated, safe, and in due course a subject
for nostalgia and revival'.[28] The primary site for this transformation of fairs and the
conduct of their publics – although never quite so complete as Cunningham suggests
– was supplied by the fair zones of the late-nineteenth-century expositions. It was
here that two cultures abutted on to one another, the fair zones forming a kind of
buffer region between the official and the popular culture with the former seeking to
reach into the latter and moderate it. Initially, these fair zones established themselves
independently of the official expositions and their organizing committees. The
product of the initiative of popular showmen and private traders eager to exploit the
market the expositions supplied, they consisted largely of an *ad hoc* melange of both
new (mechanical rides) and traditional popular entertainments (freak shows, etc.)
which frequently mocked the pretensions of the expositions they adjoined. Burton
Benedict summarizes the relations between expositions and their amusement zones
in late-nineteenth-century America as follows:

> Many of the display techniques used in the amusement zone seemed to parody those
> of the main fair. Gigantism became enormous toys or grotesque monsters.
> Impressive high structures became collapsing or whirling amusement 'rides'. The
> solemn female allegorical figures that symbolised nations (Miss Liberty, Britannia)
> were replaced by comic male figures (Uncle Sam, John Bull). At the Chicago fair of
> 1893 the gilded female statue of the Republic on the Court of Honour contrasted with
> a large mechanical Uncle Sam on the Midway that delivered forty thousand speeches
> on the virtues of Hub Gore shoe elastics. Serious propagandists for manufacturers
> and governments in the main fair gave way to barkers and pitch men. The public no
> longer had to play the role of impressed spectators. They were invited to become

frivolous participants. Order was replaced by jumble, and instruction by
entertainment.[29]

As Benedict goes on to note, the resulting tension between unofficial fair and
official exposition led to 'exposition organisers frequently attempting to turn the
amusement zone into an educational enterprise or at least to regulate the type of
exhibit shown'. In this, they were never entirely successful. Into the twentieth
century, the amusement zones remained sites of illicit pleasures – of burlesque shows
and prostitution – and of ones which the exposition themselves aimed to render
archaic. Altick's 'monster-mongers and retailers of other strange sights' seem to have
been as much in evidence at the Panama Pacific Exhibition of 1915 as they had been,
a century earlier, at St Bartholomew's Fair, Wordsworth's Parliament of Monsters.[30]
None the less, what was evident was a significant restructuring in the ideological
economy of such amusement zones as a consequence of the degree to which, in
subjecting them to more stringent forms of control and direction, exposition
authorities were able to align their thematics to those of the official expositions
themselves and, thence, to those of the rest of the exhibitionary complex. Museums,
the evidence suggests, appealed largely to the middle classes and the skilled and
respectable working classes and it seems likely that the same was true of expositions.
The link between expositions and their adjoining fair zones, however, provided a
route through which the exhibitionary complex and the disciplines and knowledges
which shaped its rhetorics acquired a far wider and more extensive social influence.

97

THE EXHIBITIONARY DISCIPLINES

The space of representation constituted by the exhibitionary complex was shaped by
the relations between an array of new disciplines: history, art history, archaeology,
geology, biology, and anthropology. Whereas the disciplines associated with the
carceral archipelago were concerned to reduce aggregates to individualities,
rendering the latter visible to power and so amenable to control, the orientation of
these disciplines – as deployed in the exhibitionary complex – might best be
summarized as that of 'show and tell'. They tended also to be generalizing in their
focus. Each discipline, in its museological deployment, aimed at the representation of
a type and its insertion in a developmental sequence for display to a public.

Such principles of classification and display were alien to the eighteenth century.
Thus, in Sir John Soane's Museum, architectural styles are displayed in order to
demonstrate their essential permanence rather than their change and development.[31]
The emergence of a historicized framework for the display of human artefacts in
early-nineteenth-century museums was thus a significant innovation. But not an

isolated one. As Stephen Bann shows, the emergence of a 'historical frame' for the display of museum exhibits was concurrent with the development of an array of disciplinary and other practices which aimed at the lifelike reproduction of an authenticated past and its representation as a series of stages leading to the present – the new practices of history writing associated with the historical novel and the development of history as an empirical discipline, for example.[32] Between them, these constituted a new space of representation concerned to depict the development of peoples, states, and civilizations through time conceived as a progressive series of developmental stages.

The French Revolution, Germaine Bazin suggests, played a key role in opening up this space of representation by breaking the chain of dynastic succession that had previously vouchsafed a unity to the flow and organization of time.[33] Certainly, it was in France that historicized principles of museum display were first developed. Bazin stresses the formative influence of the Musée des monuments français (1795) in exhibiting works of art in galleries devoted to different periods, the visitor's route leading from earlier to later periods, with a view to demonstrating both the painterly conventions peculiar to each epoch and their historical development. He accords a similar significance to Alexandre du Sommerard's collection at the Hôtel de Cluny which, as Bann shows, aimed at 'an integrative construction of historical totalities', creating the impression of a historically authentic milieu by suggesting an essential and organic connection between artefacts displayed in rooms classified by period.[34]

Bann argues that these two principles – the *galleria progressiva* and the period room, sometimes employed singly, at others in combination – constitute the distinctive poetics of the modern historical museum. It is important to add, though, that this poetics displayed a marked tendency to be nationalized. If, as Bazin suggests, the museum became 'one of the fundamental institutions of the modern state',[35] that state was also increasingly a nation-state. The significance of this was manifested in the relations between two new historical times – national and universal – which resulted from an increase in the vertical depth of historical time as it was both pushed further and further back into the past and brought increasingly up to date. Under the impetus of the rivalry between France and Britain for dominion in the Middle East, museums, in close association with archaeological excavations of progressively deeper pasts, extended their time horizons beyond the medieval period and the classical antiquities of Greece and Rome to encompass the remnants of the Egyptian and Mesopotamian civilizations. At the same time, the recent past was historicized as the newly emerging nation-states sought to preserve and immemorialize their own formation as a part of that process of 'nationing' their populations that was essential to their further development. It was as a consequence of the first of these developments that the prospect of a universal history of

civilization was opened up to thought and materialized in the archaeological collections of the great nineteenth-century museums. The second development, however, led to these universal histories being annexed to national histories as, within the rhetorics of each national museum complex, collections of national materials were represented as the outcome and culmination of the universal story of civilization's development.

Nor had displays of natural or geological specimens been organized historically in the various precursors of nineteenth-century public museums. Throughout the greater part of the eighteenth century, principles of scientific classification testified to a mixture of theocratic, rationalist, and proto-evolutionist systems of thought. Translated into principles of museological display, the result was the table, not the series, with species being arranged in terms of culturally codified similarities/dissimilarities in their external appearances rather than being ordered into temporally organized relations of precession/succession. The crucial challenges to such conceptions came from developments within geology and biology, particularly where their researches overlapped in the stratigraphical study of fossil remains.[36] However, the details of these developments need not concern us here. So far as their implications for museums were concerned, their main significance was that of allowing for organic life to be conceived and represented as a temporally ordered succession of different forms of life where the transitions between them were accounted for not as a result of external shocks (as had been the case in the eighteenth century) but as the consequence of an inner momentum inscribed within the concept of life itself.[37]

If developments within history and archaeology thus allowed for the emergence of new forms of classification and display through which the stories of nations could be told and related to the longer story of western civilization's development, the discursive formations of nineteenth-century geology and biology allowed these cultural series to be inserted within the longer developmental series of geological and natural time. Museums of science and technology, heirs to the rhetorics of progress developed in national and international exhibitions, completed the evolutionary picture in representing the history of industry and manufacture as a series of progressive innovations leading up to the contemporary triumphs of industrial capitalism.

Yet, in the context of late-nineteenth-century imperialism, it was arguably the employment of anthropology within the exhibitionary complex which proved most central to its ideological functioning. For it played the crucial role of connecting the histories of Western nations and civilizations to those of other peoples, but only by separating the two in providing for an interrupted continuity in the order of peoples and races – one in which 'primitive peoples' dropped out of history altogether in

99

effacing divisions within the body politic in constructing a 'we' conceived as the realization, and therefore just beneficiaries, of the processes of evolution and identified as a unity in opposition to the primitive otherness of conquered peoples. This was not entirely new. As Peter Stallybrass and Allon White note, the popular fairs of the late-eighteenth and early-nineteenth centuries had exoticized the grotesque imagery of the carnival tradition by projecting it on to the representatives of alien cultures. In thus providing a normalizing function via the construction of a radically different Other, the exhibition of other people served as a vehicle for 'the edification of a national public and the confirmation of its imperial superiority'.[42] If, in its subsequent development, the exhibitionary complex latched on to this pre-existing representational space, what it added to it was a historical dimension.

THE EXHIBITIONARY APPARATUSES

The space of representation constituted by the exhibitionary disciplines, while conferring a degree of unity on the exhibitionary complex, was also somewhat differently occupied – and to different effect – by the institutions comprising that complex. If museums gave this space a solidity and permanence, this was achieved at the price of a lack of ideological flexibility. Public museums instituted an order of things that was meant to last. In doing so, they provided the modern state with a deep and continuous ideological backdrop but one which, if it was to play this role, could not be adjusted to respond to shorter-term ideological requirements. Exhibitions met this need, injecting new life into the exhibitionary complex and rendering its ideological configurations more pliable in bending them to serve the conjuncturally specific hegemonic strategies of different national bourgeoisies. They made the order of things dynamic, mobilizing it strategically in relation to the more immediate ideological and political exigencies of the particular moment.

This was partly an effect of the secondary discourses which accompanied exhibitions. Ranging from the state pageantry of their opening and closing ceremonies through newspaper reports to the veritable swarming of pedagogic initiatives organized by religious, philanthropic, and scientific associations to take advantage of the publics which exhibitions produced, these often forged very direct and specific connections between the exhibitionary rhetoric of progress and the claims to leadership of particular social and political forces. The distinctive influence of the exhibitions themselves, however, consisted in their articulation of the rhetoric of progress to the rhetorics of nationalism and imperialism and in producing, via their control over their adjoining popular fairs, an expanded cultural sphere for the deployment of the exhibitionary disciplines.

The basic signifying currency of the exhibitions, of course, consisted in their

arrangement of displays of manufacturing processes and products. Prior to the Great Exhibition, the message of progress had been carried by the arrangement of exhibits in, as Davison puts it, 'a series of classes and sub-classes ascending from raw products of nature, through various manufactured goods and mechanical devices, to the "highest" forms of applied and fine art'.[43] As such, the class articulations of this rhetoric were subject to some variation. Mechanics Institutes' exhibitions placed considerable stress on the centrality of labour's contributions to the processes of production which, at times, allowed a radical appropriation of their message. 'The machinery of wealth, here displayed,' the *Leeds Times* noted in reporting an 1839 exhibition, 'has been created by the men of hammers and papercaps; more honourable than all the sceptres and coronets in the world.'[44] The Great Exhibition introduced two changes which decisively influenced the future development of the form.

First, the stress was shifted from the *processes* to the *products* of production, divested of the marks of their making and ushered forth as signs of the productive and co-ordinating power of capital and the state. After 1851, world fairs were to function less as vehicles for the technical education of the working classes than as instruments for their stupefaction before the reified products of their own labour, 'places of pilgrimage', as Benjamin put it, 'to the fetish Commodity'.[45]

Second, while not entirely abandoned, the earlier progressive taxonomy based on stages of production was subordinated to the dominating influence of principles of classification based on nations and the supra-national constructs of empires and races. Embodied, at the Crystal Palace, in the form of national courts or display areas, this principle was subsequently developed into that of separate pavilions for each participating country. Moreover, following an innovation of the Centennial Exhibition held at Philadelphia in 1876, these pavilions were typically zoned into racial groups: the Latin, Teutonic, Anglo-Saxon, American, and Oriental being the most favoured classifications, with black peoples and the aboriginal populations of conquered territories, denied any space of their own, being represented as subordinate adjuncts to the imperial displays of the major powers. The effect of these developments was to transfer the rhetoric of progress from the relations between stages of production to the relations between races and nations by superimposing the associations of the former on to the latter. In the context of imperial displays, subject peoples were thus represented as occupying the lowest levels of manufacturing civilization. Reduced to displays of 'primitive' handicrafts and the like, they were represented as cultures without momentum except for that benignly bestowed on them from without through the improving mission of the imperialist powers. Oriental civilizations were allotted an intermediate position in being represented either as having at one time been subject to development but subsequently

degenerating into stasis or as embodying achievements of civilization which, while developed by their own lights, were judged inferior to the standards set by Europe.[46] In brief, a progressivist taxonomy for the classification of goods and manufacturing processes was laminated on to a crudely racist teleological conception of the relations between peoples and races which culminated in the achievements of the metropolitan powers, invariably most impressively displayed in the pavilions of the host country.

Exhibitions thus located their preferred audiences at the very pinnacle of the exhibitionary order of things they constructed. They also installed them at the threshold of greater things to come. Here, too, the Great Exhibition led the way in sponsoring a display of architectural projects for the amelioration of working-class housing conditions. This principle was to be developed, in subsequent exhibitions, into displays of elaborate projects for the improvement of social conditions in the areas of health, sanitation, education, and welfare – promissory notes that the engines of progress would be harnessed for the general good. Indeed, exhibitions came to function as promissory notes in their totalities, embodying, if just for a season, utopian principles of social organization which, when the time came for the notes to be redeemed, would eventually be realized in perpetuity. As world fairs fell increasingly under the influence of modernism, the rhetoric of progress tended, as Rydell puts it, to be 'translated into a utopian statement about the future', promising the imminent dissipation of social tensions once progress had reached the point where its benefits might be generalized.[47]

Iain Chambers has argued that working- and middle-class cultures became sharply distinct in late-nineteenth-century Britain as an urban commercial popular culture developed beyond the reach of the moral economy of religion and respectability. As a consequence, he argues, 'official culture was publicly limited to the rhetoric of monuments in the centre of town: the university, the museum, the theatre, the concert hall; otherwise it was reserved for the "private" space of the Victorian residence'.[48] While not disputing the general terms of this argument, it does omit any consideration of the role of exhibitions in providing official culture with powerful bridgeheads into the newly developing popular culture. Most obviously the official zones of exhibitions offered a context for the deployment of the exhibitionary disciplines which reached a more extended public than that ordinarily reached by the public museum system. The exchange of both staff and exhibits between museums and exhibitions was a regular and recurrent aspect of their relations, furnishing an institutional axis for the extended social deployment of a distinctively new ensemble of disciplines. Even within the official zones of exhibitions, the exhibitionary disciplines thus achieved an exposure to publics as large as any to which even the most commercialized forms of popular culture could

lay claim: 32 million people attended the Paris Exposition of 1889; 27.5 million went to Chicago's Columbian Exposition in 1893 and nearly 49 million to Chicago's 1933/4 Century of Progress Exposition; the Glasgow Empire Exhibition of 1938 attracted 12 million visitors, and over 27 million attended the Empire Exhibition at Wembley in 1924/5.[49] However, the ideological reach of exhibitions often extended significantly further as they established their influence over the popular entertainment zones which, while initially deplored by exhibition authorities, were subsequently to be managed as planned adjuncts to the official exhibition zones and, sometimes, incorporated into the latter. It was through this network of relations that the official public culture of museums reached into the developing urban popular culture, shaping and directing its development in subjecting the ideological thematics of popular entertainments to the rhetoric of progress.

The most critical development in this respect consisted in the extension of anthropology's disciplinary ambit into the entertainment zones, for it was here that the crucial work of transforming non-white peoples themselves – and not just their remains or artefacts – into object lessons of evolutionary theory was accomplished. Paris led the way here in the colonial city it constructed as part of its 1889 Exposition. Populated by Asian and African peoples in simulated 'native' villages, the colonial city functioned as the showpiece of French anthropology and, through its influence on delegates to the tenth Congrès internationale d'anthropologie et d'archéologie préhistorique held in association with the exposition, had a decisive bearing on the future modes of the discipline's social deployment. While this was true internationally, Rydell's study of American world fairs provides the most detailed demonstration of the active role played by museum anthropologists in transforming the Midways into living demonstrations of evolutionary theory by arranging non-white peoples into a 'sliding-scale of humanity', from the barbaric to the nearly civilized, thus underlining the exhibitionary rhetoric of progress by serving as visible counterpoints to its triumphal achievements. It was here that relations of knowledge and power continued to be invested in the public display of bodies, colonizing the space of earlier freak and monstrosity shows in order to personify the truths of a new regime of representation.

In their interrelations, then, the expositions and their fair zones constituted an order of things and of peoples which, reaching back into the depths of prehistoric time as well as encompassing all corners of the globe, rendered the whole world metonymically present, subordinated to the dominating gaze of the white, bourgeois, and (although this is another story) male eye of the metropolitan powers. But an eye of power which, through the development of the technology of vision associated with exposition towers and the positions for seeing these produced in relation to the miniature ideal cities of the expositions themselves, was democratized in being made

available to all. Earlier attempts to establish a specular dominance over the city had, of course, been legion – the camera obscura, the panorama – and often fantastic in their technological imaginings. Moreover, the ambition to render the whole world, as represented in assemblages of commodities, subordinate to the controlling vision of the spectator was present in world exhibitions form the outset. This was represented synecdochically at the Great Exhibition by Wylde's Great Globe, a brick rotunda which the visitor entered to see plaster casts of the world's continents and oceans. The principles embodied in the Eiffel Tower, built for the 1889 Paris Exposition and repeated in countless subsequent expositions, brought these two series together, rendering the project of specular dominance feasible in affording an elevated vantage point over a micro-world which claimed to be representative of a larger totality.

Barthes has aptly summarized the effects of the technology of vision embodied in the Eiffel Tower. Remarking that the tower overcomes 'the habitual divorce between *seeing* and *being seen*', Barthes argues that it acquires a distinctive power from its ability to circulate between these two functions of sight:

➡ **5.4 The Chicago Columbian Exposition, 1893: view from the roof of the Manufacturers and Liberal Arts Building. Photograph courtesy of the Chicago Historical Society, Chicago, Ill.**

> An object when we look at it, it becomes a lookout in its turn when we visit it, and now constitutes as an object, simultaneously extended and collected beneath it, that Paris which just now was looking at it.[50]

A sight itself, it becomes the site for a sight; a place both to see and be seen from, which allows the individual to circulate between the object and subject positions of the dominating vision it affords over the city and its inhabitants. In this, its distancing effect, Barthes argues, 'the Tower makes the city into a kind of nature; it constitutes the swarming of men into a landscape, it adds to the frequently grim urban myth a romantic dimension, a harmony, a mitigation', offering 'an immediate consumption of a humanity made natural by that glance which transforms it into space'.[51] It is because of the dominating vision it affords, Barthes continues, that, for the visitor, 'the Tower is the first obligatory monument; it is a Gateway, it marks the transition to a knowledge'.[52] And to the power associated with that knowledge: the power to order objects and persons into a world to be known and to lay it out before a vision capable of encompassing it as a totality.

In *The Prelude*, Wordsworth, seeking a vantage point from which to quell the

tumultuousness of the city, invites his reader to ascend with him 'Above the press and danger of the crowd/Upon some showman's platform' (vii, 684–5) at St Bartholomew's Fair, likened to mobs, riotings, and executions as occasions when the passions of the city's populace break forth into unbridled expression. The vantage point, however, affords no control:

All moveables of wonder, from all parts
Are here – Albinos, painted Indians, Dwarfs,
The Horse of knowledge, and the learned Pig,
The Stone-eater, the man that swallows fire,
Giants, Ventriloquists, the Invisible Girl,
The Bust that speaks and moves its goggling eyes,
The Wax-work, Clock-work, all the marvellous craft
Of modern Merlins, Wild Beasts, Puppet-shows,
All out-o'-the-way, far-fetched, perverted things,
All freaks of nature, all Promethean thoughts
Of man, his dullness, madness, and their feats

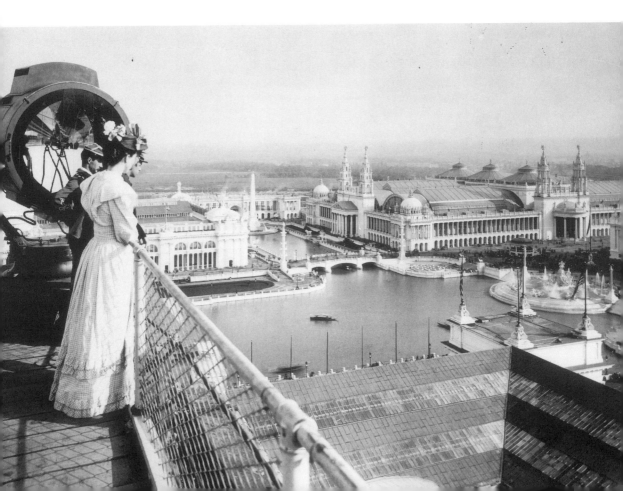

All jumbled up together, to compose
A Parliament of Monsters.

<div align="center">(vii, 706–18)</div>

Stallybrass and White argue that this Wordsworthian perspective was typical of the early-nineteenth-century tendency for the educated public, in withdrawing from participation in popular fairs, also to distance itself from, and seek some ideological control over, the fair by the literary production of elevated vantage points from which it might be observed. By the end of the century, the imaginary dominance over the city afforded by the showman's platform had been transformed into a cast-iron reality while the fair, no longer a symbol of chaos, had become the ultimate spectacle of an ordered totality. And the substitution of observation for participation was a possibility open to all. The principle of spectacle – that, as Foucault summarizes it, of rendering a small number of objects accessible to the inspection of a multitude of men – did not fall into abeyance in the nineteenth century: it was surpassed through the development of technologies of vision which rendered the multitude accessible to its own inspection.

CONCLUSION

I have sought in this essay, to tread a delicate line between Foucault's and Gramsci's perspectives on the state, but without attempting to efface their differences so as to forge a synthesis between them. Nor is there a compelling need for such a synthesis. The concept of the state is merely a convenient shorthand for an array of governmental agencies which – as Gramsci was among the first to argue in distinguishing between the coercive apparatuses of the state and those engaged in the organization of consent – need not be conceived as unitary with regard to either their functioning or the modalities of power they embody.

That said, however, my argument has been mainly with (but not against) Foucault. In the study already referred to, Pearson distinguishes between the 'hard' and the 'soft' approaches to the nineteenth-century state's role in the promotion of art and culture. The former consisted of 'a systematic body of knowledge and skills promulgated in a systematic way to specified audiences'. Its field was comprised by those institutions of schooling which exercised a forcible hold or some measure of constraint over their members and to which the technologies of self-monitoring developed in the carceral system undoubtedly migrated. The 'soft' approach, by contrast, worked 'by example rather than by pedagogy; by entertainment rather than by disciplined schooling; and by subtlety and encouragement'.[53] Its field of application consisted of those institutions whose hold over their publics depended on their voluntary participation.

There seems no reason to deny the different sets of knowledge/power relations embodied in these contrasting approaches, or to seek their reconciliation in some common principle. For the needs to which they responded were different. The problem to which the 'swarming of disciplinary mechanisms' responded was that of making extended populations governable. However, the development of bourgeois democratic polities required not merely that the populace be governable but that it assent to its governance, thereby creating a need to enlist active popular support for the values and objectives enshrined in the state. Foucault knows well enough the symbolic power of the penitentiary:

> The high wall, no longer the wall that surrounds and protects, no longer the wall that stands for power and wealth, but the meticulously sealed wall, uncrossable in either direction, closed in upon the now mysterious work of punishment, will become, near at hand, sometimes even at the very centre of the cities of the nineteenth century, the monotonous figure, at once material and symbolic, of the power to punish.
>
> (p. 116)

Museums were also typically located at the centre of cities where they stood as embodiments, both material and symbolic, of a power to 'show and tell' which, in being deployed in a newly constituted open and public space, sought rhetorically to incorporate the people within the processes of the state. If the museum and the penitentiary thus represented the Janus face of power, there was none the less – at least symbolically – an economy of effort between them. For those who failed to adopt the tutelary relation to the self promoted by popular schooling or whose hearts and minds failed to be won in the new pedagogic relations between state and people symbolized by the open doors of the museum, the closed walls of the penitentiary threatened a sterner instruction in the lessons of power. Where instruction and rhetoric failed, punishment began.

NOTES

This essay was originally published in *New Formations*, 4 (Spring 1988), pp. 73–102.

1 Douglas Crimp, 'On the museum's ruins', in Hal Foster, ed., *The Anti-Aesthetic: Essays on Postmodern Culture*, Washington, Bay Press, 1985, p. 45.

2 Michael Foucault, *Discipline and Punish: The Birth of the Prison*, trans. A. Sheridan, London, Allen Lane, 1977, pp. 115–16; further page references will be given in the text.

3 Jeffrey Minson, *Genealogies of Morals: Nietzche, Foucault, Donzelot and the Eccentricity of Ethics*, London, Macmillan, 1985, p. 24.

4 This point is well made by MacArthur who sees this aspect of Foucault's argument as

inimical to the overall spirit of his work in suggesting a 'historical division which places theatre and spectacle as past'. John MacArthur, 'Foucault, Tafuri, Utopia: essays in the history and theory of architecture', unpublished M.Phil. thesis, University of Queensland, 1983, p. 192.

5 Graeme Davison, 'Exhibitions', *Australian Cultural History*, 2 (1982/3), Canberra, Australian Academy of the Humanities and the History of Ideas Unit, A.N.U., p. 7.

6 See Richard D. Altick, *The Shows of London*, Cambridge, Mass. and London, The Belknap Press of Harvard University Press, 1978.

7 Dean MacCannell, *The Tourist: A New Theory of the Leisure Class*, New York, Schocken Books, 1976, p. 57.

8 See Dana Aron Brand, *The Spectator and the City: Fantasies of Urban Legibility in Nineteenth-Century England and America*, Ann Arbor, Mich., University Microfilms International, 1986.

9 For discussions of the role of the American state in relation to museums and expositions, see, respectively, K.E. Meyer, *The Art Museum: Power, Money, Ethics*, New York, William Morrow, 1979, and Badger Reid, *The Great American Fair: The World's Columbian Exposition and American Culture*, Chicago, Nelson Hall, 1979.

10 Nicholas Pearson, *The State and the Visual Arts: A Discussion of State Intervention in the Visual Arts in Britain, 1780–1981*, Milton Keynes, Open University Press, 1982, pp. 8–13, 46–7.

11 See Debora Silverman, 'The 1889 exhibition: the crisis of bourgeois individualism', *Oppositions: A Journal of Ideas and Criticism in Architecture*, Spring 1977, and Robert W. Rydell, *All the World's a Fair: Visions of Empire at American International Expositions, 1876–1916*, Chicago, University of Chicago Press, 1984.

12 See H. Seling, 'The genesis of the museum', *Architectural Review*, 131 (1967).

13 MacArthur, 'Foucault, Tafuri, Utopia', pp. 192–3.

14 Cited in Neil Harris, 'Museums, merchandising and popular taste: the struggle for influence', in I.M.G. Quimby, ed., *Material Culture and the Study of American Life*, New York, W.W. Norton, 1978, p. 144.

15 For details of the use of rotunda and galleries to this effect in department stores, see John William Ferry, *A History of the Department Store*, New York, Macmillan, 1960.

16 Manfredo Tafuri, *Architecture and Utopia: Design and Capitalist Development*, Cambridge, Mass., MIT Press, 1976, p. 83.

17 For further details, see Edward Millar, *That Noble Cabinet: A History of the British Museum*, Athens, Ohio, Ohio University Press, 1974.

18 A.S. Wittlin, *The Museum: Its History and Its Tasks in Education*, London, Routledge & Kegan Paul, 1949, p. 113.

19 Cited in Millar, *The Noble Cabinet*, p. 62.

20 Altick, *The Shows of London*, p. 500.

21 See David White, 'Is Britain becoming one big museum?', *New Society*, 20 Oct. 1983.

22 See Audrey Shorter, 'Workers under glass in 1851', *Victorian Studies*, 10: 2 (1966).

23 See Altick, *The Shows of London*, p. 467.

24 Cited in C.H. Gibbs-Smith, *The Great Exhibition of 1851*, London, HMSO, 1981, p. 18.

25 Cited in Toshio Kusamitsu, 'Great exhibitions before 1851', *History Workshop*, 9 (1980), 77.

26 A comprehensive introduction to these earlier forms is offered by Olive Impey and Arthur MacGregor, eds, *The Origins of Museums: The Cabinet of Curiosities in Sixteenth- and Seventeenth-Century Europe*, Oxford, Clarendon Press, 1985. See also Bazin, below note 33.

27 I have touched on these matters elsewhere. See Tony Bennett, 'A thousand and one troubles: Blackpool Pleasure Beach', *Formations of Pleasure*, London, Routledge & Kegan Paul, 1983, and 'Hegemony, ideology, pleasure: Blackpool', in Tony Bennett, Colin Mercer, and Janet Woollacott, eds, *Popular Culture and Social Relations*, Milton Keynes, Open University Press, 1986.

28 Hugh Cunningham, *Leisure in the Industrial Revolution*, London, Croom Helm, 1980, as excerpted in Bernard Waites, Tony Bennett, and Graham Martin, eds, *Popular Culture: Past and Present*, London, Croom Helm, 1982, p. 163.

29 Burton Benedict, 'The anthropology of world's fairs', in Burton Benedict, ed., *The Anthropology of World's Fairs: San Francisco's Panama Pacific Exposition of 1915*, New York, Scolar Press, 1983, p. 53–4.

30 For details, see McCullough, *World's Fair Midways: An Affectionate Account of American Amusement Areas*, New York, Exposition Press, 1966, p. 76.

31 See Colin Davies, 'Architecture and remembrance', *Architectural Review* (Feb. 1984), p. 54.

32 See Stephen Bann, *The Clothing of Clio: A Study of the Representation of History in Nineteenth-Century Britain and France*, Cambridge, Cambridge University Press, 1984.

33 G. Bazin, *The Museum Age*, New York, Universal Press, 1967, p. 218.

34 Bann, *The Clothing of Clio*, p. 85.

35 Bazin, *The Museum Age*, p. 169.

36 For details of these interactions, see Martin J.S. Rudwick, *The Meaning of Fossils: Episodes in the History of Palaeontology*, Chicago, University of Chicago Press, 1985.

37 I draw here on Michel Foucault, *The Order of Things: An Archaeology of the Human Sciences*, London, Tavistock, 1970.

38 Cuvier, cited in Sander L. Gilman, 'Black bodies, white bodies: toward an iconography of female sexuality in late nineteenth-century art, medicine and literature', *Critical Inquiry*, 21:1 (Autumn 1985), pp. 214–15.

39 See David K. van Keuren, 'Museums and ideology: Augustus Pitt-Rivers, anthropological museums, and social change in later Victorian Britain', *Victorian Studies*, 28: 1 (Autumn 1984).

40 See S.G. Kohlstedt, 'Australian museums of natural history: public practices and scientific initiatives in the 19th century', *Historical Records of Australian Science*, 5 (1983).

41 For the most thorough account, see D.J. Mulvaney, 'The Australian Aborigine 1606–1929: opinion and fieldwork', *Historical Studies*, 8 (1958), pp. 30–1.

42 Peter Stallybrass and Allon White, *The Politics and Poetics of Transgression*, London, Methuen, 1986, p. 42.

43 Davison, 'Exhibitions', p. 8.

44 Cited in Kusamitsu, 'Great exhibitions before 1851', p. 79.

45 Walter Benjamin, *Charles Baudelaire: A Lyric Poet in the Era of High Capitalism*, London, New Left Books, 1973, p. 165.

46 See Neil Harris, 'All the world a melting pot? Japan at American fairs, 1876–1904', in Ireye Akira, ed., *Mutual Images: Essays in American–Japanese Relations*, Cambridge, Mass., Harvard University Press, 1975.

47 Rydell, *All the World's a Fair*, p. 4.

48 Iain Chambers, 'The obscured metropolis', *Australian Journal of Cultural Studies*, (Dec. 1985), p. 9.

49 John M. MacKenzie, *Propaganda and Empire: The Manipulation of British Public Opinion, 1880–1960*, Manchester, Manchester University Press, 1984, p. 101.

50 Roland Barthes, *The Eiffel Tower, and Other Mythologies*, New York, Hill & Wang, 1979, p. 4.

51 Ibid., p. 8.

52 Ibid., p. 14.

53 Pearson, *The State and the Visual Arts*, p. 35.

6

THE MUSEUM FLAT

Johanne Lamoureux

SUMMER SOLSTICE
There is a series of spaces, interstices created by certain stable events in the
international visual-arts calendar. Between the annual recurrence of the art fairs and
those biennials, triennials, and quinquennials with longer cycles, certain "spaces"
acquire a strategic importance because they are able to attract part of the
international attention aroused by the "premier" events. In actual fact, with a
somewhat novel formula, catchy title, or reasonably exhaustive list of familiar names,
as well as adequate publicity and an offbeat (or off-the-beaten-track) location
(though not devoid of charm), these "opportunist" exhibitions have every chance of
getting more extensive journalistic or critical coverage than the better-established
events which constitute their context and act as their drawing card.

Flattered with pre-opening hype, the latter events are almost always disappointing in word-of-mouth and grapevine accounts – at least until their next equally disappointing occurrence which, with hindsight, validates what was deemed worthless or ordinary the previous time. In an old monologue, Québec comedian Yvon Deschamps impersonated a television viewer who, intoxicated by his recent acquisition of cable, remained glued to the screen due to American network rhetoric: "Stay tuned, our next program will be much better." On the visual-arts circuit people are implicitly ruled by a similar rhetoric: "Stay tuned, this program will be much better than the next one." As a result, any seemingly more timely exhibition is far more seductive.

One of the increasingly desirable "spaces" falls between the Basel art fair and the cyclical event (Venice, Paris, Kassel) preceding or following it. In 1986, between Basel and Venice, the *Chambres d'amis* exhibition organized by Jan Hoet opened in Ghent: some fifty artists were invited to work in one or more rooms in private apartments placed at their disposal. In 1987, between Kassell and Basel, the German city of Münster launched the *Sculptur Projekte*. Its organizers, Klaus Bussmann and Kaspar König, similarly dispersed some sixty contributions throughout the city, but at outdoor locations.

114

➡ **6.1 *Chambres d'amis*, installation by Bertrand Lavier, Ghent, 1986. Photograph by Attilio Maranzano.**

These two exhibitions, which we shall re-examine later, share more than the same paradigmatic slot in the calendar. Both sought a city venue outside the confines of a museum or other building with a centralizing vocation: the interior/private version in *Chambres d'amis*; the exterior/public version in Münster. Each stressed the site-specific character of the works presented; this was not so much the work's response to a physical setting as its conforming to a specific order, to a context henceforth demanding the made-to-measure, disdaining the ready-to-wear.

Fifteen or twenty years ago, stereotypical congratulations affirmed that a work "held together"; today, the facile but supreme compliment is "it works well in that space." From that point of view the pertinence of a work's insertion in a given location establishes an ab-solute[1] criteria (etymologically speaking that is) and, paradoxically, in this case, "detached from everything." Thence ensues an urgency to renew the premises and scenarios for the exhibition since the artists could not be asked to adapt their work to accommodate the rapid succession of events. Jean-Marc Poinsot recently put a label on exactly this situation, opening a fourth generation of

specificity after those of medium, object, and site: event specificity.[2]

The hypothesis of this essay is that event specificity is linked with the enhancement of pragmatic habits developed through contact with works (minimal, post-minimal, site-specific) requiring the spectator to move – to move literally in space itself, but also to dis/place the very notion of "spectator." So it appears to me that the installation, especially in its theoretical formulation, is an inescapable junction in the flight from museum to city and the "broadening" of the spectator through tourism. Whether through its domestic or its public scenario, the dissipation of the exhibition into the city will later lead me to discuss the pragmatic models proposed by the curators of these events. What role is proposed, allotted to us each time by the accompanying literature? From one year to the next, can Ariadne's thread be discerned in the solstice-event paradigm linking these different pragmatic proposals? Despite the private/public dichotomy which seems to oppose them, these two exhibitions generate a similar type of traffic in the city. They are to be seen *à la carte*, literally with street map in hand. The museum/station visit is replaced by a series of itineraries through the city.

Before developing the pragmatics of this exhibition type, it seems important to consider the imbrication of private and public in the heart of the museum and to sketch the shape, more circular than is generally believed, that connects the museological function and the private apartment. Then we shall see how "off-circuit" installation affects these relationships and reformulates the artistic experience so as to set in play elements which today are the joy of the "train set" that travels throughout Europe when the days are so long.

The indissociability of private life and public matters may be approached in two apparently antagonistic ways. On the one hand, what we term "private life" has a public dimension; that is, a dimension determined by a whole series of conditions of belonging and by an historical context particularly favourable to the cult of *moi*. From this perspective, there is no "private" refuge: not only because the private behaviour of an individual is determined, but especially because the very idea of private life as a refuge is a historical construction (and one which is/has a political effect); because everyday activities have a social-effect coefficient, and because the choices that come into play may be more determinant on a wider scale (whether this concerns a sexual practice or a product boycott).

It can also be argued that the current indissociability of private and public stems from the fact that the private dimension has absorbed public discourse and that the public scene no longer knows how to express itself except through a type of intimate speech and emotion. This is the hypothesis defended by Richard Sennett in *The Fall of Public Man*,[3] where he analyses in particular the compulsion of political discourse to take the jocular or knowing tone of confidentiality in lieu of a program or

measures geared for action. For the moment, let us maintain that the two concepts are not incompatible and may in fact be complementary.

THE MUSEUM: ROOM FOR A PIECE

In the exhibition *Chambres d'amis*,[4] Bertrand Lavier set up an apartment in a manner highly revealing of the private origins of site-specific work.[5] After wallpapering several rooms with blue-spotted paper, he hung paintings repeating the same all-over motif in complementary colours. It was impossible to miss the parodic inversions of Seurat's procedures. For Seurat, the frame, painted in complementary colours to the picture, exacerbates and anticipates the chromatic effects provoked in the periphery by the work's palette. The frame was made to match, determined by the palette. For Lavier, on the contrary, the frame, a thin border of gold metal, makes a perceptual cut, a brief glitter that accentuates the anteriority of the background, of the wall covering, which this time determines the choice of the rectangular pictures. Lavier thereby not only draws attention to the bourgeois practice of harmonizing artwork and decor, he also shows how, despite different motivations, there is a certain similarity of effect between installation and interior decoration. Paradoxically, he weaves this relationship via a "modern" reference whose aim — we have so often been told — is to protect the work from the actual physical space.

Allow me to quote, after Jean-Marc Poinsot, this letter from Pissarro to his son Lucien regarding a decorating idea:

> How I regret having missed the Whistler exhibition, both for the fine drypoints and the whole production which, where Whistler is concerned, is no trifling matter; he puts a bit too much puffism in it for my taste. Aside from that, it seems to me that white and yellow must give a charming effect; we were indeed the first to do such colour tests; my room was lilac with a canary yellow border, without papillon. But we minor painters, rejected pariahs, could not afford the costs of our decorating idea; as for pushing Durand-Ruel to hold an exhibition of that sort, I think our efforts would be wasted; you saw how I fought for white frames and finally had to give up; no, I do not think Durand would go that route.[6]

Following the practice of modernist museums (as analyzed in Reesa Greenberg's timely MOMA study),[7] art historians generally quite graciously agree to eclipse modern artists' concerns with the contextualization of their work — on the pretext that the modern artwork asserts itself in the insular mode of a self-contained fragment. But this very quest for insularity, though less systematic than is generally believed, has sometimes forced artists to pay excessive attention to the site in order to guarantee the precise conditions of visibility sought for their works.

To be sure, behind Whistler's "puffism" or neo-impressionist complementarity (with its alibi of "scientific naturalism"), the intent is never to create a work on the basis of site contingencies but rather to control any peripheral attack on the piece's integrity. I do not mean then to postulate here that Seurat or Pissarro were the unrecognized precursors of *in situ* before its time. Nevertheless if, from modern "decor" to site-specific practice, the direction of motivations and determinations is reversed, then the nature of the sought-after relationship remains the same: compatibility between work and site, or between site and trace inscribed on it. The "snapshot", examined by Rosalind Krauss as a model of installation, reformulates this compatibility through the contiguous relationship that exists between the referent and the indexical sign.[8] We shall return to this later.

For the moment let us note that, from this viewpoint, it appears less dramatic when a modernist museum "omits" to restore the original moulding or frame to modern works and continues to feed the fantasy of a neutral or neutralized space. For this is precisely the way it is called upon to deal with the phantasm of modern works like those already mentioned: the museum shares their conviction that the private-space model offers ideal exhibition conditions.

➡ 6.2 *Chambres d'amis*, **installation by Daniel Buren, Ghent, 1986. Photograph by Attilio Maranzano.**

The failure of the "first" Beaubourg, the pre-renovation Beaubourg, is related to an attempt to wipe out this museological conviction. Former museum director Dominique Bozo comments that the interior spaces recently redesigned by Gae Aulenti (also responsible for the Musée d'Orsay renovation) are now "apartment-sized, reminiscent of the studios of the period (Bateau-Lavoir, La Ruche) . . . of collector's apartments."[9]

One could think that the model of the second Beaubourg was displayed – yesterday as a "maquette," today as a legend – on the very piazza of the museum: it is none other than a reconstruction of Brancusi's studio, of whose autarchic dimension Isabelle Monod-Fontaine writes:

> Everything in the studio bears the trace of his hand: his artworks, naturally, and the necessary working tools, *but also every modest and utilitarian article of everyday living.* . . . Thus, *this space rendered perfectly homogeneous* is not really separable from the works it houses.[10]

Brancusi's insistence on keeping his works together with the studio illustrates the modern concept of giving due consideration to the space (private in this instance)

which harmonizes it with the work, with the mark of the same hand, instead of opening the work up to the context.

The Beaubourg privatization of interior space is not an isolated phenomenon. Upon the reopening of the Museum of Modern Art, Catherine Millet wrote: "William Rubin said to me, 'The floor covering we laid reinforces the intimate character of the museum ... it gives rise to an association with private space.'"[11] According to Peter Busman, the architect of the colossal Wallraf-Richartz Museum in Cologne, a museum significantly sandwiched between a monumental cathedral and a stately train station:

> With Holberer and our architectural team, we wanted visitors to have an individual – I'd even say intimate – experience of the museum and music auditorium. I have an extreme dislike for mass demonstrations; I prefer private conversations. That may seem a paradox when you know the museum's dimensions. . . . But now that you've visited the whole thing, you'll understand quite well what I mean.[12]

Although post-modern architecture is fond of scale changes (between outside and inside), modernists and post-modernists come to terms around a common reference: the privatization of public museum space. The Beaubourg "privatization" on the model of the *bottegha* has historical reverberations more symptomatic: it somehow reverses the museification process of the Louvre which necessitated the eviction of *Académie* artists lodged in the semi-deserted palace at the King's favour. Transforming the Louvre into a museum sounded the death knell for a labyrinth of artists' studios and lodgings. When the King's collections became national property and had to be made accessible, it is easily understandable why in renovating the museum no attempt was made to evoke the small and private *cabinets d'amateur*. The *grande galerie* crystallized the museum project into a wide boulevard, a fast-lane where the history of painting unfolds school by school, and where one travels without detour or traffic jam.

Moreover, in the last decade of the eighteenth century, private life was not yet envisaged as the refuge it would become in the next century with growing urbanization. It certainly had not yet incarnated in a particular concept of private space and the apartment that refuge-value analyzed by Walter Benjamin:

> Since the days of Louis-Philippe the bourgeoisie has endeavoured to compensate itself for the inconsequential nature of private life in the big city. It seeks such compensation within its four walls. Even if a bourgeois is unable to give his earthly being permanence it seems to be a matter of honour with him to preserve the traces of his articles and requisites of daily use in perpetuity. The bourgeoisie cheerfully takes the impression of a host of objects. For slippers and pocket watches, thermometers and egg-cups,

120

cutlery and umbrellas it tries to get covers and cases. It prefers velvet and plush covers which preserve the impression of every touch. For the Makart style, the style of the end of the Second Empire, a dwelling becomes a kind of casing. This style views it as a kind of case for a person and embeds him in it together with all his appurtenances, tending his traces as nature tends dead fauna embedded in granite.[13]

A two-fold observation is required here. From the outset, the apartment assumed a museological function (whereas the museum originally sought to get rid of its private connotations). *The apartment is a depot.* Moreover, it is appropriated and personalized by a series of indexical procedures. The historical birth of this type of bourgeois apartment (contemporary with the advent of photography) links it from the start with the indexical semiotics of the photograph, which served as a model for the art of the seventies and has been exemplified in the practice of installation. Here, however, instead of the building making a ghostly appearance in traces of an intervention, it is the things cast and effaced in their casings which serve as a model for the relationship a person maintains with the space where he leaves his trace.

The renovation of the *grande galerie* of the Louvre predates this compensatory compartmentalization of private space. As seen in certain paintings by Hubert Robert,[14] the proposed plans (brought to fruition in the nineteenth century) with their zenithal lighting and window displays of paintings, anticipate rather what will be the delight of the *flâneur* – the 'interior street' or arcade:

> If the arcade is the classical form of the intérieur, which is how the *flâneur* sees the street, the department store is the form of the *intérieur*'s decay. The bazaar is the last hangout of the *flâneur*. If in the beginning the street had become an *intérieur* for him, now this *intérieur* turned into a street, and he roamed through the labyrinth of merchandise as he had once roamed through the labyrinth of the city.[15]

The *flâneur*, it seems today, is back in town. In the *Rundgang* for *Skulptur Projekte*, an exhibition in 1987 in Münster where the sculptures on display had to be closely related to the city or its history, Kaspar König and Klauss Bussmann wrote:

> So the ideal visitor to this exhibition is not the participant in international art tourism – though we welcome him as well, if he takes a little time – but the *flâneur* who idly walks through Münster and follows the interplay of art and city.[16]

But is it so certain that the international art tourist is not precisely the very paradigm of the contemporary *flâneur*? And that the artistic diversion he is able to effect from the spectacle of the city is not, at least in part, attributable to the pragmatic approach acquired through contact with minimal and site-specific works?

ST. ELSEWHERE, INSTALLATION METROPOLIS

If the picturesque emerged as an aesthetic category in the eighteenth century, and Nature was progressively recognized and organized as tableau, this is evidence that a certain cultural elite had just acquired unprecedented familiarity with paintings via collections, the circulation of engravings and prints, and, of course, the Grand Tour.[17] The exchange value of paintings increased as a result. But the picturesque led to an understanding that the tableau is exchangeable not only for money or for another painting: its circulation as an aesthetic value is moreover increased by the fact that it can also be transformed into a garden or a "natural" landscaping experiment, a theatrical pause, a critical narrative (Diderot), or a libertine practice (de Sade).

With Minimal Art, the hegemony of the picture approached dissolution. True, the literality of the space that minimal art seems to consider has been slightly exaggerated. Jean-Marc Poinsot has demonstrated how minimalist space is not 'real' space:

> Indeed, considering that a sculpture's space was physical space, and Euclidean space at that (not that they call it such; they think they're rid of the concept but they give their

➡ 6.3 Hubert Robert, *Projet d'aménagement de la Grande Galerie au Louvre en 1796*, Musée du Louvre, Paris. © Photo R. M. N.

> space virtually all the characteristics of Euclidean space), this amounted to taking what they called real space to be a space free of any construction or signification and, as such, exempt from constraints and limitations.[18]

Through the confrontation of the known and the perceived, through the sudden valorization of the experience (and length of experience), minimal art induced a new pragmatic. In so doing, it modified the conventions of pleasure for the spectator.[19] It taught us a different form of pleasure; one that soon evolved into a demand and established new criteria for judgment. From then on, instead of the formalist fantasmatic where an encounter with a painting is postulated as an instant of aesthetic petrifaction, we began to demand that the journey itself be one of the conditions of our aesthetic pleasure or interest.

The advent of site specificity in turn refashioned the notion of the journey by no longer confining it in the abstract gallery space. For, in its first phase of experimentation, the site-specific work (where a place's physical qualities or

constraints determine the artistic gesture) turned us away from the established circuit of art institutions.

Ever since Rosalind Krauss exemplified the art of the index by the practice of installation, it has become commonplace to link site specificity to an indexical work:

> In each of these works it is the site itself that is taken to be a message which can be presented but not coded. The ambition of the works is to capture the presence of the building, to find strategies to force it to surface into the field of the work. Yet even as that presence surfaces, it fills the work with an extraordinary sense of time-past. Though they are produced by a physical cause, the trace, the impression, the clue, are vestiges of that cause which is itself no longer present in the given sign. Like traces, the works I have been describing represent the building through the paradox of being physically present but temporally remote.[20]

Krauss evokes a new category of space-time here, namely, "physically present and temporally anterior." These observations, while entirely pertinent and operative at the theoretical and semiotic levels, nevertheless neglect one of the important

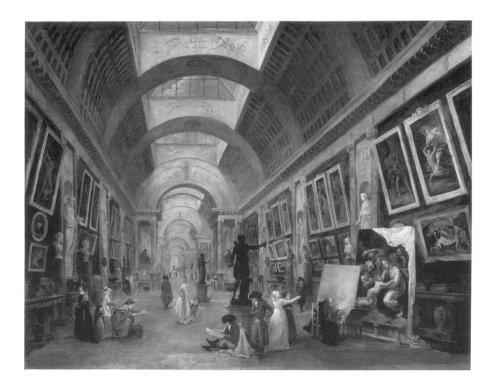

pragmatic dimensions proposed to spectators in the practice of installation: *local exoticism*.

Abandoned office blocks, public buildings, or monuments of industrial archeology are often the urban counterpart of the deserts sought by land artists. They have the cumulative advantage of a dual experience of space, for the "ghostly" presence grazing the surface here (in the contiguous overlap between place and trace) is intensified by the fact that the here is never fully integrated as such, never fully familiar. It is often off-circuit. It is always, from the outset, an *elsewhere*.

"The illogical conjunction of the here and the formerly," mentioned by Krauss, alludes to the architectural referent which becomes manifest through experience. But if we agree to consider the installation in its invitation to a journey or a detour, in its marking of marginal city sites outside and parallel to established circuits, we must then admit that acceptance of this practice is also based on the *here-as-elsewhere* mode. That is, it is both the experience of a specific change of scenery and an inebriation in the face of the possibility of this scene change occurring virtually anywhere – *here-for-instance*. Next time, elsewhere.

This deictic tension (here/elsewhere) paradoxically threatens the specificity of the original inscription in which the practice was anchored. By mobilizing the vestige value or the picturesque resources of the building, this tension helps re-privatize the premises and the experience. This happens despite the abstract, descriptive character of the works mentioned by Krauss – a character since modified by the renewal of interest in figuration and narrative – and also despite the monumental scale of the buildings where these installations leave their trace.

In the city of Montréal alone, and probably in many other North American cities as well, how many unusual semi-abandoned, semi-recycled places are we invited to visit each year? An installation exhibition of fine-art students above the Ben Ash restaurant; "A.S.A." has photography installations in a building to be demolished behind the Théâtre du Nouveau Monde; exhibitions/installations in the studios of Irene Whittome, Eva Brandl, Raymonde April; a fire station, a post office, or the Corona Theatre occupied by Lyne Lapointe and Martha Fleming. This list is far from exhaustive.

Many of these works play on a dissociation between a public or industrial space and its conversion into a private, even intimate space: the studio becomes the work or at least the site, if not pretext, for the exhibition. For Lyne Lapointe and Martha Fleming, the strategy of the intimate functions otherwise: the buildings they choose are not only always public but, moreover, are wrested from the city at the price of lengthy bureaucratic wrangling. The metaphorical properties of the site develop into themes for each intervention. It always has to do with the initial function of the building: the clash of everyday living with fire-hall heroics; postal handling (sorting,

distribution, etc.) and the medicalization of women; the theater and female delinquency.... This increasingly metaphorical relationship with a vast building, with the heroic or spectacular dimension of the site selected, is constantly relayed, mediated by more intimate sceneography that makes good use of nooks and crannies, low-ceilinged corridors, theater boxes, cupboards, flights of stairs. The architecture is also pressed into service in that it allows an almost secret articulation of the space and, thereby, a more intimate confrontation with spectators.

Betty Goodwin was probably one of the first to feel the slide of abandoned buildings toward the intimate and to come to terms with it through a private apartment site. After an intervention in a commercial building on Montréal's Clark Street (where four pillars became a frame for an interior tarpaulin-walled "room"), she rented an apartment on Mentana Street and moved her artistic activities there.[21] Logically pushing to their ultimate meeting-point the ideology of lived experience and the aesthetics of the trace (which had hitherto strongly oriented her work), she managed to dismantle them in this project by reactivating them in their original, preferred ground.

Each time, premises either too big, or too empty, or too dark.... Through this, we reinvented a form of domestic tourism, renewing ties with the modern tradition of the *flâneur* and his fascination with the strangeness of the city, its slightly trite glamour. The urban landscape is also explicitly invoked in many of these works. The scintillating iconography of the city by night (iconography of cinema and television, if there is one) forms an integral part of the privileged contingencies in *Jour de verre* by Raymonde April or *The Golden Gates* by Eva Brandl, for instance – both to be visited only after nightfall.[22] The electrical fairyland of the city, heightened by the nudity of big windows and by the surrounding darkness, constituted an additional declination of light in *The Golden Gates*, becoming a major theme of the installation.

"City lights" were also a complementary point of interest in the *Lumières* exhibition organized by the Montréal International Centre of Contemporary Art (CIAC) in 1986. Upon leaving the labyrinthine converted shopping-mall where CIAC operated, the spectators could profit from a tour through town allowing them to aestheticize the everyday experience of light *in situ*, in 'real life'. No further need of artistic intervention; here the city became the ultimate referent, the real scene, with no other alibi than the contextual framing of the event.

THE MODEL FLANEUR

To appreciate the symptomatic value of the *flâneur*, proposed as the ideal spectator in Münster, and to fully measure the effect of his return to the city, he must be added to the end of a series of pragmatic models developed for the calendar "slot" mentioned

earlier, all of which apostatized itineraries and journeys. These models, we shall see, share something else as well: they all extend the role of artist to the spectator, associating the spectator with an artistic behavior, or even with the name of a specific artist. Let us examine how before why.

As early as 1985, a year before *Chambres d'amis*, Adelina von Fürstenberg occupied the same calendar "slot" by organizing a sculpture exhibition in Parc Lullin entitled, almost too appropriately given the site (an eighteenth-century garden), *Promenades*.[23] The catalogue expressly wished to avoid any reference to Rousseau's solitary *promeneur* (for whom, we recall, the promenade was first and foremost a literary project). In place of Jean-Jacques, we find the unexpected image of Armstrong:

> Contrary to the solitary, redeeming promenades of Jean-Jacques Rousseau, the tormented vagabondage of the romantic "Wanderer," the pedestrian exploration of the dark continent by Stanley and Livingston, the promenade in Parc Lullin resembles the first astronaut's steps on the moon.[24]

The comparison is surprising: first because walking on the moon has nothing of the

➡ **6.4 Eva Brandl, *The Golden Gates*, 1984, partial view in studio. Photograph by Benny Chou.**

gratuitousness used to characterize the promenade just a few lines earlier; and second because the astronaut's landing is not at all far removed from the Rousseauian conception from which attempts are made to differentiate it:

> All that is external to me, is now strange. I have, in this world, neither neighbours, nor kinsmen, nor brothers. I am upon this earth as upon a strange planet, whence I have fallen from that which I inhabited.[25]

The divergence stems to some extent from the degree of familiarity with the strange planet. The elsewhere of Rousseau is something radically different; at Parc Lullin, the elsewhere remains arrangeable, without clash or disjunction. The desire for harmony aspires even here to the union of art and nature.

The following year, in the *Chambres d'amis* catalogue, Jan Hoet almost seems to write in open protest against the *Promenades* point of view:

> In order to break out of its isolation, the museum did not consider it advisable to exhibit its objects in sunny, elegantly laid-out parks or in strategically chosen squares in the

centre of town. That kind of exhibitionism is indeed the worst remedy for the
museum's isolation.[26]

Nonetheless, the pragmatic model for the event's publicity again relied on an artist;
posters at the train station door and beyond proclaimed: "Albrecht Dürer will always
find a room in Ghent." Besides calling to mind the artistic history of the city, this
quotation soothes the art tourist's possible qualms by allowing us a flattering
identification with the visiting artist.

Münster's *flâneur* of this past summer re-adopted a behaviour clearly associated,
since Baudelaire and Benjamin, with the painter of modern times. But to appreciate
the subtlety of his relationship with the city, we must again step back and return to a
1984 exhibition organized by Kaspar König. At that time, shortly after the Berlin
media coup of *Zeitgeist*, the patronage of a banker allowed Düsseldorf to lure part of
the crowd attending the neighbouring Cologne art fair by asking König to organize
a huge contemporary art exhibition. This was *Von hier aus*. A major criticism of the
exhibition was the absence not just of a theme, but of a proposal or a resolution. And
with reason! The motive of the exhibition was entirely summarized in the indexical

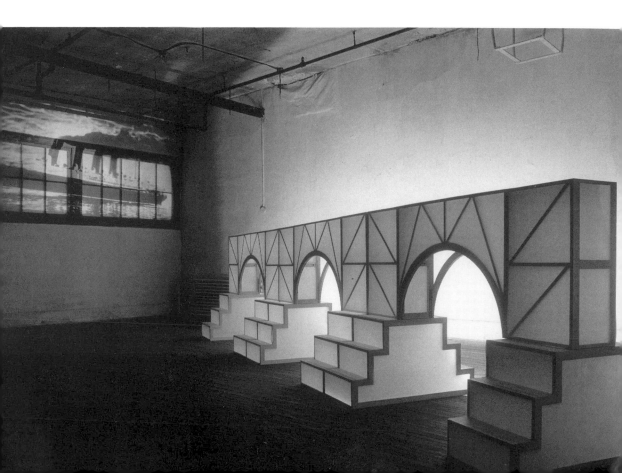

rhetoric of its title, "from here on," which I have explored at length elsewhere.[27]

König decided to travesty the lack of cohesion created by the eclecticism of his selection through the metaphoric decor of a "city of art":

> The architecture is designed to avoid absolute peaks and instead presents numerous centres of equal importance. Its design is comparable to a comprehensive urban plan. Open or closed areas are provided, and places around "squares" and along "streets". Spaces are clearly distinguished by their height and width. Wall surfaces and lighting conditions also vary. Decisions on presentation format always depend on the individual artistic contribution and special conditions required by the work.[28]

The resulting picturesque concept of the city brings to mind Laugier's urban planning proposals:

> Whoever knows how to design a good park will have no trouble drawing plans for a city with reference to its expanse and location. Squares, crossroads, and streets are needed, along with regularity and happy extravagances, relationships and oppositions, accidents introducing variation into the picture, great order of detail, confusion, din and commotion throughout.[29]

It is interesting here that König already presents the city of art as a decentralizing mechanism for the exhibition (which intensifies the concept of the eclectic content). However, with the sole entrance to *Von hier aus* higher than the exhibition hall itself, from our first steps the disorder of the "city" was organized into picture-form, perceivable at a glance. For one brief moment, the decor of the city created an impression of unity in diversity, planning amidst disorder which, I imagine, the organizers hoped would function as a unifying framework.

But this city decor, with its desire to dress and cover up the exhibition's lack of subject and motivation, was hardly effective. Quite the contrary, it revealed this shortcoming by betraying, in the very model favored, that the only alibi for the urban planning concept stemmed from a desire to hold an event in the real city – Düsseldorf, in this case. In comparison, it is clear that the exhibition in Münster adopted a much subtler strategy. By spreading exhibits around the city the curators ensured a dual role for the exhibition. The city was to be the exhibition site, the expanded perimeter of a new discourse on specificity, but also the referent:

> Each proposal and its realization is connected with Münster and at the same time documents the international avant-garde, and often is evident of a very dynamic developmental process which is implied in the long-time preparation phase of the exhibition.[30]

The presence of the city, if only ghostly, was therefore guaranteed; there was no need

to duplicate it or re-present it ideally through decor. It sufficed to dis/place the postulate of ideality from the city to the spectator. Enter the *flâneur* as the ideal visitor. This "good" pragmatic relationship allows for the spectator's identification with an artistic behavior, that is *with the pole of the artistic enunciator at the very instant the latter is, more than ever, obliged to share the place of enunciator* with the curator and the city controlling the event.

All three events (*Promenades, Chambres d'amis, Skulptur Projekte*), whose proximity in the arts calendar binds them together, aim to detach the event from the centralized exhibition. In *Promenades* of course, the unity of the park site is maintained but countered by the merging compulsion of most of the works displayed there, by their intentional near-invisibility. In Ghent and Münster, the traditional exhibition, complete with its clashes and joys in the placing of works, yields to the journey. *As the map substitutes for the picture, the city replaces the museum*.

Lastly the *promeneur*, the visitor, and the *flâneur* – the three models which propose to return the spectator to the city – are also related through a common asociality. This means that, in order to modify cultural behavior, it is not enough to change the place where art is put on display. Jan Hoet himself notes this fact in the results of the flight from the museum to the "interior":

> *Chambres d'amis* teaches the museum a great deal about itself and not only in a parodical way. It was already mentioned that the museum has learned to question its code via its confrontation with the quite tangible everyday reality, and via its infiltration into places and corners which are essentially strange to the museum. The museum's authority has been blurred and upset by the project. But there is yet more to it. The museum is slowly finding out how it is reappearing in all the places where it propagated. As if the museum is only now discovering for the first time that its space – a space which usually simply *exists* – is developing all over town, in all its aspects. The museum, reflecting itself in all the spaces where it propagated, is now witnessing its structural *origin*.[31]

Indeed, in *Chambres d'amis*, many of the artists selected premises favourable to museification. It was as if a domestic transplant was the most effective, because the most literal, way of revealing that the private apartment is already the museum.

In this respect, Daniel Buren's "room" is still by far the most critical. Refusing to leave the museum, he undertook to reconstruct, full-size, the guest room, the *chambre d'ami* he had chosen in the city and removed from the circuit. In the heart of the museum, like a lining, he built what constitutes the implicit model of the museum. In this way he points out that we can leave the museum via the "interior" only so long as we recognize that that's how we got into it in the first place.

Translated from the French by Le Dernier Mot and Barbara Godard.

bearing the name of someone they knew who had died of AIDS; these were then hung on the facade of the federal building. The effect was stunning: a wall of memory that, simply by naming names, exposed both private loss and public indifference.

Rather than connecting this wall display with the Vietnam Veterans Memorial, however, Jones had another association: the sight of the massed placards instantly reminded him of a patchwork quilt handed down within his family and used to comfort those who were ill or housebound. Yet the quilt Jones imagined was more than the recollection of a private family possession; it was also a public metaphor. At a later time he would suggest its meaning by saying that "quilts represent coziness, humanity and warmth"; they are "something that is given as a gift, passed down through generations, that speaks of family loyalty."[10] But surely from the beginning it was not lost on him that quilts have also come to represent America itself. As our quintessential folk art, the patchwork quilt is linked to nineteenth-century sewing bees and a nostalgia for a past sense of community. Perhaps the only thing like it in our national mythology is that other needlework of fabric, color, and pattern that Betsy Ross turned into America's most revered symbol, the American flag.[11]

136 ➡ **7.1 The AIDS Quilt, Washington, DC., 1987. © 1995 Marc Geller.**

In the patchwork quilt, then, Jones discovered the domestic equivalent for the sign of national unity. It offered a metaphor of *e pluribus unum* that was (to recall his words) cozy, humane, and warm. It was also a brilliant strategy for bringing AIDS not only to public attention but into the mainstream of American myth, for turning what was perceived to be a "gay disease" into a shared national tragedy.[12] Jones made the first panel of what was to become the NAMES Project Quilt in late February 1987. In memory of his best friend, he spray-painted the boldly stenciled name of Marvin Feldman on a white sheet that measured 3 feet by 6 feet, the size of a grave; the only adornment was an abstract design of five stars of David, each one dominated by a pink-red triangle. Jones's panel, at once a tombstone and a quilt patch, served as a model for the improvised handiwork of others, members of a highly organized gay and lesbian community who also felt the need to respond publicly to the epidemic.

The NAMES Project was formally organized on 21 June 1987 and went public only a week later when its first forty panels were displayed in San Francisco's Lesbian and Gay Freedom Day Parade. National coverage came with an Associated Press feature

story in August, by which time 400 panels had been received. By October 1987, only two months later, the NAMES Project Quilt was displayed on the Mall in Washington, D.C., not far from the Vietnam Veterans Memorial, as part of the National March for Lesbian and Gay Rights: almost 2,000 panels, covering a rectangular area the size of two football fields, extended between the Washington Monument and the Capitol (fig. 7.1). In 1988, there were more than 8,000 panels arranged in a huge polygon just behind the White House on the Ellipse; in 1989, 10,000 were laid out in a square. For the October 1992 display the official count was slightly over 20,000, with an additional 1,600 brought to the site for last-minute inclusion (fig. 7.2). As of September 1, 1995, 32,000 panels have been received.

The Quilt's provocative appearance on the Mall give the project's leadership an opportunity to denounce the country's indifference to the AIDS epidemic and to rally for greater attention to research and support.[13] For others it offered a way to suffer intimate losses in the most public space in America, to leave behind ghetto and closet, to bring mourning from the margin to the center. But apart from any of the political uses to which it has been put – to raise consciousness or money – the Quilt in any of its forms is most profoundly about the naming of names: the sight of them

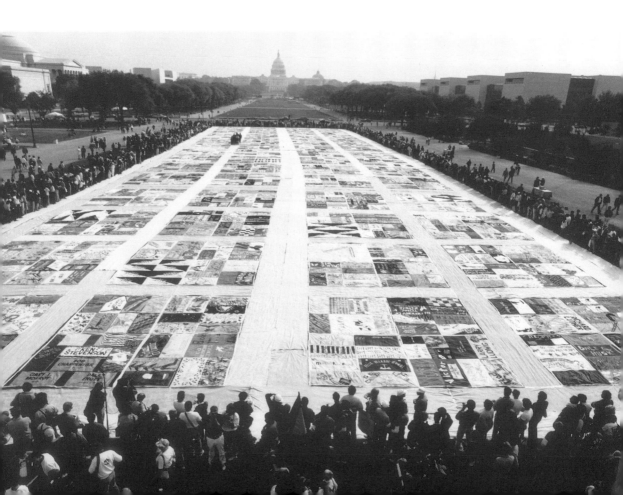

on the myriad panels, the sound of them read aloud. As with the Vietnam Veterans Memorial, the names themselves are the memorial. In both cases they are the destination of pilgrimage, the occasion for candlelight vigils and song. They also serve as surrogate graveyards, consecrated ground where the living can come to pay respects to the dead, many of whom, their bodies missing in action or their ashes scattered in the wind, have no actual burial site. Indeed, both the VVM and the Quilt are commonly treated as places to speak out loud to the dead or to leave behind written messages for them to read – as if the name of the deceased itself provided a medium of communication with another world.[14] Far more than the rituals officially sanctioned by the state, the acts of piety that have grown up around both the VVM and the Quilt offer the most vital examples of popular civil religion we have.[15]

Despite all that the Quilt shares with the VVM, however, its particular naming of names marks a radical innovation in the art of national memory. This is not to deny that Lin's work has been a dramatic departure from the mystique of heroism and triumph that otherwise rules the Mall. Nonetheless, it is precisely on the Mall that the Vietnam Veterans Memorial has its permanent location, at the heart of what passes for our Acropolis or Forum. The replicas of the VVM now traveling around

138

➡ **7.2 Washington Mall from above: AIDS quilt, 1992. © 1995 Marc Geller.**

the country – faux granite facsimiles of Lin's design that include all 58,183 names – suggest how mobile a Washington monument can become. And yet the power of the traveling memorials depends precisely on the "real" memorial being in the national capital; the authority of the copy ultimately lies in the fixed siting of the immoveable original.[16] Nor should we forget that despite its private and quite improvisational beginnings, the VVM's design was the result of national competition, its ongoing maintenance is paid for with public funds, and its roster of names is elegantly incised into granite, a stone that signifies unyielding perseverance in the face of time and change. The memory of *these* dead, to use the unspoken rhetoric of all such materials, will endure forever.

The Quilt, by contrast, has no official status, no public funding, no fixed location in Washington, indeed, no single place where it can be seen as a whole. Unlike the VVM, which is now complete, the Quilt's response to AIDS keeps growing with the losses from the epidemic. Its increasing size, and the fact that it can barely be contained or even experienced all at once, serve to dramatize a present reality over which we seem to have no control. While the Vietnam War is over, AIDS has only just begun to take its toll. The names currently comprising the Quilt, just a fraction

of the more than 160,000 Americans acknowledged to have died from the virus, are but the first casualties to be enrolled.

If there is no end in sight for the NAMES Project's work of commemoration, neither is there a precedent for its determination to memorialize a civilian population killed not by war but by disease. Here again comparison with the VVM is instructive. However striking Lin's innovative design may be, she was nonetheless playing with and against the architectural history of national memorials. Cleve Jones had no such models, for never before has illness inspired a national monument intended to name the deceased, not even the influenza pandemic of 1918–19. Despite the fact that the "plague of the Spanish lady" claimed approximately 22 million lives – almost twice as many as the victims of World War I – it inspired no popular naming of names, no collective (let alone individualized) memory.[17] Epidemics are typically indiscriminate, cutting a swath through every sector of a population. The victims of AIDS, however, are by and large young; their deaths, like those of soldiers, untimely. They seem singled out for tragedy – and therefore, perhaps, for memory.

Given the extraordinary control exerted by Lin over her work from start to finish, it is startling to realize that a memorial on the scale of the NAMES Project Quilt is

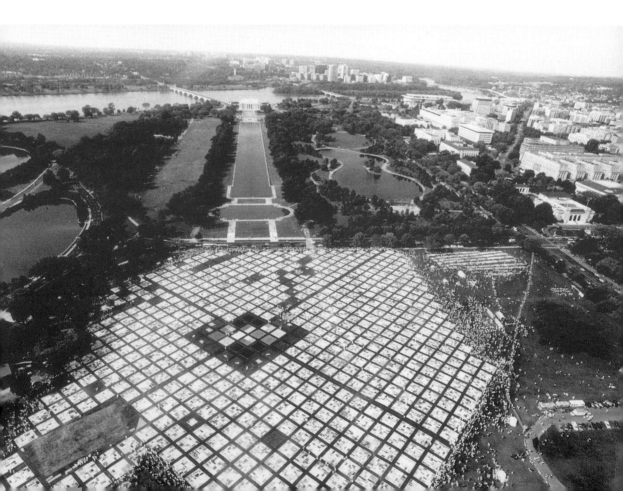

"authorless," having neither designer nor design. It is true that Jones "invented" the initial three-by-six foot panel, which he then imagined as one patch taking its place in a larger patchwork.[18] Since then, however, he has had no control over how the Quilt would look, either in its parts or in its larger configurations, nor has the NAMES Project, beyond requiring specific dimensions for each panel and the name of the person to be remembered. Otherwise, design depends entirely on the quilters.

The range of panel designs, as well as the materials used in construction, vary as widely as the makers' skill and sophistication. Shirts and ties, teddy bears, crushed beer cans, merit badges and credit cards, photographs and computer-generated images, leather and lamé, wedding rings, cremation ashes – anything goes. Unlike the paraphernalia of memory that mourners bring each day to the VVM and each day is taken away, the personal souvenirs incorporated into the Quilt are not extraneous to its formal act of memory. They are intrinsic to it, "snapshots of the soul" that no one touches up, censors, or edits.[19]

The same freedom seen in the making of individual panels also characterizes how the Quilt is shown. Aside from the grommeting together of panels in twelve-foot squares for major displays, there is no larger principle of organization at work: no hierarchy, subordination, or ranking; no "metanarrative" that tells a single story or even settles on a particular tone. The Quilt is the ultimate collage, one that is constantly being reformed, reinvented. Its center is wherever you find it; no one tells the viewer where to start, finish, or pay particular attention. Nor does it require of the viewer anything like an "appropriate" response. For despite the enormous grief that inspired and attends it, tackiness and camp also play their irrepressible roles – the carnival always interrupts the wake. For instance, in a small "sampler" display at San Francisco's De Young Museum (1–3 August 1990) there was a panel made for a Quaker man named Esperando Roseberry that included his wistful last words, "Perhaps now I'll see the Peaceable Kingdom." Next to it, and pointing toward another "beatitude" altogether, was a memorial to George Kelly, Jr, whose appliquéd T-shirt, stitched onto the panel, even now pulls no punches: "Fuck Art. Let's Dance." Juxtapositions like these, repeated hundreds of times over, prevent any clear or conventional response; the viewer is free to laugh, cry, or do both at once.[20]

This freedom is also reflected in how the name of the deceased appears. In many cases the name is rendered "legally," as on a birth certificate, marriage license, or tombstone. Often, however, the Quilt's names are more private than public, as likely to have been spoken as written down. For every "David R. Thompson" or "Willi Smith" there is a "Patty," a "Clint," a "Fuzzy," or a "Best Daddy in the World." First names or nicknames insist on informality, as if in refusal of the grand occasion or in tribute to a cherished intimacy. But private usage can also conceal rather than reveal,

withholding an identity that a surname would give away, protecting a family from its fear of exposure.

That such names appear on fabric rather than cut into granite is also key. Unlike stone, with its illusion of an eternal witness, cloth fades and frays with time; its fragility, its constant need for mending, tell the real truth about "material" life. Jones exploited the novelty of a fabric memorial in his remarks at the 1988 Washington display:

> Today we have borne in our arms and on our shoulders a new monument to our nation's capitol. It is not made of stone or metal and was not raised by engineers. Our monument was sewn of soft fabric and thread, and it was created in homes across America wherever friends and families gathered together to remember their loved ones lost to AIDS.[21]

In this description, the Quilt becomes a kind of cross "borne in our arms and on our shoulders." But what really interests Jones is the possibility of something new under the sun, a monument sewn of "soft fabric" at home rather than one erected on the Mall in "stone or metal" by engineers.

What Jones did not say outright is that cloth and thread, as opposed to stone and steel, are traditionally the materials worked by women. And indeed it has been women who, within the private worlds of their own homes and circles, have long used quilting as a way to name names and remember lives. The NAMES Project has been astute in claiming some measure of this American heritage; it has used the homey associations of the patchwork quilt to domesticate AIDS, to neutralize hostility toward "high-risk" populations by appealing to a national legacy. "We picked a feminine art," Jones has said with the hindsight of 1991, "to try and get people to look beyond this aggressive male sexuality component" (quoted in "C," p. 82). Whatever the marketing benefits of this strategic approach may have been, there is a great deal more that can be said about quilting as a distinctively female historiography with its own traditions and set apart from the official channels of cultural production. If the NAMES Project Quilt is indeed a "new monument," it nonetheless comes in a long line of memorials sewn by women.

In the nineteenth century, these works of memory served a variety of purposes. In the 1845 *Lowell Offering*, for instance, an anonymous mill-worker writes about her quilt as if it told the history of her family in all its vicissitudes and joys. To the casual observer it might seem but a "miscellaneous collection of odd bits and ends": pieces taken from the calico dresses of girlhood, from her mother's mourning dress, her brother's vest; a blood stain from a sister's illness. Yet for her it is nothing less than a "reliquary of past treasures," a "volume of hieroglyphics."[22] But often it was not so private an affair. A woman might make a memory quilt for another person in order

to celebrate his or her life. Worked into the design would be bits and pieces of a world: cotton dress material or a silk necktie, cigar bands, dance cards, jewelry, even photographic likenesses. Here the quilt itself becomes a portrait, a fabric reconstruction of another's life that functions almost like a talisman.

If the memory quilt honored a living friend or paid tribute to a prominent member of the community, the mourning quilt served to maintain contact with the dead, to remember them by sewing together fragments of their lives. These works were usually pieced from the clothing belonging to the deceased, with the design centered on a block whose cross-stitched inscription gives the name, date of death, and often a sorrowful verse. But sometimes the bereaved quilter would make her own clothing the material of memory. This can be seen most strikingly in the work of a turn-of-the-century widow who took her black silk mourning coat, opened it up at the seams, and so covered it with embroidered imagery as to turn the surface of the fabric into a complex of signs – a mass of stitched butterflies, an Easter lily, flags and sailboats, pairs of hearts, a cluster of knives.[23] These symbols, some traditional and others intensely private, express the woman's grief and suggest the complex reality of her husband's life.

Some mourning quilts may very well have been made in anticipation of a loss, as if to forearm against it. This seems to be the rationale behind the 1839 work of Elizabeth Roseberry Mitchell, who created a bedspread that had at its center a representation of the family cemetery. Within its confines appear the coffins of family members already deceased; at the quilt's borders there are other appliqué coffins representing those still alive. By sleeping under this comforter night by night, Mitchell could perhaps minimize the sting of death by anticipating its arrival. More commonly, however, the mourning quilt would serve not as an anticipation of grief but as a response to it. As in the example of the widow's transformed coat, making a quilt might be a major part of the bereavement process itself, enabling the quilter not only to hold on to the deceased but also to let go.

A revival of interest in quilts took place in the early 1970s, when the art world discovered what it took to be precursors of modern abstract painting, and the women's movement rediscovered its own heritage – "the prime visual metaphor for women's lives, for women's culture," according to critic Lucy Lippard.[24] What the NAMES Project has effectively done, however, is revive the quite specific function of quilts to name names, to remember lives, and to make something of mourning. For what Jones initiated in 1987 was the construction of a national AIDS mourning quilt; his initial panel for Marvin Feldman opened the door for textile once again to become a medium for holding on and letting go.

Yet if the NAMES Project Quilt stands in a tradition, it does so on its own new terms. To begin with, it has taken a female art form and opened it up to men, "that

ignorant and incapable sex which could not quilt."[25] For centuries, of course, women have made quilts for men, to recognize a coming of age, to celebrate an achievement, to mark a death. What the NAMES Project has done, however, is play with gender. Men are not only remembered with the Quilt, they are also – together with women – the makers of it. That the male quilters are by and large gay seems at first to confirm a stereotype of effeminacy. While straight men erect public monuments in stone and steel, homosexuals ply needle and thread, do "women's work."[26] Yet by turning the domestic sewing bee into a national effort – and one with a strong affinity with the most popular veterans memorial – the NAMES Project in effect makes quilting the work of American "citizens," a large-scale response to public crisis more in keeping with "masculine" monuments than with traditional women's quiltmaking. According to Elaine Showalter, the Quilt's "attendant metaphors of football, sales conventions, and cargo planes evoke a normative American masculinity, perhaps in a deliberate effort to counter the stigma of homosexuality associated with AIDS."[27]

By taking the quilt out of the space of the intimate object, by monumentalizing it, the NAMES Project may well have invented a hybrid form that owes as much to war memorials as to traditional quilting – a "folk art" made for the mass audience of the late twentieth century. And yet if the immensity and scale of its displays mark a rupture with a specifically female and domestic past, it is also apparent that the AIDS Quilt has in effect made intimacy its object; it has enabled quite private reality (sometimes sentimental and homey, sometimes kinky and erotic) to "come out" in public. Moreover, in contrast to most of its nineteenth-century antecedents, the NAMES Project Quilt places emphasis on the sheer specificity by which persons are remembered. A mourning quilt, for instance, might incorporate clothing of the deceased, be centered on a name and date of death, and stitch together signs, symbols, and texts. Nonetheless, all such details were contained by and subordinated to the quilt itself, to its inherited pattern, its fund of largely stock images, its sense of propriety. Names could be named, but they also disappeared into the form; personal clothing ultimately became fabric once again.

In the AIDS Quilt, however, the three-by-six-foot panel is nothing less than the stage-setting of an individual life. The name looms large, sometimes to the exclusion of anything else. Clothing also remains unmistakably clothing, as a name is spelled out in neckties or as a pair of worn Levis suggests not only a wardrobe but also a particular body and an entire life style. Photographs and likenesses abound. Some of the panels are indeed "volumes of hieroglyphics," reconstructions of human narrative that rely as much on private associations as on any public discourse – life stories that need to be decoded. Moreover, intimacies are everywhere confided to strangers. The panels betray a delight in the telling of tales, revealing in those who have died a taste for leather or for chintz, for motorbikes or drag shows. Secrets are

shared with everybody. It is as if the survivors had decided that the greatest gift they could offer the dead would be telling everything, breaking the silence that has surrounded gay life long before the advent of AIDS. Piety now demands that the truth be spoken without embarrassment or circumlocution.

Survivors, of course, are the ones who remember and mourn, the ones who make the Quilt. But here too the similarity with past practice reveals a telling difference. Typically, the women who used quilting to memorialize a spouse, a sibling, or a child, were coming to terms with someone else's death. So many of the NAMES Project quilters, however, are preparing for their own. For them, making panels is not only an act of faithfulness to those who have died of AIDS but a way of living with it themselves. In Cindy Ruskin's *The Quilt: Stories from the NAMES Project*, for instance, a panel made for John Booth shows twelve red candles appliquéd against a purple background; only three of the candles are burning. On the reverse side, the maker says that his work is dedicated "'to 12 men I expected to grow old with, nine who have passed on and three who will join them soon.'"[28] What the quilt portrays, therefore, is more than the death of John Booth. It shows the gradual extinguishing of a generation, the loss of a shared world. With the three burning candles standing next to the nine that have been quenched, the panel may also be prophecy of the quilter's death – a death that may indeed come "soon." As in the Kentucky Coffin Quilt made by Elizabeth Mitchell, the living and the dead are shown here to occupy different positions within the same territory: reunion is only a matter of time. But whereas Mitchell's *memento mori* enabled her to keep track of an entire family, including those who one day would move her coffin into the graveyard at the center, the maker of the memorial for John Booth foresees the imminent disappearance of his personal community. Instead of making an object to be passed down through generations, the quilter confronts the *end* of a world. The "family" that inherits his work is the NAMES Project itself.

In the nineteenth century, quilts served explicitly political ends as well as those more personal and private. At a time when women had little public voice and no right to cast a ballot, they used quilts to declare commitments for which they lacked other means of expression. Even abstract patterns sometimes conveyed a heartfelt conviction. For instance, the Radical Rose design, popular in the North during the Civil War, had a black center for each flower and was a wordless statement of sympathy for the slaves; the Drunkard's Path and Underground Railroad designs did the same. Other quilters were more direct, using their craft to identify explicitly the candidates for whom they could not vote and the causes they wanted to champion, such as abolition, the Union or the Confederacy, temperance, women's rights. Quilting bees were often the female equivalent of ward meetings. No wonder

144

Susan B. Anthony made her first speech on women's suffrage at just such a gathering.[29]

Contrary to the common NAMES Project disclaimer, "politics" is by no means foreign to the AIDS Quilt. It was born in the gay rights movement and despite both the changing demography of AIDS and the project's desire to be all-inclusive, it continues to be overwhelmingly a memorial to homosexual men. This is not to say, however, that the Quilt is endorsed by the entire gay community. For some activists it is too mild and tearful, too focused on the dead rather than on those still alive or at risk. According to *Village Voice* columnist Michael Musto, for instance, the Quilt should always come with a warning sticker that reads, "Don't feel that by crying over this, you've really done something for AIDS."[30] This uneasiness may arise from the perceived "femininity" of the Quilt, out of a fear that the NAMES Project has organized an androgynous sisterhood (acceptable to both media and mainstream) rather than having kept faith with a gay brotherhood of sexual rebels and outlaws. *Real* queers don't quilt; they act up. Still others, like Douglas Crimp in his influential essay "Mourning and militancy," have argued the necessity of grief alongside militancy, granting the AIDS Quilt a unique role in carrying out "the psychic work of mourning."[31]

In any event, what characterizes the overt political witness of the NAMES Project is the degree to which social or political statements are not only personalized but actually personified. When each panel bespeaks an individual life, it is impossible for even abstract statements to remain abstract. Instead, positions become last wills and testaments; causes are transformed into epitaphs. For Paul Burdett: "The San Diego 50-hour AIDS prayer vigil was his creation. Please – more prayers, more funding." For Billy Denver Donald: "My Anger is, that the government failed to educate us." A panel for Roger Lyon cites the testimony he gave before Congress on 2 August 1983: "I came here today to ask that this nation, with all its resources and compassion, not let my epitaph read, 'He died of red tape.'"[32] The point here is not to weep; rather, panels become platforms, the record of voices raised in a forum where the dead can still have their say.

By and large, however, to make a point is neither the purpose of the Quilt nor the effect of its display. As with the Vietnam Veterans Memorial, it evokes a numbing sense of loss. But whereas the VVM makes its primary impression by force of number, it is the sense of irreplaceable personal lives that makes the Quilt unforgettable. The individual parts end up being more than their collective sum.

The poignancy of this personal focus is brilliantly realized in a panel for Jac Wall (fig. 7.3).[33] Occupying almost the entire space is the life-size silhouette of a man, viewed frontally shin to crown, standing against what appears to be a wallpaper pattern of tiny flowers. The silhouette is cut in reverse, in white rather than black.

There is no one to see, no distinctive feature to note, no volume or weight, yet the whiteness of the form makes it radiant, as if light itself were projecting outward, away from the minute detail of the background and moving forward into the viewer's space. The effect is paradoxically to make the represented man both an absence and a presence; in either case, the frame of the panel cannot entirely contain him.

From a distance the form reveals only a generic man. Coming closer, however, one realizes that the silhouette is defined by a text. The dark outline that edges the light, that brings a human shape into recognition, is, in fact, a series of terse statements about a particular person, whose identity is conjured up by the continuous repetition of his name. Beginning at the bottom left of the figure and reading up, one traces a description of a life and of a relationship.

> Jac Wall is my lover. Jac Wall had AIDS. Jac Wall died. I love Jac Wall. Jac Wall is a good guy. Jac Wall made me a better person. Jac Wall could beat me in wrestling. Jac Wall loves me. Jac Wall is thoughtful. Jac Wall is great in bed. Jac Wall is intelligent. I love Jac Wall. Jac Wall is with me. Jac Wall turns me on. I miss Jac Wall. Jac Wall is

➡ **7.3 Panel for Jac Wall, AIDS Quilt. Photograph by Matt Herron.**

146

> faithful. Jac Wall is a natural Indian. Jac Wall is young at heart. Jac Wall looks good naked. I love Jac Wall. Jac Wall improved my life. Jac Wall is my lover. Jac Wall loves me. I miss Jac Wall. I will be with you soon.

This unfolding line of text enables the survivor to represent the person he lost. Oscillating between past and present tenses, he creates a composite "now" in which the dead man is still powerful, still loving and benevolent. Predication all but constitutes the text, as if by the repeated assertion of verbs the dead man might be made alive, brought back through the "wall" of mortality that separates the living from the dead. As with the NAMES Project in general, the most private things are said out loud, without concern for convention or decorum. But what in fact is said most often is the dead man's name. The reiteration of *Jac Wall* literally *re*members him, brings the shape of his body into view and recalls the features of his life. And so the *I* of the quilter holds on to his lover through his lover's name, until the final sentence, with its sudden projection into the future, transforms *Jac Wall* into *you*: "I will be with you soon."

The power of this single panel, now mass-reproduced on the compact-disc cover of John Corigliano's First Symphony,[34] lies first of all in its memorial function. While

memory offers no cure for AIDS any more than the repetition of *Jac Wall* brings him
back alive, the panel asserts what it can in the face of death: the enduring importance
of a particular person, a loving relationship, and intimate human connection itself.
But taken out of the quilter's private world, the panel becomes evocative of much
more. Indeed, seen in a regional display or placed on the Washington Mall in the
company of 32,000 other such tributes, individual loss is put in the context of national
devastation. Such a vision must inevitably disturb the peace, for whenever the Quilt
is temporary neighbor to the Vietnam Veterans Memorial, the White House, and the
Capitol, there are certain disturbing connections that become inescapable: links
between the war we did not win, the epidemic we cannot cure, and a government
that has not yet developed a comprehensive AIDS policy. There are reasons why,
when the NAMES Project came to Washington, Presidents Reagan, Bush, and
Clinton left home or looked the other way.

Although boycotted by the powers that be, the Quilt has nonetheless made an
assault on official oblivion. Occupying the Mall for a weekend at a time, it has
claimed the traditional site of not only governmental authority but of civil protest
against it. In its bid for both legitimacy and license, it has, to quote Cleve Jones,

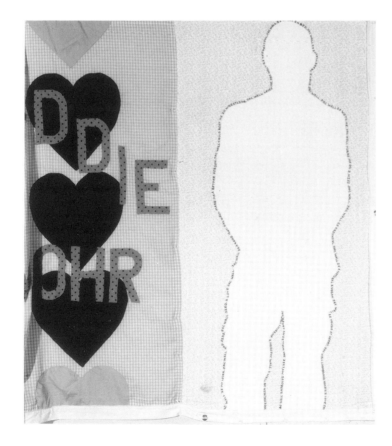

brought "'evidence of the disaster to the doorstep of the people responsible for it'" ("C," p. 69 – see n. 10 to this chapter). At the same time, it has created a place for lesbians and gays to hold hands, kiss in public, feel safe, act like tourists. Challenging Washington's conspiracy of silence, the Quilt enables the "love that dare not speak its name" to insist outright on public naming, to refuse the very notion of the "unspeakable" and "unmentionable" whether in reference to the fact of AIDS or of homosexuality.

So too, despite the often sentimental piety that informs so many of the individual panels, the NAMES Project has kept free of the quasi-religious consolations often used in Washington to soften the blows of reality. The Quilt appeals to no cause or higher purpose, to nothing that might justify the loss of life or provide some image of transcendence. This is not to deny that the NAMES Project is often used to identify the good that has come out of the epidemic: the construction of a diverse AIDS community built on responsibility and shared commitment; the formation of a new kind of "family" that joins together gays and straights, men and women. Still, no flag is ever raised over this Iwo Jima. Instead, private identity is held up as monumental; the intimate stretches as far as the eye can see. In fact, by overdramatizing intimacy, by taking small gestures of domestic grief and multiplying them into the thousands, the Quilt makes a spectacular demonstration of the feminist dictum, the personal *is* political.

But to what end? The primary strategy of the NAMES Project has been to create a consensus, a myth of inclusion. From the beginning, as Jones has said, "We very deliberately adopted a symbol and a vocabulary that would not be threatening to nongay people. . . . We mobilize heterosexuals; we mobilize the families that have been afflicted" ("C," p. 85). This inclusivity is especially apparent in Washington, where the Quilt offers the capital a patchwork version of the Big Umbrella and the Rainbow Coalition. Occupying acres of the Mall, in space the project measures not in the seamstress's square feet but in macho football fields, the Quilt redescribes the entire nation in terms of the epidemic – it says, America has AIDS. Here sorrow would knit together the social fabric and personal loss to become the common bond of citizenship: we're all in this together.

This *we*, however, is less global than the epidemic itself. For although the Quilt includes panels from different countries, even as the NAMES Project is affiliated with almost twenty foreign chapters, American national identity is at the center of its discourse. Thus, in the speech delivered before the Lincoln Memorial in 1988, Jones appealed to his fellow Americans to make a wartime response to AIDS, to rise up as a nation on behalf of soldiers dying on behalf of all. America, he said, has lost "more sons and daughters to AIDS than we lost fighting in Southeast Asia." We are the "one nation on earth with the resources, knowledge, and institutions" to

fight this new battle, and our failure to do so now is the result of "ignorance, prejudice, greed, and fear." Where does blame reside? "Not in the heartlands of America, but in the Oval Office and the halls of Congress." In other words, homophobia and indifference to AIDS have nothing to do with America; they belong instead to Washington. By playing on the time-honored distinction between the heartland and the capital, as well as drawing implicitly on the idea of a redeemer nation, Jones in essence stages a sit-in on behalf of the people. AIDS is an *American* problem, and it is only this nation's response that can save not just ourselves but the world.

But who constitutes this nation? Or, to put it in other terms, who gets to be remembered, and by whom? From its beginning, the NAMES Project has wanted to draw the circle larger than its first constituency of Castro Street and Fire Island. But while it has undoubtedly succeeded in creating a diverse coalition of men and women, lovers and mothers, its America – the dead, their quilters, and the crowds who come to the displays – remains solidly middle-class and mostly white.[35] This is not to say that inclusion in the Quilt depends on the "importance" of the deceased, for unlike the notices of AIDS deaths in the obituary pages of the *New York Times*, the NAMES Project is not limited to those artists, designers, and professionals who have made a name for themselves. Nor does it imply that the quilters themselves represent anything like a cultural hegemony. But while anyone can be remembered, the fact that not everyone is memorialized has everything to do with those who choose the Quilt as the space of memory. Placing the dead in the context (and company) of the AIDS epidemic has to mean something vital to the survivors, as must the myth of America as a patchwork, or the desirability of making intimate reality public (perhaps even against the wishes of the dead, as presumably in the cases of Michel Foucault or Roy Cohn). That there are many NAMES Project volunteers who make panels for people virtually unknown to them – marking the name of an infant who died in a county ward or of a stranger who happened to live across the hall – suggests that the worth or the will of the deceased are finally not at stake. Memorial depends on the quilters' ability not only to design, construct, and then mail off a panel to San Francisco but also to imagine the value of such a venture in the first place.

Despite its oft-noted "likeability," the NAMES Project has been taken to task for not covering all the needs of AIDS. Some survivors do not join the project either because of their own alienation from its "America" or because they respect the real or imagined wishes of the dead. For others it is too sanitized to do justice to gay reality, too male to represent the growing numbers of women and children who are not finding quilters, too tied to Castro Street to appeal to other inner-city AIDS populations. More irascible critics have found it "whitebread," maudlin, ingratiating,

self-censorship on the part of the panel makers, with the result that the lives of the deceased are sanitized. Squeamishness leads the survivors to tell lies of omission: "Aside from scattered trinkets of leathermen, sex is bleached right out of The Quilt, although sex was what was most distinctive of so many of the dead" (Mohr, *Gay Ideas*, pp. 109, 121). It seems to me more accurate to say that the "sex" of the Quilt is roughly equivalent to that of a lesbian/gay pride parade or a New Orleans Mardi Gras, that is, flamboyant in comparison to the conduct of normal life but inevitably constrained by the reality of a public occasion. It may also be that from the perspective of death, a person's sexual practices may not seem to be what is most "distinctive" about him or her.

20 It is precisely the power of the Quilt's wild juxtapositions that transformed the initial skepticism of British AIDS theorist Simon Watney into an appreciation for the NAMES Project memorial as a "map of America": "'To have Liberace alongside Baby Doe, to have Michel Foucault alongside five gay New York cops. In many ways it's a more accurate map of America than any other I've ever seen'" (John Seabrook, "The AIDS philosopher," *Vanity Fair*, 53 (Dec. 1990), p. 111). On the place of humor as "a form of gay soul," see Paul Rudnick, "Laughing at AIDS," *New York Times*, 23 Jan. 1993, p. A21.

21 Jones, "Address at the Lincoln Memorial," p. 1.

22 Annette [Harriet Farley or Rebecca C. Thompson], "The patchwork quilt," *The Lowell Offering: Writings by New England Mill Women 1840–1845*, ed. Benita Eisler, New York, 1977, p. 150.

23 The widow's mourning-coat quilt, now in the collection of Julie Silber, is pictured in Penny McMorris, *Crazy Quilts*, New York, 1984, pp. 86–7.

24 Lucy R. Lippard, "Up, down, and across: a new frame for new quilts," in *The Artist and the Quilt*, ed. Charlotte Robinson, New York, 1983, p. 32. The importance of quilting to the women's movement is reflected in the use of patchwork in Judy Chicago's 1979 *Dinner Party* (in the place setting for Susan B. Anthony), and in her 1985 *Birth Project*. Its significance in the lives of African–American women is explored by Alice Walker both in fiction (*The Color Purple*, New York, 1982) and in essay ("Ordinary use," *In Search of Our Mothers' Gardens*, San Diego, 1983). See also Whitney Otto's novel, *How to Make an American Quilt*, New York, 1991.

25 Harriet Beecher Stowe, *The Minister's Wooing*, 1859, ed. Kathryn Kish Sklar, New York, 1982, p. 789.

26 Sturken notes that in reading through the letters sent by quilters to the NAMES Project, she was struck by how few quilt panels had been made by straight men as fathers, brothers, or friends. "It has been widely noted that involvement in AIDS organizations has been almost exclusively the work of gay men and women (both lesbian and straight). In the case of the quilt, however, this dynamic is further complicated by the quilting and sewing process" ("C," p. 81). For clear evidence that there is male resistance to quilting as "women's work" – and quite apart from AIDS – see Lena Williams, "Foreign competition for an American art: quilt making," *New York Times*, 14 Jan. 1993, pp. C1, C6. Williams interviewed James Thibeault, director of Cabin Creek Quilts in Malden, West Virginia: "'Men who couldn't find work were resisting coming to work for us,' Mr. Thibeault said. But new quilting tools like the rotary cutter, which cuts geometric shapes, have made it easier for men to accept quilting as a way of making a living, he said" (p. C6). A tool, apparently, makes all the difference.

27 Showalter, *Sister's Choice*, p. 172.

28 Ruskin, *The Quilt*, p. 29.

29 For an excellent survey of the role of quilts in women's social and political lives, see Pat Ferrero, Elaine Hedges and Julie Silber, *Hearts and Hands: The Influence of Women and Quilts on American Society*, San Francisco, 1987, esp. pp. 66–97. See also Patricia Mainardi, "Quilts: the great American art," *Radical America*, 7 (1973), pp. 60–1.

30 Michael Musto, "La dolce musto," *Village Voice*, 25 Oct. 1988, p. 46; quoted by Dan Bellm, "And sew it goes," *Mother Jones*, 14 (Jan. 1989), p. 35. Steve Abbott had this to say:

> One reason the quilt was so readily embraced by the media is because it can also be read as a memorial to a dying subculture (i.e. "We didn't like you fags and junkies when you were wild, kinky and having fun. We didn't like you when you were angry, marching and demanding rights. But now that you're dying and have joined 'nicely' like 'a family sewing circle,' we'll accept you."
>
> (quoted in "C," p. 91)

31

> Of our communal mourning, perhaps only the NAMES Project quilt displays something of the psychic work of mourning, insofar as each individual panel symbolizes – through its incorporation of mementos associated with the lost object – the activity of hypercathecting and detaching the hopes and memories associated with the loved one. . . .
>
> The fact that our militancy may be a means of dangerous denial in no way suggests that activism is unwarranted. There is no question but that we must fight the unspeakable violence we incur from the society in which we find ourselves. But if we understand that violence is able to reap its horrible rewards through the very psychic mechanisms that make us part of this society, then we may also be able to recognize – along with our rage – our terror, our guilt, and our profound sadness. Militancy, of course, then, but mourning too: mourning *and* militancy.
>
> (Douglas Crimp, "Mourning and militancy," *October,* 51 (Winter 1989), pp. 7, 18)

32 Quoted in Ruskin, *The Quilt*, pp. 24, 98, 34.

33 I am indebted to Mohr's brief but sensitive reading of this particular panel in *Gay Ideas*, pp. 126, 128; see also "C," p. 81.

34 In the notes to the Erato recording of Corigliano's symphony, the composer writes the following:

> During the past decade I have lost many friends and colleagues to the AIDS epidemic, and the cumulative effect of those losses has, naturally, deeply affected me. My First Symphony was generated by feelings of loss, anger, and frustration. A few years ago, I was extremely moved whe I first saw "The Quilt," an ambitious interweaving of several thousand fabric panels, each memorializing a person who had died of AIDS, and, most importantly, each designed and constructed by his or her loved ones. This made me want to memorialize in music those I have lost, and reflect on those I am losing. I decide to relate the first three movements of the Symphony to three lifelong musician-friends. In the third movement, still other friends are recalled in a quilt-like interweaving of motivic melodies.
>
> (John Corigliano, *Symphony No. 1*, Chicago Symphony Orchestra, Erato Recordings 2292 45601–2, 1991)

35 See "C," pp. 87–9, for the gap between different efforts of the white gay community (whether the NAMES Project or Act Up) and communities of color. Sturken notes that

most organizations struggling to deal with AIDS in inner-city black and Latino communities do not have the energy or resources to involve themselves in quilting. Is it a privilege to be able to mourn in the middle of an epidemic? The quilt's display and creation are both grassroots-defined; the quilt only travels to those communities that can raise the money to sponsor it.

("C," p. 88)

GRAMMATIC ACTS

The aim of the exhibition is to bring this interrogation into the limelight and intensify it. The selection of the illustrations will not be made according to technological criteria, nor even anthropological ones (in terms of their social effects, their psychic effects, etc.), but rather for the manner in which they may set off and dramatise these questions. The term 'immaterial', which in its contradiction denotes a material which is not matter for a project, is proposed to convey this uncertainty.

The Intention

The conception of the exhibition will be philosophical. We will first of all ask questions, and incite others to ask questions, not only about what the material is, but also about what is associated with it: material versus spiritual, material versus personnel (in the administration, the army), hardware versus software (in a computer), matter versus form (in the analysis of a manufactured object, a natural object or a work of art), matter versus mind (in philosophy and theology), matter versus energy (in classical physics), matter versus state (in modern physics), matrix versus product (in anatomy, printing, minting and casting; the problem of reproduction and, in art, of multiples), mother versus child, mother versus father, etc.

⬇ **8.1 Plan of *Les Immatériaux*, Centre Georges Pompidou, Paris, 1985. Plan in collaboration with Philippe Delis, architecte DPLG; courtesy CCI, Centre Georges Pompidou, Paris.**

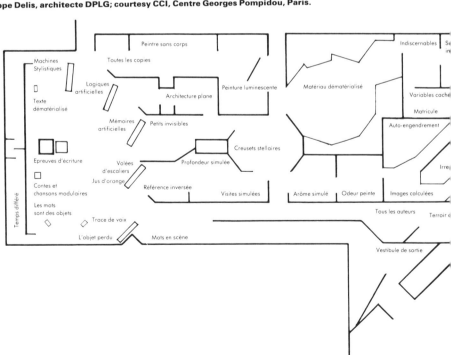

Note, the sanskrit *mâtram*: matter and measure (root *mât*: to make by hand, to measure, to build).

The semantic field is considerable (see, for example, the works of Bachelard). Although the intention of the exhibition is not to cover it in its entirety, nor even to focus attention on this fertile aspect, the 'objects' presented should nonetheless evoke passages, overlaps and slippages from one semantic zone to another. The visitor must at least sense that the material is not simply what human activity operates on, and that if it is indeed a new material, then the whole network of associations suggested above is altered as a consequence.

The importance given to this semantic aspect enables us to broaden the investigation of 'immaterials' along lines which would be neglected by sociological or psychological approaches or by the history of technologies; for example, on the one hand, the 'dematerialisation' of transferable securities or electronic money, and, on the other, Suprematism and Minimal Art in painting, or Serialism in music.

However, the broadening of the area to be investigated can only remain philosophical if another condition is met: if it is ordered according to a clear

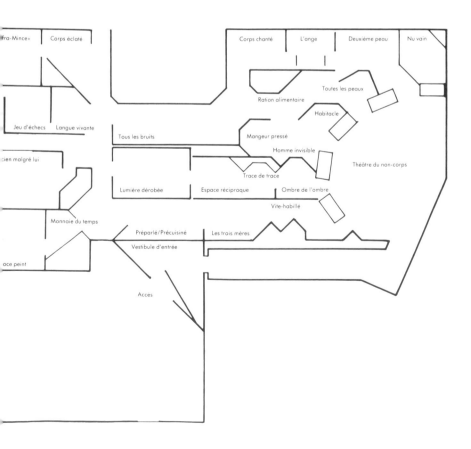

which constitute the material (electronic waves, sound waves, light waves, elementary particles and their differential features, etc.). The material disappears as an independent entity. The principle on which the operational structure is based is not that of a stable 'substance', but that of an unstable ensemble of interactions. The model of language replaces the model of matter;
– the scale on which the structure is operational in contemporary technoscience and artistic experimentation is no longer a human one. Humans are overwhelmed by the very small, which is also the only means of information about the very large (astrophysics). This change of scale is required by particle physics, genetics and biochemistry, electronics, data-processing, phonology. . . .

With 'immaterials', the attribution of an identity (thing, man, mind, etc.) to one of the poles of the structure appears as an error. A 'same' identity may occupy various poles of the structure.

CONCEPTION

The Principle
From the root *mât* five terms are chosen:

- material
- materiel
- maternity
- matter
- matrix.

These are located on the operational structure:

- the material is the support of the message;
- the materiel or hardware is what handles the acquisition, transfer and collection of the message;
- maternity designates the function of the sender of the message;
- the matter of the message is its referent (what it is about, as in the French for 'table of contents');
- the matrix is the code of the message.

In Laswell's nomenclature:

- material = through what medium does it speak?
- materiel = to what end does it speak?
- maternity = in whose name does it speak?

- matter = of what does it speak?
- matrix = in what does it speak?

 ('it' = the message; the signification = what it says).

The Context

The exhibition attempts to characterise an aspect of our contemporary situation, associated with the new technological revolution. Whereas mechanical servants hitherto rendered services which were essentially 'physical', automatons generated by computer science and electronics can now carry out mental operations. Various activities of the mind have consequently been mastered. Thus the new technology pursues and perhaps accomplishes the modern project of becoming master and possessor. But in so doing it forces this project to reflect on itself; it disturbs and destabilises it. It shows that the mind of Man is also part of the 'matter' it intends to master; and that, when suitably processed, matter can be organised in machines which in comparison may have the edge over mind. The relationship between mind and matter is no longer one between an intelligent subject with a will of his own and an inert object. They are now cousins in the family of 'immaterials'.

Yet technology is not the cause of the decline of the modern figure; rather, it is one of its signs. Our grief is another of its symptoms. At the end of the eighteenth century, Europe and America, in the name of the free and virtuous enlightened mind, claimed to spread light, law and wealth over the human world. After two centuries of massacres and civil, international, world wars, we are now beginning to go into mourning for this arrogance. In its scenography at least, *Les Immatériaux* should distantly echo this wise melancholy.

The 'target' of this exhibition is a precise one: to arouse the visitor's reflection and his anxiety about the postmodern condition, by means of our five questions derived from the root *mât* and applied to domains where they are most critical.

– compare this arrangement of the visual gallery with that of the city dreamed by Descartes: the conflict between formal organisation and the disorder of the data, with victory going to the former. Once again, the modern project.

It is consequently impossible to present *Les Immatériaux* in a space–time of this nature. It is necessary to seek a 'postmodern' space–time. For a preliminary approach to this space–time, we take inspiration on the one hand from the scriptural practice of Diderot in his *salons*, and on the other from the intuitions of town-planners, architects and urban sociologists such as Virilio and Daghini.

When you drive from San Diego to Santa Barbara, a distance of several hundred kilometres, you go through a zone of 'conurbation'. It is neither town, nor country, nor desert. The opposition between a centre and a periphery disappears, as does even the opposition between an inside (the city of men) and an outside (nature). You have to change the car-radio wavelength several times, as you go through several different broadcasting zones. It is more like a nebula where materials (buildings, highways) are metastable states of energy. The streets and boulevards have no facades. Information circulates by radiation and invisible interfaces.

This is the kind of space–time, hardly sketched out here, which has been chosen for *Les Immatériaux*. The eye will be deprived of the exclusive privilege it enjoys in the modern gallery. Nor will there be a clearly signposted itinerary, given the uneasy reflection which the exhibition hopes to provoke. Indeed, it is not a question of presenting an exhibition (*exposition*), but rather an 'overexposition', in the sense employed by Virilio when he speaks of an 'overexposed city'. And nor is it a question of arranging the objects shown according to 'subject matter' or discipline, as though the delimitations from which these resulted were still intact today.

The Hypothesis
Localisation is in the Georges Pompidou Centre, at the heart of modern old Paris: the Great Gallery on the fifth floor (the highest). A rectangular space of 3,000 square metres, with two foyers (mezzanine on the fourth floor, the entrance). Level floor, outer walls of plateglass, cables and ducts visible in the ceiling, permanent foyer entrance and exit lights. In short, relatively few constraints, except for the lighting.

On this level there will be 20 or 30 radio transmitters, each one covering a carefully limited zone. Each transmitter will broadcast a soundtrack relating to one of the *mât* questions examined above (cf. 'Conception', 'The Principle'). The visitors are supplied with headphones. The oral messages they receive are not necessarily instructions, but also poems, prose, questions, exclamations, quotations, explanations. . . . Musical messages too. Arts of time, the most immaterial.

In each zone *sites* are assembled. They are taken from diverse domains (foodstuffs, painting, astrophysics, industry, etc.), but grouped together according to

the common question which they illustrate. For example, maternity: who is the composer of a piece of electronic music? Who is the mother of a child born of an ovum impregnated *in vitro*, implanted in a 'surrogate mother' and later adopted? What is the source of light of an abstract painting? The sites may either compare two moments in the same discipline, or confront two different disciplines.

Between the zones are 'desert', neutralised regions. The visitor, passing from one zone to another, becomes an investigator; he is accosted by the voices and the music, as well as by the sites he sees. His own individual itinerary might be recorded on a magnetic memory card, and given him in the form of a printout when he leaves.

April 1984.

The examples given below are a selection from among sixty-seven different sites which may possibly feature in the exhibition, serving to clarify and to dramatise the principal question which underlies it.

MATERIAL SITES = SUPPORT

Site of Indiscernibles
The meaning of the message does not change even when the elements which constitute its support (or material) are exchanged.

The electron is indiscernible in quantum physics, just as a man in uniform is indiscernible in a functional community.

- 3 photographs of individuals:
in civilian clothes
in uniform
unidentifiable in a crowd of
uniformed men.
- Panel of 6 colour permutations (urban furniture, cassette posters)

Soundtrack: 'Belle marquise vos beaux yeux d'amour me font. . . .'

169

Site of Hardware
The new 'hard' ware of 'heavy' industry. Simultaneity and simulation of projects, of supports. Multiplicity of receivers, singularity of materials.

- Audiovisual show on 16 screens.

Site of Neon Painting
Pictorial art is replacing the chemical
colours of paint by physical colours.

- Moholy Nagy, *Télélumière*
- Takis, *Télélumière*
- Fontana, *Ambianze speziale*
- Moree, *Neon hologram*
- Dan Flavin, *Four neons*
- Kosuth, *Five words in five orange colours*
- Dan Graham, *Glass pane + mirror*

Soundtrack: Goethe/chemical
light/physical light.

Site of Second Skins
Skin as the ideal of clothing. The
skin is doubled as clothing in order
to improve the protection of the
body and its performance.

- Protective materials for the body,
synthetic skin, skin-grafting surgery,
moulded works and dwellings.

MATERIEL SITES = PROPAGATION, COLLECTION, RESTITUTION

170

Site of Stellar Crucibles
The birth of stars. Classification of
stars according to their life
expectancy and cosmic fertility. The
death of stars. The star as 'material
for the propagation and
transmutation' (= laboratory) of
elements.

- 'Baby stars' on the computer of
the C.E.A. at Saclay
- The life of stars in fast forward –
laboratory video.

Soundtrack: text + cosmic echo.

Site of the Musician Despite Himself
How is a musical message set in
motion?
What law does it obey?

- In a space of 10 square meters,
microphones and sonars are
connected to a computer which
translates into music every
movement within this space.

Read-out of the sound produced by
the transmitter circuit +
headphones.

Site of Self-Procreation
A complex robot produces a life-size
mock-up of a car, using synthetic
images drawn by a computer under
the control of a designer.

• Computer enhanced imaging or
graphic computer, digital milling
machine.

Site of the Living Computer
The best prosthesis is bio-compatible
and transmits information at a
cellular level.

• Video game showing
three-dimensional structures which
assemble themselves.

MATERNITY SITE = ORIGIN, AUTHOR

Site of the Forgotten Soil or Orphan House
The material of architecture is no
longer generated from the earth.
Building no longer exists.

• Audiovisual show on building
materials of the past: texture, grain,
finish, etc. .
• Permits, materials exhibited as
art.
• Two series of architecture design:
the architect Aalto versus present
government design and computer
enhanced drawing.

Soundtrack: Kahn, F.L. Wright.

Site of the Pre-Cooked
Who is the author of a culinary
message?

• The time spent preparing meals
and in budgeting the purchase of
foodstuffs.
• Dramatised presentation of frozen
foods and supermarket shelves.

Soundtrack: advertising jingles.

171

kind of dead artists, the number and kind of women, the kind and number of media, etc. – constitute a highly observable politics, with representations as their currency and their measure of equality in a democratic process.

To disregard or displace exhibitions from the emerging discourse around representation and its social values seems all the more remarkable because exhibitions of art are, by virtue of their visible prominence, structurally intrinsic and perhaps psychologically necessary to any full understanding of most art. Exhibitions can be understood then as the *medium* of contemporary art in the sense of being its main agency of communication – the body and voice from which an authoritative character emerges.[1] Exhibitions are the central speaking subjects in the standard stories about art which institutions and curators often tell to themselves and to us.

Further, vision – the historical conditions of visibility through methodologies of perception and technologies of inspection – is the primary subject of contemporary theoretical inquiry. In these arguments, it is fundamentally claimed that ideologies and their attendant social agendas are most hidden within imagistic forms. The idealization of knowledge through vision, Western philosophy's predominant assumption which fundamentalized "seeing as believing," is now the fundamental characteristic under skeptical examination in the postmodern debate about cognition.[2] Yet presentations or displays or exhibitions of art, all terms associated with vision and vision's sometimes subsequent symptoms in the directions of narcissim, voyeurism or fetishism, have been allowed to remain aloof from, or even invisible to, theoretical critique.[3]

Instead, art objects themselves are the continuing subject of rigorous re/decontextualization, and institutions of art, especially museums, have become *de rigeur* subjects of much interdisciplinary thought and writing. Both the art object and the musuem in which it is found then are the special subjects of a new critical industry whose criticality often ignores the genres, systems, histories and architectonics of exhibitions and their reception. Uncannily, which is to say unconsciously, the active catalytic ingredient – the institutional tone of forceful articulation – the systematic delivery of art in a dynamic moment from object to concept – the exhibition – has been overlooked, for the most part.[4]

Art objects have now been included within the larger semiotic field of a "language paradigm" or "linguistic turn" and are transliterated as the equivalents of "texts." Art is treated as a semiotic object with something to say that can be coded, decoded and recoded in a syntactical and critical manner by methods like those used in academic literary criticism and cultural studies in general. But the move to a different form of "close reading," even one with presumed political overtones, does not necessarily restructure the art object's special place within its ensuing discourses. Contemporary art history and art criticism continue to privilege the single art object

176

as an autonomous experience just as they did in the past. Even the new hermeneutics emerging from neo-Marxism or various feminisms or other deconstructive "isms" has not greatly altered that pedagogical penchant for art's purity. In fact, it would seem that the emphasis on art's resemblance to a linguistic element tends to make more conservative the possible radicalness of its material poetics. Art's material strangeness and its visceral erotics are often reduced to an understandable textuality, a premature closure within language. Such critical writing preserves the art object as static, replete with meaning which waits patiently and passively for a proper (meaning prophetic and professional) unfolding.

Art objects are still most often seen separated from social spheres as singular bodies with inherent definitions or within the slightly expanded context of a single artist's chronology. In the highly regulated and genteel spheres of museums and art history, the monograph and the single-artist exhibition catalogue continue to have enormous purchase within art writing and critical thought as they most forcefully support individual markets. And the tradition of contextualizing art within social history is most often confined to 'historical' works rather than contemporary art. While monographical writing influenced by semiotics, for instance, can specify meanings more deeply than former art-historical writings whose authority was the well-placed adjective of connoisseurship, they still do not locate the significances of art in a larger context of time and space. Such analyses do not situate art's significances in social history, preferring the time-honored "aesthetic" values tied to "charismatic" figures to those of public and common social values, thus making the new interpretations ahistorical in the extreme.

The museum is one of the most conspicuous of the institutions whose roles are under inquiry. Its public role is changing in response to the new theories of representation which situate art and its functions in a larger semiotic environment together with strong economic and social demands which are unique to today's Western culture. As a result, the public museum, like the university and the church (all of which are what Althusser called "ideological state apparatuses" like the family or the school), is under fierce and sometimes violent contestation over who controls its agenda and what its fundamental purpose is.

An unexamined museological tradition of functioning for a wealthy class is in urgent confrontation with contemporary demands for social relevance from a renewed democratic impulse. This institutional and intellectual shift in the museum field is occurring both because of outside reform forces like government agencies and philanthropic organizations whose economic and social priorities have changed and because of internal forces which have to do with the inconstant nature of contemporary art in particular and the changing roles of participants in the artworld, including patrons and, in particular, curators.[5] Modes of exhibition are likely to

177

change to accommodate these new realities which means shifts that are not necessarily conscious or planned but which will radically alter a museum culture.

But institutional analysis still tends to be sociological and historigraphic, concentrating on museums' public political role rather than on the dogmatic narratives within each and every exhibition, the constituents of address which give every institution its character and tone. The exhibition is more often than not glossed over as a "natural" form within the life of an institution, even in attempts to discover the "deeper" levels of power that institutions generate and work within. While intellectual labor on works of art and musuems is extremely valuable and worthy, the actual work that goes into exhibitions and the work that exhibitions themselves do, on and through audiences, remain somewhat unremarked. The hyperbolic claims for exhibitions by large institutions (*Magiciens de la Terre*, *Primitivism and Twentieth Century Art*, etc.) serve as rare but true moments of political and even social unrest within the very large international context of the artworld. Otherwise, the performative aspect of exhibitions, in opposition to the linguistic one mentioned earlier, is hardly mentioned. Or its performance is reduced to demographics at best and fantasized speculation about the "general" public at worst.

It is my contention that, like art and museums, exhibitions are an intrinsic and vital part of the "cultural industries," a term originated by Theodore Adorno and Max Horkheimer to cover a multiple of ideological sins within what was then known as "mass" culture. They meant primarily what we commonly refer to today as the entertainment and news industries: communications enterprises of mass reception. The general name has been both updated and expanded by Hans Enzensberger to "consciousness industries" which include advertising, education and any institutional use of media techniques intended for vast audiences or what is now often referred to cynically as "infotainment." The consciousness industries are contemporary forms of traditional rhetoric; complex expressions of persuasion through complex transmissions of voice and image. Like rhetoric itself, they might be best described as strategic systems of representation; strategies whose aim is the wholesale conversion of its audiences to sets of prescribed values to alter social relations.

And this is precisely what an exhibition is – a strategic system of representations. The system of an exhibition organizes its representations to best utilize everything, from its architecture which is always political,[6] to its wall colorings which are always psychologically meaningful, to its labels which are always didactic (even, or especially, in their silences), to its artistic exclusions which are always powerfully ideological and structural in their limited admissions, to its lighting which is always dramatic (and therfore an important aspect of narrativity and the staging of desire), to its security systems which are always a form of social collateral (the choice between

178

guards and video surveillance, for example), to its curatorial premises which are always professionally dogmatic, to its brochures and catalogues and videos which are always literacy-specific and pedagogically directional, to its aesthetics which are always historically specific to that site of presentation rather than to individual artwork's moments of production. In other words, there is a plan to all exhibitions, a will, or teleological hierarchy of significances, which is its dynamic undercurrent.

Carol Duncan, in her work on museums, has astutely written that: "They are modern ritual settings in which visitors enact complex and often deep psychic dramas about identity, dramas that the museum's stated, consciously intended programs do not and cannot acknowledge."[7] But, whether this acknowledgement is conscious or not, the art institution's inner mind, as it were, or what Fredric Jameson has called the "Utopian dimension" of any public spectacle which celebrates the renewal of the social order, is, I am arguing, most available through anlysis of the medium of exhibitions. That is where the systems of representation which formulate and uphold identities (artistic, national, subcultural, "international," gender- or race-specific, avant-garde, regional, etc.) are most available for investigation and, perhaps, treatment or even exorcism. The will to influence is at the core of any exhibition.

Like other media used in the consciousness industry, art exhibitions are at once a generalized and a particularized form of communication directed at art professional spheres and other subcultures, meaning artists, critics, art historians, and students, as well as at respective patrons from government or commerce and other private spheres. Public presentations of private intentions, like court cases or religious services, they raise the stakes of individual expression to the level of the social. Exhibitions can be considered to be like texts, if the linguistic model is invoked, but they are also intertexts situated as moments of articulation within systems of signification of which they are but one, a material moment in which extra-aesthetic forces impinge and can be revealed as competing systems of strategic representation.

Exhibitions are part of a political economy of culture which, with increasing frequency, when understood as a medium, can be recognized as rhetorical arrangements to produce massive audiences for historical, modern and contemporary art. No longer restricted to the exposition of an academic thesis, or the animated exposure of the connoiseurship of the collection of a museum, the *temporary* art exhibition,[8] particularly, has become the principal medium in the distribution and reception of art and therefore is the principal agency in the debates and criticism around any aspect of the visual arts. Exhibitions leave traces in discourses as various as contemporary art history, journalistic and academic criticism, and forms of cultural anthropology, as well as in the active interests of collectors,

artists and arts bureaucrats. They also, it turns out, have huge, differentiated vocal publics whose complex interests, passions, and habits of consumption seem to be never satisfied.[9]

A simpler and more comprehensive way of saying this is that the ways in which art is talked about, understood and debated are largely determined through the medium of exhibitions – through the exhibition as a complex representation of institutional, social and, paradoxically, often personal values, simultaneously. And the exhibition's representivity then is an exemplary identification of the direct political tendencies (democratic, nationalistic, feminist, regionalistic, postcolonial or whatever) on offer.

A graphic example of an exhibition's clear links to institutional representation and to representing in its political sense is the didactic panels or labels which accompany works of art. Traditionally, it might be possible to find a text in an art museum which reads like the following: "Found earlier this year, the picture is a primary example of the brilliant, still Rubenesque manner employed by Van Dyck during his first English period." Within this fistful of rhetoric ("primary," "brilliant," "Rubenesque," "first," etc.) of authority, many assumptions from traditional art-historical and museological practices prevail. The unquestioned genius author (male) with already established credentials is trotted out yet again to herald a new discovery, now grateful for a newly assigned provenance. This is the heroic, adjectival narrative of a work of art formerly neglected, now found to be of aristocratic stock and rescued at the last moment to be restored to its patriarchial family name (think of the Prince and the Pauper). It could also read, for example, "overly influenced by Rubens" and still be the same image but with other connotations. In other words, it expresses an opinion, not any sort of empirical information, a semantic opportunity ripe for misuse by authorities and interpretive reform by untested new theories.

For many reasons, then, such texts are disputed by other kinds of language use, such as a poster distributed by the Guerrilla Girls, a New York interventionist collective. Their work has words whose rhetorical question "What's fashionable, prestigious and tax-deductible?" is answered below on the same sheet by "Discriminating against women and non-white artists." Their categorizations, argumentative and informative, can be found both within and without museums. Its exhibition value changes with its context (on the museum wall or on a SoHo hoarding) but its persuasive and self-reflective intentions are equally bound to a politics of culture and anchored by a graphically opinionated text. But what is clear is that the actual presentation of the work, the site in which it is found, in the case of both Van Dyck and the collective, is a unified strategy of representation and a clear signal of each form of representivity. (And of course, the Guerrilla Girls' opinion can

be, as it often is, backed by statistics, a part of the rhetorical "little war" to which their Spanish name refers.)

But an analysis of neither a work of art nor the institution in which it finds itself will fully come to terms with these kinds of ongoing accompanying texts and contexts which bear on the understanding of art. By emphasizing an artwork's content (whether it should be gazed or glanced at) or an institution's sociology (who owns it and how they conspire with others like themselves), the extra-textual's or the con-textual's important discursive address will be excluded from consideration. All exhibitionary procedures – labels, didactics, advertising, catalogues, hanging systems, media in their modernist sense, lighting, wall colors, security devices, posters, handouts etc. – combine as aspects of the exhibition's active recitation. They emphasize, de-emphasize and re-emphasize braided narratives with purposes – fictions of persuasion, docudramas of influence. All are contributive to the ways in which art is more or less understood.

One reason to set these two examples side by side is also to let them act as a reminder that "curators" from outside institutions (literally cultural guerillas in this case), as well as those traditionally trained in art history and museology, have the expertise, the skills and the experience of the dominant styles and ideas at play in exhibiting art. This liberty is especially a function of contemporary art practices in which many objects and forms on display haven't yet been actively collected or overly institutionalized. Conservative museological gatekeeping and elite professionalism are harder to instigate and maintain before official categorizations have been widely accepted. The activities of artists and critics and curators outside institutions are always closer to new methodologies, new forms and, increasingly, new interdisciplinary approaches. Curatorial imperatives within museums, on the other hand, are often linked inextricably to market-driven forces, the social pressures of a small body of vested-interest gate keepers, disciplinary diversions and institutional stereotypes of public roles.

An evident recent example of this is the Whitney Biennale in which the latest registers of the highly regionalized, even parochial, New York market are inscribed in the Whitney Museum of American Art (a name whose nationalism is already formally inscribed) as a kind of sanction or blessing, disguised as a "survey."[10] And because museum curators often act as unpaid advisors to collector/board members, they perpetuate, unconsciously and consciously, the interests of dealers whom they consider "advanced" for instance. Dealers, then, are very real power-brokers within the museum system in America through their careful relations with collectors and the collectors' with trusteeships and so on. All of which is just to suggest that no exhibition is pure in any sense; rather it is the result of mixed desires and values from within a network of interests which run from the academic to the economic and

from the semiotic to the institutional and from the professional to the amateur as a hybrid of spoken and unspoken assumptions of congruence.

One question then might be what kinds of desire and value those assumptions contain and how can we know them? Exhibitions are the material speech of what is essentially a political institution, one with legal and ethical responsibilities, constituencies and agents who act in relation to differing sets of consequences and influences at any given historical moment. And like other political institutions with socially authorized voices, what they do and in whose name are important to any sense of a democracy, especially a democracy of representations.

What I am suggesting, at the risk of anthropomorphizing the exhibition and its institutional body beyond this provisional metaphor, is that the building, its agents and its projects have personalities and traits which combine to produce what might be called a character – the speaking and performing body by which it is known and judged, seen and heard. This complex projection is sent outward to its constitutents through the sound and image of its exhibitions. The institution has a perceivable image of itself and a set of images which others have of it; a marketing strategy and a set of demographic responses. It is in closing the gap between the differences and, even, antagonisms that it is most effective, most readable. The institution probably has an unconscious, a possibility that was explored by curatorial students at the Whitney Program in a show called *The Desire of the Museum*. This would be its unspeakable side but a side which nevertheless communicates and is understood – the way the ambiguous authority of the new National Gallery of Canada is understood by its mall-like exterior and entrance and its fascist, Italianate hallway inside, for instance. Its unconscious desire to both soft-sell (to be consumer-accessible) and hard-sell (to be authoritative, if not authoritarian) seems obvious, although it might only be understood subliminally, not as a conscious effect desired by its architect.

These architectonics (and the new museum at Bonn has them just as the alternative Thread Waxing Space has them) are part of a complex desire to have a cultural conversation, whether dialogical or not. The desire of a public with regard to exhibitions is to establish the proper distance from the art on display and to have a reasonable debate about it. To be too close would be to be blindly identified with the objects, the definition of fetishism, a closeness which is uncomfortable and which leads only to pedantic and authoritarian defenses, a condition which often affects curatorial preserves. To be too far away is to be only voyeuristic and to have no empathy whatsoever with the objects, to see them only as signs of foreignness and otherness; to repeat the symptoms associated with superiority and imperialism. The exhibition as material speech must speak with a voice which is already sensitive to its audience's desire for a proper cultural distance from which to learn and enjoy a

democratic version of meaning. Exhibitions, seen as a medium, expose this kind of tension between unconscious and conscious and between known and unknown, between silence and sound. They often are used to act out a normality, in spite of the desires of the works of art on view. They contain and control through nomination, hierarchy and textuality the undependable nature of art.

If an exhibition of art is like an utterance or a set of utterances, in a chain of signification, it can be considered to be the speech act of an institution. And, like a speech act the exhibition finds itself in the center of an environment of signifying noises. Less like a text then, and more like a sound. Thus, the work of art finds itself located in the disquieting context of its display, in the messiness of the world of received meanings. The exhibition brackets out the work of art and sublimates it to its own narrative ends as a minor element in a major story. The art institution without equal – the museum – stands neo-classically or modernistically or gothically within the architectural discourse of the city, and also within the sociological discourse of the arts or the bureaucratic discourse of public administration or the mass-media discourse of cultural information or the anthropological discourse of material culture or the educational discourse of art history or the culturally political discourse of nations and individuals, and so on. But when this institution speaks, it speaks exhibitions. It utters a kind of sense that it believes to be true. Exhibitions are its instrument of pitch, regardless of their content.

To ask what kind of vocality is that of an exhibition which is constructed along lines of nationality, lines of inter- or trans-nationality, lines of biography, lines of chronology, lines of connoiseurship, lines of thematic unity, is just the beginning. This might offer up a typology of vocal or filmic genres – a series of exhibitionist tropes and audience expectations. Like genres in mass media – the sitcom, the detective story, the news, the soap opera – such genre identification would help to situate the constructions of meanings and the constructions of specific audiences. It would be possible to differentiate the Hollywood exhibition or the documentary exhibition or the consistency-building exhibition or the melodramatic exhibition or the epic mode and certainly the *auteur* exhibition or even the exhibition *noir* and the buddy exhibition (i.e. Picasso and Braque), and the Western (i.e. *Magiciens de la Terre*) with aboriginals as the horizon of difference. This would be a beginning.

Who speaks TO and FOR WHOM and UNDER WHAT CONDITIONS as well as WHERE and WHEN the particular utterance occurs are significant questions that can be asked of any communications performance. By asking who speaks it is possible to establish the gender, ethnicity, race, age and cultural background and the history of texts of the speaker. By asking TO WHOM and FOR WHOM we can establish the administrative nature of the relationship: whether it is commercial or casual, individually professional or institutionally mediated, intimate

183

or formal, a teacher to a student, a slave to a master, and so on. In other words how is this particular voice filtered and mediated by its connections to other people, other institutions, other kinships and networks of influence?

Art museums and other officially sanctioned art institutions are some of the legitimized social characters who speak the language called exhibitions. They are an authorized institutional WHO – one of the cultural bodies, like libraries and universities – who are designated to speak about identity and history through productive material subjects in performance. And good work is done about the nature of the individual works being shown in an art museum along semiological and sociological and other critical lines at the textual level. And some analysis of the social traces of art's production is beginning to surface primarily because of feminist, cultural-studies and language-analysis analogies which make the objects themselves more contextualized. But the work on the nature of that institutional speech called exhibitions has just begun.

What are the social spaces in which it is heard or in which it remains silent? Whose codes are being recoded, decoded or overcoded and whose subcodes or metacodes are, at what level of significance? What kind of delivery is it, in relation to what kind of set of receptions?

The relations of power which surge and course through any speech environment and the conventions that underwrite it can start to be assessed by an understanding of the complex nature of the contextual elements of that exchange. It is possible to begin to establish the material speech of an exhibition in relation to a larger history – to its contemporary place within the actions of groups and individuals and their changing situations within an already established context. It is possible to appraise the position of that institutional utterance within ideological frameworks and dominant organizations of meanings in the larger social frame. It is possible to see how art is used as accent, as emphasis, as dialect, as stutter and mutter, as thick tongue, as fluid eloquence, as polysemous imprints of culture, as ideology and as the unknown, numinous, erotic breath of managing meanings. It is possible to see how art serves exhibitions as their very element of speech.

As a system of critical representations, exhibitions must be seen in terms of their differentiating forms, media, content and expressive force within the environment and historical conditions in which each of their solicitations are proposed and received. The surprise, of course, given the multiplicity of forms of art, is how few genres of exhibitions there actually are and how few are animated differently from one another. The labryinth of possible utterances from multiple voices and complex cultures seems to remain unsearched and unresearched. Repetition of genres and figures remain systematically patterned and structurally repetitious. But if other authentic classes, races and formerly marginal voices are committedly introduced,

the exhibition form may produce unexpected flourishes, new subgenres, new sites of speech. New dimensions of the signifying field may expand the play of exhibitions, and thus expand the possibility of serious achievements.

It is possible to trace more specifically the form of any speech act or utterance and start to assess its aesthetics: its intangibles, its expressive qualities, its patois and dialect, its emotional mytho-poetics. We can look carefully at its iconic functions. We can judge its ritualistic abilities to perform effectively and we can adjudicate its inventive uses of tropes; its persuasive forces. We can evaluate a speech act's sense of conviction, its logic or its convulsive irrationality, its acuity or its obliqueness, its hard edges or its soft contours or its contradictions and oxymoronic surfaces and unconscious subtexts and its encrustations within other texts and discourses that precede it. The poetics and politics of exhibitions are interrelated and interdependent.

In short, an institutional utterance is a complicated and somewhat enigmatic performance of expression and a very real audience for each and all of its discursive elements is an essential and diverse part of understanding its significances. Moments of communication are primarily acts of persuasion, not grounded in some independent truths outside of their performance, a recognition that speech realizations are never complete and that they are always open to further change and value construction by receivers. Further, if there is agreement that works of art are the most eminent objects in stimulating meanings, because they are as Leo Bersani writes "material metaphors for moves of consciousness which do not intrinsically belong to any particular cultural domain but rather transversely cross, as it were the entire range of cultural expression," then the nature of exhibitions, the nature of the ways in which their meanings are managed and maintained, is crucial to understanding art's possibilities.

The management of meanings is explictly the goal of any strategy of representation that is any medium's prime objective. How exhibitions do this and under what conditions they do it in order to maintain essential identities or to disrupt them, then, is not just (if at all) a matter of content but a matter of medium. The number of ways in which art can move on any trajectory of meaning is opened up or constrained by judicious use of the exhibition's many instrumental elements. The codes of the exhibition itself must be deconstructed in order to produce effective art and effective institutions. It would seem obvious that different forms of exhibition would produce different audiences as well.

And given that the theories of the end of history and the end of meaning that were so popular a few years ago have been put on hold by recent political events in Eastern Europe and the Middle East, it seems clear again that meanings are *always* just about to be undermined and opened out again and that only their vulnerability is

185

universal. The idea that meanings are *impossibly unstable* is embraceable because inevitable. With works of art, meanings are only produced in context and that is a collective, negotiated, debated and shifting consensual process of determination. Representation is always in crisis, which is always a form of freedom. The "accumulating selves," as Friedrich Dürrenmatt calls the never ending process of individual identity formation or any nation's or region's or group's constructing of its accumulating self under ever new historical conditions, are continuously shifting, assembling and dissipating notions of identity which never come together, which always betray one another. Only exhibitions in self-conscious crisis or in which accumulating selves are spoken in complex and contradictory methods will answer to the possibilities for an effective art in an increasingly heterogeneous world of representations and identities.

If we are to have dialogue between hemispheres or between peoples, it is necessary to understand and discuss the nature of that speech called exhibitions, an utterance which is always also a betrayal. But that is what people with an interest in art have in common, an utterance which is never a truth. We may speak languages differently, and have different cultural and socio-economic backgrounds and different histories of art production and reception, but what we do share in contemporary art is modernist institutions which speak the same kind of rhetorical force, in the same medium, however seemingly different in content. Exhibitions are a rhetorical force as a medium of art with a degree of congruence if not universality. They act as sustaining cultural narratives, as material talk from one individual and one region and one country to another. The state, corporations and individuals spend a great deal of money to enable art exhibitions to become their saga of identity, to affirm the consent of their various constituents to that identity. They are major players in the modern saga. But it is necessary to remember that their congruence exists only in relation to the possibility of interpretation, not a unity of thought.

But in order to really understand and come to terms with a possible dialogue between cultures and their artistic productions, the expanded meanings must not be just the interiorized contextualization of the art objects by styles and then further by debates on wall labels, framing devices, catalogue texts, audiovisual aids, educational strategies and display techniques, however much these would serve to establish a vocabulary of exhibitionary techniques. We would still be left with a kind of content analysis like art criticism itself, which however necessary, forgoes the obligation to place the institution within its social context. For we are all aware that the most radical artworks are neutralized in institutions almost regardless of the technical means of exhibiting. The historical avant-garde died a death of acceptance, not rejection, after all.[11]

The work to be done is to contextualize the institutional exhibition itself as a kind of

speech, as an utterance. To analyze the character, conscious and unconscious, of the art exhibition through its institutional stagings: the elite position of the Museum of Modern Art in New York – all cubist aristocracy flavored by a chauvinistic "internationalism"; the rough-and-tumble street-smart ICAs and artists'-run spaces with their all too easy allegiances to bohemianism and avant-garde strategies as rituals of critique; the respectable and liberal city and regional museums which obey a hierarchial system of center–periphery and yet lay claim to speak with a specific provincial and local accent. Analysis of this institutional character and its exhibitions simultaneously will allow us to respeak the institution from a grounded and connected historical site, not from an ideal, semi-autonomous place where art merely apes the rituals of contemplative religion with its misplaced social authority. It will also allow us to see how another's speech is accepted or rejected within that context. It will allow answers to Michel Foucault's question "What difference does it make who is speaking?" What happens when a small provincial museum speaks homosexual desire as in Cincinnatti, Ohio, with the exhibition of the photographs of Robert Mapplethorpe, or when a city museum in Sheffield, England speaks another's national tongue or a national museum speaks another nation's or individual's claims to identity?

The list of interrogations of this speech could go on forever and is divided between an exhibition as a text of conscious and unconscious motivations and audiences of reception which vary considerably. The techniques used in this kind of genealogy would follow those methods used in poststructuralist literary criticism and those used to analyze mass-media productions and receptions. Such questions and others would start to uncover whether or not this speech, called the exhibition, of any particular institution or organization, admits to its own necessary contradictions and multiplicities or whether it is almost always an attempt at realist transparency and avoidance of the alienation at the center of the art's complexity?[12]

And if the exhibition is more often than not an affirmative narrative, analysis could begin to show how it performs its realist or its individualist or its nationalist narrative to maintain and reify social relations by acting to resolve conflict through exhibitionary alignments. It could begin to find its textual gaps, pauses, ellipses and other tell-tale signs of strategic interruptions in its conventions and conformisms; its slips of tongues and anxious "parapraxes." In other words how can an art museum's face be composed when its exhibitionist heart and mind are conflicted? How can it speak realistically when its true speech can only be surrealist, fragmentary and incomplete, full of doubt and vulnerability and poetry? And mortality.

The hallucination of full identity deliberately and too carefully spoken by many art exhibitions must be countered by an analysis of these institutional representations as relationships of tangible difference where the borders of each narrative are always the beginnings – the starting points – not the ends of experience. Then dialogue

might occur, not because of the voices of artists or objects whose articulations are always somewhat muted or repressed in such institutions and exhibitions today, but because the embodied voice of art itself will be understood as positioned strategically in the cultural environment. By understanding the exhibition as an institutional utterance, we will begin to know who speaks to whom, why, where and when and under what conditions. Only when museums are utterly articulate will anyone be able to understand what is authentically being said. Otherwise the exhibition as a speech performance will remain a loud monologue followed by a long silence, the silence that unfortunately reigns in most art institutions today, the sound of curatorial failure and audience disappointment.

NOTES

With the support of the Canada Council for the Arts, this essay is a revised version of a paper published in *American Visions/Visiones de las Américas: Artistic and Cultural Identity in the Western Hemisphere*, ed. Noreen Tomassi, Mary Jane Jacob and Ivo Mesquita, New York, ACA Books/Allworth Press, 1994.

1 I understand that "medium" is often used more conventionally to refer to the materiality of a work of art, e.g. paint, film. In using it to mean the instrumental form of its public address I am aligning exhibitions to the idea of "medium" in the sense generally understood when speaking about mass media. This is my deliberate attempt to pry the term "medium" loose from its usual and unquestioned modernist connotations as a material with fundamental qualities. Accepting "medium" to mean a communicative network or meanings obviously allows for exhibitions to be associated with reproductive technologies from photography to laser disc, CD-ROM players, and so on rather than its more restrictive and essentialist use in a particular modernist history.

2 The writings of Jean Beaudrillard, Fredric Jameson, Annette Kuhn, Martin Jay *et al.* serve as testament to this generalization.

3 As Timothy Landers has pointed out, all museums have their own "perversions" in the Freudian sense because they are concerned with "exhibitionism, voyeurism, and fetishism." "And each is a psychic function made known through psychoanalysis as bodily desires of displacement. The museum wants to expose itself through exhibitions; it encourages voyeurism on the public's part and it is dedicated to the fetishism of objects." "Introduction," *The Desire of the Museum*, Whitney Museum of American Art, Downtown at Federal Reserve Plaza, 12 July–12 Sept. 1989.

4 There are exceptions of course and authors included in this anthology represent some of those. An excellent exception in which an institution and its exhibitions have been analyzed together is Debora Silverman, *Selling Culture: Bloomingdale's, Diana Vreeland, and the New Aristocracy of Taste in Reagan's America*, New York, Pantheon Books, 1986. And, as importantly, artists from Joseph Kosuth, Daniel Buren, Lawrence Weiner, Marcel Broodthaers and Art & Language to Jenny Holzer, Barbara Kruger, Judith Barry, Jac Leirner, Sherrie Levine, Jane Ash Poitras, Haim Steinbach and Fred Wilson, to mention only a few, have formulated practices and exhibition strategies which inform all contemporary curatorial and museological practices with regard to contemporary art today.

5 The etymological origins of "curator" are very conservative, even obstinate, and are reinforced by the equivalent term "keeper," in use in many museums, a reminder that zoos and museums developed at the same time in the histories of imperialist nations as ways of absorbing and classifying the "foreign" or "other." As passive nouns, both "curator" and "keeper" emphasize the functions and disciplines of collecting, not exhibiting, and the idea of possessions, not interpretations. From policing property in the neighborhoods of ancient Rome to policing the soul in religion, the noun "curator" enjoyed a long and stable evolution until its more abrupt recent development as a wannabe verb or transitive noun. "Curation" and "curating," the active elements I am speaking about here, have yet to enter the dictionary, for instance, but they serve to index the shift from collecting to exhibiting and interpreting.

6 For an explanation of architectures for art as "political," see for example, Albert Müller, "Josef Hoffmann's pavilion on the Biennale grounds in Venice and the issue of Austrian identities in the 1930s," *Stellvertreter, Representatives, Rappresentati: Austrian Contribution to the 45th Biennale of Venice*, Vienna, Bundesministerium für Unterricht und Kunst, 1993. Also the work of artist Krzysztof Wodiczko has often been a powerful social attempt to disclose architecture's deep meanings within civic culture.

7 Carol Duncan, *The Aesthetics of Power: Essays in Critical Art History*, Cambridge and New York, Cambridge University Press, 1993, p. 192.

8 In emphasizing "temporary," I am deliberately stressing the condition of time rather than space which is the usual assumption of an exhibition's principal form–occupation of space, a hangover from the imperialist notions of representation. Rather, time links exhibitions to orality rather than text, to utterance rather than writing, and thus to mutuality and sociality rather than exclusion and individuality. Time (or its sounds, as John Cage might say) always reminds us that subjectivity has a collective aspect.

9 In this I am in agreement with Clifford Geertz who argues against the modernist assumption of art's much-touted "silence" in writings such as Susan Sontag's, or Rosalind Krauss's. But, as Janet Woolf and Peter Berger have written, there is a confusion that exists in thinking that the social isolation of the artist means a silent work of art. Instead, as Geertz writes (in "Art as a cultural system," *Local Knowledge: Further Essays in Interpretive Anthropology*, New York, Basic Books, 1983, p. 95):

> the perception of something important in either particular works or in the arts generally moves people to talk (and write) about them incessantly. Something that is meaningful to use cannot be left just to sit there bathed in pure significance, and so we describe, analyze, judge, classify; we erect theories about creativity, form, perception, social function; we characterize art as a language, a structure, a system, an act, a symbol, a pattern of feeling; we reach for scientific metaphors, spiritual ones, technological ones, political ones; and if all else fails we string dark sayings together and hope someone will elucidate them for us. The surface bootlessness of talking about art seems matched by a depth necessity to talk about it endlessly.

10 The exception to this was the much reviled 1993 Whitney Biennial exhibition in which the curators tried to see art within a larger cultural matrix and to tie contemporary art production in America to certain social crises. In the *Members' Guide*, Elizabeth Sussman, Chief Curator, had written hopefully that members would be "open to redefining the art world in realistic terms – not as a seamless, homogenous entity but one involved in a process of exchange and difference." The failure of nerve was that of the artworld audience who almost universally decried the lower status of art in the new exhibition arrangement. For my purposes here, the transparency of Sussman's desire

shows the rhetorical aspect of the exhibition to have been paramount.

11 In this I am in agreement with Peter Berger, Andreas Huyssens, Janet Woolf, *et al.* Joshua Decter says its succinctly when he writes, "high culture is allowed to perenially manufacture its own regimes of apparent subversions." "The administration of cultural resistance," *Texte zur Kunst*, 5 (1992), p. 107.

12 Alternatives exist of course. For an interesting comparison between an avowedly "political" exhibition and an interventionist approach, see Maurice Berger, "Of Cold Wars and curators: the case of Julius and Ethel Rosenberg," in *How Art Becomes History*, New York, Harper Collins, 1992, pp. 23–41.

10

CREATING SPACES

Gerald McMaster

The installation at the UBC Museum of Anthropology – which I was responsible for, along with exhibition designer David Cunningham – included six paintings and a number of small installations of "Indian-kitsch" and reappropriated consumer-based popular representations of "Indians." In one of the installations, a chief's feather bonnet, a pair of moccasins, and a tomahawk/pipe from the Museum's permanent collection were also used. This group of works was installed in two different galleries within the Museum's visible-storage area. As well, there were two participatory components in the exhibition: a comment book, and a display unit which also served as a collection box for viewers' voluntary contributions of objects related to the issues raised in the exhibition.

As this exhibition tours nationally it will continue to alter, as participating

institutions co-curate the exhibition with McMaster to make it relevant to their own space,
place, and time.

Rosa Ho

With the exception of this exhibit – everything in this museum is highly complimentary
and tastefully presented. This negative exhibit seems out of place while it is recognized
there is a negative message to convey – this does not appear to be that appropriate
vehicle!

500 years since Columbus is a good date for Americans to remember their own
Holocaust.

(excerpts from the comment books)

Ironically, these two quotes taken from the visitors' comment book on the opening
day of *Savage Graces*, 24 July 1992, established a polarity for the exhibition. The
visitors' comment book, which is present at most exhibitions, had a particular
function. It became part of the "process-oriented" style of the exhibition. Debates,

➡ **10.1 *Savage Graces "after images"*, detail of installation, UBC Museum of Anthropology, Vancouver, 1992. Photograph courtesy of Gerald McMaster.**

points of view, and opinions, not often expressed by visitors, were deliberately
requested. Comments indicated to us whether or not objectives were being met.
Comments ranged from the inflammatory to the sympathetic, from the innocent to
the critical, and from a self-discovery to the bleeding heart. As the subject/artist of
the exhibit I wanted to encourage "silent debates": to see audience reaction to the
works and their placement in a non-art/anthropology museum. I wanted these silent
voices heard. Unfortunately, the debates found among the visitors' comments

The Native Canadian is the least understood and the most misunderstood of all Canadians. The
greatest sin of all is to pretend that there is no problem. Do Native people have to be dead to be
in museums? Are you threatened by "others"? Why do you call us Indians? Why do you call this
land British Columbia? Is there a universalizing intelligence? Is there a conspiracy to legitimize
only one version of the way we see the world? Does Western knowledge control the
framework of relevant evidence? Do we need permission to destroy the natural world? Are
non-Western cultures irrational and invalid? The term "medicine" means sacred power. I never
knew I was an Indian until someone told me. Do I represent only the past to you? If we are to be
guided by our elders, we need a clear direction.

Gerald McMaster

provide readers with very few conclusions, except perhaps that audiences when provoked do engage in verbal exercises often not asked of them.

This project was a learning process in discovering the unexplored self as a contemporary (Native/Cree)[1] artist. As an exhibition it is a reflection of that self, an autobiography, which I want to share with you.

It all began, in preparation for *Savage Graces*, when I arranged to consult with some knowledgeable people of my tribe (Nêhiyawuk) concerning the specifics about the "spiritual." I had understood that Western artists had experimented with this subject for years. I somehow wanted to know if what I was addressing was "culturally" correct. This proposal, called "Mystic Warriors," had as its framework the ideas of spirituality and warriorship. Therefore, I was hoping some timely advice would guide me in the right direction. I returned home (to the Battelford area) one summer to attend the Thunderchild Thirst Dance, where I knew my questions would be addressed.

During the dances, a dear old friend and his elderly father greeted me. Both are respected members of the community.[2] After explaining to them my interest in Cree aesthetics and thoughts about the spiritual in art, I was surprised how well the younger man understood my views. As it turned out, I had provided many of my

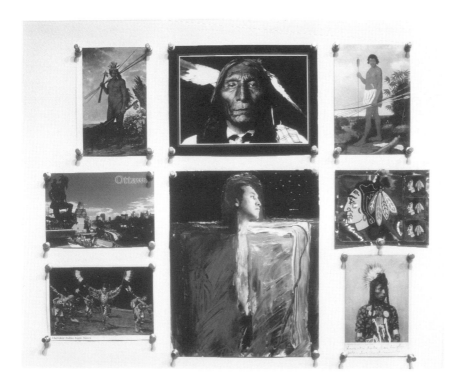

own answers, and later wondered if the conversation was a test of my competence, knowledge, and attitude. An old Cree strategy? Perhaps.

Surprisingly, my principal concern shifted over to understanding boundaries which restrain certain forms of representation: from the Cree perspective it became evident that it was the spiritual and art, rather than the spiritual in art. A distinction was being made. Could they articulate these perspectives in an understandable way? I needed to know their concerns. Also, could I try explaining to them issues commonly debated in the museum,[3] such as: sacred/profane, secret/obvious, political/aesthetic, and traditional/modern? To say the least, I think I answered those questions myself. Nevertheless, could they make sense of these spaces and the boundaries that separate them? As we talked, I realized these boundaries of understanding are always in constant flux. I then questioned which side of the boundaries I stood on? Was I in some "liminal"[4] zone, that is, a neutral space, from where I could see both sides (perspectives) simultaneously? I reasoned that if these boundaries shift, which they often do, then representation and interpretation would be problematic and difficult to negotiate; therefore, one must be scrupulous with certain knowledge and its use, or face the consequences. I've come to realize the

➡ **10.2** *Savage Graces "after images"*, **installation view, UBC Museum of Anthropology, Vancouver, 1992. Photograph courtesy of Gerald McMaster.**

shifting of boundaries is about the politics of negotiation; quite often uninformed individuals, like myself, may find out the hard way.

I realized that by gaining access to specific knowledge I ran the risk that may or may not be worth the effort or predicament: for example, using certain images and ideas, to which I may not have any rights and privileges. This is a question I believe (Native) artists often face. My questions were seeking reassurance against breaching a trust for the sake of an artistic expression. Because I was a contemporary (Native) artist, I was outside the Cree context, so I felt I had to reconsider my objectives. The elders at the Thirst Dance made these issues clear: leave some matters alone. In doing so, one protects oneself. The dangers may be as subtle as a misunderstanding, as contemptuous as breaking a taboo, or as simple as appropriating something to which one does not have a right!

That day, I learned many Cree traditions remain unsevered by Western modernity; many traditional epistemologies, like spiritual beliefs, have endured. Consequently, this cautionary advice convinced me to adjust my focus. Instead of representing the spiritual outside its context, I decided upon another approach.

The question of boundaries and borders began to play heavily upon my thinking.

So, I started working towards this notion. But how could it be realized? First, I had to conceptualize it on paper. It was at this point I proposed to Rosa Ho, Curator at the Museum, an exhibition that looked at the ideological and conceptual practices of museums. Could the museum be interrogated? Could I bring critical attention to the museum, both its representation and collecting practices?

As a contemporary (Native) artist, I wanted to open a new space in an anthropology museum. You may ask: What is so unusual about this? Let me explain: anthropology museums often represent objects, viz. "material culture," of non-Western peoples, whereas art museums represent the history of "aesthetic" objects by Western peoples. Both represent ideas; but, both offer only Western points of view. When contemporary (Native) artists began to exhibit their works, very often they were caught in between these two representational apparatuses. They did not want to be treated as "objects" in the former, yet were being marginalized by the latter. They realized in both cases they had little or no voice. With the rise of the "Other," the under-represented bodies, the politics of representation began to open up new territories and possibilities, which I'll not get into. But what is important to my discussion is that artists began to think more in terms of negotiating with spatial

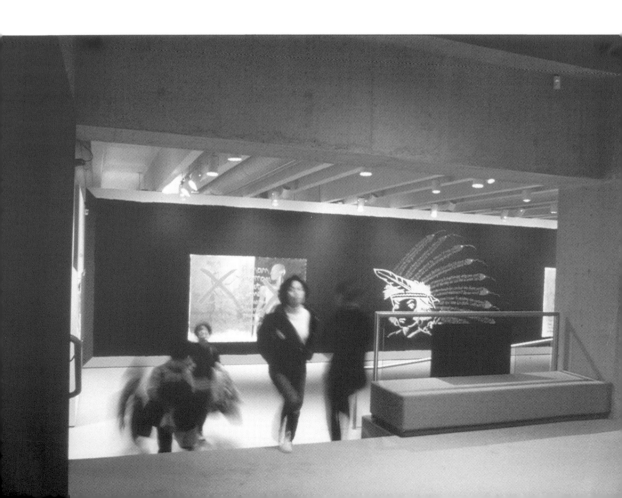

possibilities. For the (Native) artist this meant that cracking the immutable art spaces – where they always wanted to be represented – was not the only exhibition possibility: it could be virtually anywhere. For me it was looking at the anthropology museum. Here I did not have to accept my subjectivity as "object," rather I could be the subject/artist. Furthermore, the anthropology museum could be transformed into a "site" for playful possibilities. In other words, I could engage in shifting the boundaries, which then become negotiated between the museum and myself.

At this point, Rosa Ho and I discussed my involvement, not only as artist, but as co-curator. I wondered if this dual role could adequately question the role of museums; similarly, could audiences be challenged to view the museum and its representations differently? Both she and the Director, Michael Ames, were familiar with my work as a curator and now were beginning to understand my alternative artistic strategy.

Creating an exhibition involves a trust relationship between artist/curator and the institution where it is to be accommodated. Part of that trust involves coming to terms with certain principles. In this instance, there was at least one: it had to be "open-ended." Its opposite is "closure," which disallows change of mind or

➡ **10.3 Gerald McMaster, *Cultural Amnesty (Stereotypes Hurt)*, "Deposit Here," UBC Museum of Anthropology, Vancouver, 1992. Photograph courtesy of Gerald McMaster.**

adaptability to circumstance. Being open-ended meant the project would be organic, with process being the guide. Though this is not often an acceptable format for public exhibitions, because open-endedness usually suggests unforeseen liberties, MOA was willing to accept the possibilities. From an artist's perspective closure limits the opportunity to work with an audience. From a curator's perspective it leaves little opportunity to evaluate the changing conditions.

As a result, through the entire process, I became much more aware of my juxtapositioning within the museum and the British Columbia Native community. When MOA first asked me to do an exhibit, I knew its identity was consistently being questioned by its critics, Native and non-Native. I also knew how much of a force it was, as an institution, in presenting to the public the cultures of the West Coast Aboriginal peoples. Of course, I knew many more things about it, but more importantly, I knew how much they would be challenged by someone like me coming to question their practices. Whether or not they have changed from my presence is one thing, but somehow I changed during this experience. I know that I will continue to change and adapt to other circumstances, whether working with other curators, or artists, or institutions.

Joyce Carol Oates once said: "All art begins with conflict." Somehow this idea has a double-edged meaning to it. As I reflect on my project with MOA, I am not sure how far this notion could have been taken. I continue to feel anxious about the (in)translatability of "art" into certain areas of Native culture. Somehow I knew a potential conflict would have resulted if I pursued my initial ideas. I knew only too well the conflicts that Salman Rushdie went through in the Muslim community. On the other hand, it remains to be assessed whether or not I was in conflict with MOA, not so much with its staff, but what it represents as an institution. MOA took an intellectual leap away, perhaps beyond, its traditional ethnographic position. They did not make me feel like an artifact. They allowed me to be a (Native) artist and all that this subjectivity brought with it, including an opportunity to change my mind. This occurred quite frequently. Sometimes it was good to be 4,000 rather than 4 miles away. MOA is an anomaly of sorts. It has not been given credit for its efforts to expand its horizons of possibility. I believe it is changing its stereotype and wanting to pack new bags. Its identity needs to be redefined.

To summarize, let me return to the two visitors' comments. My work as a contemporary (Native) artist/co-curator, with this project, should not be viewed as

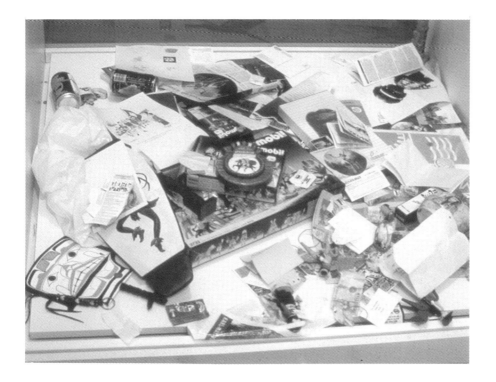

"negative." And neither should MOA's. For the two of us, it was a learning process; for the many visitors who came to the Museum, they shared similar perspectives. If I had not begun on the journey, I would not have discovered the many ideas that made me see clearly. My role as a contemporary artist is not only to ensure my work is "tastefully presented," but to bring to public attention different perspectives. *Savage Graces* is about that journey, and the exhibition and catalogue are the "after-images" of everyone who worked on this project, and those who have yet to see it. To ignore the differences between these many perspectives is to perpetuate that profoundly disturbing attitude I once encountered in print: Kill the Indian, save the man!

GERALD McMASTER: AN INTERVIEW

Walker *tânsâteweya?*
Gerald *nâmoya nantow! keya mâka?*
Walker *payaquon. . . .*
Gerald *êkosaysa!*
W. *we tamowin maka*, in *Savage Graces* you created a piece called *Cultural Amnesty*, *âhow âchimostawinah*.

➡ **10.4 Gerald McMaster, *Cultural Amnesty (Stereotypes Hurt)*, "Deposit Here," UBC Museum of Anthropology, Vancouver, 1992. Photograph courtesy of Gerald McMaster.**

G. *payakwow* David Cunningham *oka neya* were deciding an exhibition design for one room. There was this cabinet they couldn't hide anywhere because there was no hidden storage. Ironic, isn't it, for a museum with an "open-storage" concept. *oka mena*, many of my friends were giving me small "kitschy" gifts thinking I could somehow use them in the show. Tokens of awareness, I thought. This ubiquitous "Indian-stuff!" Usually this stuff gives me mild anxiety. If that wasn't enough, Rosa Ho indicated to me that complete strangers were leaving this stuff at the front desk. I didn't know what to do, as I had already used all the bogus material I could find. This got me wondering: "Are my friends and those anonymous donors feeling guilty and implicated?" Why were they giving me all these questionable objects? *nâmoya niskaytayn!* I'm sure they understood how insulting these visual stereotypes were to Aboriginal peoples, women, and others? *ni mumtinaytayn*, were all these contributors helping me out, did they understand and want me to acknowledge their empathy? Did they want exorcism? *saymak*, I seized the possibility for reusing the "displaced" cabinet.

 êkwa mena, ne kayskisin oma tansi spayak, "amnesty." You see, amnesty is given to

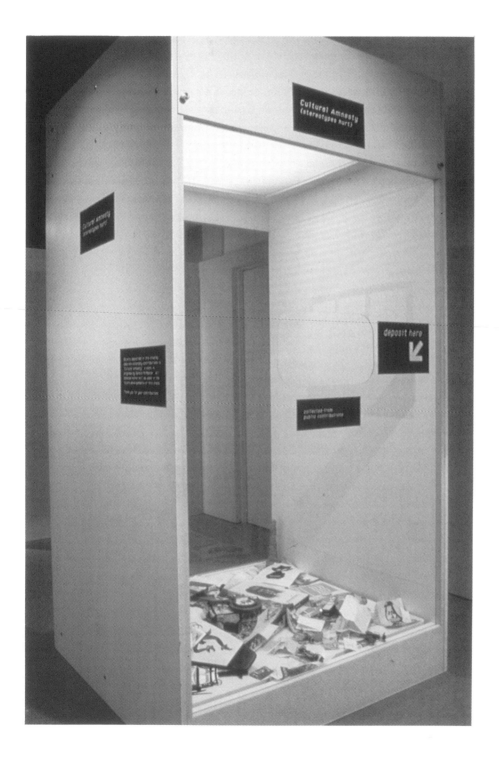

those who "fess up" to questionable activities, *tâpiskooch* : gun-control, *oka mena* the evasion of war duty, *apo* the returning of library books. So then, for those with an urge to participate in exhibitions, could I encourage them to bring a questionable object or two? Could their contributions in effect be a "cultural exorcism?" Theoretically, could they be given amnesty? I decided to do so.

êkosi, if others saw these objects in *Cultural Amnesty*, maybe they could conceivably question racial, sexual, and cultural stereotypes, in addition to the noble/savage "Indian." *ni miaytayn tânsisi ayseenowuk* are responding. Presumably *Cultural Amnesty* will expand into a work that critiques society's values, rather than the objects' value. In other words, the objects themselves give value to the idea rather than to themselves. The objects are of little or no value to you or me.

NOTES

This essay was originally published in *Harbour: Magazine of Art and Everyday Life*, 3:1 (Winter 1993–4), pp. 8–13.
 There are many people I wish to thank, for this is a good Cree thing to do. First, a special thanks to Michael Ames who first asked me to do this project, and to Rosa Ho whom he then asked to be curator. To Rosa's assistant Patti Pon, David Cunningham, exhibition designer, it was fun working with you and your assistants Viviane, Peri, and Dwight. To Allison, Kersti, Skooker, and Bill from the Museum staff and the Museum Volunteers. To Walter Bonaise and his late father Ernest Bonaise, both of Little Pine Reserve. To Jeff Dirkson who made editorial comments. To Lani Maestro and Stephen Horne at *Harbour* for producing such a beautiful publication. To the Canada Council for their generous support to get the project going, and keep it going. To Lynn and Meryl who both made many sacrifices along the way to give me this opportunity. To the Musqueam people for allowing me into their traditional territory. And, finally to all those anonymous donors who will contribute to their "Cultural amnesty."

1 Although the term "Native" is in common use and has been substituted for many other formal definitions, like "Indian," "Aboriginal," or "indigenous," I place it in parenthesis to indicate its tenuous application and acceptance. This statement suggests the simultaneous "presence/absence" of identity, which is central to contemporary discourses.

2 My friend's father passed away about a year and a half ago. Of course this was very sad for him, but especially for the community, as his father was a tremendous source of knowledge. As is often said: it's as if a library has burned down.

3 I use the term "museum" to conflate both art galleries and anthropology museums, as is done in the US. The term "gallery" is often used in commercial contexts.

4 Liminality comes from Arnold Van Gennep's (1909) idea of a state of suspension, or a state of ambiguity. He considered "rites of passage" as being a liminal phase, that is, being as the threshold "betwixt and between" two states, or as I am using it: between two spaces.

I I

THE DISCOURSE OF THE MUSEUM

Mieke Bal

THE NEW MUSEOLOGY?

Over the past twenty or so years, the humanities have developed toward an increasing awareness of their own limitations: of the arbitrariness of disciplinary boundaries, of the aesthetics on which much of humanists' work is based, of their separation from real social issues, relegated to the social sciences. These three self-critical notes can, indeed, be alleged to explain why the museum is an attractive object of study: it requires interdisciplinary analysis, it has the debate on aesthetics at its core, and it is essentially a social institution.

Part of this self-critical interest from humanists in museums is in turn due to an impulse coming from critical anthropology. As the social discipline that, more obviously than others, emerged out of a political practice no longer acceptable – that

of imperialism and colonialism – anthropology is today the most self-critical
discipline. There, I like to think, the most serious work offers at least some reflection
on the predicament of a discipline thus entangled in a history of bad faith. In
addition to this exemplary self-criticism, fulfilling Habermas's epistemological
requirements for a hermeneutic science,[1] anthropology as a discipline offers the
holistic perspective on culture that the humanities so sorely miss and that helps them
to position their interdisciplinary endeavors.[2] Anthropology, moreover, has no vested
interest in aesthetics, an absence which for humanists represents a refreshing
indifference toward their own obsolete obsessions.

If this conjecture concerning the motivations for an interest in museums is in the
least true, then the recent work furnished by humanists must demonstrate these
allegiances. And indeed, as a consequence or side effect of the conjunction between
the interests in anthropology and in museums, most work of the "new" museology
focuses first on the ethnographic and second on the historical museum, whereas the
art museum is less intensely addressed.[3] True, the ethnographic museum is clearly
the most obviously politically charged institution, and it does pose the immediate
problem of "cultural property" and collective ownership. The first question it raises
today is: are former colonists entitled to hold onto objects taken by their ancestors
from former colonies, or should they give these back to the country of origin the
ancestors of whose inhabitants were their original owners, or at least – since the
notion of ownership sits uneasily in such a context – makers and users?

So, to approach the present exploration of the discourse of the museum, I will
begin with that issue, the politics of ownership, as the first of three case studies. A
specific example, one of many relatively recent cases, may illustrate this complex
problematic of ownership: the negotiated return to Mexico of the murals of
Teotihuacan, discussed by Thomas Seligman in the volume *The Ethics of Collecting
Cultural Property*.[4] The past is the main problem in the question of ownership. The
problem for a policy for cultural property is the difficulty of identifying the
continuity from past to present that substantiates claims for objects to be returned.
Often the original owner is hardly identifiable, as, for example, in the case of
pre-Columbian art for which the state of Mexico is only obliquely the appropriate
owner. This became painfully obvious in the problem of this negotiated partial
restitution of the murals. The culture of which the murals are a part is dead. It has
been killed by the very culture whose descendants are now "Mexico." To consider
that culture the lawful guardian of the murals has an ironic twist to it. On the other
hand, the United States qualifies as little, or even less. Its claim to the property is
twofold. As the appointed heir of the previous owner of the murals, its
representative, the San Francisco museum, has a claim based on individual
ownership that is vital to US culture but irrelevant to the culture that produced the

murals. Second, the claim is based on the ability to preserve. But preservation, precisely, kills.

This problem is complicated by the very terms of the debate, since, as property laws demonstrate, ownership is itself a semi-transient category, as well as a capitalist one. How can ownership settle the problem in and for a culture where property itself does not have meaning, or has a different meaning? Finally, if the past is the point to return to, it is also the point of no return. The tragedy of time is that it cannot be reversed.

Seligman wonders at one point in his disarmingly honest account: "Are we becoming moral imperialists?" and he refrains from answering the question. The author seems to be aware of the imbrication of cultural and moral imperialism, for he adds:

> It seems quite clear that we are viewed as cultural imperialists, and are we now guilty of trying to impose our new-found values on the responsible methods for dealing with another culture's property on that culture? It is something that troubles me.

It is typical, however, that he asks the question without making the consequences of an eventual affirmative answer explicit. More relevant for our present discussion, the discursive strategy obscures the issue. First, there is the narrative device of placing focalization with the other party (not "we are" but "we are viewed as" cultural imperialists'.[5] Then the troublesome possibility is phrased as a question which, remaining unanswered, becomes rhetorical, provoking a partisan denial. And finally, the issue is framed in a "first person" discourse, constituting an in-group, referred to as "we" defined by the exclusion of the other, the out-group "they" (Seligman 1989: 83).

I would like to answer Seligman's question in the affirmative, but add that the ethic in question, the one that is imposed on the case as its undiscussable starting point, is already profoundly capitalist, and hence inherent in the culture that is a party in the negotiations. Therefore, moral imperialism can only be, also, cultural imperialism. And hence, the problem of this case re-emerges in light of the more general problematic of the museum, not just the ethnographic one.[6] This conflation questions the usually maintained distinction between issues of "cultural property" and "cultural imperialism," raised in connection with ethnographic museums, and issues of aesthetic dominance, emerging from discussions of the art museum.

ETHNOGRAPHIC VERSUS ART MUSEUMS?

The art museum doesn't have such a clearly and immediately political problem, or so it seems. I wish to argue that this difference is only apparent, or at most relative; at

the core of the "problematic of the museum" sits the same issue, that of cultural imperialism. Let me briefly illustrate this suggestion with reference to the case of Rothko's legacy.[7] I don't mean, of course, to rehearse the scandal that cast a shadow over the art world in the years of the trial in the 1970s, but the artistic legacy in a concrete sense: what happened to the paintings afterwards. To put it briefly: with a sense of artistic democracy, the executors of Rothko's legacy made sure his work ended up in a great variety of museums. Thus, as many museums and visitors as possible might have access to Rothko's work.

This dispersal of the works of a great innovator of Western art seems to represent the exact opposite of the concentration of "ethnic" art in Western museums under the deceptive denominator of "artefacts." Yet, from the particular perspective I am proposing to develop here, the semiotic one, this dispersal has something in common with the colonialist legacy of the ethnographic museums. What happens when works like Rothko's figure, ideally, in every art museum of the world is that a single *meaning*, a particular aesthetic conception, one concept of what is "art," is repeated and thereby somehow imposed in many different contexts. Thus an essentialist and centripetal idea of artistic value is produced or at least underwritten by a seemingly generous gesture. For those who believe in Rothko's greatness this may be self-evidently right and no problem at all. But that self-evidence is precisely the issue. For my part, I am not suggesting an aesthetic, nor even primarily an ethical view, but a semiotic one, analyzing rather than evaluating the museum. I'm not denying greatness; I'm just talking about meanings, one of which is "greatness." The question whether Rothko's art is great must therefore not be addressed but bracketed.

Semiotically speaking, this omnipresence of Rothko sustains a particular strategy of cultural imperialism, namely *repetition*. Indeed, by the repeated encounter with the same style or concept, the public is bound to get used to the idea which the particular work represents. To be sure, this *sameness* or identity is, again semiotically, indispensible. We know since Aristotle that recognition is the basis for imagination; we cannot imagine what has no relation whatsoever with what we know already, the exemplary modernist attempts to escape this sameness notwithstanding. If there is an aesthetic that acknowledges and exploits this basic fact, it is postmodernism (van Alphen 1989).

Paradoxically, it is the art of a modernist, sharing the belief in originality that denies this necessity of recognition, that by its very repeated presence in museums confirms what it tries to deny: the need for repetition and sameness. And this is not the only paradox, for repetition itself is a profoundly paradoxical phenomenon, that thereby lends itself to the use I am evoking here. For as Shlomith Rimmon-Kenan has pointed out in a brief but seminal survey of the problematic of repetition in fiction, repetition is based on sameness *as well as* difference. And the emphasis on

sameness that the dispersal of the Rothko paintings entails is, according to her classification, a destructive use of repetition.[8] This destructive effect is often connected with Freud's theory of the death drive and the function of repetition therein.[9] Here, I would rather draw attention to the blinding effect of sameness in repetition. By seeing what one already knows one cannot see what one doesn't know (yet). What is destroyed, then, is the educational function of art which is so central to the museum's self-image. And inevitably, the generous dispersal of the Rothko paintings thus partakes of the same cultural imperialism that produced and sustained the ethnographic museum.

To put it more strongly: the very distinction between ethnographic and art museums is itself an ideological fallacy that sustains what it should critically examine. This makes it a typical instance of discourse. Discourses share with the notion of paradigm in the philosophy of science[10] the structural enclosure they effectuate: for those who share the presuppositions which structure a discourse or a scientific inquiry, it is hard if not impossible to step outside them. Yet, the distinction at stake here has such a blinding effect that it is badly in need of critical analysis. In order to begin such an analysis I propose to frame the distinction within what is most frequently viewed as a rhetorical taxonomy. And the terms that explain the issue illuminate by the same token another side of the interdisciplinary encounter of literary theory and museology. For it is not just to remedy the limitations of humanistic disciplines, but also to reach out and offer our tools to others, that humanists are beginning to explore other areas. And this, too, coincides with a development: that, beginning with structuralism, of an increasing awareness in other, non-humanistic disciplines, of the linguistic nature of their objects and the discursive nature of the practices they study. The two kinds of museums, the ethnographic and the art museum, offer an opportunity to see what a linguistic perspective entails. A "new museology," then, should be an interdisciplinary study of the institution of the museum within the dual framework of critical anthropology and discursive analysis.

RHETORIC, NARRATOLOGY, AND MUSEUMS

Discursivity, most notably rhetoric imbricated with narrative, is in effect a crucial aspect of the institution. And I do not mean by this that museums inevitably produce discourse in their information flyers, brochures, and catalogues. I mean something more central, at the core of the idea of exhibition. Again, the alleged but in fact dubious distinction between the ethnographic and the art museum can help us to understand this central discursivity and its effects.

The ethnographic museum conserves and exhibits artefacts, the art museum,

For rhetoric is not the only perspective that literary theory brings to museology. Another useful perspective, which provides rhetorical analysis with a *raison d'être*, is the assumption that a visit to a museum is an event that takes place in space and in time, and that it therefore produces a narrative. The perspective of narratology can therefore help us understand the effectivity of the museum's rhetoric.[13] In terms of narrative analysis, then, the Bishop museum in Honolulu, through this particularly selective rhetoric, told a narrative "in the third person," obliterating all reference to the "first person," the subject of the colonization of which this museum is a representative. In spite of some historical information that preceded the actual walking tour, it omitted to refer to itself. Yet, obviously, the entire museum, its choices of articulation and modes of display, is overwhelmingly "spoken" by, or rather, "focalized" by this "first person": American culture. Its curators, in turn, synecdochically stand for that culture. This relationship was obliterated, however, by the omission of a window on, in addition to statements from, the curators.

Rhetoric, then, helps to "read" not just the artefacts in a museum, but the museum and its exhibitions themselves. The narratological perspective provides meaning to the otherwise loose elements of such a reading. Most importantly, the analysis yields an integrated account of, on the one hand, the discursive strategies put into place by the curators, and, on the other, the effective process of making meaning that these strategies suggest to the visitor. The reading itself, then, becomes part of the meaning it yields. And this seems an important insight, for what is a museum for if not for visitors?

A REAL ALLEGORY OF HYPERFRAMES

This brings us back to the art museum and to the question of what a new museology can do there. Aware of the need to rethink the manners in which art is presented to the public, the National Office for the Arts of the Netherlands commissioned two volumes of reflections on exhibiting. The first volume which appeared in 1989 carries the French title *L'Exposition imaginaire*, in reference to Malraux's museum without walls, and presents ideas from experts on what an ideal exhibition should be like; it is bilingual, English and Dutch (Beer and de Leeuw 1989). The second volume appeared in the Fall of 1991 and is called *The Art of Exhibiting*, is more historical and limited to the Netherlands, and is monolingual (Dutch only) but bi-medial. Half of it consists of essays, the other half of a photographic history of recent exhibitions (de Leeuw 1991). Both volumes offer a lot to think about.

L'Exposition imaginaire was organized around Courbet's painting *The Painter's Studio*, also called *Real Allegory* with reference to its long subtitle.[14] Potential contributors to the volume were sent a postcard with a reproduction of that famous

painting and asked to begin reflecting there. The painting lends itself to reflection, discussion, polemical or not, as the recent exchange between Michael Fried and Linda Nochlin demonstrates.[15] After explaining that the painting appealed to them for its unfinished and therefore open quality, its plurivalent meanings, and its often-noted complexities, the editors write:

> To us, then, the painting acted as a catalyst of ideas. In a letter setting out our considerations and points of departure, we invited people to regard it as a model, a yardstick for opinions about the positions of those who converge on the exhibition. In short, then, to think about how an "allégorie reelle" of our times would look.
>
> (Beer and de Leeuw 1989: 12)

I am interested in the effect of this solicitation. Notably, the question I would like to address is, what does it say about the project of the new museology to frame this particular volume on framing art in this way?

Some potential contributors responded to the assignment with more cheer, wit, and autonomy than others.[16] Some bluntly refused to take part, others criticized the framing as a set-up and proceeded to make their contribution an explanation of their negative response. Some ignored it completely. For now I just wish to mention that none of the contributors addressed the question of the real place of the *Real Allegory* in the real museum, in the Musée d'Orsay in Paris. And that omission, I would argue, was already programmed by the frame itself. This has to do with the allegorical impulse.

Like most paintings that suffer from over-interpretation, this painting's fascinating effect is at least in part due to a problem of coherence, perhaps a visual pun related to the position and activity of the viewer.[17] Here, the discomfort arises from the representation of framing, and thus, it can be read as a work that thematizes what is sometimes called the *hyperframe* (Collins and Milazzo 1989: 168). Thus, Collins and Milazzo, presenters of a lecture series at Yale called *Hyperframes: A Post-Appropriation Discourse*, also titled their response to the Courbet postcard as "Hyperframes" (Collins and Milazzo 1989) and criticized the project in unambiguous terms:

> Given the premises of *L'Exposition imaginaire*, and the "ideality of openness" that accompanies the role or position of the model in this scheme of things, it would not be difficult to impose upon the painting within Courbet's painting the value of the hyperframe.
>
> Given the allowances it encourages, it would in fact, on the contrary, be rather difficult not to resolve the disparate coordinates of inner and outer worlds it recommends, the world of the real value – in short, that late world of Truth as appropriated Value and the recent world of the "child as an allusion to originality."

209

The most powerful rhetorical effect of this painting as frame is perhaps the metaphorical mode of reading which its allegorical status induces, even for these critical readers. Whatever it stands for, good or bad, it will always *stand for something* other than itself; other than itself *in situ*, in the Musée d'Orsay on a particular wall. Allegory does that, as I have discussed extensively elsewhere.[18]

The problem of interpretation, of coherence, that induced so many commentators to have a go at it, is intimately connected, I contend, with the escapism inherent in allegory. If we take the painting "at face value," in the usual mode of perspectival realism, the problem hardly shows, but then, how could we consider perspective and the realism that comes with it at its "face value," given its obviously fictional mode emphatically stated by its allegorization? If, in contrast, we *also* read it at face value in a more literal sense, that is as a painted surface, the frame enclosing the landscape also encloses the artist, whereas the model, who does not figure in the painting, stands outside the frame. In other words, the artist, subject of framing, is then also its object.

In contrast with the centralized artist, the nude woman, classical subject of painting, is standing out of visual reach of the painter, hence, cannot serve as model.

➡ **11.1 Gustave Courbet, *L'Atelier du peintre*, 1854–5, Musée d'Orsay, Paris. © Photo R. M. N.**

Ousted from her *place* – as model, in front of the artist, and as figure, in the represented painting – she remains quite clearly a painted figure. Undressed and holding the traditional veils that emphasize nudity by opposing a token resistance to it, she does not belong to the diegesis and therefore can only be what she is, non-allegorically: the allegory of painting. She is, however, strictly speaking neither copy nor model, for the landscape that represents "painting" in this painting excludes her.

Reluctant contributors Collins and Milazzo, inventors and astute users of the term "hyperframe," severely criticize the use of this painting, precisely, as hyperframe or set-up for the project of *L'Exposition imaginaire*. As a token of their criticism they returned the postcard by regular mail so as to have it inscribed and stamped – to which gesture the editors responded by reproducing that copy of the postcard, front and back, in the book. By mailing it, having it inscribed and stamped, and losing it again, Collins and Milazzo located it in time and space, and in relation to the viewer, not the artist as Daniel Buren in *his* critical response would have it. The editors, then, re-framed – in the sense of set up – Collins and Milazzo's response by giving it yet another context, that of negativity: they reproduced it with the letter

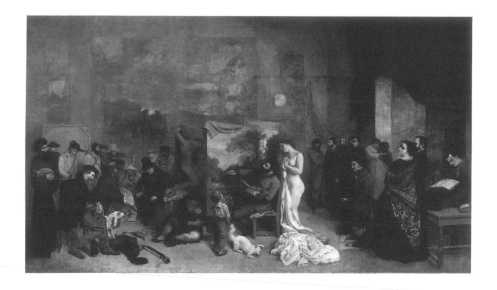

stating the reasons for their refusal to contribute an article. But unwittingly, they also did what their initial solicitation had not done: neutralizing the allegorical reading, they gave it a *place*. And place is, precisely, the painting's problem.

In relation to Collins and Milazzo's attempt to take the framing function of the Courbet painting seriously and expose its ideological effects, the place of the woman in the painting gains another meaning. For her exclusion from the painter's vision and work is not the final word on her. The painter, on the other hand, proudly centered, extends his hand and brush into the bushes in the landscape. Might this be a displaced metaphor for the penetration that visual representation of women so often allegorizes, as Picasso likes to suggest? Although this interpretation seems plausible enough, it requires the leap that makes metaphor so elusive as to be almost by definition metaphysical. Such a leap will not do, in a critique of allegorical escapism.

But here, museal discourse is helpful. Taking the museum space seriously as a discourse that frames the subject of framing at one more remove, as none of the contributors seems to have done when it comes to this kick-off painting, immediately suggests a ground for such a metaphoric interpretation in another figure, metonymy. For next to it we see an equally famous work by Courbet, *The Source*. Zooming in on a very similar landscape, this work places the landscape on a different diegetical level, not embedding it within the story of the *real allegory* but giving it the status of

a realistic fiction. And this work does put the nude within it, framing her, while a stream comes out of the same rocks at which the artist pointed his brush in the background of the represented landscape in the *Allegory*. Thus this painting almost yields to Michael Fried's pressure to feminize absorption against all odds.[19]

The nude woman, then, is reinstated at the center of the painting by the discursive collocation of these two paintings on the same wall. Within the narrative of the walking tour, they "touch" each other, or rather, they make the viewer go from *Allegory*'s nude to *The Source*'s in an act of *metonymic* troping. This metonymic link is, for me, the *real* quality of the allegory as it is displayed in the museum. This figure of metonymy is an indispensible addition to our rhetorical toolbox, for it helps remedy some of the drawbacks of metaphor and synecdoche. Where metaphor transcends the visible, thus encouraging escapism, synecdoche absorbs it, thus inducing imperialism. Metonymy, grounded as it is in the contiguity that sustains the indexical code, neither absorbs nor escapes but reminds of what was, or is also, there: it restores displacement. While metonymy, then, constitutes an extension of rhetorical analysis, it also reinserts the narratological perspective that frames the walking tour in the museum as a narrative that must be taken seriously as a

➡ **11.2 Gustave Courbet,** *La Source***, 1868, Musée du Louvre, Paris. © Photo R. M. N.**

meaning-making event. Thus, paradoxically, a figure of rhetoric instates a new kind of realism, one that is not predicated upon a naive reflection theory of representation but on a serious consideration of the museum as frame that has a real impact on the semiotic encounter with art.

The rhetorical realism contributed by metonymy is much needed in view of the escapism of metaphor, as the following quote from one of the contributions to *L'Exposition imaginaire* demonstrates: "the focus is no longer on naked, idealized humanity, but on the naturalness of the child, the woman and the landscape – three metaphors for the pristine state."[20] The gesture of escape in this metaphorical interpretation is double: the artist, focus of the painting, is forgotten, and the difference in "reality status" of the three figures mentioned remains unaddressed in favor of the abstract meaning they are alleged to have in common: "the pristine state." This is a highly problematic semantic imperialism, for several reasons. First, the semantic choice "pristine state" entails, of course, a highly dubious ideology of gender, of childhood, and of nature. This is a case of Rimmon-Kenan's destructive repetition: excessive emphasis on sameness "destroys" – evacuates the specificity of – all three elements of the metaphoric series. This is a semantic-ideological problem.

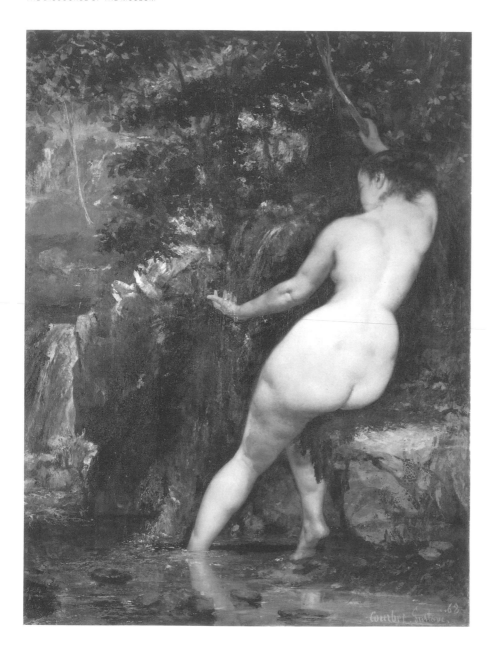

Second, the interpretation ignores the representational structure of the work. For whereas the landscape is, within the painting, being painted, hence, represented, not real, and the child is just standing by, hence, within the fictive universe of the work, real and not represented, the woman is both real – standing outside of the frame – and fictional – furnished with the attributes of the artificial pose and in her pose, forgotten. Third, the interpretation ignores the narrative structure of the work and the specification of positions of focalization therein, The child looks, the landscape is being looked at, the woman is neither object nor subject of the look.

This real disregard for the woman's reality status within the painting is in turn disregarded by the metaphorical interpretation, whereas the juxtaposition on the museum's wall draws attention to it. Thus, once reframed in the Musée d'Orsay, the *allegory* finally becomes the kind of hyperframe the editors of this volume suggested and then discarded by their relapse into the discourse of the masterpiece, reflection-realism, and metaphor: "how an *allegorie reelle* of our times would look."

CONCLUSION

If there is anything that would differentiate the "new" museology from the "old," or plain museology, it is the idea that a museum is a discourse, and exhibition an utterance within that discourse. Bringing this discursive perspective to the museum is not a fashionable linguistic imperialism, although it can easily be so misconstrued and, in fact, misused. Rather, such a perspective deprives the museal practice of its innocence, and provides it with the accountability it and its users are entitled to.

The preceding remarks have a political impact. But part of my implicit argument is that the politics come straight out of, or more precisely, are bound up with, the discourse. This indicates something about both, and it leads the way to further research and analysis. The direction I propose is threefold. First, the most obvious thing to do is to analyze systematically the narrative-rhetorical structure of specific museums, in order to refine the categories and deepen our insight into their effects. Such studies have been undertaken from the perspective of the history of epistemology, and could be supplemented from a more systematic perspective.[21] Second, the connection between museal discourse and the institution's foundation and history can help us understand what can be improved and what is, so to speak, hopeless. Studies in this area are being published, but tend to be fairly general and focused on the institution rather than on the specifics of what happens inside each of them.[22] Third, an indispensible consequence of the confining nature of discourse is the need for self-critical analysis. For as I have argued elsewhere, there is a serious problem, of logic and of politics, with the self-righteousness of many so-called critical studies of ethnocentric practices.[23] If discourse confines us all, the critic is there, too.[24]

It is obvious that the "order of things"[25] in a museum matters; if it didn't, a few curators would be out of a job. But the rhetorical and narratological reflections in this paper suggest that there is some method in that madness. Understanding that method – the discursive system that underlies apparently incidental acts – seems a real contribution from humanists to a museology that wishes to deserve its title of honor: "new."

NOTES

These notes will appear in an extended version in the forthcoming book *Double Exposures.*

1 See Habermas's classic work *Knowledge and Human Interest* (1972). Examples of critical anthropology are Fabian 1983, Clifford 1988, Clifford and Marcus 1989.

2 On this particular importance of anthropology, see Bal 1988: 51–73.

3 See, for example, the collection *The Ethics of Collecting Cultural Property* (Messenger 1989), and my recent book (1996). Vergo's collection (1989) has only one article explicitly focused on art museums, and this is an empirical, not an analytical-hermeneutic study. See Wright (1989). Recent important work on the art museum is represented by Rosalind Krauss 1990 and Douglas Crimp 1993.

4 The article by Thomas Seligman (1989), who was closely involved in the case as one of the parties, not only honestly presents the problem, but also discursively demonstrates it. See my "Give and Take" for a brief discourse-analytical perspective on this article (Bal 1992b).

5 For the term focalization, see Bal 1985.

6 Of course, the case was not ethnographic but artistic in the first place. Because of the "ethnic" origin of the murals, however, it has been considered in an almost exclusively "ethnic" perspective.

7 See Lee Seldes' extensive journalistic account of the Rothko scandal (1974).

8 Rimmon-Kenan 1980: 153. This point is part of the second of three paradoxes of repetition she distinguishes: 1 Repetition is present everywhere and nowhere. 2 Constructive repetition emphasizes difference, destructive repetition emphasizes sameness. 3 The first time is already a repetition, and repetition is the very first time.

9 See Freud 1958; 1961. For a discussion of the function of the death drive for the construction of narrative which I consider applicable to the problem at hand, see Brooks 1984. Bronfen (1989) brilliantly analyzes *Beyond* from a gender perspective which has far-reaching consequences.

10 The concept of paradigm has been developed by Thomas Kuhn (1962).

11 See Miller Keller 1989: 66 (my translation).

12 See Bal 1991a, for an extensive discussion of what the notion of "reading" visual objects entails.

13 For a survey presentation of the basic concepts of narratology, see Bal 1985.

14 Gustave Courbet, *The Painter's Studio, A Real Allegory defining a Phase of Seven Years of My Artistic Life*, 1855, Paris, Musée d'Orsay.

15 The exchange is in chapters 2, by Linda Nochlin, and 3, by Michael Fried, in the Brooklyn Museum catalogue accompanying the Courbet exhibition in 1988. See Faunce and Nochlin 1988: 17–42 and 43–54. Incidentally, Nochlin demonstrates in this article how unfairly her work has been treated by other feminist art historians, caught in an oedipal-generation scheme of things. This is visible, for example, in Gouma-Peterson and Mathews (1987).

16 The editors give an honest overview of these responses, many of which severely criticize the way the contributions were framed by the initial letter and the Courbet postcard (Beer and de Leeuw 1989: 18–22). Thus, Daniel Buren (predictably) hardly concealed his irritation at being asked to think up something out of site, and Benjamin Buchloh criticized the fact that "the conception of an ideal exhibition is tantamount to pandering to the authority of the existing art apparatus" (ibid.: 20). Buchloh's contribution is highly relevant for the issues at stake here.

17 See Nochlin's article already mentioned, and Fried 1990 with references there. The same interpretive problem holds, for example, for Velázquez' *Las Meninas*, which was used by Foucault to open his epistemological discussion of museums and display in *The Order of Things*, an interpretation that was criticized by philosopher John Searle (1980), who was in turn violently attacked by Snyder and Cohen (1980), whereas Alpers (1983) and Steinberg (1988) added their own interpretation. All these pieces dealt with the question of the mirror and the position of the viewer. See chapter 7 of my *Reading "Rembrandt"* (Bal 1991) for an extensive analysis of this debate.

18 See Bal 1991a, chapter 3, where I discuss the paintings and texts on the rape and suicide of Lucretia.

19 This is meant as a critical footnote to Fried's article in the Courbet catalogue. In my opinion Fried loses sight of the very reality he appeals to here, as when he sugests "a downpour of menstrual blood" in the *Grainsifters*, unaware, as a woman would be, that menstrual blood doesn't pour (1988: 47). Fried demonstrates in this paper the unfortunate result of the kind of Freudian translating from the page that Freud himself cautioned against in *The Interpretation of Dreams*. Turning every brush into a phallic object and hair into streaming blood, the paintbrush is just too easily feminized. This is unfortunate, as Fried has demonstrated elsewhere a keen sense of the need for corroboration of interpretations (1987). For the concept of absorption, see Fried 1980.

20 Werner Hofmann 1989: 34. Hofmann takes precisely the position Collins and Milazzo caution against (1989: 168).

21 An excellent example is Debora J. Meijers' (1991) painstakingly detailed study of the Habsburg painting gallery in Vienna around 1780.

22 Krauss 1990 analyzes the phenomenon of the contemporary art museum in general, as a function of the capitalist logic that sustains it. Crimp (1993) analyzes the need of museums to break out within society.

23 See Bal 1996, in which I analyze closely a few studies of critical anthropology, looking in particular at their use of visual images as citations and the hopeless attempts to reframe these images.

24 The ideological nature of language has been analyzed helpfully by Kress and Hodge 1979.

25 The allusion is, of course, to Foucault's contribution to museology (1973); for the concept of discourse in relation to epistemology, see Foucault 1972.

REFERENCES

Alpers, Svetlana (1983) "Interpretation without representation," *Representations*, 1: 1, 31–42

Alphen, Ernst van (1987) *Bang voor schennis? Inleiding in de ideologiekritiek*, Utrecht, Hes Publishers.

———— (1989) "The heterotopian space of the discussions on postmodernism," *Poetics Today*, 10: 4, 819–38.

———— (1992) *Francis Bacon and the Loss of Self*, London, Reaktion.

Bal, Mieke (1985) *Narratology: Introduction to the Theory of Narrative*, trans. Christine van Boheemen, Toronto, University of Toronto Press.

———— 1988 *Murder and Difference: Gender, Genre and Scholarship on Sisera's Death*, trans. Matthew Gumpert, Bloomington, Indiana University Press.

———— (1991) *Reading "Rembrandt": Beyond the Word-Image Opposition*, New York, Cambridge University Press.

———— (1996) *Double Exposures: The Subject of Cultural Analysis*, New York, Routledge.

Beer, Evelyn and Riet de Leeuw, eds (1989) *L'Exposition imaginaire: The Art of Exhibiting in the Eighties/De kunst van het tentoonstellen in dej aren tachtig*, 's-Gravenhage, SDU/Rijksdienst Beeldende Kunst.

Bronfen, Elisabeth (1989) "The lady vanishes: Sophie Freud and 'beyond the pleasure principle,'" *South Atlantic Quarterly*, 88: 4, 961–91.

Brooks, Peter (1984) *Reading for the Plot: Design and Intention in Narrative*, New York, Alfred A. Knopf.

Buchloh, Benjamin H.D. (1989) "Since realism there was . . .," in E. Beer and R. de Leeuw, eds, *L'Exposition imaginaire*, 's-Gravenhage, SDU/Rijksdienst Beeldende Kunst, 96–121.

Clifford, James (1988) *The Predicament of Culture: Twentieth-Century Ethnography, Literature, and Art*, Cambridge, Mass. Harvard University Press.

———— and George Marcus, eds (1989) *Writing Culture: The Poetics and Politics of Ethnography*, Berkeley, University of California Press.

Collins and Milazzo (1989) "Hyperframes: a reply to the Netherlands Office for Fine Arts and 'L'Exposition imaginaire,'" in E. Beer and R. de Leeuw, eds, *L'Exposition imaginaire*, 's-Gravenhage, SDU/Rijksdienst Beeldende Kunst, 160–9.

Crimp, Douglas (1993) *On the Museum's Ruins*, Cambridge, M.I.T. Press.

Fabian, Johannes (1983) *Time and the Other: How Anthropology Makes Its Object*, New York, Columbia University Press.

Faunce, Sarah and Linda Nochlin, eds (1988) *Courbet Reconsidered*, New Haven, Yale University Press.

Foucault, Michel (1972) *The Archeology of Knowledge & the Discourse on Language*, trans. A.M. Sheridan Smith, New York, Pantheon Books.

———— (1973) "Las Meninas," in M. Foucault, *The Order of Things*, trans. Alan Sheridon, New York, Vintage Books, 3–16.

Freud, Sigmund (1958) "Remembering, repeating, and working through," *The Standard Edition of the Complete Psychological Works of Sigmund Freud*, London, The Hogarth Press and the Institute of Psychoanalysis.

———— (1961) *Beyond the Pleasure Principle*, New York, Norton.

Fried, Michael (1980) *Absorption and Theatricality: Painting and Beholder in the Age of Diderot*, Berkeley, University of California Press.

———— (1987) *Realism, Writing, Disfiguration: on Thomas Eakins and Stephen Crane*, Chicago, University of Chicago Press.

———— (1988) "Courbet's femininity," in Sarah Faunce and Linda Nochlin, eds, *Courbet Reconsidered*, Brooklyn, Brooklyn Museum, 43–53.

———— (1990) *Courbet's Realism*, Chicago, University of Chicago Press.

Gouma-Peterson, Thalia, and Patricia Mathews (1987) "The feminist critique of art history," *Art Bulletin*, 66: 3, 326–57.

217

12

THE GREAT CURATORIAL DIM-OUT

Lawrence Alloway

> Hypothesis: That the profession of curator is in crisis. It will be discussed by means of a typology (*the* curator, *the* museum, *the* dealer) and by details of typical cases.

The role of the curator is different in different museums. A curator is never "the person in charge of a museum," as the unabridged *Random House Dictionary* has it, but is usually close below the director, who *is* in charge. Curators' duties include (1) acquiring work for the museum, (2) supervising its preservation in store, and (3) displaying it, putting it on exhibition. These traditional duties are based on the running of a permanent collection and to them must be added the act of arranging temporary exhibitions. This, in fact, is one of the main occupations of curators

devoted to modern art. In this area they have to make a creative effort and do the research necessary in deciding what to show. This work contributes considerably to attendance. Only occasionally does the permanent collection have a comparable box-office value.

Out of the multiple possibilities for exhibitions presented by the artworld at any moment, the curator selects what he/she wants to present and calculates the feasibility of the project. Hence his function is one of input as he sorts out the massive information about the art around. When he puts on an exhibition his position changes: as the exhibition is visited it is assessed as a part of the museum's output. Thus the curator is at the interface of the museum as an institution and the public as consumers. The temporary exhibition is particularly the form in which the museum declares the form of its commitment to art. This is true of what use is made of the permanent collection, but this occurs within limits imposed by a stable store of past work. Though the collection can be viewed ideologically it is less generally interesting on this basis than the avowal by the museum of its present beliefs.

Any criticism of the Whitney Museum, for example, must take cognizance of the fact that in the five-and-a-half years between September 1969 and March 1975 there were about 140 exhibitions. This is an impressive figure, even making allowance for the fact that some of the units called exhibitions are rearrangements of bits of the permanent collection. However, forty of these shows were held in the lobby, in the "Nigger" room between the sales desk and the elevators.[1] In addition, there were six shows on the lower-ground floor, between the restaurant and the lavatories, and two more combined the Nigger room and the lower-ground floor. Thus about a third of the exhibition program consisted of small brief shows, such as four paintings by Morris Louis or interim reports on such artists as Frank Bowling, Lee Lozano, Gladys Nilsson, and Johan Sellenrad.

Without all these small shows, which act as a strung-out, one-at-a-time supplement to the Whitney Annual/Biennial, what does the schedule look like? There has been an absolutely first-rate series of nineteenth-century exhibitions, including such theme shows as *The Reality of Appearance*, *The American Frontier*, *American Impressionism*, and *The Painter's America* and one-artist shows such as those devoted to Eastman Johnson, Albert Bierstadt, Frederick Law Olmsted, and Winslow Homer. The twentieth-century exhibitions for the same period are less authoritative. Theme shows include: *Human Concern and Personal Torment* (curated by Robert Doty), *22 Realists* (James Monte), *Contemporary Black Artists* (Doty), and *The Structure of Color* (Marcia Tucker). The *Torment* and *Black* shows acknowledged a new source of art, but in carrying out the shows protest withered to a Peter Selz-ish Expressionist revival, and the Black artists liked their show no more than I did. The color abstraction show was a conventional reshuffling of current and recent abstract

222

art without any updating by reinterpretation. *22 Realists* was largely O.K. Harris uptown. One-artist shows included: Jim Dine, Robert Morris, Georgia O'Keeffe, Jackson Pollock, Louise Nevelson, John Marin, Romaine Brooks, Andy Warhol, Edward Hopper, James Rosenquist, Lucas Samaras, Sam Francis, Bruce Nauman, Jules Olitski, Joan Mitchell, and Al Held (the roster is chronological). This list does not distinguish between shows originated by the Whitney, shared, or taken whole from other institutions: my criticism remains the same. Of these half a dozen represented substantial additions to the state of knowledge concerning the artist shown. They are: Morris, O'Keeffe, *The Psycho-Analytic Drawings of Jackson Pollock*, Romaine Brooks, Andy Warhol, and the Hopper Bequest. What was wrong with the other shows was not, on the whole, the choice of artists but feeble interpretation by the curators and complacency of evaluation. If I am right, it seems that various dysfunctions can be located on the curatorial level.

Museums have to be seen in relation to the rest of the artworld as a system of information.[2] If a museum is in the field of modern art, it depends, of course, on the co-operation of dealers and artists. This is easy to get while artists are in the initial stages of their careers but it gets harder as they become more prominent. Then artists like to curate their own shows and so do their dealers. What happens is that artists, dealers, and collectors have a shared taste and a common interest. The center of their attention is the work of art: it is a product of the artist, the commodity of the dealer, and the possession of the collector. The three types represents an alliance for the purpose of furthering the work both as cultural sign and as object on the market. Thus the dispute of Robert Rauschenberg and Robert C. Scull at Parke-Bernet in 1973 can be viewed as an argument about how to divide the take.[3] They fell out on the details of this: Scull got $90,000 for Rauschenberg's *Double Feature*, a picture he bought for far less when it was worth less.

Now that large sums are involved, the curator of modern art has a problem. Modern art in America developed at first in terms of a Bohemian, avant-garde, and slightly underground context. As a result the artists' independence conferred on the museums that bought them a kind of audacity, but the basis of this mutual enhancement, in which each side complimented the other on their freedom, has changed. The collection of modern art, even by new artists, has acquired another meaning as its prices rose. The American museum is approaching the status of a national board collection and ironically the market benefits particularly from patriotic acquisition. Is a curator supposed to join the artist–dealer–collector group and thus make the museum a service for the expanded market or is he to figure out strategies of independence? One recent case of a curator's decision to supplement the dealer's interests with a museum show was Monte's Richard Pousette-Dart show at the Whitney. Of the 31 paintings, 23 of them came from a New York dealer and four

223

from one in Boston. The artist has recently left Betty Parsons for Andrew Crispo and it is clear that Crispo, with Monte's co-operation, mounted a new market campaign on behalf of his new artist.

Of course, this has occurred before. In the Samaras show at the Whitney in 1972, the curator, Robert Doty, relinquished control to the artist's dealer, the Pace Gallery. As a result Samaras's early work, the fetishistic boxes and other objects, were jammed into the periphery of the display area, while the new work, the boutique period chairs, dominated the gallery completely. Here we see the museum functioning as an extension of the showroom. The dealer's interest in the work for sale suppressed the far more interesting but commercially used-up early period. Its only function was to provide background and a touch of history to the present conceived as a bazaar.

Collectors, incidentally, frequently serve as museum trustees so that even if they are not actively pressing for exhibitions of artists in their collections, and some of them do, they at least constitute a niche of market compliance in the top echelons of museums. Collectors who are trustees may get preferential treatment from dealers who can expect in return not a direct payoff necessarily but sympathetic attention to future proposals in which they may be involved. If we equate the knowledge of collectors with their enthusiasm for ownership, it follows that the taste brought to the formation of the collection is likely to be a limiting factor on their decisions as trustees.

The curator is subject to numerous pressures, some of them welcome and some of them not recognized perhaps, to keep within safe zones of activity. The pressures include:

1 The desire to get along with the artist or artists.
2 The necessity to keep good relations with the artist's main dealer or dealers.
3 The necessity of maintaining collector contentment.
4 Taste expectations emanating from the trustees and director.
5 Taste expectations of other members of the curator's peer group.

In addition to keeping the supply of objects open, the curator must define himself in relation to the culture of two subgroups: that is to say, the opinions held by the section of society that already owns some of the art he is interested in, and the opinions of a younger generation to which the curator may be predisposed by age, education, style, or ambition. All these pressures tend to keep curators in conforming rather than dissenting postures. The pleasures of belonging to the group, an elite, often outweigh the satisfactions of nonconformity.

The position of the artist is complex in all this: on one hand he/she produces the work because art is a task of absolute control and personal satisfaction. But this

esthetic level is not all that the dealer and the collector are concerned with. They advance by entrepreneurial means the work of art and the career of the artist through exhibitions, color reproductions, and loans. And at this point, artists' solicitude for their work can become indistinguishable from its promotion. As artists become, in a sense, their own curators the museum curator is forced to narrow his ideas to those that are agreeable to the artists' reading of their own art. This constitutes one more problem for the curator who might want to control his show.

One weakness of the present generation of curators is their subservience to artists. Because the artist made the work, he is not necessarily the sole judge of how it is best seen, or even of what it means. Production and consumption (interpretation) *are* different acts. The temptation to manage the work after it is done is hard to resist, especially when the artist seems to be confirmed in his original intentions by the market reaction on which he depends for a living. Deference is owed to the artist but an excess of it can lead to inflated or lopsided shows, such as Brydon Smith's Dan Flavin (National Gallery of Canada, 1969) or Tucker's Rosenquist (Whitney Museum, 1972). Smith's catalogue contains a great deal of information but he was clearly prevented from interpreting it. Tucker's choice of works seemed to have been subverted by the artist. A large exhibition is not simply a mirror held up to an artist who is then objectively disclosed. The curator is present either as the interpreter of a critical point of view or as agent for somebody else. If the latter, he can be viewed as either the artist's servant or the market's slave. (By critical I mean a point of view that is thought out, consistently argued, and checkable against other data.)

In the early days of recent American art, that is to say the 1950s, many artists felt themselves neglected or they remembered neglect and resisted group shows with some justification. There is no situation of neglect now, however, and we have been sated with monographic shows. The monograph, in the form of a book or a catalogue, has enormous potential: it can reveal an artist at unaccustomed length, but it should rest on work that we haven't seen, or seen often enough. H.H. Arnason's exhibition at the Guggenheim in 1962 of Philip Guston was of this type, and incidentally the biggest show an Abstract-Expressionist had had at that date.

This is simply not the case with many of the large one-artist shows today, in which extended showing tends to reduce our admiration rather than extend our knowledge. The Robert Ryman show at the Guggenheim (1972) was monotonous in the absence of any direct painting done on the wall, which is the artist's especial contribution. When asked about this, he said that he was so interested in seeing all his old work gathered together that he did not feel like doing new work. Diane Waldman, the curator of the show, apparently acquiesced in his withholding of the one gift that might have made his show extraordinary (Ryman paints Frank Lloyd Wright). I can see that the challenge might be unnerving, but Sol LeWitt tackled it

later with complete success. In fact, the cambered walls suited his all over drawing style very well.

In the last five or six years, the Guggenheim Museum has arranged one-artist shows of Robert Mangold and Brice Marden as well as Ryman. This sequence of painters looks purposeful, especially in the absence of painters in other styles of a comparable age. Stylistically, these artists all continue the reductive mode of abstract painting in terms of sensuous painterly handling; their art picks up the fields of Abstract Expressionism but replaces sublimity by sensibility. It is a fact of social and economic record that these painters, like any artists, came to the museum with prior support from other segments of the artworld, some critics but more decisively dealers and collectors. These three artists enjoy a particularly high repute in Europe; they are a constitutive part of the international American art market (as is Carl Andre who has also been shown at the Guggenheim). These shows, so prominent in the museum schedule, seem to be the result of the convergence of conservative curators and a pro-European director, Thomas Messer, whose taste would tend to be susceptible to European marketing successes. Incidentally Marden, as readers of this magazine must know, has become a central painter in the present attempt to expand formalist esthetics by an input from linguistics. This is a conservative tactic to ditch Clement Greenberg, but hold on to the sort of painting that he liked or that has developed from his kind of painting.

Thus the shows seem promotional in effect. The desire to further one kind of painting reveals an ideological bias that happens to favor a single section of the market (specially the John Weber, Fischbach, and Bykert Galleries). Obviously any show that a curator puts on will have some commercial repercussions inasmuch as museum exhibitions are status-conferring. The point here is that in the absence of alternatives, one bit of the market is being overstressed by the Guggenheim. The defense against this is optimal assortment in programming. What directors should see, if their curators cannot, is that as museums become more dependent on galleries, they risk the unique character of their institutions. Exhibitions in museums will lose their status-conferral value if they become continuous with the marketing plans of dealers. Linda Shearer acknowledges in the Marden catalogue the help of a critic "who is writing the catalogue raisonné on Marden." Why should an artist born in 1938, whose style is ten years old, okay eleven, need a catalogue raisonné? A card file in his dealers' office should be sufficient. A full catalogue will confirm the artist's market value, and the methodology of scholarship is available for hire.

To the extent that museums exhibit the work of living artists, the dealer is a proper and essential source of information. This includes the location of works, their dating, persuading collectors to make loans, and all that. Since the fifties, as American art has been more and more esteemed and as museums have participated

increasingly in current art, the two forms of organization, gallery and museum, have overlapped. As American art has become more expensive, however, the liaison has shifted in emphasis. It now strengthens dealer penetration of museums rather than favors curatorial control of the diverse sources of the artworld including the market.

Let me give an example of loss of control. In 1963 I arranged a memorial exhibition of Morris Louis at the Guggenheim. I proposed the show because of my admiration for the Veils which were less well known then than they are now. I knew that this would benefit dealers and others who had invested in Louis, but so what. A conflict arose, however, when I stated in the catalogue the number of paintings left by Louis at his death. Under threat of losing all the paintings from the estate – and obviously Louis's dealer, André Emmerich, would have followed the estate's lead – I had to change the figure to the phrase "a great number." The reason for the change is that Louis was being sold at the time in terms of scarcity; it was only later, when he had been firmly established as a "master" (to which my show contributed) that his copious output could be acknowledged without harm to the prices.

A symptom of the weakening of curatorial function is the decline of the catalogue, a serious matter inasmuch as the catalogue has a greater duration than an exhibition. Catalogues are the repository of both the result of research and the critical ideas formed in contact with originals. As museums constitute, to some extent, a protected form of publication (as when a museum membership absorbs a preknown number of copies), an opportunity for uncompromising study is provided. In addition, despite the complaints of curators at always being rushed, there is usually ample lead time to prepare a decent catalogue, if the curator is capable of doing so. The standards for catalogues were set originally at the Museum of Modern Art in the forties by Alfred Barr and James T. Soby (I exempt J.J. Sweeney from this commendation). Their subjects were researched with a skill and thoroughness far in advance of anything else available. Some of Barr's works retain their summarizing position to this day. The high standard was maintained by William Seitz, most notably in monographs on Gorky, Tobey (both 1962), and Hofmann (1963). Notice that all three, written in two years, are still indispensable. These catalogues were a major achievement of American museology. Only William S. Rubin has maintained this standard, in two collection catalogues, Picasso (1972) and Miró (1973), and in a monograph on Frank Stella (1970). The Abstract Expressionist catalogue he is understood to be preparing will show him at his best when it appears, but he is also preparing a large Anthony Caro exhibition with no doubt, a matching catalogue. Caro, a Greenberg-influenced sculptor, indicates the cutoff point in Rubin's interests.

For art since that esthetic and historical point, we shall have to rely on other curators in the museum. What can we expect from them? Kynaston McShine has published nothing since *Information* (1970) and there his function was mainly

editorial. Jennifer Licht who recently curated *Eight Contemporary Artists* failed to produce a printable catalogue essay at all. In the absence of a reasoned argument about her artists, what does the conjunction of this eight look like? It is simply a 420 West Broadway package (six of the artists are from Castelli, Sonnabend, and Weber in that building, one from Bykert, plus an assimilable stranger). Why waste a museum's resources on showing such familiar art, if the curator cannot even verbalize her reasons for keeping the bunch together? It does not look as if the museum can be expected to contribute much, in the near future, to the study of contemporary art.

On the whole, catalogues now carry unread bibliographies and short-winded writing. Errors can and do occur in any bibliography, but there is a difference between scattered slips and the kind of inertness that characterizes a bibliography that has been compiled by a researcher but not used by the curator. A blind compilation does not have the consultability and enabling emphases of a read and understood bibliography. As for the writing itself, this often seems to have been produced under a misconception of what a museum catalogue is for. It is not for puffing and it is not for amateur esthetics; it is useful if it contains verifiable biographical, stylistic, comparative, or social information in easily consultable form. When Linda Shearer wrote of Marden's paintings, "whether they are romantic, sympathetic, sentimental or austere, they project, in an emphatic and moving way, a very real sense of alienation," she has mistaken her channel. This is the stuff you write in reviews to generate attention for a new artist, and it is not needed when thirty-odd paintings of the past ten years are brought together. Analysis, which is not the enemy of cordiality or passion, is what is needed.

To stay with Shearer, simply because her catalogue is the most recent and what she writes is characteristic, she feels compelled to deal carefully with Marden's influences, inasmuch as she is writing to please the artist (and, by extension, his market). She refers to Newman's *Who's Afraid of Red, Yellow and Blue* group and writes: "Like Newman, Marden is able to use this basic color scheme and lend it *a quality uniquely his own*." Elsewhere she writes: "Marden's two and three-panel pieces bear a superficial resemblance to certain of Ellsworth Kelly's paintings, although, in reality, they are artists *of greatly differing sensibilities*" (my emphasis). Well, sure, obviously, but in both cases Marden is the recipient of an influence. This is perfectly normal so why postulate a synchronic realm in which first-time and second-time uses are equal? It is because she is associating the lesser with the greater to enhance the lesser. In short, the act of flattery, which slides into promotion, is mixed up with the act of analysis.

To the extent that curators admire the same artists that influential dealers support, their intake of information will be restricted. This shows in various ways

but perhaps with especial clarity at the Whitney Museum because of the Annual/Biennial survey shows. The curators should be expected to be in touch with changing social and stylistic forces, but the history of the exhibition does not support this expectation.[4] It was only after demonstrations that the curators increased the representation of women in the annuals. Why had the curators not anticipated the pressure of women artists and recognized their exhibitability before the issue became a crisis? The fact that the representation of women climbed steeply is, of course, an admission of their previous error. If women's work had not been esthetically acceptable to them, I assume that the curators would not have modified their original position. It is hard to imagine a more difficult task for a White curator than the Whitney's *Contemporary Black Artists in America*. Then why was it organized in such a way as to antagonize the Black community and embarrass the curator Doty? It is another failure of the power to assess correctly the changing situation in the artworld. It is moreover a failure for which the director and trustees, with whom ultimate responsibility for curatorial projects rests, must be held responsible. The professional autonomy of the curator is not immune to executive judgment, of course, though this should not be casually invoked. The trustees' executive view should have been engaged at these crucial points. The Guggenheim has avoided such outward twists and turns by remaining withdrawn, not understanding and not understood by the artworld, and the Modern, despite cracks during John Hightower's brief and bizarre regime, is armored and complacent. The Whitney, however, is a museum of American art and thus exposed to repeated encounters with a mobile and active art scene. The Whitney's sins, therefore, are those of commission whereas the other New York institutions are protected to some extent by the fact that theirs are largely sins of omission.

229

Assuming that there is an academic ideal, it can be expressed in terms of knowledge. To quote Karl Jaspers: "The eagerness to know expresses itself through observation, through methodical thought, and through self-criticism as a training for objectivity."[5] Clearly museums are continuous with universities in the aim of training our investigative capacity and increasing self-knowledge. From this point of view, it can be seen that the contribution of dealers to museums, though essential, should not be dominant. The legitimate special interest of dealers as a group, as it functions unchecked, restricts the cultural range of museums. The market, though not incompatible with art, is obviously not the source of art's prime meaning. Curators, instead of maintaining intellectual independence which can be equated with cultural responsibility, have allowed decisions to slide from their hands to others. The artist–dealer–collector triad has a monopolistic hold on art which acts to limit its interaction with society.

In a real sense there has been a failure of education in museums. This can be seen

in the way in which museums habitually restrict the term, so that "education" has come to mean the complex of school visits, gallery guides, talks, the provision of slides, simplified literature, and direct community services, all the peripheral activities around the collection and temporary exhibitions. The curators often provide the education department with cues and notes for the wider program, but as an additional chore, not as a central activity. Actually the fundamental educative acts are the presentation and interpretation of art, both in the exhibition and in the catalogue, which is the basis on which museums and universities are comparable and indeed complementary. By assigning "educational" functions to others, the directors and trustees have separated curators from what should be a central factor in determining their conduct. In the absence of an ideal of the museum's unified educational service, curators have gravitated into various phases of dependency on the market, making a serious imbalance in the distribution of art.

If one wonders how it is that curators have fallen into this position, it may have something to do with their isolation within their institutions. They constitute a stratum *under* the director/trustee level and *above* the increasingly articulate and self-aware staffs below them.[6] Close to the top table, but not at it, they take their lead where they can find it, in the artist–dealer–collector alliance. Possibly what is needed is some form of association which would be as much concerned with self-regulation as with job protection. A standard of ethics would begin to protect curators from reluctant inadvertent, or conscious complicity in entrepreneurial pressure.

NOTES

This essay was originally published in *Artforum*, May 1975, pp. 32–4.

1 The Nigger room is a coinage of Black artists who are accustomed to being shown in this small area at the Whitney.

2 See my "Network: the art world described as a system," *Artforum*, Sept. 1972, pp. 27–31.

3 For general information, see John Tancock's "The Robert C. Scull auction," *Art at Auction 1973–74*, New York, 1975, pp. 136–45.

4 See my "Institution: Whitney Annual," *Artforum*, April 1973, pp. 32–5.

5 Karl Jaspers, *The idea of the University*, London, Peter Owen, 1960, p. 20.

6 See my "Museums and unionization", *Artforum*, Feb. 1975, pp. 46–8.

13

FROM MUSEUM CURATOR TO EXHIBITION *AUTEUR*
Inventing a singular position

Nathalie Heinich and Michael Pollak

This article, touching on the sociology of art and the sociology of professions, is concerned with the conditions and modes involved in the transformation of the role of the curator – in France, in the first instance. While various morphological factors contribute to the crisis in the profession, expansion, increased authority and a change in the nature of exhibitions combine to offer curators, or at the very least several among them, the possibility of attaining the status of auteur. *The hypothesis of an evolving schema, which introduces particularly the idea of deprofessionalization as a form of transition, is then reinforced by evoking a development comparable to the one we have observed in the cinema. Finally, the analysis of an important exhibition will permit us to illustrate the pertinence of the schema*

and to propose several possible evolutionary scenarios.

The profession of curator is currently in the throes of a crisis which is attributable to a number of factors, morphological especially: a crisis of expansion in the wake of increases in the number of posts (made possible by the swelling of public funds dedicated to culture and made necessary by the intensification of 'cultural' practices, in terms of the consumption of artistic products);[1] a crisis, by correlation, brought about by the widening of recruitment criteria and the opening up of entry routes into the profession (since the creation of a competition accessible to anyone with a university degree, in addition to the traditional recruitment by the Ecole du Louvre and, recently, to any *Ecole du patrimoine* graduate) as well as the multiplication and diversification of the institutions concerned (of the 1,200 museums in France, 34 are national, the remainder being either 'classified' or simply 'controlled', public or private, fine arts, the sciences, technical, ecomuseums, etc.); a crisis, finally, in the division of labour with an increasing specialization of tasks allocated to the various categories of curators.

In recent years we have witnessed several halting attempts towards homogenizing and privileging the profession: the organization of meetings and public events,[2] claims of a financial (salary increases) and statutory (harmonizing the pay and conditions in relation to the different categories of curators) order. Here can be found the characteristic elements of the process of professionalization which can briefly be described along the following lines: the creation and autonomization, under the *ancien régime*, of the function of the care and conservation of artwork – initially conducted by the painters themselves – in the framework of the royal collections; the institutionalization and increase in the number of positions accompanying the founding of museums during the Revolution; the formalization and uniformity of recruitment and criteria of competence with the creation of the Ecole du Louvre in 1882 and, consequently, the bestowing of the title of curator on members of 'the corps of curatorship of the museums of France' (recruited by competition, they number slightly over 200 at the present time); ethical regulations governing professional competence, formalized by a deontological code; self-control throughout the various associations (Association générale des conservateurs des collections publiques de France, created in 1922) or institutions such as the International Council of Museums (ICOM, created in 1946, or its subgroup CIMAM, Conseil international des musées d'art moderne).[3]

At first glance, the activity of the curator can be defined according to both Parsons' criteria of a profession (access regulations, objectivized co-opting mechanisms, a professional code of ethics, a relatively autonomous control of the field) and Weber's, that of a highly bureaucratized occupation subject to the rules that govern the functioning of the state (a predictable career pattern, promotion

according to seniority).[4] But, as we shall see, this profession is also reliant on the artistic realm which confers certain characteristic traits upon it.

OCCUPATIONAL HAZARDS AND DEPERSONALIZATION OF THE POST

The curator's task is not only the safeguarding, analysis and presentation of a cultural heritage; it includes enriching it, principally through the acquisition of contemporary works – a function which confers upon the curator a role in the art market by the selection of objects and names and similarly calls upon him or her to resist the times or fashion. By so doing, the curator engages, initiates – and, at times, squanders – *credit*: both the curator's professional credit and the institution's moral credit, in addition to the financial credit of the state. By the same token, the curator runs the risk of incurring discredit; formerly, this discredit was linked to traditional custodial work (a good example would be the keeper of the collections of the *ancien régime* who, it is said, hanged himself after not being able to find a miniature) but which today is primarily concerned with purchasing. There are, in effect, several ways a curator can err: for example, by not buying enough (an error by default) or by acquiring too much (an error of excess, which would appear to be a particular menace to current representatives of the profession, collectively traumatized by historical errors committed by their predecessors under the Third Republic, notably those involved in the Caillebotte legacy affair).[5] Thus error constitutes a risk to the curator's craft, whether it consists of an error concerning the authenticity of a work (the purchase of a fraudulent copy) or its value in terms of the judgement of posterity (the purchase of works of inflated value and especially the non-acquisition of works of proven value; this risk is heightened when one deals with contemporary collections). In contrast to private collectors, whose personal tastes can confer a sort of 'mark' on their collections, curators, responsible to the wider community, will see their competence measured by the equivalence of their selections to the hierarchy of works and artists as established in the history of art. The curator is thus in opposition to Parsons' professional, whose competence rests upon objectifiable scientific knowledge, as well as, if not more so, Weber's functionary, whose task it is to follow judiciously defined procedures.

Thus the curator is confronted with the paradoxical injunction – when faced with the task of enriching the heritage with contemporary works as yet uncertified by art history – of investing in selections that are at once reflective of the curator's own tastes (an extremely personal quality) and of collective values, certified by relatively formal procedures (the advice of peers, sales commissions, financial controls). So everything is conducted as though the inherent risk and discomfiture of such an

233

occupation would be likely to reinforce the tendency towards the erasure of the person in the post; this attitude is the only one capable of minimizing the risk of error which, as we have seen, is deeply inscribed in this profession, devoted as it is to highly unstable and strongly held artistic values.

This erasure of the person occupying a position that is part of a public-service institution becomes even more necessary in the case of curators because of the inherent risk of error in the profession; this would appear to be even more evident because the position places its occupant in a relationship with artists – an extremely individual lot – at least in terms of the works which the curator is charged with acquiring, protecting, circulating and, generally speaking, exposing to public scrutiny either materially (hanging, framing, lighting) or symbolically (attributive research, documentation, analysis, cataloguing). Traces of this form of abnegation, devotion on the part of the individual curator to the binary cause of art and public service, can be found at various levels: institutionally, in accordance with the long-standing tradition of avoiding 'conflicts of interest' imparted to all civil servants and in addition to the lofty level of self-imposed and deontological controls and constraints (the interdicts against participation in the art markets, by family members too, against compiling a personal collection concurrently with that of the museum and against acquiring expertise beyond that which is required by the job, etc.); psychologically, in accordance with the voluntary assumption of those traits deemed appropriate for a curator – reserve, modesty, discretion; and financially, due to the relatively low earnings (salaries are, considering the high level of education and training required for curators, the lowest among the entire public service). The last characteristic is, in part, due to the high proportion of women curators (120 women to 103 men in the 'corps'), the legacy of a time when those who held the posts, recruited from the financially and culturally privileged sector of society, could well afford to perform their tasks on a benevolent basis. But it should be acknowledged more generally that the dual sacrifice of wealth and fame that is required of the curator's profession is compensated by its prestige and the personal gratification derived from frequent contact with the privileged objects and lauded individuals that are works of art and artists.[6]

NEW FUNCTIONS, NEW POSITIONS

The current crisis in the profession, then, tends to call the established order into question, including this erasure of the person. Any crisis carries with it new perspectives that cannot be realized except along the individual trajectories of those who seize an opportunity of accelerating certain evolutions; they also contribute to defining new positions in the constitution of the future space of the professional

234

realm in question. Among these perspectives, we found the emergence of an authorial position through the expedient of the exhibition particularly interesting to analyse in that it introduces, in the midst of the realm of personal abnegation that is the museum, a criterion of singularization, bestowed with a legitimacy where it would ordinarily be disparaged as an indication of 'deprofessionalization'.

We shall see that it is possible to envisage this phenomenon from a positive rather than a negative point of view in the emergence in this realm of an original manner, validated from within and without, of conducting curatorship through the function of curator of exhibitions. Access, even if it remains rare and in large part indirect, to the position of exhibition *auteur* conjures a figure imported from other disciplines. This figure is as irreducible to the notion of a post (it is not the institution that defines the 'author' – and as it happens the latter is so defined in opposition to the former) as it is to that of function (to the extent that the mere accomplishment of a task does not make an author, rather it is the singularity of an author's production that does so).[7]

It would seem that it is through the redistribution and redefinition of the functions traditionally given to the curator that new positions tend to emerge. In effect, among the four crucial tasks which define the job (safeguarding the heritage, enriching collections, research and display), the only one which would allow a certain personalization – in the dual sense of the singularity of the accomplished task and any increase in stature it derives – is presentation to the public. And it is precisely this one which traditionally occupied the lowest level in the hierarchy of functions. Thus museum staff are readily suspected – if not accused outright – of working only for their peers, of ignoring the aesthetics of display, of neglecting the comfort of visitors, of not concerning themselves with pedagogy and of setting out unreadable captions, etc.[8] The indignant denials of those accused demonstrate that it is no longer legitimately possible to affect a manifest disdain for the function of public presentation, regardless of the effective quality of the work accomplished in this regard. There is every indication that a new legitimacy is conferred upon contact with the uninitiated or, at the very least, non-professionals through the intermediary of 'hanging' (and the physical 'hanging' can coincide with the mental 'hanging' of visitors).

This transformation would appear to be linked to a change in the equilibrium between the two constituent facets of the task of presentation. These are the permanent display of collections on the one hand and the temporary mounting of exhibitions on the other. If the former has barely evolved – and with good reason – except by formal choices which are not always perceptible to the lay person (lighting, wall colour, juxtapositions),[9] the phenomenon of temporary exhibitions has continually increased in scale for nearly a generation: in the number of organized

vernissages) and the press (savage attacks or praise, a simple recitation of content or an in-depth production evaluation); obscure operations invariably follow on, such as the transport of works or of copies and the storage or striking of sets.

In addition, the personnel or credits (mentioned at the beginning of the catalogue, in much the same way as names and duties of technicians appear on the screen) include an equivalent number of collaborators, of the order of fifty or so people (not including subcontracters, technicians and those on the commercial side of the venture). To dwell further on the similarities, one need only invoke the analagous conditions experienced on a film set and an exhibition site: similar mysterious displacements, alternating frenetic activity and stasis, an indeterminate number of people performing more or less identifiable tasks, a manifestly rigid hierarchy which is oblivious to outsiders, the same atmospheric mixture of urgency and relaxation, vigilance and release, complicity and mutual supervision. And, above all, the same solidly entrenched boundary dividing 'inside' and 'outside' which protects the area of the set or site from everyone but the initiated; areas where, once past the intense selection process at the outset, director, technician, star and intern work closely in what appears to be a democracy.

It is understood that there remain uncontestable differences between a film and an exhibition. In the latter, the primary material is not people (the actors) but works of art – albeit both are obtained at great cost and heavily insured. Furthermore, the exhibition as a temporary product cannot survive beyond its presentation in the way a film can if the copy is not destroyed after the first screening as was long the case (from this point of view, the exhibition is closer to live performance). Finally, the exhibition is not inscribed in the economy of the traditional marketplace where exchanges are strictly financial but in a public economy where persons are, for the most part, salaried by the state (for temporary collaborators' fees are directly charged to the exhibition budget) and where the works are quite often the collective property of the state, administered by a public establishment, or the private property of a collector.

One must therefore obtain (and not purchase) authorizations for loans rather than rent services. The monies used are not the economic capital of an enterprise but the prestige capital of a public establishment, as also is the value of the personal relations developed by the curator during time devoted to negotiations: phone calls, meetings, lunches, *vernissages*. . . . Thus, the primary material of an exhibition – the works of art – is the object of a relatively informal system of long-term exchanges, concluded *not* according to contractual agreements but through dealings between individuals which combine diplomacy, professionalism and friendship in a politic of mutual acknowledgement where reputation presides over caution and profit.

We are familiar with the notion of the *auteur* in the cinema – a product of French

240

criticism since the fifties – to promote and elevate the director's role to a level comparable, in a creative sense, to that enjoyed by a painter, writer or composer. This investment in the director's role by critics associated with the 'New Wave' gave what had been a matter of 'competency' an explanation of such concreteness and breadth that, a generation later, the pretension to *auteur* status is a common feature on the film scene, at least in France.[21] This validation of the director followed closely the gradual emergence of the role through the thirties, when, with the invention of 'talkies', the editor (hitherto a primordial figure among technicians) no longer had the same latitude, given the constraints of sound, to construct a film according to his whim from the stockpile of infinitely manipulable silent scenes. With the advent of sound, mastery over continuity became a primal element during filming and the director, who had previously simply directed actors (not very differently from a theatre director), was transmuted into a master of the realm – in a context in which rising costs, due to a marked increase in material expenditure, heightened the importance of control over production.

However, in the Hollywood studio system (including independent companies which, from our perspective, are not much different), recognition of the director's role continues to encroach upon that of the producer, who has had massive responsibilities: both in pre-production (choice of subject, screenwriters, stars, technicians, shooting conditions, etc.) and post-production (editing, distribution, advertising, etc.). The director did not even impose his or her views on the set. In fact, it is only at the moment when the producer, while retaining financial control over operations, delegates his functions to the director that the latter, in control of subject and scenario, actors and sets, camera movement and the actors' movements, and editing, can be considered as a fully fledged *auteur*. This is a status only attained in certain segments of French cinema and only rarely in television where the producer is the true creator who organizes the broadcast; the role of director hinges upon his or her technical aptitude, as was the case during the Hollywood studio era.[22]

A CASE STUDY: THE *VIENNA* EXHIBITION AT THE BEAUBOURG

We would now like to apply the process of constructing the notion of *auteur* to a specific exhibition, organized at the Centre Pompidou in 1986 under the title *Vienne, naissance d'un siècle*. This exhibition seemed to us, by its intrinsic qualities as well as its singular audience, to represent a key moment in the evolution of the curatorial profession towards a relatively more singularized position, achieved through the function of curator or, better still, the 'creator' of exhibitions. If in fact the curator in this case only achieved more or less marginal recognition as *auteur*, and if his work

241

the exhibition title; ambivalence in the opposition between modernity and the
avant-garde (the theme of the catalogue introduction), between the local and the
universal, between hatred and fascination. Dissonance is repeatedly invoked as a
common thread, a principle developed as much in the interpretation of ideas as in
the choice of colours or music.[27]

As for the second point, the stylistic aspect of the exhibition, it is effectively to be
found in the curator's remarks and in the conscious choices regarding the
installation, whether in relation to the architecture of the space (a circular trajectory
reminiscent of the Viennese 'Ring'), the play of mirrors or the colours of the
dividing walls to which he devoted extensive attention. Perhaps, more generally, the
curator adopted a formal stance consisting of privileging *visibility*. In other words, he
emphasized the sensitive correspondences between the works and the objects on
display – over their *readability* or the systematic explanation of historical elements
underlying the choice of presentation. The tension between two stylistic options
became manifest in the opposition between two people: the curator, museologically
formed, and the specialist historian, who as a consultant brought other
considerations of an academic kind to the equation – hence the 'dialogue of the deaf'
between 'an academic who doesn't know how to visualize' and 'museographers who
have grown accustomed to manipulating objects but not necessarily concepts'. The
museographer, in this instance the overall curator, tended to privilege 'the
subconscious' over 'the meaning'; form, material, the image over the text; 'shock' or
'astonishment' over the 'reading'; 'visual sensation' over 'linguistic explanation'; the
'work of art' over the 'document'; 'seeing' over 'understanding': in short, 'pure
visibility', which operates in 'immediacy', rather than 'explanation', which requires
duration.

One can also address the genuine stylistic choices in relation to the installation of
the exhibition – choices eventually buttressed by explicit references to other artistic
realms such as theatre (as examples: 'dramatization' or 'tragedy'), opera (the small
exhibition journal designed like a 'libretto'), film (the exhibition circuit constructed
like a 'film set'). Such an exhibition, to the degree that its aim is not merely to display
the works but to demonstrate a certain interpretation of works and ideas (an
interpretation necessarily constructed and thus, in a certain way, signed), has a
tendency to nudge the 'creator' from his or her anonymity. At the same time such an
exhibition has to admit to being defined as an attempt to construct ideas out of
matter.

In this context, two possible approaches are offered to the visitor: either
consumption of the ideas (by abstracting those 'things' which constitute the
installation, the arrangement of documentation, the materials and colours of
decorative elements or, more directly, the selection of works), or consumption of

those same items by appreciating, above all, the quality of the exhibition as such and remaining disinterested, except perhaps secondarily, in the 'ideas' which are the object of the exhibition. In the first case, the installation would tend to remain 'transparent' to the eyes of the consumer of ideas, indifferent as he or she is to the support which makes them visible. In the second case, the exhibition will interpose the 'opacity' of the work of mediation between the object and the visitor. As is the case with works of art, it is understood that the second approach is likely to be disseminated among those who, whether it be the result of professional specialization (critics, for example) or due to their cultural habits, have a sufficiently developed aesthetic perception to see the 'form' as well as, if not better than, the 'background'. As for the rest – those 'consumers of ideas' – the exhibition will above all be seen as a signifying system (in part largely the case) as opposed to pure spectacle. In semiological terms, the works and their installation would be the signifier, ideas and interpretations the signified, the exhibition's object (turn-of-the-century Vienna) the referent. From this perspective, the exhibited works will achieve their justification, either in their artistic values and the enjoyment that they give rise to, or in their symbolic or metaphoric value.

FROM THE PARTICULAR CASE TO THE PARTICULARIZATION OF STATUS

245

Much as the perception of exhibitions can be refracted, according to various contexts and publics, in different more or less favourable directions in what we might call an aestheticization of museum visitation, so too can the status of curator follow various evolutionary routes in the wide universe of possibilities which the current situation offers. In fact, we have seen that traditionally, when the exhibition was merely a secondary function of museums – which were principally devoted to the conservation of works and content periodically to mount a selection of their holdings – the particular role of the exhibition curator was confused with that of the general curator, requiring little in the way of qualification. However, with the development and specialization of exhibitions and the increasing tendency to stage a 'theme' with attendant historical and cultural resonances instead of simply exhibiting a collection, it has become necessary to impose a more specialized and in-depth application of the three main competencies: conception, management of works and presentation (script, acting and direction).

One can foresee two types of evolution. On the one hand, in the absence of professionals fluent in all three skills, we might see a clear-cut differentiation between functions under the supervision of an overseer (for example, the 'creator' or architect to whom the establishment would temporarily delegate the organizational

responsibility, or the curator who would hire a 'screenwriter' and a 'director' while reserving for his or herself the traditional role of producer – retaining, of course, responsibility for choosing, and negotiating with, 'stars'). Or we might see the complete opposite – as is most often the case with the *cinéma d'auteur* – the forming of a specialized elite of exhibition professionals, *auteurs* whose services would be temporarily on loan in much the same way that a director will form an alliance with this or that producer for a film which will be perceived, by critics and at least a part of the general public, as being the director's film and not the producer's. If we may draw a comparison, the first case would represent the 'American' model (a relatively formal division of labour within an association managing various 'professional' bodies). The second, however, incorporates more of a 'French' model: the concentration of functions within one individual who remains relatively singular and autonomous in relation to the institution – in other words, the *auteur*.

The case we have just explored would seem to incline towards the second option. However, as we have stated, this constitutes one particular case from which it would be foolhardy to make generalized predictions. It is nevertheless its very particularity which makes it of interest: in effect, the exceptional or marginal nature of the phenomenon here analysed – the ongoing constitution of an authorial position within a relatively bureaucratized profession – does not signal a systemic aberration or a dysfunction or even an exception that proves the rule. It represents much more. It is symptomatic of an evolution which conforms to a process antithetical to ordinarily privileged, sociological notions of what constitutes 'professionalism': an evolution from a professional position which is institutionally and collectively defined in terms of its *post* (for our purposes, the curator) to the progressive autonomization of *function* (the exhibition curator), itself capable of authorizing a more independent and personalized *position* which is that of the *auteur*.

Finally, the fact that the former case is analysed in a very individualized way does not detract from the validity of the demonstration (in the way that one could object to a narrowly statistical sociological concept). One can consider that the sociology of professions should also include the notion of *individual creators of status*, people capable, in periods of crisis or of redefinition of the professional landscape, of creating and incarnating new positions, generalized and formalized from the outside. More precisely, we can discern three possible examples in the relations between individual and professional identity. In the first, individual characteristics precede identity (which was the case with certain artists at the beginning of the Renaissance);[28] in the second, it is precisely from among the 'individual creators of status' that a new identity is constructed, crystallizing around eponymous figures (Raphael, Leonardo da Vinci or Michelangelo among Renaissance artists, Van Gogh as the figure of the accursed artist, Orson Welles or Godard as film *auteurs*). Finally,

the third case is one where a collective identity, however constituted, acknowledged and, at times, even institutionalized, precedes the individuals, condemned as they are either to construct their personal identities in terms of the collective one (often in reference to the heroic individuals they incarnate), or to deconstruct it with a novel identity strategy (as Duchamp did for example).

It seems to us that it is from this perspective that 'individual creators of status' in the various domains (whether they be art or medicine, politics or religion) should be studied and compared; the sociology of professions would do well to integrate these singular objects which it ordinarily tends to neglect. In any event one would then be able to generalize the particular case of museum curators that we have analysed here.

Translated from the French by Robert McGee.

NOTES

This article was drawn from a study by N. Heinich and M. Pollak, conducted for the Centre Georges Pompidou in co-operation with l'association ADRESSE: *Vienne à Paris: portrait d'une exposition*, Paris, Editions du Centre Pompidou – BPI, 1988. It was published as 'Du conservateur de musée à l'auteur d'expositions: l'invention d'une position singulière', in *Sociologie du Travail*, 31: 1 (1989), pp. 29–49.

1 See *Des chiffres pour le patrimoine*, Paris, La Documentation Française, 1981; *Pratiques culturelles des Français*, Paris, Dalloz, 1983; as well as J. Chatelain, *Administration et gestion des musées*, Paris, La Documentation Française, 1987.

2 Notably: colloquia at the Centre Georges Pompidou (June 1987, March 1988, April 1988); Salon de la muséologie (Nov. 1987); Salon international des musées et des expositions (Jan. 1988); public debate at the Musée d'Orsay (Jan. 1988). This essay draws from facts gathered at these events.

3 For a critical bibliography on the notion of professionalization, see J. Heilbronn, 'La professionnalisation comme concept sociologique et comme stratégie des sociologues', *Historiens et sociologues aujourd'hui, Journées de la Société française de sociologie*, June 1984.

4 See T. Parsons, 'Professions', in *International Encyclopedia of the Social Sciences*, 12 (1968); M. Weber, *Economie et Société*, 1, Paris, Plon, 1971. See also, for an application to artistic professions, R. Moulin, 'De l'artisan au professionnel: l'artiste', *Sociologie du travail*, 4 (1983), pp. 388–403.

5 See J. Laurent, *Arts et Pouvoirs*, Saint-Etienne, CIEREC, 1983.

6 'No other profession of an intellectual nature has, to this degree, its ambition determined by the institution to which it belongs. . . . Curatorial quality is identified with the collection the curator manages and studies, for the hierarchy of the position mirrors that of the objects; its *connoisseurship* and professional value depends upon those pieces he or she handles or has claim to', notes D. Poulot adroitly in 'Les mutations de la sociabilité dans les musées français et les stratégies des conservateurs, 1960–1980', *Sociologie de l'art*, under the direction of R. Moulin (minutes from the Marseilles

247

colloquium, June 1985) Paris, La Documentation française, 1986. For more on the subject, see J. Clair, *Paradoxe sur le conservateur*, Caen, L'Echoppe, 1988, and N. Heinich, 'La muséologie face aux transformations du statut de l'artiste', *Cahiers du Musée national d'art moderne*, 1989.

7 For internal opposition in the cultural professions between the processes of professionalization and deprofessionalization, see N. Heinich, *Du peintre à l'artiste. Artisans et académiciens à l'age classique*, Paris, Minuit, 1993, and 'Les traducteurs littéraires: l'art et la profession', *Revue française de sociologie*, 2 (July 1984).

8 For all of the above, see P. Bourdieu, A. Darbel, *L'Amour de l'art*, Paris, Minuit, 1969, and Heinich and Pollak, *Vienne à Paris*.

9 For more on this subject, see numbers 17–18 of *Cahiers du Musée national d'art moderne*, devoted to 'l'oeuvre et son accrochage'.

10 See *Des chiffres pour la culture*, Paris, La Documentation Française, 1980.

11 We would like to cite, as it concerns private galleries, the words of Kahnweiler at the turn of the century: 'We no longer do exhibitions, I am content to mount paintings': *Mes galeries et mes peintres*, Paris, Gallimard–Idées, 1982, p. 59.

12 Gérard Régnier's intervention at the colloquium on exhibitions organized by the Centre Pompidou, June 1987.

13 An anecdote reported by Pierre Soulages from a conference at the Salon international des musées et des expositions, Grand Palais, 16 Jan. 1988.

14 See *Beaux-Arts Magazine*, June 1987. A reading of the cultural pages of *Le Monde* and *Libération*, two dailies which devote the most space to exhibitions (as shown by a study conducted by the press service of the Musée national d'art moderne), reveals that both offer numerous examples of this heightened taking into account of the curator's role.

15 *Vienne: L'Apocalypse joyeuse*, 1986, by Jean Clair; *Matisse* and *Rembrandt*, 1987, by Jacqueline and Maurice Guillaud.

16 For example, the charter tours organized especially for visiting the exhibitions *Vienne* and *Europalia* in Brussels, Kassel's *documenta* or the Venice Biennale. These major events are increasingly showcased and reviewed in the principal European dailies.

17 D. Poulot refers to the possibility of 'mapping out a literary career which would be more or less detached from the institution by metamorphizing a catalogue piece into an intellectual essay, thereby acquiring personal renown at the universities and, thus, the cultivated public': 'Les mutations de la sociabilité', p. 107.

18 For a description of this process in the magical properties, see M. Mauss, *Sociologie et anthropologie*, Paris, PUF, 1950.

19 See N. Heinich, *The Glory of Van Gogh. An Anthropology of Admiration*, Princeton University Press, 1996.

20 To our knowledge, there are no studies specifically relating to the economy of the exhibition. For the social role and perception of exhibitions, see J. Davallon, *Claquemurer pour ainsi dire tout l'univers: la mise en exposition*, Paris, Editions du Centre Pompidou – CCI, 1986; *Les Immatériaux*, Paris, Expo-Media, 1986; Hana Gottesdiener, *Evaluer l'exposition*, Paris, La Documentation française, 1987; *L'objet exposé le lieu*, Paris, Expo-Media, 1986; *Utilisation et évaluation de l'exposition*, actes

248

du colloque de Marly-le-Roi, Nov. 1982, Paris, Peuple et Culture, 1983. On the economy of museums, cf. H. Mercillon, 'Les musées: institutions a but non lucratif dans l'économie marchande', *Revue d'économie politique*, 87: 4 (1977); Werner W. Pommerehne and Bruno S. Frey, 'Les musées dans une perspective économique', *Revue internationale des sciences sociales*, 32: 2 (1980); A. Peacock and C. Godfrey, 'The economics of museums and galleries', in M. Blang, ed., *The Economics of Art*, Martin Robertson, 1976.

21 See Y. Darré, 'Les créateurs dans la division du travail: le cas du cinéma d'auteur', *Sociologie de l'art*, under the direction of R. Moulin, Paris, La Documentation française, 1986.

22 See N. Heinich, 'Peintres et cinéastes', minutes from the *Peinture et cinéma* colloquium, Quimper, March 1987.

23 See P. Bourdieu, 'L'économie de la production des biens culturels', *Actes de la recherche en sciences sociales*, 13 (Feb. 1977).

24 This quotation, and those which follow, are taken from interviews conducted with the exhibition curator as part of the study we have cited. The 'we' in the passage refers to himself and his direct collaborator, an art historian not affiliated to the Centre Pompidou. However, at other moments during the discourse, the use of personal pronouns gives expression to the fundamental ambivalence between the collective responsibility and individual leadership, team collectivity and authorial singularity: the prevalent form is 'one', ambiguous and impersonal, designating both visitors and conceptualists; locutions referring to a kind of objectivity of selections are equally impersonal ('it was evident', 'what was needed', 'it was important', 'it was indispensible', 'the idea was to', etc.), imparting characteristics inherent to the object itself which are beyond any individual decision. But we also found more personal forms; for example 'we' is used (rarely) in an effort to evince the Parisian specificity of the exhibition in terms of its Viennese counterpart; and, more frequently, 'I' is used both to justify personal positions or general ideas and to establish a differentiation from other players (architects, peers, critics).

249

25 We here refer to a scheme propounded by Ph. Junod in his history of the aesthetic perception of painting: *Transparence et Opacité. Essai sur les fondements théoriques de l'art moderne*, Lausanne, L'Age d'homme, 1976.

26 See A. Bazin, *Orson Welles*, Paris, Ramsay-Poche Cinéma, 1986, p. 71.

27 As an example, we would like to cite the following remarks by the curator concerning music:

> There is another problem which underscores the use of music in an exhibition: music is used in an attempt either to reinforce or underline the climate (as was the case in Vienna where in each room you had Mahler or Schoenberg or Strauss waltzes); however, in that particular instance, I believe the end result was the opposite of the one intended – in other words, there was a redundancy of music in relation to the work, to the exhibited objects, such that the redundancy in a sense effaced the sought-after effect – instead of underlining, it erased. So if one wishes to introduce a musical element into an exhibition which is, to repeat, essentially a phenomenon of a visual order, the music must not intervene by underscoring but must effect a dissonance with the visual material. Wherefrom derives the idea of playing a Strauss waltz throughout the exhibition – the well-known, celebrated and cliched *Blue Danube* – thus conforming to the idea the general public has of Viennese culture, the Vienna of tourist brochures and postcards. This impression persists until the discovery, at the very end of the

the way the viewer feels about the artwork and the artist who made these things. Being an artist and being African-American and Native American and actually working in the museum at that time, I was in a position to notice some of the incongruities in these spaces. So with that background I worked in alternative spaces and then was offered the directorship of Longwood in the Bronx.

At that time I decided to try some ideas that I had that had been brewing when I worked at these museums. Once I went to a dance concert with a dancer, and while I was enjoying the general performance, the dancer I was with was constantly looking at how the person's toe was pointed. When you're in a field you notice the smaller aspects that the average person does not see. It's the same with someone working in museums and galleries – you notice when the lighting is not right, you notice when the labels are not right in a museum. As an artist who had had work on the walls and also looked at work, I had questions about what those spaces were really doing to the artwork and to artists.

So one of the first shows I did in the Bronx, in the late eighties, was called *Rooms With a View: The Struggle Between Cultural Content and the Context of Art*. I took three rooms; one room looked like a contemporary gallery, the white cube; one I redesigned to look like a small ethnographic museum, not very well appointed; the third I made to look like a turn-of-the-century salon space. I asked thirty artists to be a part of my experiment. All thirty had work in the white cube, half had work in the ethnographic space, and half had work in the turn-of-the-century space. I chose the work according to how it might look in those spaces. Many artists at that time were making work that seemed to fit in an ethnographic museum, because they were working on Third World cultural idioms. There were other artists who were working more with the history of Western art in their work. When I placed the work in the ethnographic space, I would have visiting curators say with surprise, "Oh, you have a collection of primitive art." And I had to tell one curator, "No, Valerie, that work you're staring at was in your gallery a month ago." The environment really changed the work; the labels just had the materials, not the names, because in most ethnographic museums – Ivan can bear me out or jump on me for saying this – the labels don't have any names because the works were collected at a time when the names of the people who made the objects were not important. The labels just gave the materials and things like "Found, Williamsburg section, Brooklyn, late 20th century." Students would walk up to the barrier around the installation by Linda Peer – and the barrier of course is mine, it's the museum's presence on the artwork – go up to the label, read it, look at the object, and think they knew what they were looking at, when actually they knew very little. I didn't say anything false, but they really had a totally different view of what that object was about. The works became exotic, they looked like something made by someone you

could never know; the works in many instances were dehumanized because of the way they were installed. In the turn-of-the-century space, the works looked like they had a certain authority that the works didn't have in the white cube. The white cube also had a way of affecting you: it looked cold, it looked sort of scientific.

For me, this was a watershed event. If the work was being manipulated that much, that was the area I wanted to work in. From that point on, I didn't want to ask artists to be involved with this, since I was actually manipulating their work. I figured I'd just do it with my own work. I made an installation called *The Other Museum* – in one part, *The Colonial Collection*, I wrapped French and British flags around African masks. These were all trade pieces, but when you put something under that beautiful lighting, it looks, whatever the word means, "authentic." I had this vitrine made which looks somewhat like a turn-of-the-century vitrine, in which I placed *Harper's* lithographs from the turn-of-the century of the punitive expeditions between the Zulus and the British and the Ashanti and the British. I wrapped the masks because they're sort of hostages to the museum. If they had been in the museum since the turn of the century – and many of the collections do date from this time – they were taken out during these wars. So I consider them hostages in these institutions. There are a lot of questions surrounding this – should they go back, shouldn't they go back – but I like to bring history to the museum, because I feel that the aesthetic anesthetizes the historic and keeps this imperial view within the museum and continues the dislocation of what these objects are about. One object I didn't change except for the label: "Stolen from the Zonge tribe, 1899. Private collection." This got a lot of collectors upset, but indeed, if it came out of the African country in 1899, more than likely it had been just swiped. In a newly installed space in one museum, a label next to an object read, " Acquired by Colonel So-and-so in 1898." How does a colonel acquire something? He goes up there and says, "Give that to me or I'll shoot you."

So I use the museum as my palette. Curators, whether they think about it or not, really create how you are to view and think about these objects, so I figured, "If they can do it, I can do it too." Everything in the exhibition environment is mine, whenever I organize the space. I painted one contemporary gallery a dark color, and it felt like *The Truth*, like "well, this has got to be *serious*." My exhibition at Metro Pictures, *Panta Rhei*, was a gallery of classical and ancient art. What it consisted of were plaster casts. I painted the walls a light-blue color that I saw over and over again in many museums that still had plaster casts. Rooms of plaster casts were common in American museums at the turn of the century; though they couldn't get the actual objects from Europe, they wanted the people of the United States to experience these objects. Since they're not getting the same aesthetic experience from plaster they would get from the original objects if they traveled to Greece or Rome or

253

chair of the last royal governor and a painting of who was carrying it, and a model ship with account logs of various slaveholders with names of the slaves and other "livestock." I placed two old baby carriages in the space; one had, instead of the baby's bedding, a Ku Klux Klan hood. Next to it on the wall I had an early photograph on the wall of Black nannies with a White baby in a baby carriage.

Under the heading "Cabinet making" I placed baroque chairs facing a public whipping post which was still used by the city jail in the 1950s and had been hidden in the basement of the Maryland Historical Society since 1963. I used doll houses to depict a slave revolt; beside it is a manuscript by a young woman who was writing of her fear at the time of the slave uprisings.

The final section was about dreams and aspirations; in the crevices of the museum, totally unnoticed, I found things made by Africans and African-Americans, including American made pottery and basketry and personal adornments that came from Liberia, circa 1867. A book by Benjamin Banneker, a mathematician and freeman who surveyed Washington, D.C. for Jefferson, and also was an amateur astronomer. He made a book of all his astronomy charts that he figured out mathematically. I made slides of these charts and projected them on the

➡ 14.2 Fred Wilson, *Mining the Museum*, installation view, Maryland Historical Society, Baltimore, 1992. Photograph courtesy of Metro Pictures, New York.

wall; in addition to his charts, he wrote about his dreams and mentioned in diary fashion who wanted to kill him.

By bringing things out of storage and shifting things already on view, I believe I created a new public persona for the historical society, one that they were not likely to soon forget nor will the Baltimore community allow them to forget. To my mind, for this to happen in America, where local community residents are not empowered to chart the course of their local museum, is a huge success.

Ivan Karp: some of my friends have told me recently that I'm in my anecdotage, so that means I can begin by telling you three stories. The first of them is about a curator who went to see Fred Wilson's exhibit *The Other Museum* – actually the room that had the colonial gallery, the masks with their national flags over them. I'm the curator, I had just finished signing some papers for loans, and I walked in and I said, "How the hell did he do that?" The labels said "Loan courtesy of the Musée de L'Homme," "Loan courtesy of the British Museum" – "How the hell did he do that? How did he get permission? The British Museum doesn't do that, they insist on couriers who carry everything, and then control precisely how the objects are

displayed." So I think that we have here is testimony to Fred's ability to manipulate his audience, which was the word he used.

The second story I want to tell you is about the founding of the Metropolitan Museum in New York. The Metropolitan was originally founded as a museum of reproductions, plaster-of-paris reproductions most of them, put in place by the founders to elevate the taste of the working class of New York City. They ran into a little problem, however, because in deference to the religious sensibilities of the founders, the museum was not open on Sundays, which of course was the only day the working class of New York City had off. Some people might say that the Metropolitan Museum of Art hasn't changed a great deal in the interim period.

The third story is about the founding of the Museum of African Art at the Smithsonian Institution, a sister institution to my institution, the Natural History Museum. When I came aboard, as we say at the Smithsonian (we're very big on nautical terms – that's government: the ship of state), I started going through the papers of my predecessor as curator, and found a letter from the founding director of the Museum of African Art. He wrote a very friendly letter saying that there really should be a division of labor at the Smithsonian, now that there were two museums

METALWORK

social constituency, which, in other words, "think globally but act locally." The effort to promote *documenta 9* itself as a kind of Wagnerian total artwork represents a move to relegate the very artworks which compose the exhibition to the status of raw material. The implied "naturalization" militates against artists' critical intentions, but also – and more importantly – against the ability of the audience to evaluate the show in an analytical fashion. Portraying the exhibition itself as an artwork is an undisguised allusion to discredited precepts of inspiration and genius – qualities which presumably accrue to the curator. The exhibition takes on an air of inevitability; the audience is encouraged to accept it as an organic – created yet predetermined – whole. It doesn't matter then if one loves or hates the event so long as one responds within the prescribed institutional framework. The tactic of conflating curator and artist owes something to Andy Warhol. If business is the highest art, then the curator, as the maker or breaker of careers, becomes a mega-artist. Privileging the curator's subjectivity like this, moreover, reconventionalizes the last remnant of critical potential to be found in late, Reaganera Warholism: neutralization of the cult of personality.

Although Coosje von Bruggen once likened *documenta* to the Olympics, a more

272 ➡ **15.2 *documenta 9*, installation by Joseph Kosuth, Kassel, 1992. Photograph courtesy of Joseph Kosuth.**

appropriate analogy is the international World's Fairs. Just as these presented the public with a phantasmagoria of goods bestowed upon them by technology under the aegis of Progress, so the first mega-exhibitions consecrated the ideology of liberal democracy as a set of eternal values – especially in the case of *documenta* where modernism symbolized a bastion of freedom against Nazi repression. Conversely, the universalist pretensions of the classical modernist artwork rendered it the perfect vehicle for this kind of mega-exhibition. By the time of *documenta 7*, the ability of contemporary art to fulfill a quasi-official state function had broken down completely. The needs of the state had changed; art had changed; the world had changed. In the catalogue for that show, Gerhard Storck stated that "documenta 7 had to abandon the belief in progress and the concept of development inherited from the founders in 1955." In fact, all the contributors to that catalogue were obviously casting around for a sense of purpose. Storck further stated that the exhibition's organizers nonetheless all agreed that the individual artworks maintained a kind of intrinsic value which – possibly – justified the enterprise of the mega-exhibition. Yet he also allowed that artworks alone do not constitute an exhibition and that, conversely, an exhibition is not a work of art, except in extreme cases. Although this

was intended as a warning, it reveals that the spectre of the curator-as-artist has haunted the enterprise for quite some time, leaving it open for Jan Hoet to represent his work as an exceptional case, transcending ordinary curatorial criteria in a manner not unlike the way American Abstract Expressionist painting claimed to transcend its context. Thus, the promotion of *documenta 9* as an artwork is played as a kind of trump card. The terms may be more melodramatic, but the cycle would seem guaranteed to repeat itself with higher highs and lower lows. With the metaphor of the trump card I hope to dispel the idea of conspiracy on one hand and that of pure whimsy on the other. Rather, I want to suggest "the feel for the game" of someone faced with a knot of possibilities and problems. Our purpose, today, is to change the rules of that game.

NOTE

This essay was originally published in *Texte zur Kunst*, Reden U.A. auf der *documenta 9*, 1992, pp. 4–7.

16

FREE FALL — FREEZE FRAME
Africa, exhibitions, artists

Clémentine Deliss

Imagine you are in flight. You believe you may be moving from one geographical location to another and you are prepared. But as you travel across space you find yourself looking downwards and within rather than beyond the clouds which surround you. You recognize shapes, formations, patterns and you think you can map out the sites below. As you move on what appears to be a stable horizontal axis, you suddenly realize that you are in free fall, no longer moving ahead but shifting diagonally and downwards, catching and locking into different gravities. The burr of the engines has ceased and although another dynamic seems to be potent, one in which interaction may be your only means of survival, you can't help worrying that you may just land with a thump in a territory hostile to your experience.

the mainstream gaze and, in that instance, I was primarily concerned with how the object intervened as a thing, a material support structure, channelling different perceptions of what art or culture might constitute at home and abroad. With *lotte* I was working from the premise that an exhibition is a short-term operative site and can be used to expose ideas around the interpretation of art as well as the art itself.

The exhibition combined a number of new artefacts produced in West Africa together with selected works by five contemporary artists: Lubaina Himid (born in Tanzania, raised in Britain and a leading figure in the Black British art scene); Rosemarie Trockel (from former West Germany); Mike Kelley and Jeff Koons (from the USA), and finally Haim Steinbach, an Israeli resident in the United States. The exhibition took on board the legacy of the 'ethnographic object' by referencing the early period in twentieth-century French anthropology when expeditions such as the Mission Dakar–Djibouti (1931–3) enabled methodologies to be constructed around material culture which had been looted on a large scale from Africa.[4] As a result, the contemporary West African objects included specially commissioned 'Fashion Devils' from the urban, Yoruba-derived Odelay society, Firestone, in Freetown, Sierra Leone; a Fante 'Parable Tree' or *Abebuinsam* made by Kwame Mensah in Cape Coast, Ghana; various tin toys built by children from northern and southern Ghana; a selection of graphic work by signwriters; mass-produced plastic artefacts; and twenty-three commemorative cloths of the 'Dutch Wax' variety produced in Africa, in particular in Burkina Faso, and which had been sponsored by multi-national corporations for local sales and publicity purposes. These exhibits evoked the collections of ethnographic museums engendered during the colonial period which denied the creative individuality and name of the artist in favour of anonymous objects which might 'speak' the culture in question.

Following this, a conscious effort was made in the *lotte* exhibition to move away from the artist figure and focus instead on the potentiality of the material object to become a catalyst for a whole series of power relations and articulated strategies of legitimation in the African and contemporary Western artworlds. The works by Koons, Steinbach, Kelley, Trockel and Himid were selected because, not only did they thematize a certain crisis in the aesthetic paradigm and the idea of the art object in the late eighties, but they clearly made references to the power of positioning in the marketing of contemporary art. The works could be recognized as conscious reflections on the critical apparatus which consolidates the artists' marketability and frames their aesthetic and ideological stance and as a result could be seen as pertinent to the Euro-American appropriation and classification of contemporary art from Africa. In addition, several pieces made reference to a transformational concept of material culture, in many cases literally mediated through a transposition or transfiguration of a specific object or image of an object. Jeff Koons transformed the

warm, wooly texture of a teddy bear into the hard-edged fragility of porcelain, and Rosemarie Trockel machine-knitted the painter's canvas, evoking both the relegation of women's art production to the cottage industry of a minority as well as the growing syntheticization of art's iconic and material dimensions in the late eighties. The 'Fashion Devils' made of Chinese enamel bowls, imported adhesive Fablon and nylon rice-sacking were in contradistinction to the preferred 'ethnographic exhibit' whereby a museological inversion of the missionaries' fears in the African ritual object had resulted in a predilection for the very carved masks and figurines which were the embodiment of an unchartered territory.

Lotte suggested islands within particular mappings of artworlds. Each island was a container of a discourse, be it in the form of a Jeff Koons piece in a Max Hetzler gallery, a Haim Steinbach domestic museum display at Jay Gorney Modern Art, Lubaina Himid's politicized pink paintings of looted African objects, or the icons, logos and plastics from urban West Africa which contradicted so vehemently the preservation instinct of European ethnographers. The presence of artists living and working in Africa within the *lotte* exhibition could barely be felt. Indeed it was their exclusion from the narrow vision of mainstream art which I wanted to highlight and aggravate. Equally I had not asked Steinbach, Kelley or Koons to produce works for the show. On the contrary, the acquisition of the pieces by these artists had to be as mundane a process as the lending of an object from one gallery to another – i.e. exchanging goods at a market place.

The contrasting installation of the exhibits in the two showings in 1990/1, first at the Grazer Kunstverein and Stadtmuseum, spaces characteristic of a large white gallery, and then at the Academy of Fine Arts in Vienna, an example of late-nineteenth-century imperialist architecture, punctuated the different histories associated with the objects. Without any labels on the walls to help them differentiate their various origins, visitors were forced to recognize the limits of their own reference systems. They realized that oppositional categories such as 'Western/non-Western', 'individual/community', 'traditional/contemporary', 'academic'/'popular', 'high/low', so often resorted to in the breakdown and interpretation of art from Africa, were no longer practicable solutions in the face of the multiplicity of cultural and artistic identities suggested by the juxtaposition of the different objects. If a visitor was seduced, once again, into making formalist comparisons between a Mike Kelley and an Odelay construction from the Firestone Society in Freetown, Sierra Leone, or a Rosemarie Trockel knit bearing hammer and sickle and a similarly stylized, political and repetitive design on a society print from West Africa, then these comparisons proved immediately insufficient and dissatisfying.

Lotte was disturbing because it highlighted the sense of loss experienced by the

279

public in the face of markedly different critical and cultural systems. If the exhibition had one overriding message, then it was in terms of an analysis of what Michel Foucault called 'grids of specification',[5] those systems of division, classification and differentiation which circumscribe objects as communicators of cultural power and, in this particular case, determine their relationship to the art system with all its various agents of evaluation including critics, collectors, dealers, gallerists, museum practitioners, politicians and fellow artists. Next to the contemporary art model for which the selected works by artists were decisive in conveying the current power of the critical system in the late eighties was the highly politicized stance taken by the Black arts in Britain, all too often positioned ambivalently on the 'margins' of the 'mainstream'. Against these two complexes of critical-artistic production, the series of urban objects signified a whole area in which transformational processes specific to West African cultural identity were interwoven with a critique of the perpetuation by Western anthropologists and historians of a closed, non-dialogical discourse on African art.

The emblem of the show was a red plastic doll with bright turquoise eyes produced in the early seventies in a Chinese factory in Nigeria using a typical

➡ **16.2 *lotte or the transformation of the object*, installation showing work by Haim Steinbach, to left of door, and Lubaina Himid, to the right, Grazer Kunstverein, Austria, 1990. Photograph by Clémentine Deliss.**

German mould from the forties. According to research carried out by Marilyn Hammersley-Houlberg in 1973, this doll was of a similar type to those incoporated at the time by aspiring middle-class Yoruba women as a substitute figure in the Ibeji twin cult.[6] The red doll belonging to the historian John Picton and which he used as a teaching aid in his class on African art represented the historical voice or myth in the exhibition. I renamed her lotte both in view of her German origins (she was after all the standard female icon for little girls), and to emphasize the many fictions within her meaning as a cultural object. Her presence, under a perspex bell-jar, made reference to the highly sought-after category of 'traditional' African art by Western art collectors and dealers, an exclusive and powerful category which, in the context of the international art market, perpetuates a Eurocentric model of desire and longing for the 'authenticity' of pre-industrial and pre-colonial manifestations.

Ironically, no sooner had lotte attempted to highlight the limitation in interpretative tools with which new work from Africa is unpacked and understood, than her own identity was classified. The very same red doll which belonged to John Picton and which I had borrowed temporarily and exhibited under the name of lotte was then borrowed by Susan Vogel a few months later to become emblematic of her

category of 'New Functional Art' in the exhibition *Africa Explores*.[7] Rather than
remain openly dialogical to the question of the classification of African art in the
West, Vogel had succeeded in making the plastic doll become a part of it, not as a
critique of the past, but as a leading category for future collectors. When *Africa
Explores* went on its world tour, the red doll was sent back to John Picton wrapped
up in layers of padded foam and carefully placed in a crate fifty times its size. The
insurance came to several hundred dollars.

As an exhibition, *lotte* situated itself within several debates. It engaged in a
critique not only of the efficacy of the American neo-conceptualist strategy to play
games with 'material' culture but questioned equally the resurgence of interest in
'African art' and with it the monopolies over its interpretation and commodification,
controlled on the one hand by the museographic discourse and on the other by a
speculative search for a new African authenticity championed by a handful of
economically powerful collectors.[8]

For a discussion on contemporary art from Africa to be successful today, it has to
structure itself as an on-going debate acknowledging the existence of a multiplicity
of indigenous art-critical systems and no longer exclusively framed through the gaze

objects, then this specific relationship to art discourse was completely overlooked.

Magiciens not only confused the reception of the non-Western artists it invited, but it managed to misrepresent issues at the heart of a lot of the Western art it included by regressing further into a retinal mode of appreciation which together with the sweeping meta-theme of the magician and the subsequent overevaluation of the spiritualist role of the artist, could not have been more diametrically opposed to the agenda of certain conceptual artists, to give but one example. Here we have a situation in which a globalizing thematic within an exhibition is unable to contain the contradictions generated by the specificities of the cultural and artistic voices it includes. *Lotte*, in response, underlined the very aspects of closure and contradiction within the mainstream critical discourse that *Magiciens de la Terre* was attempting idealistically to look past.

Exhibitions limit both the curator and the public to a spatial environment in which a form of visual conceptualization becomes the prime interpretative activity. They succeed best by providing a dynamic forum for the exchange of ideas, if the installations and subsequently the perspective on the thematics are transient. If the constellation of issues raised in the research pertaining to the exhibition itself transforms as a result of the critical debates ensuing from the show and related to it on a wider international scale, then the exhibition no longer becomes relevant as an operative site. Having taken nearly two-and-a-half years from initial concept to final installation, *lotte* could not be perpetuated as a touring exhibition in an extended temporal framework. It was an exhibition at a moment in time and ended there and then. The follow-up came in 1991 when the question of art criticism was debated at a twelve-week long series of artists' talks and seminars organized at the School of Oriental and African Studies in London.[11] Artists headed the seminar series giving illustrated talks about their work followed by an interdisciplinary forum in which questions of art patronage, criticism, internationalism and art education were discussed.

Whilst the problematics raised by the *lotte* exhibition have not yet been exhausted in the sense that models of critical evaluation are in the majority of cases petrified in the same structures which purport to be internationalist and are ultimately Eurocentric, the focus on the discursive apparatus somehow seems antiquated in face of current interactions. Suddenly, as if resuscitated, the artist is being given the benefit of the doubt and, eager for elbow room, is challenging white-cube politics,[12] the insularity of the mainstream artworlds and the sanctity of the exhibition space. In contrast with the post-modernist tendencies of the last fifteen years, the active presence of the artist as a key agent in this new scenario is becoming unavoidable. Such that whilst Rirkit Tiravanija, the Laotian artist, cooks curries in galleries in New York and London and offers suitcases of American bacon-yoghurt crisps to the

Warsaw artworld, the American critic Dan Cameron (who once pushed Steinbach and Koons) now asks:

> What does it mean that art-culture continues to focus our attention on the display of exotic objects in near empty rooms when most of the world does not have enough to eat? . . . To what extent does the art community's discourse of values and meanings function as a mere shield, protecting against the realization that we have constructed a microcosm that keeps itself arrogantly positioned beyond the issues of the general populace?[13]

It appears we are facing a situation of curatorial paranoia where risk-taking and experimentation are dampened not only by overriding economic constraints in public and private sector funding, but also by a general hesitancy to use the exhibition space in less conventional ways. Risk-taking in the context of creating an exhibition is about highlighting the transient and dialogical potential of constructed art exhibitions. In the post-*Magiciens* situation, curators are uncertain about how to show new work from circuits which appear to be 'outside of' the mainstream. Yet this 'outside of' the mainstream applies equally to younger artists whose interventions are no longer dependent for their activation on the gallery site alone. The focus today is on actions which bring the artist out of that closet of objects and identifications and into a new dramaturgy of artistic practice. Here one can begin to see a shift in the relationship between the work and the public which is predicated less on the final results exposed in an exhibition setting than on the processes of interaction possible between other artists and other audiences. The question becomes what happens to the exhibit if the gravity of the exhibition space and its circuit are not maintained?

Increasingly, collaboration and movement across borders are becoming key features of artistic and curatorial strategies, a reflection of the growing practice of itinerancy in nineties art. Although Achille Bonito's attempt at 'cultural nomadism' within the Venice Biennale of 1993 was somewhat overshadowed by a greater interest in the visceral and morbid conditions of contemporary human existence exemplified by the success of Damien Hirst, Andres Serrano and Hans Haacke over and beyond the inclusion of African artists for example, the interest in cross-connections has still increased. In 1994, in one month alone, two significant exhibitions in Prague and Vienna have shown collaborations between artists from different locations in non-domestic settings. In the Royal Riding School in Prague, Albert Oehlen exhibits with Heimo Zobernig from Austria and Christopher Wool from the United States, expanding notions of painting far from the immediate gaze of New York or Cologne. At the Kunsthalle in Vienna, Saskia Bos asks Peter Kogler to work with Tatsuo Miyajima from Japan and Svetlana Kopysstiansky from Russia

285

with four exhibitions running each year. Gradually, as this artist-led initiative, run on a micro-political level by a *chef de village*, gained in autonomy, the Senegalese government increased its inspections of the site and in September 1983 succeeded in expelling the inhabitants and destroying most of the artworks. Its key element had been the artists' sense of autonomy and the setting up of professional studio space.[19]

The new Tenq in the shape of the St Louis workshop therefore had several histories within it. It reflected a far earlier mission than Triangle, generated by Senegalese artists and centred on building a long-term site for articulation without the constraint of the state. The new Tenq aimed to help solder professional contacts between artists in different parts of Africa on the basis of short-term creative exchange. Yet unlike the Botswana or Namibian Triangle workshops where the conditions of artistic practice in these countries was very rudimentary, the Senegalese artists came from a professional circuit which had already, since the sixties, accommodated the development of an elaborate art scene. This constellation of factors had a strong impact, for better or for worse, on the ability of the workshop to create a site for communication. If one gauges its success by the rate and quality of work produced there then there is no doubting the energy and impetus it provided

➡ **16.4 Flinto Chandia (Zambia) at work at Tenq, 1994. Photograph by Djibril Sy, reproduced by courtesy of Clémentine Deliss.**

for the majority of participating artists if for only two weeks. The role of the artist as instigator of the situation ultimately outweighed that of the organizational structure such that there was little if no press during the event, and very few purchases of work at the public open day.

If one keeps in mind the conditions set up by the *lotte* exhibition, where the presence of the artist had been actively suspended, then the Tenq experience can be seen as a reverse experiment, a response on behalf of artists to define their own parameters of action and briefly outweigh the powerful draw of conventional exhibition structures and their agents of legitimation. If *lotte* had excluded the artist's voice then it was only momentarily in order to draw attention to the public's dependency on a certain formulaic systems of interpretation when looking at art and material culture more generally. *Magiciens de la Terre* had in effect provided seed ground for such a contrasting analysis, given its conflation of the two approaches. *Magiciens de la Terre* wanted the liberation of the artist as magician, transformer and cliché of creation, in as ambiguous a sense as it was ready to deny the presence of differing contextual and critical references. It unleashed a huge area of discussion and debate which has yet to be fully resolved. Tenq, which had been inspired by the

Triangle concept that presupposed the innate creative urges of artists, in effect transgressed the workshop concept into another register of activity by making Triangle itself into a found object washed up on the shores of Africa. The romanticism of creativity in Triangle's early formulation had found a politicized counterpart in the Tenq of 1977 in Senegal, which could now be jointly reinvented in the St Louis Tenq of 1994. Common to both approaches was the sense of autonomy directed at the artist, over and above the specific institutional framework, and as a result each artist occupied and defined the space in which he or she operated differently. Tenq signalled the different spaces of communication which could be set up. It showed the overlap between the personalized studio environment, the installation of a working process in the context of the classrooms and the architecture of the school and the shift at the end of two weeks into a public space.

The current discourse about art is fragile and in formation, not, as one might assume, because the object is Africa, but because of an attempt, of which Tenq was a part, by artists and organizers alike to break into a new experimental space where the parameters of individual work are confronted with a collective situation, and where the space of definition and classification is in debate. This is clearly related to

overlapping fields of human and cultural expression in art is fragile, easily shattered by the very weight of recent colonial history and the seduction of newly emergent ethnic, racial and national identifications. Jumping out of a moving plane may be nothing more than trying to escape the monolithic siting of artistic debate within one geographical and cultural complex. For each one of us comes from somewhere different, lives somewhere different and moves in different circles. We are all part of this current 'socio-aesthetic transformation', claims the New York art critic Dan Cameron, and like Rirkit Tiravaniya perhaps we too should pause, cook, eat and talk for a moment and 'forget the distinctions between the artwork and the world to which it must eventually return'.[21]

To submerge oneself in the formulation of new practices, which involve the critic and curator as much as the artist in a new technology of representation, can feel precarious and lacking in analytical distance. Perhaps *lotte* and Tenq as two contrasting models, one emphatically recognizing the power of the critical system in art, and the other offering release from the strictures of this classificatory straightjacket in favour of the artists' autonomy to interact beyond such institutionalized grids, need to be looked at if only to be rejected and superceded? Artists in Africa may have different systems of patronage and interpretation which support their work, but is their debate not ultimately tied to those of artists in Europe? What is internationalism if it is not the assumption that ideas and their objects must be part of a wider exchange? If curating art can be opened up to include the questions which artists are raising in their work, then we may be closer than we thought to surpassing the cul-de-sac of existing systems of classification.

December 1994.

NOTES

A part of this essay was published in an earlier version in *Third Text*, 18 (Spring 1992), pp. 27–51.

1 James Roberts, 'Bas Jan Ader – The artist who fell from grace with the sea', *Frieze*, 17 (June–July 1994).

2 See for example the collection of essays *Global Visions: Towards a New Internationalism in the Visual Arts*, ed. Jean Fisher, Kala Press in association with the Institute of New International Visual Arts, London, 1994.

3 *Lotte or the transformation of the object*, Oct. 1990–Jan. 1991, Grazer Kunstverein and Akademie für Bildende Kunst, Vienna, Austria. Catalogue includes contributions by Stuart Morgan, Paul Rabinow, John Picton, Isabelle Graw, Michel de Certeau and Georges Bataille (German/English edition). The installation included a contextual video produced by Simon Underwood during the research in Ghana, Burkina Faso and Sierra Leone.

4 See my 'Exoticism and Eroticism: Representations of the Other in Early Twentieth Century French Anthropology', Ph.D Thesis, School of Oriental and African Studies, University of London, 1988.

5 Michel Foucault, *The Archeology of Knowledge*, London, Tavistock Press, 1974, p. 42.

6 Marilyn Hammersley-Houlberg, 'Ibeji Images of the Yoruba', *African Arts*, 1 (1973).

7 *Africa Explores*, Centre for African Art (now renamed and relocated as the Museum for African Art, New York, 1991.

8 See Andre Magnin, *Africa Hoy* or *Out of Africa* at the Centro Atlanico de Arte Moderno, Las Palmas and the Saatchi Collection London, respectively, 1992. These exhibitions are based entirely on the collection of John-Christophe Pigozzi which aims to be the largest collection of contemporary African art.

9 From a statement by Jean-Hubert Martin in an interview with Benjamin Buchloh in *Cahiers du Musée national d'art moderne*, 28 (Spring 1989), reprinted in English in *Third Text*, 6, p. 20.

10 See Charles Harrison, *Essays on Art and Language*, Oxford, Blackwell, 1991, pp. 4–6.

11 I am grateful to John Picton and the Department of Art and Archaeology at the School of Oriental and African Studies for enabling the seminar series 'Contemporary African art criticism' to take place between October and December 1991. This seminar series was interdisciplinary and involved several leading artists from Africa and the diaspora including David Koloane, Olu Oguibe, Sonia Boyce, Sokari Douglas-Camp and Gavin Jantjes.

12 *Elbow Room* was also the title of the gallery initiative of Lubaina Himid and Maud Sulter in London in 1986.

13 Dan Cameron, in *Frieze*, 17 (June–July 1994), p. 52.

14 From 'For the theatre and its double' (1931–36), in Antonin Artaud, *Selected Writings*, Berkeley, University of California Press, 1988, p. 235.

15 *africa95*, a season of events celebrating the arts of Africa, takes place in Africa in 1994 and in the UK in 1995. The main emphasis is on collaborations between artists working in different parts of Africa and the UK in the areas of the visual and performing arts, cinema, music and literature.

16 Tenq took place from 15 to 30 September 1994 at St Louis du Senegal and was hosted by artist El Hadji Sy with a committee of Senegalese artists including Souleymane Keita, Fodé Camara, Mustapha Dimé and Djibril N'Diaye. The invited artists were Musaa Baydi (Senegal), Anna Best (UK), Flinto Chandia (Zambia), Paul Clarkson (UK), Ndidi Dike (Nigeria), Guibril André Diop (Senegal), Mohamed Kacimi (Morocco), David Koloane (South Africa), Atta Kwami (Ghana), Khady Lette (Senegal), Amédy Kré M'baye (Senegal), Sam Nhlengethwa (South Africa), Agnes Nianhongo (Zimbabwe), Pape Macoumba Seck (Senegal), Dasunye Shikongo (Namibia), Yinka Shonibare (UK), Damy Théra (Mali), Yacouba Touré (Cote d'Ivoire), Babacar Sédikh Traoré (Senegal), Jacob Yacuba (Senegal).

17 The Triangle workshop was created in 1982 by sculptor Sir Anthony Caro and collector Robert Loder as a connecting point between the UK, USA and Canada. Loder had a passion for Abstract Expressionism, and a long friendship with Caro, and knew the South African art scene well. A few years later, in 1985 Caro travelled to South Africa where he met Bill Ainslie, a British painter with a strongly mystical approach to life who had settled there. Together with David Koloane, a leading Black South African painter

293

17

THE ONE-PICTURE GALLERY

Valery Petrovich Sazonov

Museum had the opportunity to interview the Director of the Savitsky Regional
Picture Gallery in Penza, Valery Sazonov, who also runs the branch of the gallery,
opened in 1983, known as the One-Picture Gallery. Remarkable exhibitions of the
best paintings from the major Soviet museums are held there on a continuous basis
in a small period building, a single canvas being exhibited for several months. The
exhibition is accompanied by an audio-visual programme. Since its opening, people
living in Penza have been introduced to fifteen pictures. Three of these were lent by
the Russian State Museum in Leningrad and three by the State Tretyakovsky Gallery
in Moscow.

Museum: There must be a reason why the One-Picture Gallery was set up in Penza.

Presumably, it was because of the town's specific history and its cultural traditions?
Sazonov: Certainly, Penza is an old Russian town founded in 1663. It spread out along the banks of the river Sura, which is one of the largest tributaries of the Volga.

Penza is famous for its cultural traditions. The first circus troupe in Russia was formed in the town in 1875, and the Penza Music Academy was established in 1882. The Lunacharsky Theatre in Penza, which is one of the oldest playhouses in Russia, dates from 1793. A picture gallery opened in 1892 and an art college in 1898.
Museum: The inhabitants of Penza have the opportunity to see the fine collection in the Picture Gallery which houses over 11,000 works and the temporary exhibitions organized in the town. What prompted you to arrange exhibitions of single pictures?
Sazonov: I think that when people visit exhibitions, particularly large exhibitions, they tend to be overwhelmed by the sheer number of works and find it difficult to study and 'experience' them in a relaxed way. The exhibits flash past like the countryside seen from the window of an express train. Not infrequently, all that remains after such a visit is a feeling of tiredness and irritation. The exhibition of a single work produces a greater emotional impact on the visitor.

The idea of exhibiting a single picture is not new. In the last century Bryullov

➡ **17.1 The One-Picture Gallery, Penza. Photograph courtesy of Penza Regional Picture Gallery.**

exhibited his painting *The Last Day of Pompei* in a number of European towns. Huge queues formed in Bolshaya Morskaya Street in St Petersburg to see Kuindzhi's picture *Moonlit Night on the Dnieper*. In 1974 Leonardo da Vinci's *Mona Lisa* was exhibited in a room by itself in the Pushkin Fine Arts State Museum in Moscow. The exhibition was organized in such a way that people were admitted directly to that room, saw the picture and then left the museum. Pictures may be presented separately in galleries for the purpose of acquainting people with new acquisitions, new attributions, newly restored pictures, etc., although as a rule such paintings are exhibited in the same room as other works.
Museum: You obviously didn't care for that arrangement?
Sazonov: Not entirely. Even if a separate room is set aside for the picture, the visitor intentionally or otherwise sees paintings by other artists in the gallery that are completely different in tone, and the impression produced by the work becomes blurred. It's also a good idea to provide additional information when people first encounter a painting or the work of a given artist. Experience also shows that the types of information usually provided in galleries – labels and explanatory comments – don't do much to encourage an interest in art. Hence the natural desire to find new approaches.

Museum: How did it all start? Where did the idea of setting up the One-Picture Gallery come from?

Sazonov: I think the idea was already in the air, so to speak, but it was first expressed in 1980 by the Secretary of the Penza Regional Party Committee, G.V. Myasnikov. He is an expert on our area and was involved in establishing and developing the activities of a number of museums in Penza.

Museum: How was this idea put into practice?

Sazonov: The One-Picture Gallery is the result of long research and much work. The town authorities granted us permission to choose premises for it, and we decided on the old postmaster's house, a small, detached single-storey building dating from the middle of the nineteenth century and situated on a hill with a good view of the town (Fig. 17.1). The area of the premises was about 120 square metres. Together with local architects, we drew up plans for converting the building into a gallery. The nineteenth-century style was completely preserved. The external and internal doors were copied by the restorers from mid-nineteenth-century originals, and the wrought ironwork of the internal staircase and windows was made on the basis of old originals by a self-taught smith from the town of Kuznetsk in Penza region.

The original idea was that a well-known painting would be exhibited for a limited period in a small building, in a room by itself with casually arranged armchairs. During their visit, the visitors would be able to consider the picture while sitting undisturbed in the armchairs, approach it, exchange opinions, etc.

Since then, we have changed our plans. Now – although we don't consider this solution to be final – visits to the gallery take the following form.

Visitors obtain tickets in advance, first because we consider that they should come prepared for the visit and second because the great success of the gallery in the town and region means that it's difficult to get in.

We've tried to create a favourable atmosphere for an encounter with art. The agreeable conditions help visitors to feel relaxed. They're asked to leave their coats in the cloakroom in the basement, and they then go up the stairs into the picture room, where they sit in comfortable armchairs. An average of thirty-five people attend each session. We've purposely not increased the number of places as we want to put the visitor in the right frame of mind for the rather intimate nature of the experience. The restful interior decor contributes to this aim.

The lights are turned off, and we start the slide show, which is accompanied by a

➡ **17.2 In the exhibition room, One-Picture Gallery, Penza. Photograph courtesy of Penza Regional Picture Gallery.**

soundtrack. The picture is meanwhile concealed behind a curtain.[1] Following a short pause at the end of the slide show, the screen is raised, the footlights are switched on, the curtain slowly opens and the visitors see the painting (Fig. 17.2). They can now examine it carefully without a commentary while hearing a specially selected musical accompaniment. The session lasts 40 minutes.

We had intended to exhibit the artist's drawings for the picture together with photographs, books, etc., in the room next to the viewing-room. But experience has shown that as our programmes provide visitors with a great deal of information and require a certain amount of emotional commitment from them, it's not a good idea to show them other material afterwards. However, we may look at this again if an extension, in which visitors can wait for the showing to start, is added to the original building. They could also be informed there about the origins of the One-Picture Gallery, for example.

Museum: How did you come to prepare audio-visual programmes based on slide shows with a soundtrack?

Sazonov: We intended from the outset to provide visitors with a certain amount of information about the work on show. We planned to do this by having a member of

the staff of the picture gallery give a 15- to 20-minute talk on the picture, and its painter, etc. But I thought that this approach was inappropriate, first because it had been decided that the showing of the picture would be accompanied by music that would create a suitable atmosphere and secondly because a guide could unintentionally distract visitors from the work by his speech and other mannerisms. Besides, it's impossible to talk about the very same picture maybe six times a day. It's too tiring and boring and must affect the quality of the commentary. Then we had the idea of showing a few slides to draw attention to specific areas of a painting or to introduce visitors to other works by the artist. Initially there were five slides, but we now show as many as fifty a session.

The next stage in our research was to do with the script for the slide show. We discovered that the museum staff could only produce scripts for standard lectures, a type of material that wasn't suitable for an experiment aimed at establishing a unique institution. We decided to approach a professional writer and art critic. It had been intended that the first picture to be exhibited in the gallery would be *Peter 1 Questioning the Tsarevich Aleksei*, by N.N. Ge, so we asked V.N. Porudominsky, the author of a monograph on the artist, to write the script. However, the gallery

Museum: An institution like yours does not have to face the problem of conserving its collections. But under what conditions are the works displayed?

Sazonov: That's a very important question, of course. The restorers from galleries who travel with the pictures are able to satisfy themselves that conditions for the display of pictures in the exhibition room are extremely good: temperature and humidity are maintained at a constant level, the number of visitors is very small, and air extraction ensures that the artificial lighting by 60-Watt bulbs does not lead to overheating. Also, the picture is behind the curtain most of the time. The building is fitted with a warning system to ensure that various parameters remain within safe limits for the picture.

Museum: What kind of people are your programmes aimed at?

Sazonov: When we set up the One-Picture Gallery we were principally thinking of using it to interest the general public in fine art. We are aiming at the local population of the town and the region and not at visitors. The gallery is gradually introducing them to quite a number of outstanding works of art, and the level of presentation is high enough to satisfy art lovers while remaining comprehensible to the uninitiated. The entries in the visitors' book indicate that many become regular visitors to the gallery and look forward to its next programme. It is interesting that visits to the Penza Picture Gallery have greatly increased since the opening of the One-Picture Gallery. After seeing our exhibitions many visitors become interested in art books and have a completely different perception of artists' works.

Museum: How many people visit the gallery?

Sazonov: Since it opened [twelve years ago] about 700,000 people have visited the gallery. You must bear in mind that there are only six sessions a day and, like the Picture Gallery, the One-Picture Gallery closes on one day a week: Thursday.

During the exhibition of the first picture we prepared a public survey questionnaire and began to do some sociological research. We discovered that over 50 per cent of visitors were workers from industrial enterprises and that there were many students and teachers. Another interesting fact is that we are popular with the rural population. For example, they accounted for one-fifth of the 30,000 people who visited the gallery during the exhibition of Plastov's picture *Spring*, which lasted six months. Visits to the gallery by country people are usually part of a cultural programme that also includes a circus or a theatre show and an introduction to the sights of the town.

Museum: There can be of course no better tribute to the work of the gallery staff than the appreciation shown by visitors. Could you give a few examples of remarks about the work of the One-Picture Gallery?

Sazonov: With pleasure. Many of them are very complimentary. Ms Glukhova, who is an engineer, writes in the visitors' book: 'Now Penza has two art centres! How

lucky we are!' Mr Ivanov, who is a lecturer at Penza Pedagogical Institute, says that: 'Even the viewing of the picture, or rather the way in which it is viewed, is original and is thought out to the last detail. This increases the emotional impact on visitors.' The comments of people from other towns who have managed to visit the gallery are equally enthusiastic: 'We are from Leningrad and have seen this picture several times, but here in your gallery we have seen it in a new light, as if for the first time. Thank you for this pleasurable experience.'

Museum: Everything you have said is indicative of a creative approach and of a search for new methods. What are you working on at present?

Sazonov: The Penza Picture Gallery recently took over the old land-bank building, erected in 1912 by the architect von Hohen. Our collection will be transferred there in 1986 after restoration work is completed. The exhibition area will be increased from 300 to 1,500 square metres, but it's not just a question of increasing the size of the Gallery: we've decided to reflect local artistic traditions more fully in the new layout, concentrating on the works of the Penza artists who are the pride of our region. Popularization of the cultural heritage is a most important way of instilling a feeling of patriotism and love for one's country. The rooms of the Gallery will house three exhibitions commemorating our outstanding local artists: the first Director of the Art Gallery, Savitsky, Repins's pupil, Goryushkin-Sorokapudov, and also Lentulov. We intend to exhibit documents, photographs and personal belongings as well as their works. After all, it's possible to try out new techniques in various types of exhibition establishment. After making slide shows with soundtracks, we decided to make some films with the same script as the slide shows and to show them on TV. Now we have ten films.

Translated from Russian.

NOTES

This essay was originally published in *Museum*, 152 (1986), pp. 237–40. Statistics have been updated to 1995.

1 The curtain was specially made for the Gallery by Moscow artist L.V. Litvinova.

2 This led to the formation of a permanent production team: soundtrack-scriptwriter. V. Porudominsky; director–producer, I. Velednitskaya; slide-show director–producer, V. Sazonov; engineer, E. Frolov.

3 Produced by the artist, A. Merkushev.

305

In one of his most famous exhibition designs – the *Demonstration Room* for the International Art Exhibition in Hannover and Dresden in 1926 – Lissitzky was faced with the problem of how to display an overwhelming amount of work in a rather small and intimate space. His solution involved the use of thin wooden strips attached to the wall at 90° angles and in vertical rows; these strips were painted white on one side and black on the other and mounted against a grey wall. From one vantage the wall appeared white, from the other side it appeared black, and when viewed from the front it seemed to be grey. Thus, according to Lissitzky, the artworks were given a triple life. In addition, the paintings were double-hung on a movable panel system so that while one of the two was visible, the other could be partly seen through the perforations of the sliding plate. In this way Lissitzky claimed to have achieved a solution whereby the specially designed room could accommodate one and a half times as many works as a conventional room. At the same time, only half of the works could be seen at any one time.

We might compare Lissitzky's method to that other exhibition/display system which reached its apogee in the 1920s: the life-size diorama. Most notoriously instituted in the Museum of Natural History, New York, the diorama is perhaps best

↓ **18.1 "Coca Cola Convention", Pier 3, San Francisco, 1980. Exhibition design by a team of which Judith Barry was a member. Photograph by Judith Barry.**

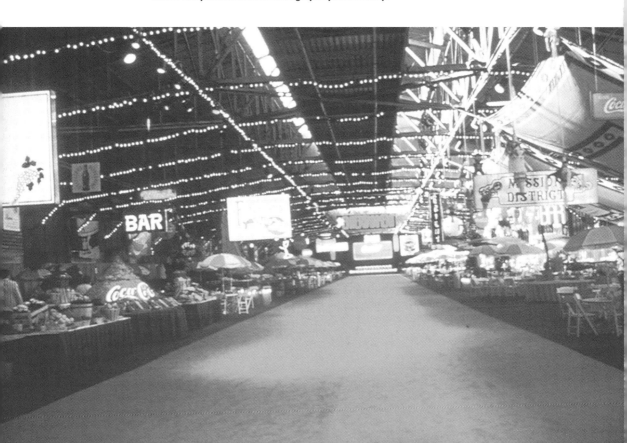

characterized by Carl Akeley's famous gorilla group diorama completed in 1926. There the spectacle itself (in this case the spectacle of 'nature' and 'wildlife') must be duplicated and recreated in such a way that the viewer might experience simultaneously the power of domination as well as the surrender of belief. At the same time, the quest for greater and greater verisimilitude had already culminated in the development of the cinema apparatuses, so that in one sense at least the dioramas of the Museum of Natural History point to a relative loss of power instilled in the object.

Previously, the Victorian era – the historical juncture of both industrialization and psychoanalysis – had produced a fetishization of the domestic object leading to the design of specific cabinets enclosed in glass for display. But the exotic and fetishized objects, often collected from foreign lands, also referred to another tradition of display: the spoils of war. In Greco-Roman times, displaying what had been taken in conquest took on various meanings since 'bounty' was exhibited not only to nobility, but also to commoners and slaves. Those who lined the streets gazed in awe at power conquered, brought home through possession, and served up as symbolic consumption. This dramatic exposition of the conquered object, surely the beginning of fetishism as developed in Freud's reworking of the myth, leads to a

⬇ 18.2 *Damaged Goods*, installation view, New Museum, New York, 1986. Exhibition design by Judith Barry. Photograph by Judith Barry.

NOTE

This essay was originally published in *Damaged Goods*, catalogue for the exhibition, New York, New Museum, summer 1986. Judith Barry's artistic contribution to the exhibition was the design of the show. It was subsequently reprinted in *Public Fantasy: An Anthology of Critical Essays, Fictions and Project Descriptions*, ed. Iwona Blazwick, London, ICA, 1991, pp. 101–4.

19

FUNCTION OF ARCHITECTURE
Notes on work in connection with the places where it is installed taken between 1967 and 1975, some of which are specially summarized here

Daniel Buren

SINCE THE RENAISSANCE
We can speak of the internal architecture of a painting, or of any other work of art.

This architecture of the work, the way in which it is constructed from its frame, the canvas and what is expressed on it (or beneath it), has an exclusive development which, since the Renaissance, has not ceased to distance it further and further from the architecture or place in which the work becomes known.

It can be said that the history of modern art (in particular) is the history,

presupposes either that this architecture is familiar, or that it is being deliberately ignored.

THE CUBE. WHITE. IDEALISM

To know the architecture without having seen it is to accept working *a priori* in the context of an aseptic and (so-called) neutral place, cubic, vertical walls, horizontal, white floors and ceiling. This architecture is the well-known kind, since it is more or less what is found in all the museums and galleries of the Western World, a place architecturally adapted to the needs of the market implied and allowed by such a transportable commodity.

This white and 'neutral' cube is therefore not as innocent as all that, but is in fact the value-giving repository already often mentioned. Certain artists consistent in their work, who know that their work can only be interpreted in a place like the one described above, have places of exhibition specially built inside which do not correspond to these norms, cubic and immaculate spaces. They thereby demonstrate that their work does indeed depend on architecture, but not just anyone, since it cannot submit to any other which is not cubic or white: ideal.

ALIENATION

316

In both cases it is obviously a question of a setting which under the pretext of illuminating the subject (the work) in order to make it as autonomous as possible – so that nothing which is not the work manages to distract the eye – in fact alienates, in a detrimental way, the aforementioned work in the context of the obligatory architectural frame, which is obviously never mentioned.

A SPIDER'S WEB

As for those who wish to ignore the architectural context in which they exhibit, they are the ones who still believe that a work is self-sufficient, no matter what surrounds it and no matter what the conditions in which it is perceived.

This is the case with practically all painting which consoles itself in a debilitating *en-soi*, which attempts to escape the external difficulties by contemplating its navel and drawing the viewer into the mesh of its woven threads, like a spider's web catching flies.

CYNICAL, IGNORANT

A work is thus dramatized or emphasized (against its will or by request) by a so-called neutral architecture, or indeed the work turns up its nose at any external

influence and attempts, despite everything, to attract the eye regardless of the context. This second attitude seems presumptuous to me, since the context (the architectural frame) always wins, rounding on those who ignore it.

The first attitude is cynical (we know what the work needs to triumph and we eliminate *a priori* any conflict likely to undermine this triumph).

The second attitude is idealistic or ignorant (and in both cases succumbs to attacks from outside).

The two attitudes both stem from art as it is, in the majority of cases, up to the present day: reactionary, depending on and accepting the ruling ideology.

WITHOUT AN ESCAPE ROUTE

To imply in the work the place where it is situated (whether internal or external) is to give the limits materially and visually, without leaving an escape route. It is also to bind oneself to a certain given reality which the work if necessary will undertake to criticize, to emphasize, to contradict, in a word to dispute dialectically. The sharpness of the comment will depend on the precision of the invention.

THE ARCHITECTURE

The architecture in which the work of art is exhibited must be taken into account, under the threat of permanently reducing the work to nothing. It is therefore certainly not a matter of carrying out a work of architecture. Nor is it a matter of choosing an architecture to suit the point one wants to make.

All architecture must be able to be used.

Few works can lend themselves to the experiment.

It is not a problem of architecture on one side and a problem of art unknown to it on the other.

Neither is it a question of art submitting to architecture, nor of architecture wedding art.

FUNDAMENTAL DIFFERENCE

It is a question of a conflict relationship, where both parties are on trial concerning a difference. And first of all concerning a fundamental difference with art, as it attempts to establish itself. The point of intersection or point of rupture with modern art – between a work and its place (the place where it is seen), is situated 'somewhere else', outside the work and no longer entirely in the place, a central point which is continually off-centre and a point on the edge, asserting its difference at the same time.

317

20

THE GALLERY AS A GESTURE

Brian O'Doherty

The value of an idea is proved by its power to organize the subject matter.

(Goethe)

From the twenties to the seventies, the gallery has a history as distinct as that of the art shown in it. In the art itself, a trinity of changes brought forth a new god. The pedestal melted away, leaving the spectator waist-deep in wall-to-wall space. As the frame dropped off, space slid across the wall, creating turbulence in the corners. Collage flopped out of the picture and settled on the floor as easily as a bag lady. The new god, extensive, homogeneous space, flowed easily into every part of the gallery. All impediments except "art" were removed.

No longer confined to a zone around the artwork, and impregnated now with the memory of art, the new space pushed gently against its confining box. Gradually, the

gallery was infiltrated with consciousness. Its walls became ground, its floor a pedestal, its corners vortices, its ceiling a frozen sky. The white cube became art-in-potency, its enclosed space an alchemical medium. Art became what was deposited therein, removed and regularly replaced. Is the empty gallery, now full of that elastic space we can identify with Mind, modernisms's greatest invention?

To present the content of that space leads to Zen questions: When is a Void a plenum? What changes everything and remains itself unchanged? What has no place and no time and yet is period? What is everywhere the same place? Once completed by the withdrawal of all apparent content the gallery becomes a zero space, infinitely mutable. The gallery's implicit content can be forced to declare itself through gestures that use it whole. That content leads in two directions. It comments on the "art" within, to which it is contextual. And it comments on the wider context – street, city, money, business – that contains it.

First gestures have a quality of blundering, indicating an imperfect consciousness. Yves Klein's gesture at the Galerie Iris Clert on 28 April 1958, may have been in search of "a world without dimension. And which has no name. To realize how to enter it. One encompasses it all. Yet it has no limits." But its implications for the

➡ **20.1 Yves Klein, *Le Vide*, Musée d'Art Moderne, Paris, 26 January 1962. Photograph by Harry Shunk.**

gallery space were profound. It was a remarkably complete event, as complete as his image of himself as mystic and angel eating the air, promise-crammed. He arrived (in his famous photograph) in free-fall from a second-floor window. From judo he learned how to land without injury. What he really alighted upon was, perhaps, the rather complacent pool of French painterliness. Time gives method to his madness and illustrates how modernism recreates, from photographs, some of its most influential touchstones.

For avant-garde gestures have two audiences: one which was there and one – most of us – which wasn't. The original audience is often restless and bored by its forced tenancy of a moment it cannot fully perceive – and that often uses boredom as a kind of temporal moat around the work. Memory (so disregarded by modernism which frequently tries to remember the future by forgetting the past) completes the work years later. The original audience is, then, in advance of itself. We from a distance know better. The photographs of the event restore to us the original moment, but with much ambiguity. They are certificates that purchase the past easily and on our terms. Like any currency, they are subject to inflation. Aided by rumor, we are eager to establish the co-ordinates within which the event will maximize its

historical importance. We are thus offered an irresistible opportunity to partake in creation, of a sort.

But to return to Yves Klein suspended over the pavement like a gargoyle. Klein's gallery gesture had a trial run at the Galerie Colette Allendy in Paris in 1957. He left one small room bare to, as he said "testify to the presence of pictorial sensitivity in a state of primary matter." That "presence of pictorial sensitivity" – the empty gallery's content was, I believe, one of the most fatal insights in postwar art. For his major gesture at Iris Clert's, "He painted the facade on the street blue," wrote Pierre Descargues in a Jewish Museum catalogue, "served blue cocktails to the visitors, tried to light up the Luxor obelisk in the Place de la Concorde, and hired a *garde republicaine* in uniform to stand at the entrance to the gallery. Inside he had removed all the furniture, painted the walls white, whitened one showcase which contained no object." The exhibition was called *The Void*, but its longer title, developing the previous year's idea, is more instructive: *The isolation of sensibility in a state of primary matter stabilized by pictorial sensibility.* An early visitor was John Coplans, who thought it odd.

On opening night, three thousand people came, including Albert Camus, who

wrote in the book: "With the Void. Full Powers." While offering itself as site and subject, the gallery primarily hosted a transcendent gesture. The gallery, the locus of transformation, became an image of Klein's mystical system – the grand synthesis derived from the symbolists in which *azur* (International Klein Blue) became the transubstantiating device – the symbol, as it was for Goethe, of air, ether, spirit. In a conceit reminiscent of Joseph Cornell, Klein had touched space through the sputnik flight in 1957, which he surrounded with a mystical halo. Klein's ideas were a nutty but oddly persuasive mix, stirring mysticism, art, and kitsch in the same pot. His art raises again, as the work of successful charismatics does, the problem of separating the objects of art from the relics of a cult. Klein's work had generosity, utopian wit, obsession, and its share of transcendence. In that apotheosis of communication that becomes communion, he offered himself to others and others consumed him. But like Piero Manzoni, he was a prime mover, very European, rife with metaphysical disgust at the ultimate bourgeois materialism: the hoarding of life as if it were a possession on the order of a sofa.

Outside blue, inside the white void. The gallery's white walls are identified with spirit, filmed over with "pictorial sensitivity." The blanched display case is an epigram on the idea of an exhibition: it raises the prospect of serial contexts (in the empty gallery, the display case contains nothing). The double mechanism of display (gallery and case) reciprocally replaces the missing art with itself. To insert art into gallery or case puts the art in "quotation marks." By making art an artificiality within the artificial, it suggests that gallery art is a trinket, a product of the boutique. What is now called the support system (a phrase that became popular with the maintenance of life in space) is becoming transparent. As time goes by, Klein's gesture becomes more successful; history obligingly curves into an echo chamber.

The theatrics – the *garde*, the cocktails (another comment on inside/outside?), the Luxor obelisk inscribing the void above like a wrinkled pencil (this one didn't work out) – brought that attention without which a gesture is stillborn. This was the first of several gestures that use the gallery as a dialectical foil. These gestures have a history and a provenance, each tells us something about the social and esthetic agreements that preserve the gallery. Each uses a single work to draw attention to the gallery's limits, or contains it in a single idea. As the space that socializes those products of a "radical" consciousness, the gallery is the locus of power struggles conducted through farce, comedy, irony, transcendence, and of course, commerce. It is a space that rides on ambiguities, on unexplored assumptions, on a rhetoric that, like that of its parent, the museum, barters the discomforts of full consciousness for the benefits of permanence and order. Museums and galleries are in the paradoxical position of editing the products that extend consciousness, and so contribute, in a liberal way, to the necessary anesthesia of the masses – which goes under the guise of

entertainment, in turn the laissez-faire product of leisure. None of this, I might add, strikes me as particularly vicious, since the alternatives are rampant with their own reformist hypocrisy.

In proper teleological fashion, Klein's gesture produced a response at the same gallery. Iris Clert's, in October 1960, the same month that the New Realists formally composed themselves as a group. Klein's *Void* was filled with Arman's *Le Plein*, an accumulation of garbage, detritus, waste. Air and space were evicted until, in a kind of reverse collage, the trash reached critical mass by pressing against the walls. It could be seen pressing against the window and door. As a gesture it lacks the ecstasy of Klein's transcendent nostomania. More mundane and aggressive, it uses the gallery as a metaphorical engine. Stuff the transforming space with refuse and then ask it, grotesquely overloaded to digest *that*. For the first time in the brief history of gallery gestures, the visitor is *outside* the gallery. Inside, the gallery and its contents are now as inseparable as pedestal and artwork. In all this, there is a bit of what Arman himself called a tantrum. Modernism with its rigorous laws often exasperates its own children whose very disobedience acknowledges parental rule. By rendering the gallery inaccessible, and reducing the excluded visitor to peering through the window at the junk within, Arman initiated not just divorce proceedings, but a major schism.

Why should the early gallery gestures have come from the New Realists in the late fifties and the sixties? Infused with social consciousness, their work was coming to an influential denouement. But it was undercut by international art politics.

325

> It was the tough luck of the Parisian avant garde [wrote Jan van der Marck], baptized by Yves Klein's presentation of the Void at Iris Clert's in Paris in 1958 and institutionally enshrined in Nieuwe Realisten at the Haags Gemeentenmuseum in June 1964, to coincide with the demise of Paris and the ascendancy of New York. In the struggle for international attention 'Frenchness' became a liability, and young American artists believed that the tradition from which it drew was bankrupt.

Americans capitalized on their idea of the raw in contrast to Europe's haute cuisine. Yet the New Realists' perception of the gallery's politics was more astute. The early New Realist gestures, apart from Klein's marvelous hocus-pocus, have a savage edge. But then the European gallery has a political history dating from at least 1848. It is by now as ripe as any symbol of European commerce that may present itself to the jaundiced eye. Even the most amiable of New Realist gestures has a hard center. In Stockholm at the Addi Køpcke Gallery in 1961, Daniel Spoerri arranged for the dealer and his wife, Tut, to sell groceries just bought from the store at "the current market price of each article." Stamped "CAUTION: WORKS OF ART," each item bore Spoerri's "certifying signature." Was this parody of commerce visible to the

dealer? Could it have happened on the Milan/Paris/New York axis?

The New York gesture that charged every particle of the gallery space had a more amiable complexion. One of the sights of the sixties was entering the Castelli Gallery in 1966 and seeing Ivan Karp shepherding with a pole Andy Warhol's silver pillows (p. 357) as they floated and drifted in that historic uptown space at 4 East 77th Street. Every part of the space was active, from the ceiling – against which the pillows bumped – to the floor where they occasionally sank, to be agitated again. This discrete, changing, and silent artwork mocked the kinetic urgencies buzzing and clanking in the galleries of the day, laid claim to pedigree (all over space) and united happiness with didactic clarity. Visitors smiled as if relieved of a deep responsibility. That this work was not a fluke was clear from the *Cow Wallpaper* papering a small adjacent room. From the heroic forties and fifties, phrases like Harold Rosenberg's "apocalyptic wallpaper" still hung in the air. Reducing the prime symbol of energy to wallpaper – etiolated further by repetition – brought matters of high seriousness into the precincts of interior decoration, and vice versa.

Warhol's astute relation to wealth, power, and chic is deeply implicated in the fictions of American innocence – very different from the European's instinctive

➡ **20.2 Arman, *Le Plein (Full-Up)*, Galerie Iris Clert, Paris, 1960. Photograph by Harry Shunk, reproduced courtesy of Arman, New York.**

ability to locate the enemy. American innocence is sustained by a variety of delusions which recent successful avant-gardes have tended to share. Arman's assassination of a white Mercedes attacked a materialism very different from that of the Americans. Anarchic gestures in America do not do well. They tend to refute the official optimism born of hope. Accumulating below the threshold of good form and acceptable style, they tend to be forgotten. I think of Tosun Bayrak's "banged-up dirty white automobile on Riverside Drive in New York City, stuffed ... full of animal guts ... a bull's head peering out the front window ... left ... until the neighborhood stank" (Therese Schwartz).

Whatever its excesses, the American avant-garde never attacked the *idea* of a gallery, except briefly to promote the move to the land, which was then photographed and brought back to the gallery to be sold. Materialism in America is a spiritual thirst buried deep within a psyche that wins its objects from nothing and will not give them up. The self-made man and the man-made object are cousins. Pop art recognized this. Its blurred fusion of indulgence and criticism reflected the bourgeois's material pleasures enhanced by a little spiritual thirst. The satiric impulse in American art, apart from Peter Saul, Bernard Aptheker, and a very few others, remains without its object,

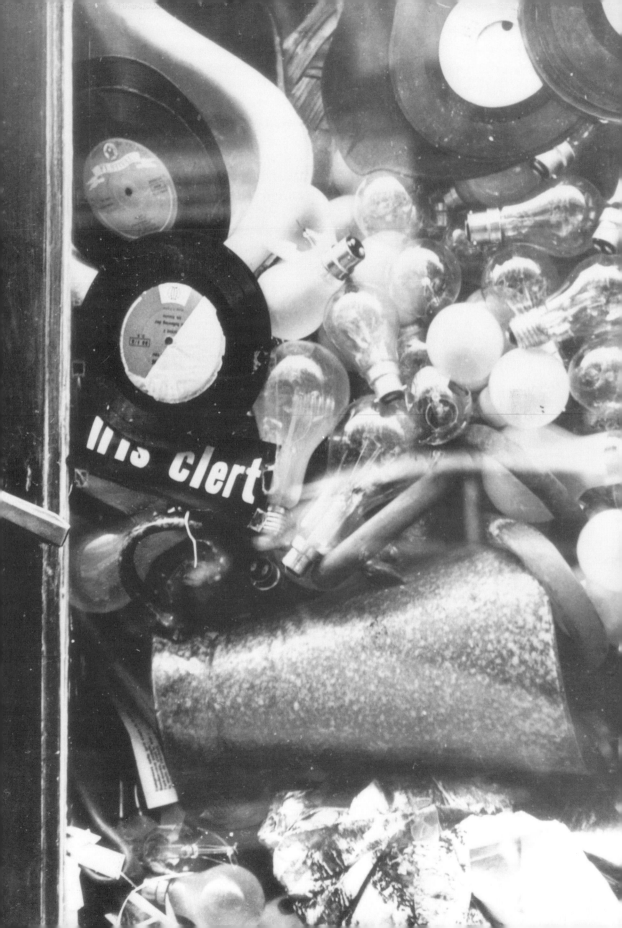

somewhat unfocused and insecure as to the nature of its enterprise. In a country where the social classes are imperfectly defined, and the rhetoric of democracy makes their separation suspect, criticism of material success often appears as a form of sophisticated envy. For the artist, of course, the avatar of all this is his or her product. It tends to be the agent of his or her alienation, to the degree that it enters the social matrix. In an operation that never fails, it has its meaning lifted. The site of that operation is the gallery. So Arman's visitor, denied entry outside the stuffed Galerie Iris Clert, may recognize some of the artist's anger in his own.

The excluded visitor, forced to contemplate not art but the gallery, became a motif. In October 1968, the European artist most sensitive to the politics of the gallery space, Daniel Buren, sealed off the Galleria Apollinaire in Milan for the duration of the exhibition. He glued vertical white and green stripes on fabric over the door. Buren's esthetic is generated by two matters: stripes and their location. His theme is encouraging the world's systems to vocalize themselves through his constant stimulus, his catalyst, monogram, signature, sign. The stripes neutralize art by depletion of content. As a sign of art they become an emblem of consciousness – art was here. "And what does art say?" the situation asks. As a sign, the stripes represent

➡ 20.3 Daniel Buren, *Les hommes-sandwiches*, work *in situ* at the Musée d'Art Moderne, Paris, 1968. Photograph courtesy of the John Weber Gallery, New York.

a recognizable aspect of European avant-gardism: a cool intelligence, politically sophisticated, commenting on the social agreement that allows art to be made and yet demeans it. So the stripes bring to the door of the gallery not art so much as a monologue in search of an argument.

This gesture was preceded, as Yves Klein's was, by a modified trial run at the Salon de Mai held at the Museum of Modern Art in Paris. Buren offered his *Proposition Didactique*. One wall of an empty gallery was covered with green and white stripes. Stripes were placed on 200 bill-boards around the city. Outside the gallery, two men with striped billboards paraded. One is reminded of Gene Swenson walking up and down outside the Museum of Modern Art in the early seventies, carrying a sign emblazoned only with a question mark. (Swenson and Gregory Battcock were the two New York figures with a political intelligence comparable to that of the New Realists. No one took them very seriously. Life, however, did: they both died tragically.)

Buren's Milan stripes closed the gallery in much the same way that public health officials close infected premises. The gallery is perceived as a symptom of a disordered body social. The toxic agent isolated within is not so much art as what –

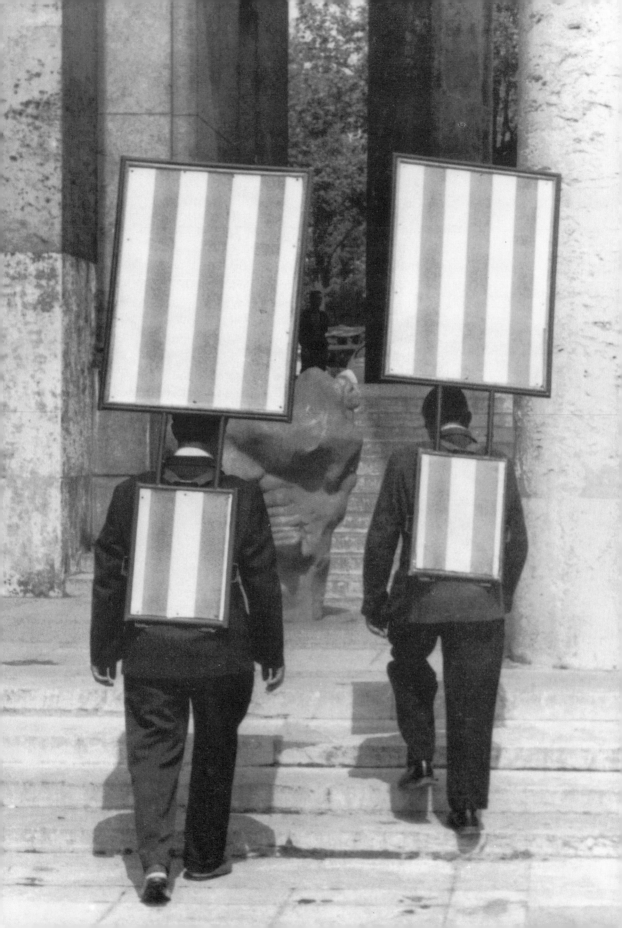

in every sense – contains it. Art is also contained by another social agreement (in my opinion, external to it) called style. The stripes, which identify a personality with a motif and a motif with art, imitate the way style works. Style is constant, so Buren's constant stimulus is a grotesque parody of it. Style, we know, extracts from the work an essence which is negotiable cross-culturally. Through style, as André Malraux demonstrated, all cultures talk to you. This idea of a formalist Esperanto goes with the placeless white cube. Formalist art in placeless galleries stands, like the medieval church, for a system of commerce and belief, insofar as style succeeded in identifying meaning with itself, the work's content was devalued. This connoisseurship facilitated the assimilation of the work, no matter how bizarre, into the social matrix. Buren understands perfectly this form of socialization. "How can the artist contest society," he asks, "when his art, all art, 'belongs' objectively to that society?"

Indeed much of the art of the late sixties and the seventies had this theme: How does the artist find another audience or a context in which his or her minority view will not be forced to witness its own co-optation? The answers offered – site-specific, temporary, nonpurchasable, outside the museum, directed toward a nonart audience, retreating from object to body to idea – even to invisibility – have not proved

➡ **20.4 Les Levine, *White Sight*, Fischbach Gallery, New York, 1969. Photograph courtesy of Les Levine.**

impervious to the gallery's assimilative appetite. What did occur was an international dialogue on perception and value-systems – liberal, adventurous, sometimes programmatic, sometimes churlish, always anti-establishment and always suffering from the pride that demands the testing of limits. The intellectual energy was formidable. At its height it seemed to leave no room for artists who were just good with their hands – inviting subsequent fictions of dumbness and a return to the canvas. Artists' revolutions, however, are bounded by the inexorable rules that include those implicit in the empty gallery. There was an exhilarating run of insights into the cycle of production and consumption; this paralleled the political troubles at the end of the sixties and the beginning of the seventies. At one point, it seemed as if the gallery's walls were turning to glass. There were glimpses of the world outside. The gallery's insulation of art from the present while conveying it to the future seemed for a moment deeply compromised. Which brings us back to Buren's closed doors. "[T]he artist who creates silence or emptiness must produce something dialectical: a full void, an enriching emptiness, a resonating or eloquent silence, " wrote Susan Sontag in "The Esthetics of Silence." "Art" forces the void behind the closed door to speak. Outside, art is saved and refuses to go in.

This conceptualization of the gallery reached its ultimate point a year later. In December 1969, in the *Art & Project Bulletin*, no. 17, Robert Barry wrote, "during the exhibition the gallery will be closed." This idea had been realized at the Galleria Sperone, Turin, December 1969, with the title "For the exhibition the gallery will be closed." It was made in another form at the Eugenia Butler Gallery in Los Angeles the following March. For three weeks the gallery was closed; outside, the legend was posted "MARCH 10 THROUGH MARCH 21 THE GALLERY WILL BE CLOSED." Barry's work has always employed scanty means to project the mind beyond the visible. Things are there but barely seen (nylon string); process is present but cannot be sensed (magnetic fields); attempts are made to transfer ideas without words or objects (mentalism). In the closed gallery, the invisible space (dark? deserted?), uninhabited by the spectator or the eye, is penetrable only by mind. And as the mind begins to contemplate it, it begins to answer. As art-in-potency, the gallery begins to ruminate about frame and base and collage – the three energies that, released within its pristine whiteness, thoroughly artified it. As a result, anything seen in that space involves a hitch in perception, a delay during which expectation – the spectator's idea of art – is projected and seen.

This doubling of the senses – advocated by such disparate characters as Henry David Thoreau and Marcel Duchamp – became in the sixties a period sign, a perceptual stigma. This doubling enables sight, as it were, to see itself. "Seeing sight" feeds on emptiness: eye and mind are reflected back to engage their own process. While this can produce interesting forms of perceptual narcissism and quasi-blindness, the sixties were more concerned with eroding the traditional barricades set up between perceiver and perceived, between the object and the eye. Vision would then be able to circulate without the impediment of traditional conventions. Such a perceptual Utopia was consonant with the radical sensory transformations of sixties culture. In the galleries, its most cogent expression was in Les Levine's *White Sight* at the Fischbach Gallery in January 1969. On entering the gallery the spectator, deprived of color and shadow by two high-intensity monochromatic sodium vapor lights, attempted to recreate the space. Other viewers became visual cues, points of reference from which to read the space. The audience thus became an artifact. Without sight, the audience turned back on itself, attempted to develop its own content. This intensified the experience of being alone in any empty white gallery, in which the act of looking, coached by expectation, becomes a kind of instant artifact. So, to return to the white space, the twin contexts of anticipation – the gallery and the spectator's mind – are fused in a single system, which could be tripped.

How could this be done? The minimal adventure reduced the stimulus and maximized its resonance within the system. In this exchange, metaphor died (this

was Minimalism's major contribution, shutting the door on Modernism). The containing box, the white cube, was forced to declare some of its hidden agenda, and this partial demythification had considerable consequences for the installation idea. Another response was to literalize life or nature within the gallery: e.g. Jannis Kounellis's horses, intermittently occupying art spaces from 1969 on; Newton Harrison's doomed fish at the Hayward Gallery in 1971. Any transformation that occurred at these extreme points was more alchemical than metaphorical. Transformation became the spectator's rather than the artist's role. Indeed the artist's role became a kind of *de-creation*, providing a stimulus for the spectator to take into his or her art-making system (art as the opiate of the upper middle classes).

In transforming what is present in the gallery – which resists transformation – we are becoming the creator, painlessly. In that process we are ourselves artified, alienated from the work even as we transform it. Spectators in a gallery begin to look like Kounellis's horses. The confusion between the animate and inanimate (object and spectator) reverses the Pygmalion myth: the art comes alive and reifies the spectator. Consciousness is the agent and medium. So the possession of a higher consciousness becomes a license to exploit its evolutionary inferiors. In such ways does the gallery situation reflect the real world outside it. The confusion of art and life invites gestures that would push it to the extreme – a murder in a gallery, perhaps? Is it art? Would that be a legal defense? Would Hegel testify to its dialectical relation to the gallery space? Would Jacques Vaché be called as a witness for the defense? Could the work be sold? Would the photo-documentation be the real work? And all the time, in Barry's empty gallery, the meter ticks; someone is paying the rent. An enlightened dealer is losing money to help make points about the space that sells things. It is as if a Bedouin were starving his horse or an Irishman suffocating his pig. In Barry's closed space, over the three weeks, the space stirs and mutters; the white cube, now a brain in a bowl, does its thinking.

These gestures seek, in short, transcendence, exclusion through excess, isolation through dialectic and through mental projection. They found their opposite in a work done, accommodatingly enough, in the southern hemisphere. Lucy R. Lippard in her *Six Years: The Dematerialization of the Art Object from 1966 to 1972* (one of the great books of the seventies) describes it thus:

333

> The Rosario group begins its "Experimental Art Cycle" . . . October 7–19: Graciela Carnivale . . . a totally empty room, the window wall covered to provide a neutral ambiance, in which are gathered the people who came to the opening; the door is hermetically sealed without the visitors being aware of it. The piece involved closing access and exits, and the unknown reactions of the visitors. After more than an hour, the "prisoners" broke the glass window and escaped.

the collaborators in Chicago were both European, one Dutch, the others Bulgarian. Van der Marck's tenure at the museum is now a fabled era, unmatched by that of any other curator of the sixties, with the possible exception of Elayne Varian's at Finch College in New York. Van der Marck became in part the co-creator of the work; offering the museum as a subject for examination was in perfect accord with modernist practice – to test the premises of every assumption and to subject them to argument. This is not the tradition of the American curator, nor of his or her trustees.

The Christos' wrappings are a kind of parody of the divine transformations of art. The object is possessed, but the possession is imperfect. The object is lost and mystified. Individuality of structure – the identifying morphology is replaced by a general soft outline, a synthesis that like most syntheses furthers the illusion of understanding. Let us confine ourselves to just a few gatherings from the harvest offered by The Wrapping of the Chicago MCA (process) or The Wrapped MCA (product). The museum, the container, is itself contained. Does this double positive, artifying the container that itself artifies, produce a negative? Is this an act of cancellation, discharging the accumulated content of the empty gallery?

⬇ **20.6 Christo and Jeanne-Claude, *Wrap In, Wrap Out*, interior view of the Museum of Contemporary Art, Chicago, January 1969. Photograph by Harry Shunk, courtesy of Christo and Jeanne-Claude Christo.**

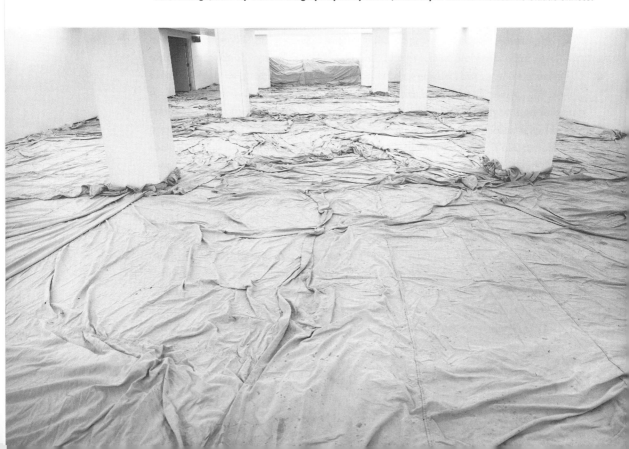

The Christos' work presses esthetic issues to their social context, there to engage in political brokerage. A position must be taken not just by art folk but by the immediate public, to whom art is usually as remote as the phyla in an aquarium. This is not a consequence of the work but its primary motivation. It is both avant-garde (traditionally engagé) as well as post-modern (if the audience is fatigued, get another audience). It is also remarkable for the firmness of its ironies, which play for keeps – the loss of vast amounts of money, the one thing the public always understands. But what gives the work a political dimension – a closely reasoned argument with prevailing authority – is the way in which its process is conducted. The corporate structure is marvelously parodied: plans are made, environmental reports sought from experts, opposition is identified and met, energetic debate is accompanied by its share of democratic madness (public arguments on a local level bring out a free society's strangest mutants). All this is followed by the hard-hat technologies of installation, sometimes revealing the incompetence of various suppliers and of American know-how. Then the work is realized, to be quickly withdrawn as if its witnesses could bear no more than a glimpse of beauty.

These public works are of Robert Moses scale, but their awesome acquisitiveness

⬇ **20.7 Christo and Jeanne-Claude, *Wrap In, Wrap Out*, Museum of Contemporary Art, Chicago, 1969. Photograph by Harry Shunk, courtesy of Christo and Jeanne-Claude Christo.**

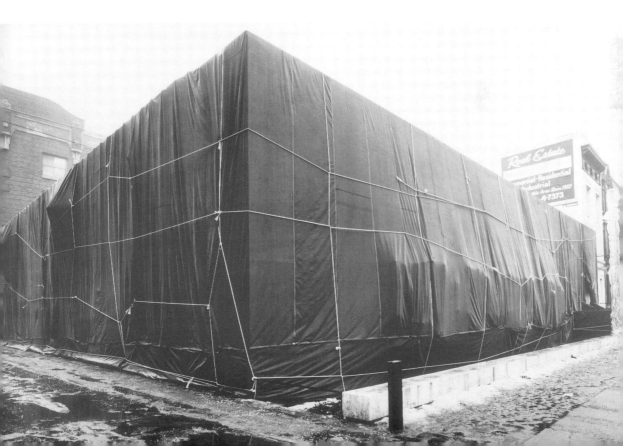

is perpetrated with the most gentle, tolerant, and insistent grace. This combination of advanced esthetics, political subtlety, and corporate methods is confusing to the audience. Siting gigantic artworks in the midst of the body social is not a part of the American tradition. The Brooklyn Bridge had to be built before Hart Crane and Joseph Stella could get to work on it. Large-scale American art generally draws the Adamic artist to remote areas where transcendence is immanent. The Christos' projects mimic in scale the good works of government. They provide the useless at great expense. What he chooses to wrap involves expenditures of such magnitude (\$3.5 million for the *Running Fence*) that it seems irresponsible to those working on their heart attacks. Yet in the imperial tradition of Ayn Rand selfhood, he raises all the money through sale of his work. Despite such serious business, I am always surprised when sophisticated people think he is having fun. Some fun. His projects are one of the very few successful attempts to press the rhetoric of much twentieth-century art to a conclusion. They force the utopian issue in the country that was once Utopia. In doing so they measure the distance between art's aspirations and society's permissions. Far from being the Russian dream of an advanced art at home in an advanced society, they use the methods of an imperfect society and its myths of free enterprise to impose a will as powerful as that of any corporate board chairman's. Far from being folly, Christo and Jeanne-Claude Christo's projects are gigantic parables; subversive, beautiful, didactic.

338

The choice of the Modern Museum as a subject for wrapping was evidence of the Christos' and van der Marck's deep seriousness; they sensed the malaise of an art often smothered by an institution that now tends to be, like the university, a corporate venture. It is often forgotten that the Christos, in wrapping the museum, were also symbolically wrapping a staff and its functions – the sales desk (that little repository of *bricolage*), the docents, the maintenance staff (blue-collar workers serving an alien faith), and also, by implication, the trustees. Paralysis of function also demanded that floor and stairs be wrapped, and so they were. Only the sensitized walls remained untouched. The nature of this wrapping has received little commentary. There was no neatness to it; it looked like an amateur job. Ropes and twine found notches to swing about, knots were vast and tied with thumbs. Slick packaging would make no comment on the American genius for such, which of course includes the packaging of people. So the Christos' packaged museum (explicit) and staff (implicit) proposes that containment is synonymous with understanding. With the museum packaged, is the way to understanding open?

Like all gestures, the project has an expectant quality, an openness that for satisfactory closure requires, like a question or a joke, a response. By definition, a gesture is made to "emphasize ideas, emotions, etc." and is "often ... made only for effect." This deals with its immediate impact. For the gesture must snare attention or

it will not preserve itself long enough to gather its content. But there is a hitch in a gesture's time, which is its real medium. Its content, as revealed by time and circumstance, may be out of register with its presenting form. So there is both an immediate and a remote effect, the first containing the latter, but imperfectly.

The presenting form has its problems. It must relate to an existing body of accepted ideas, and yet place itself outside them. Initially, it tends to be perceived – or misperceived – somewhere on a spectrum from outright hostility to just fun. In this, the "art-likeness" of the work is a liability. If it is perceived within an existing category, the category tries to digest it. Successful gestures – ones that survive their presenting form – usually abort the dialogue out of the accepted universe of discourse. In game-playing this is rule-modification. But in art the modification takes place over time and with uncertain – indeed unpredictable – results. Thus gestures have an element of charlatanry and fortune-telling. A bet is placed on an imperfectly perceived – but wished for – future. Gestures are thus the most instinctive of artworks in that they do not proceed from full knowledge of what provokes them. Indeed, they are born out of a desire for knowledge, which time may make available. An artist's career (if artists have careers) cannot suffer from too many of them, for they jump it oddly about. A gesture is antiformal (against the agreement that art reside within its category) and it may be at odds with the smooth teleology of the rest of its perpetrator's work. An artist cannot make a career of gestures unless, like On Karawa, his repeated gesture is his career.

The Christo and Jeanne-Claude Christo project is rare in that its presenting form and subsequent content are consonant, though of course the "fun" aspect was initially emphasized. The Christos' wit and humor are indubitable, but their complexities (laughter is not a simple subject) are far from fun. The project certainly negotiated a deeper understanding of a major theme of the sixties and seventies; the isolation, description, and exposure of the structure through which art is passed, including what happens to it in the process. At this time the gallery received a lot of lip-service hostility, while being used by artists in that tolerance of their split-level existence necessary to survival. This, of course, is one of the marks of advanced art in the post-capitalist matrix. Rendering to art the things that are art's and to the Collectors the things that they buy often happily coincide. Too much consciousness leads to embarrassment, the blush of the closet revolutionary. It is the particular glory of some sixties and seventies artists, including the Christos, that they met the implications of their own insights and polemics.

All these gestures recognize the gallery as an emptiness gravid with the content art once had. Coping with an idealized place that had pre-empted art's transforming graces gave rise to a variety of strategies. To those already mentioned – the death of metaphor, the growth of irony, the comedies of assigning value to the useless,

339

"de-creation" – should be added destruction. Frustration is an explosive ingredient of late-modernist art as options close off briskly in a converging corridor of doors and mirrors. A minor apocalypse forces itself upon us; it easily mistakes its dilemmas for the world's. Only two exhibitions formally acknowledged this free-floating anger. *Violence in Recent American Art* came from Chicago's Museum of Contemporary Art in 1968 under van der Marck; and Varian at Finch College, New York, put on a show of *Destruction Art* (1968) that the gallery spaces wrapped themselves rather uneasily around. No one trashed a museum although alternative (to the museum) spaces took a beating. But various methods were used to reduce the placelessness and timelessness of the gallery's hysterical cell. Or the gallery itself could be removed and relocated to another place.

NOTE

This article is adapted from a Franklin Murphy Lecture given at the University of Kansas at Lawrence in the Spring of 1980. It was first published in *Artforum*, Dec. 1981, pp. 26–34.

21

POSTMODERNISM'S MUSEUM WITHOUT WALLS

Rosalind E. Krauss

André Malraux's *musée imaginaire* moved westward into English translation to become the "museum without walls". Bowing to the English language's appetite for demonstration, for the concrete instance, for the visualizable example – for the image, in short – the translator made free with the book's title and therefore with its conceptual underpinnings as well. In French, Malraux's master conceit addresses the purely conceptual space of the human faculties: imagination, cognition, judgment; englished, it speaks instead to a place rendered physical, a space we might walk through, even though a museum without walls, being something of a paradox, will be traversed with difficulty.

This Anglo-Saxon desire for language to construct a stage on which things – even

based, on the one hand, on the "universal space" of Mies van der Rohe, and on the other, on the spiral ramps of Le Corbusier and Frank Lloyd Wright.

The universal space is what Mies finally managed to build, in reduced and truncated form, in Berlin and Houston, and what served as the model for the original exhibition spaces at the Centre Pompidou in Paris. A massive, neutral enclosure, the space is a function of its structure – the universal space frame – which is to say a modular roof construction (a three-way truss) that, due to its extreme lightness can be supported by minimal vertical elements, and due to its aggregate nature is expandable in any direction and can thus grow to "infinite" dimensions. No internal walls are needed to support this structure and so free-standing partitions can be positioned and repositioned at will. The spatial "idea" of the plan is its combination of neutrality and immensity. Being a grid of vast proportions, it is a kind of constructed mathesis, a value-free network within which to set individual objects in (changing) relation. Being an immense enclosure which nonetheless defines a space, thereby establishing a sense of unity throughout the whole, it constructs the very experience of the all encompassing idea that collectivizes the variety and diversity of production it contains: the idea that Malraux will see as transcending that of style, the idea of a collective language called Art.

For Malraux's notion of the *musée imaginaire* is, in fact, another way of writing "modernism," that is, of transcoding the aesthetic notions upon which modern art was built: the idea of art as autonomous and autotelic, the sense of it as self-valuable, the view of it that had been summarized as *l'art pour l'art*. This, Malraux argues, was the ultimate effect of collectivizing all those paintings within the nineteenth century's institutional invention – the museum. This was the release of a language that spoke not just the difference of stylistic meanings, but also the trans-stylistic expressivity of form itself. "The proper sphere of oil painting," he writes, "was becoming that which, beyond all theories and even the noblest dreams had brought together the pictures in the museums; it was not, as had been thought until now, a question of technique and a series of discoveries, but a language independent of the thing portrayed – as specific, *sui generis*, as music."[1]

The *musée imaginaire* is, then, the exercise on the part of the receiver of the prerogatives of this language. It is the possibility of experiencing the autonomous power of form that two waves of the decontextualization of art objects have wrought. In the first wave works of art are ripped away from their sites of origin and, through their transplantation to the museum, cut loose from all referentiality to the use, representational or ritual, for which they might have been created. In the second wave they are, through their transplantation to the site of reproduction (through art books, postcards, posters), unmoored from their original scale, every work whether tiny or colossal now to be magically equalized through the

democratizing effects of camera and press. Malraux is eloquent about this second effect:

> It is hard for us clearly to realize the gulf between the performance of an Aeschylean tragedy, with the instant Persian threat and Salamis looming across the Bay, and the effect we get from reading it; yet, dimly albeit, we feel the difference. All that remains of Aeschylus is his genius. It is the same with figures that in reproduction lose both their original significance as objects and their function (religious or other); we see them only as works of art and they bring home to us only their makers' talent. We might almost call them not "works" but "moments" of art. Yet diverse as they are, all these objects . . . speak for the same endeavor; it is as though an unseen presence, the spirit of art, were urging all on the same quest, from miniature to picture, from fresco to stained-glass window, and then, at certain moments, it abruptly indicated a new line of advance, parallel or abruptly divergent. Thus it is that, thanks to the rather specious unity imposed by photographic reproduction on a multiplicity of objects, ranging from the statue to the bas-relief, from bas-reliefs to seal-impressions, and from these to the plaques of the nomads, a "Babylonian style" seems to emerge as a real entity, not a mere classification – as something resembling, rather, the life-story of a great creator. Nothing conveys more vividly and compellingly the notion of a destiny shaping human ends than do the great styles, whose evolutions and transformations seem like long scars on that Fate has left, in passing, on the face of the earth.[2]

345

These great "fictions" that the *musée imaginaire* makes visible are, then, so many stories about the collective spirit of human creativity, so many versions of the inventiveness evidenced by the Family of Man, like multiple documents of Man's Fate. And further, what the *musée imaginaire* makes possible is that the user of the museum may participate in this writing, may create his or her own "fiction" – a new account that will reveal yet another transsection through the body of "Fate."

It is this dimension of the *musée imaginaire* – its endless imaginative productions – that the spiral ramp renders as built form. Initially, of course, it might seem that the ramp merely extends and hypostatizes that fact of trajectory that had been one of the major features of the arrangement *en filade*, with its emphasis on continuity and sequence, of the nineteenth-century palace/museum. Indeed, as the pull of gravity encourages one's descent down the circling ramp of Wright's Guggenheim Museum, sequence is at the very core of the experience. But this isolation of the trajectory in which the viewer's body will engage and about which he or she cannot help but be conscious since its unfolding from beginning to end is made visible as the eye surveys the sweep of the spiral around the open atrium at the building's center, this expression of the trajectory *as such* is another modernist transcoding of art as a function of the *musée imaginaire*. For this ramp is understood, within the work of,

leveling of formal value, its interest in the constant play of exchange, and its practice based on the interchangeability of style and form. Malraux taught us that the museum had been essential to the production of the art book at the time of an elitist, specialist press; we are now experiencing this logic turning back on itself as we watch how the mass-market art book is crucial to the conception of the new museum.

NOTES

This essay was originally published as "Le Musée sans murs du postmodernisme," in *L'Oeuvre et son accrochage*, special issue of *Cahiers du Musée nationale d'art moderne*, 17/18 (1986), pp. 152–8.

1 André Malraux, *The Voices of Science*, trans. Stuart Gilbert, Princeton, New Jersey, Princeton University Press, 1978, p. 112.

2 Ibid., p. 44.

3 Ibid., p. 127.

4 See Walter Benjamin, *Charles Baudelaire, Ein Lyriker im Zeitalter des Hochkapitalismus*, Frankfurt am Main, Suhrkamp, 1969.

5 Adorno's letter to Benjamin is published in *Aesthetic and Politics*, London, New Left Books, 1977, p. 130.

THE EXHIBITED REDISTRIBUTED
A case for reassessing space

Reesa Greenberg

Most discussions of the meanings of exhibitions of contemporary art minimize the
importance of the location and type of architectural space in which the exhibition is
held. It is assumed that listing the venue at the top of an article or review as part of a
title or header or referring briefly to location as an aside in initial or closing
paragraphs is sufficient to convey the significance of the space and its relation to what
is being shown. With the exception of Brian O'Doherty's *The White Cube: The
Ideology of the Gallery Space*,[1] extended discussions of the architectural spaces in
which exhibitions of contemporary art are located occur in books or articles on
museums, galleries, collectors, architects and exhibition design or when the
exhibition venue is sufficiently different from the norm to merit extensive

museums, by the late eighties, another ethos was operative. For example, when the New Museum of Contemporary Art in New York, founded by Marcia Tucker in 1977 in opposition to uptown museum practices, moved to the Astor Building on Broadway in 1983, it modeled its space on an alternative aesthetic, converting rather than building anew, leaving the tell-tale columns of its interior as a tangible marker of an alignment with its downtown neighbours.[31] By the mid-eighties new museums of contemporary art were being purpose-built in uptown locations by famous architects who eschewed the "downtown" aesthetic. The phenomenon is part of the general museum mania of the postmodern period with art museums of every kind refurbishing, adding wings, converting non-museum buildings, or building anew in styles that were spectacular in their massiveness or extensive use of glass.[32] As the era's prestige building type, the new art museum became so allied to the name of the designing "starchitect" that the structure became identified by possessive nomenclature – Kahn's Kimball, Sterling's Stuttgart, Pei's Pyramid. Hans Hollein actually signs his museum buildings.

Hollein's Stadtisches Museum Abteiberg at Mönchengladbach, opened in 1985, exemplifies some of the distinctive traits of the new museums of contemporary art. Architect-designed to display the Marx collection which was on extended loan,[33] its spaces are constructed specifically for individual or particular configurations of artworks as well as temporary exhibitions. Unlike most art museums, these "rooms" vary tremendously in shape and size. Corners are chopped or rounded. Walls are curved and opened up. The arrangement of spaces is eccentric with galleries aligned on their corner axes or placed on different levels. Often, areas flow into each other in an open, almost organic pattern that permits views into spaces to come or spaces just passed through. Rosalind Krauss has characterized this particular type of architectural configuration as a museum without walls, identifies it as postmodern, and defines the spatial arrangement as one which encourages comparative and ensemble, rather than individualized, looking.[34] According to Krauss, it was first employed by Frank Lloyd Wright at the Solomon R. Guggenheim Museum in New York in 1959 but was not incorporated into standard art-museum design until much later. As at Mönchengladbach and Hollein's Frankfurt Museum of Modern Art (1991), in Richard Meier's High Museum of Art in Atlanta (1983) wall cut-outs or interior windows are some of the devices which permit the linking views but Meier has incorporated these with updated versions of the Guggenheim ramp. In all its manifestations, this postmodern viewing experience is linked to a museum architecture based on a spectacle where not just the art is on view but those who view the art as well.[35]

Like so many of the new museum structures, the exterior of Hollein's Mönchengladbach belies its interior. If the interior, however variable, is calm, cool

and elegant in overall feel, mood, materials and white-walled/gray-floor colour scheme, its exterior silhouettes, massing and extensive use of metal, glass, brick and concrete are jagged, irregular and industrial. This splitting of the external and internal personalities of art museums and galleries is typical of postmodern architecture. In "downtown" galleries, the nondescript, un- or minimally renovated facades of an earlier era often contain a stripped-down but very contemporary, and increasingly elegant, interior. In the new art museums, the split can be stylistic as in the highly personalized, postmodern facades of James Stirling's addition to the Staatsgalerie, Stuttgart (1984), compared to its very classical new galleries, or it can be thematic as in the gray-wood, verandaed, vernacular-inspired exterior/standard gallery interior of Renzo Piano's Menil Collection, Houston (1987), where a concerted effort was made to blend the museum with the surrounding neighborhood's small-scale, single-story, wood houses, also owned by the foundation.[36] The Menil Collection is an anomaly, though, for today rarely do private museums of modern or contemporary art refer, even indirectly, to the house model used by patrons of the past going public with their collections and usually their homes. Instead, most collectors of contemporary art with foundations, in Europe and North America, prefer "downtown," no-name, cleaned-up, recycled, industrial buildings with more or less similar but "spiffier" conditions to those in which much of the work on display was made and first exhibited. Exhibiting private collections, such as the Crex's at Schaffhausen, in abandoned factory or warehouse spaces validates the dominant forms of production and display of the period and, by extension, the collection. The "downtown" aesthetic masks the split between the seemingly open, democratic character of the spaces and the private nature of the endeavor, in the same way that it obscures the reasons why so many empty industrial buildings can be converted to the display of private wealth by the moneyed classes.

If many museums and galleries of contemporary art have an architecturally split personality corresponding to a deep ambivalence about the relationship of art to social class, the Museum of Contemporary Art in Los Angeles (MOCA) has an identity crisis bordering on schizophrenia. Unlike museums and galleries elsewhere where the alienation takes place within a single building, at MOCA the ruptures take place between buildings. The Temporary Contemporary was a police garage and warehouse at the edge of Little Tokyo, renovated, but left quite raw, by Frank Gehry in 1983 as a building in which exhibitions could be held until the museum proper was built. When Arata Isozaki's very proper museum opened in 1987 on Bunker Hill,[37] it was decided that the Temporary would be kept, thereby giving the museum different architectural and geographic options in which to display art. Although not originally planned as such, MOCA's divided architectural self echoes the trajectory from artist-producer to museum-collector and the schism this can

entail when work passes from one domain to another. MOCA is more than a museum of contemporary art objects. It is a museum of the two types of spaces most often identified with the display of contemporary art, divided by gendered connotations into the masculine, non-spectacular, industrial site and the feminine, spectacular, curvilinear, sprawling, site of exhibitionism and voyeurism identified by Jo-Anne Berlowitz as the postmodern museum.[38] By the eighties, the locus and focus of the feminine had shifted from the domestic intimacy of earlier gallery spaces to a more flamboyant interpretation, demonstrating, once again, that traits ascribed to gender are never fixed.

Both Isozaki's MOCA and Hollein's Mönchengladbach share an unusual but telling architectural approach to site. Both are located on a hill but rather than building the site up as massive temple museums of the past like the Philadelphia Museum of Art did to spectacular effect, these museums are broken up into several different architectural zones which draw attention to and respect the contours of the site. Passage into or through these buildings involves a going down or into the hill, suggesting an actual archeological dig for the precious and rare, or, in Freudian terms, an archeological metaphor for a deep search for meaning.[39] When Chris Burden dug out the earth at one of the corners of the Temporary Contemporary in 1986, literally "Exposing the Foundations of the Museum," he constructed a metaphoric revelation of the unconscious of the museum and an acknowledgement of MOCA's other half through deconstruction. Other postmodern artists from Daniel Buren and Christo to Louise Lawler and Andrea Fraser have been equally aware of the importance of architectural considerations and site in the construction of meaning in exhibitions. The question is why so many art historians and critics have preferred to bury this knowledge.

NOTES

1 Santa Monica, The Lapis Press, 1986. First published as a series of three articles in *Artforum*, in 1976.

2 "Site-specific" is a term used to describe individual art projects where the location of the work is an integral component of its meaning. Since the eighties, "site-specific" also has been applied to exhibitions including a number of artists whose works reference or are inspired by the site where they are shown. Preferred venues include buildings not associated with art or locations out of doors. With both individual projects and exhibitions, site-specificity connotes the inseparability of location in relation to signification.

3 The research for this essay was undertaken in 1992–3 while holding a Getty Foundation Senior Research Fellowship with Bruce W. Ferguson and Sandy Nairne for the project *Values on Display: Exhibitions of Contemporary Art*. The present version of

THE EXHIBITED REDISTRIBUTED

this text is indebted to their insights as well those of Barbara Steinman and Kitty Scott. Kristina Huneault provided invaluable research assistance. An earlier version was published in *Exhibited*, Annadale on Hudson, Center for Curatorial Studies, Bard College, 1994.

4 For a survey of the conversion phenomenon see Helen Searing, "The Brillo box in the warehouse: museums of contemporary art and industrial conversions," Pittsburgh, Andy Warhol Museum, 1994, pp. 39–65.

5 Although Lynne Cooke links the shift with the growing importance of process in art, she refers to the change in preferred exhibition site as "ideologically neutral." See her "The Mattress Factory: installation and performance," Pittsburgh, The Mattress Factory, 1989, p. 19. Victor Burgin has elucidated the concept of art as work at length. See his "Modernism in the *work* of art," in *The End of Art Theory: Criticism and Postmodernity*, Atlantic Highlands, New Jersey, Humanities Press International, 1986, pp. 1–28.

6 Other exhibitions in domestic space in the West such as *Apartment Number*, Toronto, 1981, predated Hoet's concept but his is the best known. In the former Soviet Union, exhibitions in apartments in the sixties, seventies and eighties were alternatives of very different kind. In the nineties, some dealers, forced for economic reasons to close their factory-space galleries, have reverted to mounting exhibitions in their apartments.

7 See Norman Bryson, *Vision and Painting: The Logic of the Gaze*, New Haven and London, Yale University Press, 1983, for an extended and more directed discussion of the gaze and the glance.

8 A popular trend in museums is to create separate reading-rooms within temporary exhibition spaces or to include them in the plans for new or renovated buildings. When there is seating in front of artwork, it is usually backless and most uncomfortable, more a temporary perch than a place of long repose. See "Comments on seating," *Tate Gallery Visitor Audit Mini Survey Report*, prepared by Lord Cultural Resources Planning and Management Inc., 1994.

9 "Psychogeographies," in *On taking a normal situation and retranslating it into overlapping and multiple readings of conditions past and present*, Antwerp, 1993, p. 127.

10 O'Doherty, *The White Cube*, pp. 14–15.

11 Interview with Sandy Nairne, New York, 21 May 1993.

12 "The politics of presentation: the Museum of Modern Art, New York," in *Art Apart: Art Institutions and Ideology Across England and North America*, ed. Marcia Pointon, Manchester and New York, Manchester University Press, 1994, p. 205.

13 Interview with Sandy Nairne, London, 11 Dec. 1992.

14 "The Museum of Modern Art: the past's future," *Journal of Design History*, 5: 3 (1992), p. 209. Kitty Scott , in conversation, suggests that the mythic lab described by Wallach may correspond to the mythic white cube.

15 The concept is Henri Lefebvre's. See his *The Production of Space*, Oxford, Blackwell, 1991.

16 The first exhibition was curated by Lucy Lippard who describes it as "a 'piece' oriented show . . . it was a stunning minimal art show but it was meant to be an anti-Vietnam War thing." Interview with Sandy Nairne, Maine, 13 July 1993.

THE EXHIBITION CONDITION

artifice, art and architecture have become illusion and artifice, the unreal and the representational replacing the substantial. With the increasing crisis of public patronage, there has been a tendency toward inactivity; one might say that art and architecture are now presented as "readymades," whose only justification of being lies in their mere presence, rather than in a complex analysis and discussion of their structures. What are we seeing is a process of autosuggestion, an analysis of the past and the flux of history turned inward on itself. On the other hand the situation also engenders its opposite. Like all narcissistic attitudes, self-evaluation carries the implication of seeing oneself as "external," as absolute hero of a procedure that dies of illusions and is glorified in the illusion that it is mirrored in the Idea.

But we all know that thought cannot be preserved except through the manifestations of practice. Under the present historical circumstances, the only thing left to do is to glorify what does not exist. Art and architecture have proposed a flight into an ideal and abstract realm (seen in a return to a concern with memory of the past in neo-painting movements as well as in post-modern architecture), where language exists in an illusory condition, based on the dazzle and revelations of an already codified culture. We are in full ceremonial swing: what matters is the guise and the power of the image, springing forth from archaic representations as if from the nether world of the dead.[2] The memory of idealism – of nostalgic origin – cannot be far away, and this is where the ephemeral stage machinery of 'spectacles' becomes important. The spectacle nurtures and sustains the concept of an identity and a totality that has, in fact, already vanished. What is produced is a series of "vedettes" and, not by chance, a return to an artistic star system; these stimulate desire but fail to satisfy the needs of real culture. It is sufficient to have the pleasure of recognition, to be "shown." And it is through "the show" that this phenomenon of appearances carves out its own territory, beginning with the supposition or affirmation that every artistic emanation is an already resolved statement. The drawn or painted surface, the project sketch or model, substitute for the building, as though the watercolor or graphite or plywood version could prevail over the real thing. This process has become blown out of proportion in the past decade and is justified with the excuse of architecture's creative and unproductive negation.[3]

Art and architecture have always reveled in negation, but in the past this was seen as problematic, indicative of a crisis of the social or personal function of art and architecture, but not seen in and of itself as a vehicle of exhibition and consumption. The proliferation of the exhibition phenomenon, the sum total of the shows held annually in Europe, has assumed the appearance of an enormous avalanche. There is a tendency to emphasize the ephemeral character of the art event, negating the function of both art and architecture. This attitude encourages a culture that thrives on "display," on a process devoid of an end or a goal beyond itself. The present

372

economy of culture thrives on this system, where the principal product is represented by "showing" and by "showing oneself." With the dominance of the show over all other activity, art and architecture have come to be formulated according to exhibition requirements, often thematic, as stated by museums and galleries, editors and magazines, the Venice Biennale and *documenta* in Kassel. The making of art is now given over to the construction of images and projects whose raison d'etre is to prove the existence of art and architecture, like thoughts which have lost their effective function. It is clear that languages do exist, but they have increasingly been pushed toward written and drawn, painted or modeled forms of expression. Their only function is to be shown and to exist as esthetic consumer goods: on the wall, on the page, and on the screen.

If external acclaim is deemed essential, true power resides in the expository ceremony. And if value is ascribed to the form of exhibition, manifested by the manner in which art of architecture is shown, then the visual machine of exhibition installation becomes the new pretender to originality.

Seen as a "service," a means of building a series of paradigms which facilitate the reading of the work, the installation, with the various philosophies of exhibitions, becomes a "text," a linguistic arena in which art and architecture play a real role in the cultural life. Evidently the conditions for creating installations are not identical with those for creating art or architecture: installation lies somewhere between the other two, since the expository method must provide an adaptable spectacle, mediating an organization of spaces and an arrangement of visual materials. Yet the installation, crucial component of any exhibition, is in and of itself *a form of modern work*, whose articulation, both spatial and visual, is worthy of consideration. If this is true, the time has come to consider installation from a scientific as well as historical point of view. This does not imply, however, that one must come up with a single definition, but rather that one should recognize this area of communication we might call the "discipline of exhibiting."

What is installation throughout the course of history? In the nineteenth century it is the evocation of a place or an environment, preferably with the stamp of the bourgeois or the museum, made with pictorial means and traditional spatial concepts. From the great Parisian salons to the world's fairs, from 1863 to 1902, from Vienna to Brussels, up to the Venice Biennale and the Turin Exposition of 1905, the installation is decidedly an ornamental and illustrative process;[4] it points out a direction or a particular situation. It furnishes a temporary solution to the demands of the audience, both artists and buyers, but always remains anchored in the tradition of the classical painting gallery or the antiques warehouse. Its aim is to create a material support and a background for an object to be seen and sold. The attitude, therefore, is to have the public participate in a familiar and reassuring environmental

373

still not analytical, and the overall groupings are established according to linguistic sympathies. There is, however, the new appearance of the organizer, the curator or historian of the future, in the figure of the industrial manager or merchant.

Expository solutions, however, remain rather traditional. The wall area, always covered by fabric or built from removable materials, was thought of as an optic axis, about a meter wide, whose decorative surface framed the artwork above and below. This visual band, a common element in art galleries as well (such as "291" in New York)[5], never took the entire wall into consideration, and therefore excluded any use of the corner. In the final analysis the paintings were framed twice: by their wooden perimeters and by this wall frieze.

The situation barely changes with the development of the avant-garde, even if the 'new spirit' of art attempts to carry over into the realm of installation. In 1905, at the Salon d'Automne in Paris, the Fauves take a "thematic" approach. Beyond presenting themselves as a group, they dramatically emphasize a single element – the chromatic materials. This is an attempt to focus the public's attention to the greatest extent possible on the principal ingredient of their work – color. To differentiate themselves and reveal their diversity, the Fauves emphasize a "motif," rather than present themselves as searching, they constitute an art "scene."

Given their intentions, one can deduce that for them installation was a simple accessory, a sort of backdrop meant to vanish in the viewer's perception. This desire for negation will be systematically stated on the occasion of all future "thematic" shows, whose purpose is to exalt the expressiveness of the artist and the curator, aided by the "colorless" presence of installation devices.

But the 1913 Armory show is significantly different. Here it is the system which must emerge, for its manifestation involves the American public in the revelation of "the modern." Since the gigantic New York Armory Hall cannot be subordinate to small artistic statements, the installation itself is destined to dominate. And since the true objective of the show goes beyond the mere presentation of the artists (notwithstanding the presence of Picasso and Matisse, Cézanne and Gauguin, Redon and Kandinsky), to the cultural and educational growth of a public, the desire to extend mental space is reflected in the environmental structure. Above all, the installation is planned to accommodate around 1,600 works arranged according to a principle of dynamic perception which conceives the individual rooms as rhomboids or octagons with open corners, proceeding in a sequence from 'A' to 'R.'[6] But this environmental extension does not seem sufficient. All the artworks float upon large surfaces, on the walls and the floor. They can thus be partially glimpsed, like tips of icebergs, beckoning and determining the visual orientation of the exhibition. The organization of the show is, therefore, planned so as to expand the territory and influence of the individual works. The delineation of large open spaces around the

works of art serves several purposes: it supplies positive evidence of cultural production, but also indicates a selection based on that production rather than on consumption. What is at work, then, is an example of sophisticated marketing, where the rarefaction of spaces and supports evolves from quantitative to qualitative presentation. Above all the emphasis on the work, which is removed from the mass of artifacts produced in the studio, defines an area of selectivity – critical or economic, linguistic or thematic – which separates the work from its historic and productive context, placing it in an abstract limbo. The infinite white surface of the ideal gallery cannot be far away.

But before fading into an achromatic state, the wall continues to fulfill a decorative function, explicated in the visual motifs and material surfaces – canvas, velvet, wallpaper. Before their banishment, these signs become active participants in the art-making process. They become sensitized by the overflow of painting and drawing from the paintings outward to the walls. According to Balla's Futurist drawings, "Il progetto di arredamento futurista" ("Project for Futurist interior design"), 1918, and "La Festa futurista in casa Depero" ("Futurist holiday at the Depero House"), 1923, the wall surface is synthesized with the painting surface. That is, the walls no longer frame the painting, but are themselves painting.[7] The entire space, therefore, is subject to a color scheme which activates every detail of the interior architecture. Emphasis is given to the mobility of colors and ephemeral materials such as cardboard or sheets of metal or aluminium. There is no differentiation between furniture, paintings, and walls. Every element is imbued with plastic-visual energy, expanding the traditional art object – the painting – to encompass the total environment. In Balla's project the paintings are arranged according to the linear and geometric organization of the decorative wall elements, or else they become centers of visual outpourings. Their content is, for the moment, no longer important, a fact emphasized by Balla's writing the same description on each frame: "quadro futurista" ("Futurist painting"). Rather, they contribute to an installation totality where differentiation of artistic motives is not permitted. The edge of the frame is liberated, extending to the architectural system, and the illusionistic dimension of the painted surface overflows onto the walls. The installation is therefore specular; the environment is the reflection of the art, and vice-versa. The Futurist concept of continuity eradicates every esthetic inequality among the art objects. In the "Depero House," the pieces are all mixed together, rising and falling from the walls or ceiling, and one's perception of the space ties together a host of visual circumstances, thereby negating separations and distinctions of "higher" and "lower" or "more or less artistic." The visual continuity creates only esthetic fields where the elements float and interact. Any one grouping is the equivalent of another, and it is the relationships that are important.

In 1921 at the Sturm Gallery in Berlin, Ivan Puni installed work in an unexpected manner. Instead of lining the works low down or high up on the wall like the Russian Futurists did in the last 0.10 shows in Petrograd in 1915, or like Malevich did in his various shows from 1915 to 1919 (where he also hung his Suprematist paintings in the corners),[8] he disperses them over all the gallery surfaces – the ceiling, the doors, the windows, the floor, and the walls.

Refuting current installation philosophies, Puni covers every architectural element with letters, drawings, figures, numbers, paintings, and geometric forms. The result is a visual constellation, where verbal, visual, and environmental areas coexist. The impact is polyfunctional: Puni introduces a new consideration of spatial relationships between object and wall surface; he emphasizes the importance of the location of the artwork and the function of one's perceptual distance; he points out the active role of the wall and the possibility of altering its visual meaning as well as the capacity of both artist and viewer to understand the proportional and environmental relationships of artistic signs, including frame and canvas. This typographic vision of the environment is the large-scale consequence of the visual-sound experiments of poets like Klebnikov and Zdanevic, in quest of a "cosmogony of words and images," and is aligned to the new techniques for montage and graphics and asymmetrical arrangements which were the outcome of parallel investigations in Italian and Russian Futurist circles.

Being radical, the transition from artwork to environment in Russia tends to exclude the possibility of any preconceived and restricted position. Every artist is pushed beyond the traditional framework to attempt to extend the limits of communication, and techniques of public information, developed for reaching large numbers of people, are not deemed extraneous. This is where the great expositions once again come on the scene; the artwork becomes the prototype not only of artistic production but of the national cultural situation. For this reason emphasis is given to the decline of easel painting and the entry of the artist into the work environment, indicators of a changed artistic climate in Russia. On the occasion of the Great Exposition of 1923 in Berlin, Lissitzky and Kandinsky are not represented by artistic goods, namely painting and sculpture, which could participate in the Western market, but rather they attempt to offer environmental situations which introduce a "concrete monistic perception of the world and its activities" (Aratov).

"In that curiosity shop that is the pavilion for the 'Lehrter Bahnhof' exhibition at the Expo" (Lissitzky), the show consisted of exhibiting objects, both two- and three-dimensional, which were realized in the studio, or anyway in a location other than that of the pavilion and without any awareness of the significance or in-situ logic of the installation and exhibition process. Consequently the space was the result of a chance assemblage – insignificant and haphazard. El Lissitzky, on the other hand,

takes into account that the act of exhibiting objects is significant because it has a total meaning which cannot be broken down, but must be considered as a whole "made up of 6 surfaces (floor, 4 walls, ceiling) which must receive a form."[9] Yet the exhibition context is filled with a semantic density and can reveal the scheme of the signs which interact within it. For this reason El Lissitzky establishes a global link among all his visual and plastic elements, so that the space assumes an artistically intelligible organic unity. The result is the *Proun* environment, 1923, which carries the convergence of the visual machines of art and installation to its logical conclusion.

In the Berlin environment the art–architecture symbiosis fills the space in non-objective fashion, seeming to refute any thematic interpretation while focusing solely on "intrinsic fundamental energy applied to the raw material."[10] According to Lissitzky this is "depicted as elementary forms and materials: line, surface, segment, cube, sphere, and black, white, grey, and wood; and surfaces that are painted directly on the wall (color) and surfaces that are placed vertically on the wall (wood)."[11]

The *Proun* environment results in the ultimate art installation object. Every aspect of the environment is controlled; the entire phenomenology of the space is examined so that the project prevails over the architecture and makes it subordinate to the contemplative and creative process. Here, then, is an achievement whose development will alter the history of the exhibition mechanism.

In establishing a direct correspondence between the linguistic systems of art and architecture, this "total environment" is distinguished from its predecessors by its detachment from any impulse toward interior design or object-making. It can even be considered the first example of "pure environmental art" or "art installation." It is not surprising, then, that after his pioneering Berlin project Lissitzky went on in 1926 to create his Dresden environment for exhibiting art and, in 1927–8, an exhibition space for contemporary art in Hannover. In the Dresden project the space is divided into walls which are grouped as separate cells, within which works of art can be exhibited. The disassembling of the space is a response to the desire to focus attention not on the architectural whole, but on details, namely the spatially isolated paintings and sculptures. The room becomes a dynamic "frame," which, as in the tradition of Russian icons, is at the service of the paintings; the room actively directs and guides the observer by the chromatic variations (ranging from white to grey to black) of the walls. The observer thus perceives almost simultaneously the various surrounding visual realities as a single product, becoming aware of the fact that the visual energy of a painting or sculpture depends on one's viewing point, on one's position and movement as a conscious individual. At the same time the artifacts, which here and there enter into the larger designed context, become united into one "piece." Removed from their cultural environment they are reduced to a "system" and merged into a single identity; this is achieved according to the intentions of the

379

artist and the installer – both bring about the result defined as a "show."

The Dresden environment already presupposes an exhibition theory, that is a study and an analysis of the nature, the function, and the limits of the installation issue, distinct from issues of creativity. The realization of this "ideal gallery," meant to determine and to define the function of the art object, suffers, however, from an architectural conception which interprets the internal space as an external shell and ignores its volumetric transparency. In later developments, a refutation of the anchored wall frees art installation from its static bonds, (a freedom already apparent in industrial architecture). What follows is a new spatial conception, based on forms and arrangements freed from impediments. The decline of the masonry enclosure opens a world of exhibition possibilities: paintings, like sculpture, begin to move about in space. Freed from two-dimensional representations of foreground/background, vertical/horizontal, they begin to rotate in the space. There is no longer one way of looking at and exhibiting art, based on the frontality of the wall. Rather, there is now a sort of "spherical perception," as artworks can be exhibited on all sides.

This adaptation of the object to a dynamic, temporal vision in fact begins with Cubism, continues with the suspended and rotating forms of Constructivism, but finds its most complete resolution beginning with the work of the Bauhaus which, abolishing the supporting surface, finally defines the global and rational character of "functional design." The analytical criteria of the Bauhaus result in installations whose level of abstraction rejects all references to architectural context and serves to articulate the ideas behind the exhibition in question. The autonomy and the visual range of the tubular metallic structures for the presentation of "non-ferrous metals" put together by Gropius and Schmidt in 1934,[12] or Bayer's projects for shows and expositions dating from 1924 to 1936, exclude a priori the limitations of the wall and suggest a supremacy of visual concept over object.

At this same time techniques for accurately standardizing installation elements are developed – elements which can function completely independent from and unattached to their surroundings. The formative principles of this process are outlined by Moholy-Nagy in 1928:

> Moveable walls, illustrating the needs of our time; colored and revolving discs; lighting devices; signals; reflectors; and transparency everywhere, light, movement: this is what is needed to attract the public. Everything ought to be presented in such a manner that even the most simple man might participate. And furthermore the marvels of new materials: large celluloid panels, grid systems, extensions, small and large metal screen planes, transparent placards, writings suspended in the space, and above all clear, luminous colors.[13]

380

The consequences of an installation "abstracted" from the architectural context emphasizes the autonomous significance of the wall. And so if Balla, Puni, and El Lissitzky sought to spread the wall surface to the artwork, the complementary attitude would be one which declares the wall incompatible with any artistic use, exalting the wall's own esthetic properties. In April of 1929 Kandinsky publishes a theoretical piece praising "the naked wall" as a primary element in art:

> The naked wall . . .! The ideal wall, on which there is nothing, which supports nothing, on which there are hung no paintings, on which one sees nothing. The egocentric wall, which lives "in and of itself," which affirms itself, the chaste wall. The romantic wall. I too love the naked wall . . . Whoever can truly be affected by the naked wall, with the intensity of lived experience, is prepared in the best fashion to truly experience a pictorial work. The two-dimensional wall, perfectly smooth, vertical, proportioned, "mute", sublime, which says yes to itself, refers to itself, limited to and radiating toward the external world, is an almost primary "element".[14]

This precise awareness of the "artistic" function of the wall is relevant in terms of the history of modernist museology. The purist axiom is, from the 1920s on, the matrix for the archetypal image of the modern and contemporary exhibition hall.

The environmental circumstance for exhibiting art today cannot be other that the "ideal white cube." This assemblage of naked walls, whose splendor and impact prevail over any body of work, calms all extra-artistic doubts. The "ideal" gallery creates an aseptic container, full of visual cotton fluff, in which the visitor/collector can perceive art as uncontaminated and virgin material, and disposed, therefore, to their own desires.

The characteristics of such a space at this point constitute an international language for "showing":

> A gallery is constructed along laws as rigorous as those for building a medieval church. The outside world must not come in, so windows are usually sealed off. Walls are painted white. The ceiling becomes the source of light. The wooden floor is polished so that you click along clinically, or carpeted so you pad soundlessly, resting the feet while the eyes have [sic] at the wall. The art is free, as the saying used to go, "to take on its own life." The discrete desk may be the only piece of furniture. In this context a standing ashtray becomes almost a sacred object, just as the firehose in a modern museum looks not like a firehose but an esthetic conundrum. Modernism's transportation of perception from life to formal value is complete. This, of course, is one of modernism's fatal diseases.[15]

Moreover, the artwork on a naked wall becomes a stray waiting for its owner, and modern art a mad, aimless pursuit unless it sets in motion the gears of the galleries

381

seventies lacked sufficiently sympathetic public museums or commercial art galleries, and were also dissatisfied with the context they provided. They therefore sought something other. They created new types of exhibitions and they colonized redundant spaces in a cycle of frustration, energetic independence and, over a number of years, eventual institutionalization. The interests and initiative of these artists, rather than the demands of audiences, forced changes in the exhibiting system. Indeed some artists shifted role completely from artist to dealer in the process. Artists in Western countries then imagined alterity or otherness in what they had achieved: in the so-called 'alternate galleries', in a new generation of commercial galleries, in the 'spaces' of artists' networks, publishing and broadcast media, and, eventually, in new forms of museums. Three sharp questions asked by Ingrid Sischy in 1980 were hard to avoid: 'Alternative to what? to whom? and for whom?'[2] However, their eventual failure to avoid an 'institutionalization of dissent' does not diminish the effects that these exhibition spaces have had on the system as a whole.

The new spaces colonized by artists, the 'alternate spaces', were not created as museums with collections, nor as commercial galleries as such, nor as spaces run by collectors or lovers of art (as in the German *Kunstverein*), nor as institutes of

➡ **24.1 A.I.R. Artist members, as published in *Heresies*, 7 (1979). Photograph by David Attie, courtesy of A.I.R. Gallery, New York.**

contemporary art, nor as city-sponsored *Kunsthalles*, nor as the spaces controlled by traditional art societies. Those institutions were also going through important and not always dissimilar changes between 1960 and 1990, but the dominant new model became the North American 'artists' space'. It emerged as an image as much as an institution. Artist May Stevens conveyed this common self-consciousness in 1980:

> The alternate space is the equivalent of 'dressing down', wearing jeans and knowing what's in, intellectually, aesthetically, politically – in the sense of artworld politics. Money is nowhere to be seen. . . . The dinginess or long climb on creaking stairs to the clean white space, the unexpected content: government office building, broken down loft, business district, etc., proves sincerity.[3]

Whatever coherence exists thirty years on, through national funding patterns and joint professional associations in the USA and Canada, the significance of 'artists' spaces' should be assessed within a broader framework of artists' publications, community projects and other forms of 'alternate' public intervention.

MAKING A.I.R.

Barbara Zucker

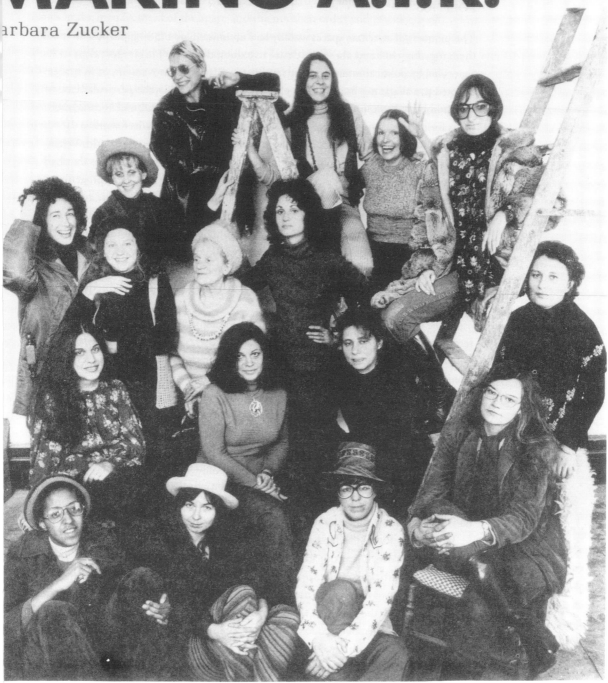

st and present A.I.R. members, from left. *First row:* Howardena Pindell, Daria Dorosh, Maude Boltz, Rosemary Mayer; *second row:* Mary
rigoriadis, Agnes Denes, Louise Kramer, Loretta Dunkelman; *third row:* Patsy Norvell, Sari Dienes, Judith Bernstein, Dottie Attie;
nding: Barbara Zucker, Laurace James, Anne Healy; *on ladder:* Nancy Spero, Pat Lasch. Current A.I.R. members not shown: Rachel
s-Cohain, Donna Byars, Sarah Draney, Mary Beth Edelson, Kazuko, Ana Mendieta, Clover Vail.

House on the Mall.[13] Both might be seen as forerunners to the artists' spaces of the 1970s.

Jim Haynes opened his Arts Lab in a warehouse space in November 1967: 'people didn't particularly come to see something specific. But they would say, "Let's go to the Lab and see what's going on tonight". When they arrived, there would be a big blackboard, like a menu, showing all the different things going on that evening. . . . There would be many spontaneous events.'[14] The Arts Lab probably took nothing as seriously as its title. Although there were distinct spaces for theatre, films and art, events were expected to be experimental, to overlap and spill in and out of the gallery or the café in creative synthesis. The sense of an 'alternative' programme is clearly directly expressed in a note sent by curators Biddy Peppin and Pamela Zoline to student representatives of art schools at the end of 1967:[15]

> We are not interested in reproducing the polish and glimmer of a Bond Street gallery. We are interested in exciting experimental work (you define these terms) in any medium, Art and non Art. We are trying to achieve a situation where a more informal (and thus, we hope more intense) experience of art is possible than is usual in the existing zoo-like museum and gallery set-up.

392

➡ **24.2 Arts Lab, London, membership form and proposal by Roelof Louw, 1967. Courtesy of Biddy Peppin.**

The opening exhibition featured two works by Roelof Louw, one a cone of $9\frac{1}{2}$ tons of black chippings and the other a pyramid of 5,800 oranges, arranged on a 5'6"-square base and 5 foot high.[16] As Louw reported it in *Studio International* the pick-up piece (of which the recent pieces of Felix Gonzales-Torres are reminiscent) opened up questions of new materials and new audience responses. Among the few other exhibitions before the Arts Lab's early demise in December 1968 were found objects, entitled *Four Thoughts*, by Yoko Ono with John Lennon. Even more expressive of the Lab's ethos was *Drawing and Writing on the Wall*, when Arts Lab members made their own images for a month. Coloured pencils were provided.

The first exhibition in the much larger ICA space on the Mall was *The Obsessive Image* and it aimed through its thematic of the human body to match in scale and élan the ICA's opening exhibitions of 1948, *Forty Years of Modern Art* and *Forty Thousand Years of Modern Art*.

As it entered its new and more public phase stresses between art forms were evident and extended the ICA's earlier history of internal dissension. In its previous Dover Street premises it had aimed to follow its 1947 manifesto to 'establish a common ground for a progressive movement' and to 'enable artists of all kinds to

join in a search for new forms of expression'.[17] The ICA was often split internally, and attempted to occupy both official and unofficial positions in the cultural life of London. It had a reputation for avant-garde outrage, modernist experiment and intellectual diversity[18] but was supported through the later sixties by an establishment figure like Arnold Goodman (who became Chairman of the Arts Council and was himself close to another supporter, the first Minister for the Arts, Jennie Lee).

The new ICA Director Michael Kustow described the opening-night party for the new space, held in April 1968, in classic bohemian terms:

> At one end of the gallery a wiry-looking avant-garde ballerina performed something erotic with a brass bedstead . . . the African band had got into its swing, and a girl was undulating above people's heads. . . . As night fell, the wine took hold, and at 2am everyone – young, old, straight, freaky, stiff-suited or near naked – joined in a Bacchanalian dance to the electronic voodoo of an impassive rock group.[19]

Mark Boyle and Joan Hills, who reworked for the occasion some of the *Son et Lumiere for bodily fluids* which they had first shown at the ICA in 1966, represented

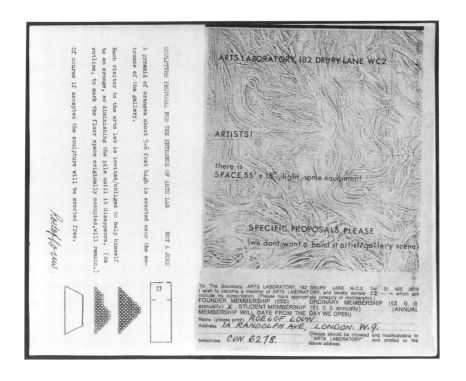

the growing London underground scene and therefore a degree of 'cross-over' between the ICA and those that were both more 'underground' and more orientated to rock music.

However, the distinctions between the structured and funded ICA and the ephemeral Arts Lab were sharp. Although the Lab claimed to do all it could to discourage any drug use on the premises, its close association with *IT* magazine (Haynes was a co-founder, as he was also, with Germaine Greer, of *Suck* magazine) and its representative position within counter-cultural associations were enough to keep official support away (in the form, anyway, of financial support from the Arts Council).[20] Perhaps this guaranteed it, before it closed, its brief position as both unofficial and alternative. Despite occasional outrages and clashes the ICA was a very official alternative; for all its independence, a site of controlled experiment. Within an increasingly widespread and popular ideology of the 'alternative society' it was to be identified with expanding cultural provision rather than with spaces controlled by artists.

394

➡ **24.3 Arts Lab, installation by Takis, October 1967. Photograph courtesy of Biddy Peppin.**

SPACE

With the advent of Minimal and Kinetic Art in the early and mid-sixties, as artists asserted a direct and seemingly unaltered employment of everyday materials within the gallery, so the *use* of space became a critical factor in exhibition making. But in the period that followed it was the *meanings* of the term 'space' that changed. The earlier perceptual implications of Minimalism and Kineticism (and even the more exploratory and experimental connotations of the Cold War 'Space Race') were transferred with Conceptual and Land Art into questions of the artist's control over space. Space had then to be considered as place. Mary Delahoyd:

> The pure absolute object isolated on gallery wall or floor could no longer be the ideal. Art became relative as its forms exposed the processes of gestation, emerged in unpredictable configurations, and even changed during the course of their existence. Art became contingent as it played out its capricious life in environment, performance, documentation, and outrageous hybrids of previously distinct media . . . the alternative spaces had to happen to give voice to these new art concepts.[21]

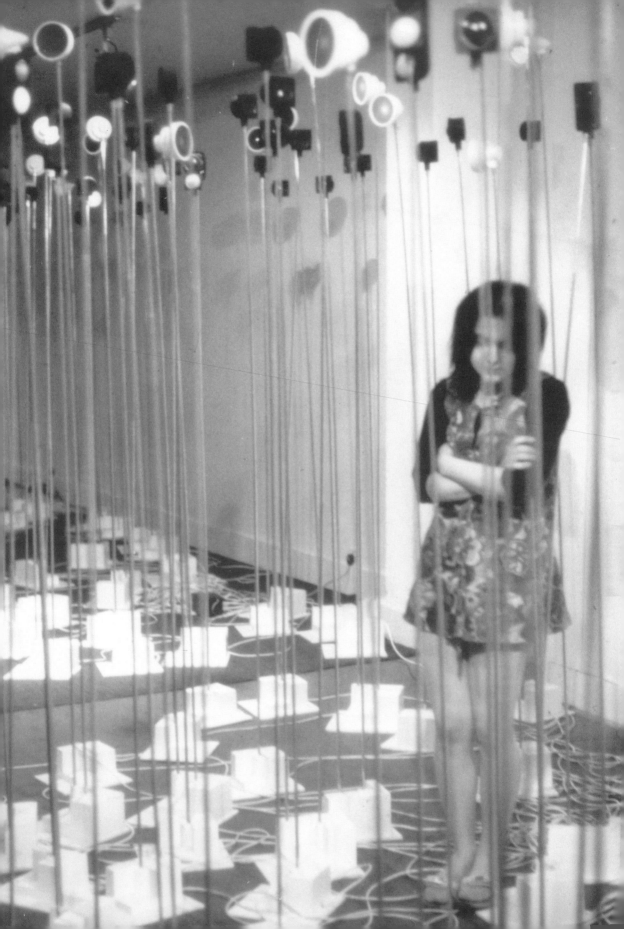

The general term 'space' replaced the word gallery (alternate spaces followed after experimental galleries and laboratories) and was used precisely because it was supposed to avoid the connotations of an institutional or commercial environment, where an hierarchical, formal arrangement might determine audience behaviour in pre-set ways. 'Space' usefully removed the immediate connotations of commodity.

If artists already had any 'space' it was because they had studios. And the connotations of studio activity had long passed from the associations of the model and the arranged tableau to a less structured, process-orientated concept of the creative site.[22] The new spaces in the early seventies were thus much less the laboratories of technological or participatory experiment than a self-consciously chaotic milieu (of which Warhol's space of the Factory is a precursor), where gesture and incident could be prominent and pre-eminent. Artists wanted space that they could control completely, they wanted space outside formal and civic networks, and they wanted space without a high investment in real estate.

A 37 90 89 was the title given to a 'space' founded in Antwerp in 1969 to counter the growing sense that the public appreciation of art was being manipulated by dealers and museums. Created out of a meeting held at the house of the collector Dr Hubert Peeters in Bruges on 24 May it was co-ordinated by Kasper König in close collaboration with artist Bernd Lohaus. It featured Belgian artists Marcel Broodthaers and Panamarenko and the LIDL activities of Jörg Immendorff, and joined a European post-Fluxus network of informal artist-led activity. The development of the early artist-run galleries in Canada, like the New York spaces, was motivated equally by a need to create an outlet for new activities. Western Front in Vancouver showed the greatest congruence between life and art, between living, domestic space and working, formalized, more public space, and was as Diana Nemiroff puts it 'a natural outgrowth of the informal communal living and working situations that were common in Vancouver, as well as the collaborative interactions fostered by the correspondence network and Intermedia [its forerunner, an experimental arts organization]'.[23] By contrast A Space in Toronto was a classic multi-use warehouse space, historically significant because of its title, the support it gave to conceptual and process art, and its later pioneering work on a programme based on invited curatorial proposals. Vehicle pioneered a new location for art in Montréal and brought together a number of different strands of new art that would previously have been untenable in the same space. The founding artists set out their desires: 'We wanted an exhibition space, we wanted a resource centre. We wanted access to information, we wanted energy.'[24]

Highly charged, turbulent and multi-disciplinary cross-currents were also to be found at 112 Greene Street in New York. Founded by artists Jeffrey Lew and Alan Saret, it emerged as a 'programme' in the autumn of 1970 out of activities in each of

their studios. The anarchic schedule of exhibitions and events unfolded, often with a strong architectural-sculptural bias, and much influenced by the charismatic figure of Gordon Matta-Clark.[25] Lew summed up the ethos: 'In most galleries you can't scratch the floor. Here you can dig a hole in it.'[26] Its influence was widespread; as Mary Delahoyd put it, 'virtually every major sculptor of the '70s encountered 112. Indeed its physical character may have impelled the sculpture of that decade on its free-wheeling experimental course.'[27]

After some initial help from a private backer, it also received regular funding from both the New York State Council for the Arts and the National Endowment for the Arts and, as with the Local Initiatives Programme and Canada Council funding in Canada, such grants allowed the widespead creation of the 'alternate scene'. Brian O'Doherty, himself an artist, was working part-time for the Endowment in this period and was the key link in the creation of new funding programmes.

> I was down in the SoHo art world. . . . Now it would be considered as a very serious conflict of interest, but it was a very much looser time. I said, 'Jesus Jeff, maybe you should get some money'. It was as informal as that. We had no processes of any great significance. We were just getting round to saying shouldn't we have panels or something? It was very small . . . the money was all going to artists.[28]

397

On one hand the new spaces represented participation in political change in challenging the existing forms of cultural control and representation, on the other hand they accentuated an individualism which the idea of the 'artists' *own* gallery' promoted. In Jeffrey Lew's words: 'There was once a time for being chaotic and letting yourself completely freak out. Now I just don't feel this way, I feel like getting it together.'[29] Even if application forms were a recent introduction, the very process of obtaining funding was bound to make the planning of exhibition schedules more formal and therefore highlight the question of selection.

SELECTION

Kay Larson commented in 1977:

> If artists can pick their own shows, they will reserve for themselves some of the power to determine the way history is written, because exhibitions help define and shape that history; in showing the artists that they feel are important, they will also partially deflect the power of critics and curators who have traditionally told artists what is good and not good.[30]

As an analyst of the growth of artist-run centres in Canada, Clive Robertson has

commented on the problems of selectivity and co-option, on the processes of self-preservation, on the conservatism that these can produce, and on the real limitations to concepts of 'alternative' or 'independent' in the face of the recent agendas of government and state funding agencies. On the question of autonomy he writes:

> One of the effects of these encounters with the various institutional authorities that determine and inscribe values is that in the course of operating within the art institutional context artist-run centres seem to have become an institutionalized hybrid of impulses on the one hand aimed at being self-governing and self-determining, on the other organized so as to secure state-support and be *marketable* in terms of government agencies.[31]

Support to artist-run centres has often been argued for within arts-funding agencies as a way of supporting artists and the production of art. But which artists would be helped? Many spaces evolved without a clear rationale for their processes of choice, others failed to change when they no longer operated effectively, others remained

398 ➡ **24.4 Exterior of Fashion Moda, mural by Crash, New York, 1980. Photograph by Lisa Kahane.**

dominated by the same set of artists, unwilling to let new artists into the process. In many cases the concept of what Barbara Kruger has called the 'green room'[32] applies: the 'alternate' space is the back-stage location from which the artists are taken on to the real stage of the commercial or museum world. Whether for the commercial galleries in New York or Europe, or for the public art museums, the 'alternate' spaces have created a convenient form of pre-selection. The choice of their exhibitions therefore matters greatly.

Different structures in alternate spaces have produced different models of choice-making: Western Front or A.I.R. are the classic collectives, while A Space, 112 Greene Street or Vehicle were founded on looser lines as co-operatives.[33] Both models rely on a degree of liberal egalitarianism which contrasts greatly with the curatorial, directorial and trustee hierarchy of most larger art museums. After a period of turmoil in 1978, A Space changed to a structure by which proposals for programmes of exhibitions including exhibitions on sites outside the gallery would be put to the board (itself made up of artists) by artists or critics; the results were some of its most interesting exhibitions. With Artists Space in New York – the classic artworld 'green room' – whenever there was a change in director, and a change in

the rules about choice of exhibitions, a singular shift in identity occurred.[34] Founding spirit Irving Sandler recalled:

> We thought we might be able to set up a real alternative structure. That of course didn't happen. What we became was a foreign team for commercial galleries who recognized that we were in tune (because the artists were doing the selection) with what was liveliest in the artworld. Indeed about 70 to 80 per cent of the people who became art stars in the eighties had their first show with us.[35]

PLACE

The place where a gallery is sited partly determines its audience. Place thus implies both physical and political geography. The desire, for example, to take contemporary art into specific neighbourhoods outside the central shopping, business or cultural districts of a city and to seek new audiences has a long history even within the mainstream (examples include the Brooklyn Museum and the Whitechapel Art Gallery).

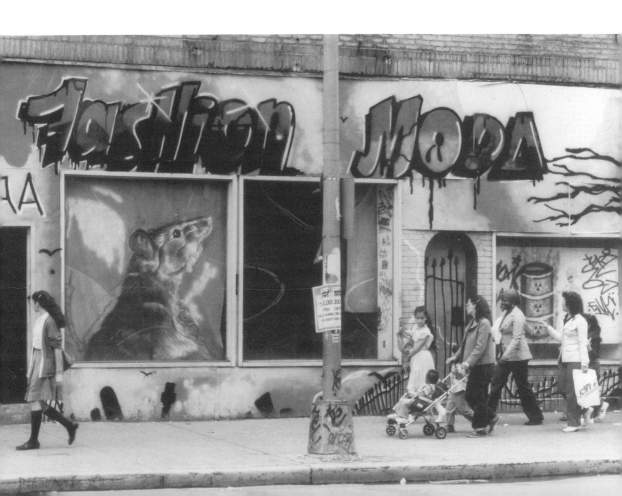

The work of an 'independent' art museum, like the artists' space, whether the New Museum in Manhattan in New York or the Orchard Gallery in Derry, is highly dependent on its *place*. For example, the New Museum exhibition space was offered in 1980 to three artists' groups, representing 'other' spaces: Fashion Moda, Taller Boricura and Colab. Marcia Tucker, director of the New Museum, pointed out that to 'relinquish curatorial control of this exhibition was a drastic change in our usual procedure.... the work shown may not have reflected the Museum's own esthetic or political point of view; the audience differed radically from the one our exhibitions usually address; the traditional museum and gallery-going public may have found the work to be distasteful or of a different "quality" than expected'.[36] With little concern for potential distaste, Colab decided at two weeks notice to withdraw from *Events*, as the Museum 'stood to gain more than Colab from the exhibition'.[37]

Fashion Moda stayed in the show. Its own location on Third Avenue in the South Bronx was intended as a deliberate foil to the cliquishness, sanctity and elitism of the Lower Manhattan artworld: a store with a front; not a loft. The founders Joe Lewis and Stefan Eins didn't see it as philanthropic but breaking barriers between 'high and low culture' (as Lynn Gumpert put it 'the inclusion of graffiti, Hispanic statuary, photographs of UFOs, and rebuilt engines marks an attempt to destroy the differences').[38] The programme started in the Autumn of 1978 with an installation of works from the South Bronx on the theme of 'Art, Science and the Imagination', and later included Jenny Holzer's *Sentence Philosophy* and an invitation to John Ahearn to start making castings of South Bronx residents. Joe Lewis: 'If someone comes in with something we like, it goes up then and there ... we realize how important it is to get the stuff up as fast as possible – especially since we deal with a wide variety of artists from real straight academics to just the most out-macho, gang-type zip-gun people.'[39]

Eins preferred to think of the audience as the patrons of the organization, but such a concept was dependent on state and foundation funding. The sharp perceptions of the artists and audiences sustained Fashion Moda's critical edge for a long time. Its appearance at the 1982 *documenta 7* (invited to make a store for t-shirts, posters and other goods from associated artists, but not included in the official catalogue) marked a certain difficulty in developing beyond the immediate aims of the gallery in the South Bronx. Its model of alternative activity, or aggressive complementarity, worked most effectively in a specific location. But its influence on the much more commercial new wave of East Village galleries was notable: it demonstrated that an alternative location could still help establish a generation of artists.

400

ECONOMY

> Dealers and museums are essentially intertwined, related, so I don't really see that as a
> big problem. . . . I mean there's value making, there's always been that connection and
> there again there's a fantasy that somehow the curator is disconnected, in some ivory
> tower while all these terrible dealers are running around. I don't really see that, I mean
> that's just a reality. Paintings are bought and sold.
>
> (Robert Smithson, 1972) [40]

The dealer makes reference to a narrative of miraculous discovery and creation, while the museum employs the language of transcendent and universal value. Such masking separates the concepts of private and public spheres and obfuscates the financial realities of the visual arts as an economic sector. The mythologies surrounding dealers in contemporary art have been greatly boosted by two figures at the heart of the New York art market: Leo Castelli and Mary Boone. Castelli has gained over thirty-five years his unassailable position as the *grand seigneur* [41] of the New York art world. Mary Boone through her sharp, high-class, hard-sell profile briefly, and more recently, became its queen.[42] Both Boone and Castelli have spoken of their work as a form of curatorship. Castelli has compared his gallery's work with a museum: 'It has always been part of my ambition to have every major artist and every important movement represented by my gallery. . . . The real question for me has always been one of historical importance. After all a museum has to pick all the good paintings of a period. I felt I should do the same.'[43]

Dealers who emerged in the sixties in the period following Castelli, such as Richard Bellamy in New York and Kasmin in London, developed new kinds of exhibition and gallery presentation. Both can be seen as pioneers of new forms of contemporary presentation. They and their artists wanted a different, more open and public atmosphere: serious, but widely enjoyable, without the complex connotations (including those of class and money) of the older dealers' galleries. Even if fashionability was not their first aim it followed on from their work. Their galleries formed part of the background against which the alternate 'warehouse' activities of the private and public sector developed in the early seventies.

Richard Bellamy's Green Gallery, and also Kasmin, combined formal innovation in the use of the space with a prescient fashionability.[44] As important as their sense of discovery was the idea of critical presentation. Commenting on Bellamy's position in particular Amy Goldin wrote:

> Today the public exhibition of art is necessary to establish its value. A style or an
> individual artist's work can become important *because* it is seen, and the confrontation
> of the work and the audience is held to be desirable in itself. This factor puts a new

weight on the gallery that functions less like a shop and more like a theater. The work's ability to hold an audience seems a condition and measure of its value, as the audience-reaction is the measure of a play's.[45]

Bellamy or Kasmin can thus be seen as 'theatrical producers', choosing the 'shows' and their timing; the artists had already become theatrical directors as well as actors, taking responsibility for whole scenarios and not just the action-event or the narrative.

Following Kasmin or Bellamy a new generation of dealers emerged at the end of the sixties who were also close to their artists but did not have the fashion or media world as such an immediate point of reference. Dealers such as Paula Cooper, Konrad Fischer and Nicholas Logsdail (of whom the last two were artists before they started exhibiting and selling work) ran their galleries in more open but less central spaces (adapting lofts or warehouse premises), SoHo rather than mid-town, Marylebone rather than Mayfair. They overlapped their activities productively between private and public sectors, organizing events and collaborating closely with interested museum curators and organizers of independent spaces.

402

➡ **24.5 Kasmin Gallery, London, paintings by Kenneth Noland, interior designed by Ahrends, Burton and Koralek, 1963. Photograph courtesy of Ahrends, Burton and Koralek.**

More recently New York's East Village demonstrated a more specific overlap between public and private sectors. In the larger artworld economy the East Village was an alternate spectacle: a kind of art fair in the city. However, it was soon swamped by the self-conscious media attention that surrounded it and had almost collapsed by the end of 1986.[46] Calvin Tomkins described how originally:

> a sense of neighbourhood solidarity and the frustration of not being able to have their work shown in SoHo galleries combined to produce the new art scene. Artists began turning their storefront studios into part-time galleries, several of which became full-time exhibition spaces. Since the time lag between innovation and discovery in today's art world now stands at approximately thirty-seven seconds, the public quickly appeared in droves.[47]

In the new East Village market the mythologies that already surrounded dealers as selectors, interpreters and distributors of art were turned into caricatures or parodies. Lucy Lippard recalled the same effect in more political presentations, like

> The Lower East Side is Not For Sale, which had 'openings' on various corners in the Lower East Side at a time when the gentrification started to happen. The corners were

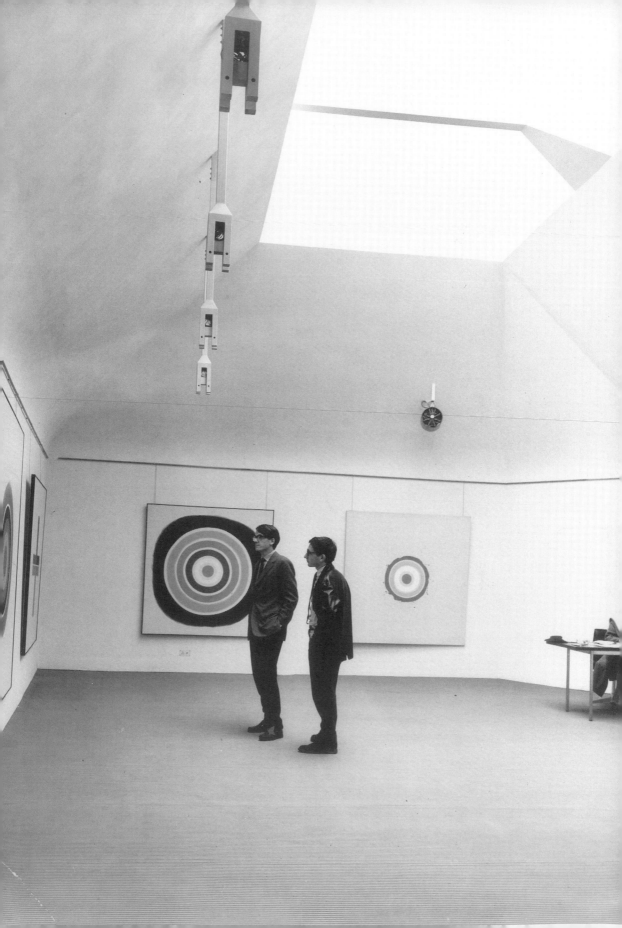

designated the Guggenheim, the Modern, the Whitney, and so forth and they were just plastered with art that was made especially for that location: it didn't look much like an art show but it was an art show: an incredible, intense show: we had our opening and stood around on the street corners and drank wine, and went from the Whitney to the Guggenheim to the Modern.[48]

Those starting East Village storefront spaces in the spirit of play soon found that they were being taken more seriously than expected, finding collectors within and beyond the Sunday afternoon crowds. The first 'commercial' gallery in the East Village was the Fun Gallery, formed in a collaboration between Patti Astor and artist Bill Stelling. Fun was decidedly a commercial gallery rather than an alternate space because, as Patti Astor put it, 'I just wanted a place to show art and didn't want to bother to fill out the grant forms'.[49] Gracie Mansion like Patti Astor is better remembered than her exhibitions or artists. Here the East Village aped the glamour and glitz that was being (re)created in the Manhattan artworld of the early eighties. As Corinne Robins noted: 'The artists are given more than respectful critical attention, but it is the dealers who are the darlings of the media. Dealing, rather than

404

➡ 24.6 *Cambriolage*, **installation by Tadeusz Kantor, Galeria Foksal, Warsaw, 1971. Photograph courtesy of Galeria Foksal, Warsaw.**

making art has become the glamour profession of the eighties.'[50]

Produced out of short-lived boom-time conditions, the East Village showed the significance both of self-conscious 'curating' by artists, dealers, critics and curators as an element of the market economy and of the emergence of a substantial subclass of art consumers. More importantly the dominance of parody, in which the 'alternate space' had become another image to be reworked and put into inverted commas, demonstrated both the pervasiveness of the idea and the power of the market to adopt and absorb it.

ALTERNATIVES

Alan Wallach wrote in 1980:

They are 'alternate' only inasmuch as they augment the number of available art spaces. But because they are conceived as art, in the same sense that a gallery or a museum is an art space, they have not significantly affected the way art is experienced nor have they noticeably influenced art itself. . . . A real alternative requires a critical examination

all existing categories of art and artistic experience. But . . . the artworld exists by maintaining and renewing the cult of art.[51]

There are obvious contradictions in the idea of alterity. Artists while seeking space for new activity and controlling space for an expression of identity have also used it to promote themselves, in the hope that dealers would offer to help sell their work and mainstream curators would choose to curate or purchase it. However, like the artists General Idea, many others in the West have also expanded their activities and filled exhibition spaces, made publications as a 'space' and extended the 'space' of video through organizing their own distribution.

There are few answers to Ingrid Sischy's questions[52] and they are probably only to be found in circumstances of political oppression where a gallery run by artists is effectively expressive of their freedom to create and publish ideas and images that are not merely alternate but unacceptable. Such a gallery conveys this subversiveness in ways that are not rhetorical or superfluous as in the West. There are many examples but the Foksal Gallery in Warsaw, created in a building next to the Artists' Union in 1969, and associated with artists in the circle of the artist and theatre director Tadeusz Kantor, is a case in point. For more than twenty years it has shown both Polish and other European and American artists: not work of direct political imagery but art that despite a strong conceptual leaning was subversive by analogy or metaphor.

Kay Larson had referred in 1977 to the growth of alternate spaces in the US as an 'eruption . . . to be seen not as an odd collection of unrelated symptoms but as an etiological event, a single spontaneous phenomenon whose causes have yet to be fully identified and and whose effects are yet to be seen'.[53] Whatever its pioneering and combatative origins this 'phenomenon' eventually reproduced many of the same relations of power and control as the museum and gallery system. But even if alterity is more rhetorical than actual, artist-run centres have given prominence to innovation, first in the nature and flexibility of exhibition installations, second in the forms of selection and third in the potential relations with interested audiences and communities. If there are actual 'alternatives', they are to be found at the very edges of the system or hidden in the cracks and crevices at the centre.

NOTES

This paper was originally presented at a seminar in March 1994 at the Center for Curatorial Studies, Bard College. It followed on from work developed during a Getty Grant program Senior Research Fellowship held by Bruce Ferguson, Reesa Greenberg and myself during 1993.

406

1 'Concretized ideas I've been working around' (Jan. 1971) in *Talking to Myself: The Ongoing Autobiography of an Art Object*, Bari, Marilena Bonomo, 1975, p. 54.

2 Ingrid Sischy, in *Studio International*, 195: 990 (1980), p. 72.

3 *Studio International*, 195: 990 (1980), p. 73.

4 There are many histories here; an early Black women's exhibiting organization was formed in 1971 by Faith Ringgold, entitled 'Where We At'. See Judith K. Brodsky, 'Exhibitions, galleries, and alternative spaces', in Norma Broude and Mary D.Garrard, eds, *The Power of Feminist Art*, New York, Harry N. Abrams, 1994, p. 106.

5 'Sexual art-politics', *Art News* (Jan. 1971), p. 62.

6 It emerged as a splinter group from the Art Workers Coalition (itself formed out of the protests around the treatment of Takis's work in the MOMA *Machine* exhibition). Faith Ringgold's and Michelle Wallace's protests against the 1970 Venice Biennale led to the *Withdrawal Show* at the School of Visual Arts in New York and in the Autumn of 1970 Lucy Lippard and Brenda Miller formed the Women's Ad Hoc Committee specifically to organize further protests around the Whitney Sculpture Biennale.

7 For a partial account see Lawrence Alloway, 'Women's art in the seventies' (1976), reprinted in *Network: Art and the Complex Present*, Ann Arbor/London, UMI Research Press, 1984; see also *Feminist Art Journal*, Winter 1973–4, and essays in Broude and Garrard, eds, *The Power of Feminist Art*.

8 The first women's space in New York was the Women's Interart Center opened in 1970 at 549 W52, and described in the *Feminist Art Journal* in 1973 as providing 'the women artists' community with workshops in various media, theatre, attractive exhibition space, and an arena for happenings, films, dance, video tapes and discussion'. On the West coast, a Feminist Art Program at Fresno State College was established in 1970 by Judy Chicago and Faith Wilding. Chicago with Miriam Schapiro went on to set up a workshop programme at Cal Arts, which became Womanhouse, and with Arlene Raven and Sheila de Bretteville formed the Feminist Studio Workshop. In 1973 several organizations joined together to form the Woman's Building in Los Angeles.

9 'An interview with members of A.I.R.', *Arts Magazine* (Dec.–Jan. 1973), p. 59.

10 'Making A.I.R.', *Heresies*, 2/3 (1979), p. 81.

11 Interview with Sandy Nairne, May 1993.

12 At a slightly earlier point David Medalla's and Paul Keeler's SIGNALS gallery in London had been tellingly subtitled the Centre for Advanced Creative Study and the co-operative, the Park Place Gallery in New York, the Gallery of Art Research Inc.

13 This was 1968, the same year as the opening in July of the large Hayward Gallery on the South Bank as a major temporary exhibitions space programmed by the Arts Council. The Council phased out its exhibition programme at the Tate Gallery and in turn stimulated that gallery to enlarge its own programme.

14 Jim Haynes, *Thanks for Coming!*, London, Faber & Faber, 1984, p. 151.

15 Information provided by Biddy Peppin, London. Quotation that follows from documentation in her possession.

16 Information from Roelof Louw's entry in *Survey '68: Abstract Sculpture*, London, Camden Arts Centre, 1968.

407

17 Quoted by Philip Hendy, 'Art – A New Institute', *Britain To-Day* (British Council), 144 (April 1948), p. 29. Hendy himself commented: 'All the nations and all the arts are to be brought together under one modernistic banner in a great forward march which will take no heed of "commercial standards". This is a brave programme. . . .'

18 For example, a long-standing strand of interest in the relation between art and science. In this spirit Desmond Morris, the naturalist and anthropologist was made its director in 1967. The runaway success of his book *The Naked Ape* brought his resignation and the arrival of theatre director Michael Kustow.

19 Michael Kustow, *Tank*, London, Jonathan Cape, 1975, also quoted in Robert Hewison, *Too Much*, London, Methuen, 1988, p. 124.

20 Cf. Arnold Goodman, *Tell Them I'm On My Way*, London, Chapmans, 1993, p. 324.

21 Mary Delahoyd, 'Seven alternative spaces, a chronicle, 1969–1975', *Alternatives in Retrospect*, New York, The New Museum, 1981, n.p.

22 For thousands of artists 'home'and studio are the same place as it makes no economic sense to hire a separate workshop or studio. Equally 'studio' has, since at least the 1960s, had a meaning in the real-estate trade as a single-room apartment: i.e. very small and with no separately demarcated areas except for the bathroom. For landlords and agents the term has useful bohemian connotations.

23 Unpublished M.A. Thesis, Concordia, Montréal, 1985. The Western Front artists had managed in 1973 (with the assistance of two mortgages) to purchase a three-storey wooden Knights of Pythias Lodge building, built in 1922, and ideal for their various activities. The performance programme was funded by the Explorations section of the Canada Council from 1974. The title was both an architectural and a military pun.

24 Suzy Lake interviewed by Diana Nemiroff, ibid., p. 136.

25 Matta-Clark was also involved with 98 Greene Street, a space created by collectors Holly and Horace Solomon, who wanted to spend their 'collecting money' more actively.

26 Introduction by Robyn Brentano, in R. Brentano and M. Savitt, eds, *112 Workshop*, New York, 1981, p. viii.

27 Delahoyd, *Alternatives in Retrospect*, op. cit.

28 Interview with Sandy Nairne, May 1993.

29 'Interview with Alan Saret and Jeffrey Lew', *Avalanche*, 2 (Winter 1971), p. 13.

30 Kay Larson, 'Rooms with a point of view', *ARTnews* (Oct. 1977), p. 37.

31 Clive Robertson, 'Invested interests. Competitive and dysfunctional autonomies within the Canadian art system', *Fuse*, Spring 1993, p. 13.

32 Interview with Bruce Ferguson and Sandy Nairne, July 1993.

33 I am indebted to a pertinent discussion of these models by Clive Robertson, 'Invested Interests', op. cit., p. 17.

34 The gallery was set up in 1973 by Irving Sandler and Trudie Grace because they knew that New York State Arts Council funds might be available for visual artists, if a suitable conduit could be formed. After a series of meetings with artists it was agreed to set up an exhibition space, initially at 155 Wooster Street, from 1976 at 105 Hudson, and subsequently on Greene Street.

35 Interview with Sandy Nairne, June 1993.

36 Marcia Tucker, 'Introduction', *Events*, New York, The New Museum, Dec. 1980–March 1981, p. 5.

37 Quoted by Tucker, ibid., and in Grace Glueck, 'The new collectives – Reaching for a wider audience', *New York Times* (1 February 1981), p. 27. Starting with *X Magazine* in 1977 Colab had been through at least one major upheaval before becoming the originating organization for the *The Real Estate Show* (visited by Joseph Beuys and Ronald Feldman in February 1980) and *The Times Square Show* of 1980 and it went on to form ABC No Rio in the East Village as an exhibition space and A. More Store on Broome Street as an outlet for low-priced artists' multiples. In 1982 it was also producing *Potato Wolf*, a live half-hour cable TV show on Manhattan Cable.

38 Lynn Gumpert, 'Observations on "Events"', in *Events*, p. 10.

39 Quoted in Lynn Gumpert, ibid.; see also Bunny Mathews, 'Fashion Moda is coming to New Orleans . . .', *Figaro*, New Orleans, 9:42 (20 Oct. 1980), p. 10.

40 Robert Smithson, 'Conversation . . . on April 22nd 1972 with Bruce Kurtz', *The Fox*, 2 (1975), p. 72.

41 This is Calvin Tomkins' phrase: cf. 'A good eye and a good ear', in *Post- To Neo-: The Art World of the 1980s*, London, Penguin Books, 1989, p. 10. See also Ann Hindry, ed., *Claude Berri Meets Leo Castelli*, Paris, Renn, 1990; Barbaralee Diamonstein, ed., *Inside New York's Art World*, New York, Rizzoli, 1979, pp. 211–26 and 305–16; Laura de Coppet and Alan Jones, eds, *The Art Dealers*, New York, Clarkson N. Potter, 1984, pp. 80–110; also Emile de Antonio and Mitch Tuchman, 1972 interviews in *Painters Painting*, New York, Abbeville Press, 1984, and Mary Lublin, 'Dealers from Steiglitz to Castelli', in *American Art in the Twentieth Century*, London, Royal Academy, 1993.

42 The article in *New York* magazine (19 April 1982), by Anthony Haden-Guest had a notorious cover image of the svelte Boone, hands on hips, titled 'The new Queen of the Art Scene'; see also discussion in Sandy Nairne, *State of the Art*, London, Chatto & Windus, 1987, ch. 2, pp. 62–8. When Willi Bongard saw the article he commented in *Art Aktuell* that everyone knew that Ileana Sonnabend was the real queen of the artworld.

43 De Coppet and Jones, *The Art Dealers*, p. 109.

44 Green started in 1960 with the hidden backing of the collectors Robert and Ethel Scull (of taxi-fleet riches). Bellamy had worked at the artists' co-op gallery, the Hansa, in the fifties (where Ivan Karp also worked in this period before he went on to Martha Jackson's Gallery and then Castelli's).

45 Amy Goldin, 'Requiem for a Gallery', *Arts* (Jan. 1966), p. 29.

46 In January 1984 Helene Winer curated *New Galleries of the Lower East Side* for Artists Space and in October Janet Kardon curated *The East Village Scene* for the Institute of Contemporary Art at the University of Pennsylvania (the catalogue of which contains a list of key exhibitions, including those abroad), also *Neo York* at the University of California at Santa Barbara. In 1985 there was an uptown show at Holly Solomon's Gallery, *57th, Between A and D*. By 1985 there had been numerous articles, as well as Roland Hagenberg's *East Village Guide*, New York, Pelham Press; and its history was further defined in Steven Hagar's *Art After Midnight*, New York, St Martin's Press, 1986. An account of the more 'politically motivated' artists' groups is Alan Moore and Marc Miller, eds, *ABC No Rio Dinero*, New York, ABC No Rio and Collaborative Projects, 1985.

47 Calvin Tomkins, 'Disco', *New Yorker* (22 July 1985), reprinted in *Post- to Neo-*, p. 188.

to build collections of national and artistic importance, viewed against the historical mandate of the National Museum of Man (now the Canadian Museum of Civilization) to collect contemporary native art "as a most important current expression of native societies, of native perceptions of their own cultures and as the continuity of those cultures,"[2] caused some institutional uncertainty over their overlapping roles.

In 1983, the Gallery, prompted by the interest of the associate curator of Canadian prints and drawings and the curator of contemporary art, and by the possibility of the donation of two significant Inuit art collections, commissioned a study on the subject by Jean Blodgett, an expert in Inuit art. Her report, based upon a review of the collecting and exhibiting policies and practices of other major Canadian art galleries and on extensive interviews with native artists and specialists in the area, strongly recommended that the Gallery pursue an active role in collecting and exhibiting the art of Canadian artists of native ancestry and put an end to its policy of exclusion, which the native art community perceived as clearly discriminatory.[3]

Blodgett's report led to several changes at the National Gallery, both symbolic and

➡ **25.1 Carl Beam, *The North American Iceberg*, acrylic, photo-serigraph, pencil on plexiglas, 213.6 cm × 374.1 cm, National Gallery of Canada, Ottawa, 1985. Photograph courtesy of the National Gallery of Canada, Ottawa.**

practical in nature. In the new draft of its collections policy, which was being revised and brought up to date for all the collecting areas, the section on contemporary Canadian art was amended to explicitly include "the acquisition of representative examples of contemporary Inuit and Indian art."[4] An Inuit art section was created and a curator from the Department of Indian and Northern Affairs was transferred to the National Gallery; gifts from collectors of Inuit art were actively solicited. In the area of Indian art, consultations took place with representatives of SCANA (Society of Canadian Artists of Native Ancestry) regarding an approach to acquiring and exhibiting the work of contemporary First Nations artists as an integral aspect of the collection of contemporary art.

An important step was taken with the purchase of Carl Beam's *The North American Iceberg* (fig. 25.1) in 1986. The title was ironic. Implying a hidden and little-known territory, at one level it was a take-off on the title of an important exhibition of contemporary art from Europe that had been held the year before at the Art Gallery of Ontario in Toronto, *The European Iceberg*. While Toronto and the North American artworld in general were discovering the new European vanguard, North American native artists like Carl Beam were waiting in the wings. The

cosmopolitan range of images in Beam's painting suggests a kind of human or cultural landscape, rather than a natural one, a landscape in which the conventional framework of space and time collapses as images from the past and present, near and far, are juxtaposed. The painting, and its subject, are indicative of the complexities of identifying and positioning today what had earlier in this century been summarily described as "Indian art" and shown chiefly within an ethnographic or romantic primitivist context. In an article on the painting written for the *Native Art Studies Newsletter* soon after the purchase, I described what I saw as its implicit cultural critique:

> The fragmented reproducible nature of these images is an essential part of the photographic technology that produced them, a technology reinforced and amplified by the advent of television, which brings the world and its events before our eyes, only to freeze and quickly forget them.
>
> Beam uses these mute images to construct a text whose underlying meaning is a critique of the technological imperative that drives Western civilization, effacing the differences between cultures and destroying what resists it. As he invites comparison between his own image and those of nineteenth century Indians, so he also draws points of contact and contrasts between Geronimo and Anwar Sadat, between the

often competing ethnic groups. A new national art may be preferable to the invidious selection of the products of one particular ethnic group.[38]

For our purposes, it is the complex entanglement of modernism, primitivism, and nationalism that Miller points to that is of interest. One exhibition that may be fruitfully examined from this perspective is the highly popular *Masterpieces of Indian and Eskimo Art from Canada*, shown at the Musée de l'Homme in Paris and at the National Gallery of Canada in 1969. Apparently the first major exhibition of aboriginal Canadian art to be shown internationally, the exhibition was initiated by the Musée de l'Homme, which had already held several exhibitions that took an aesthetic, as opposed to ethnographic, approach to the art of non-European cultures, and organized with the assistance of Canada's National Museum of Man in the context of official Franco-Canadian cultural exchanges. It may not be irrelevant to observe, in light of Miller's comments, that the show took place during the climax of Canadian nationalism two years after the Centennial, and in the midst of a period of heightened Québec nationalism as well.

Like the 1941 exhibition of *Indian Art of the United States*, *Masterpieces of Indian and Eskimo Art from Canada* was divided into comprehensive culture areas, including the Eskimos, the Indians of the Northwest Coast, the Indians of the Plains, and the Indians of the Eastern Region, although the selection of objects was limited to 185 "masterpieces." Again, the design of the exhibition was atmospheric and evocative. Visitors to the Musée de l'Homme were greeted by "the sound of Indian music and the dry rattle of Eskimo drums" and gazed at totem poles and house posts "brooding in spotlight and shadow,"[39] all calculated to create an impression of mystery and magic, while the smallest objects – prehistoric Inuit ivory carvings – were individually displayed, jewel-like, in free-standing cases that enhanced their preciousness. None of the work was contemporary. Distanced, therefore, in both time and place, the exhibition was hailed by the French press in terms that recalled the first European explorations, as a "discovery" and a "revelation" where "all is mystery, shock and marvel, since for us it's an art hitherto almost unknown."[40] It is revealing of the desire for the primitive that, when the exhibition came to the National Gallery of Canada, some reviewers complained that the objects, "lit with the light of common day," had lost their ambience, that is to say, some of their *other*ness.

The catalogue, though it contained several scholarly essays by Canadian specialists, was a vehicle for the expression of a primitivizing attitude. In the preface, a critic from France, Christian Zervos, explicitly discounts science as a means of understanding the art. Instead, he invokes magic – "the call of the unknown and the supernatural" – to explain its "primitive" attraction. Here the artist and the magician are one,[41] and we are led to the essence of art via the unconscious:

426

> But whatever are the peculiarities of the spiritual life of primitive man, and although he may be subjected to spells and charms, and preoccupied with his relationship to the mysteries of life and how they can be revealed, the instruments he fashions for magical purposes go beyond this. . . . The artist, without any aesthetic motivation, and without seeking to recognize himself in the object, exalts it . . . by allowing his vital feelings to take control; of necessity this leads him to the essence of art.[42]

In complementary fashion, the French curator of the exhibition, Marcel Evrard, proposes that the spectator has access to the art, and to "what the objects convey in terms of the universality of mankind" – in spite of the utter strangeness of the societies that produced it – through "the way of the senses, the privileged path to understanding."[43] It is precisely such expressions of a direct, unmediated relationship between the producer and the product, and between the audience and the artwork, that characterizes the primitivizing attitude, which in turn rests upon "the Romantic illusion that the ultimate solution to complexity lies in simplicity."[44]

This is far from the integrated presentation of art and culture achieved by *Indian Art of the United States*. Those viewers who shed their childhood preconceptions of Red Indians and the Wild West as a result of *Masterpieces*, as was noted by some reviewers, did so for a mythic view of native art that was as divorced from reality as the one they had abandoned.

427

NEW DISCOURSES IN FIRST NATIONS ART

It is far less difficult to chart a course through the past and to register its achievements, its shortcomings, its visions, and its blindnesses, especially when the ideological perspective has shifted, than it is to map the present and to make sense of its contradictions. The period of the seventies was relatively quiet, marked by a growing popular appreciation for certain forms of native art, particularly the decorative expressions of the Southwest and Woodlands schools and Inuit carving, whose forms were influenced by the pressures of the marketplace for a romantic or naive traditionally oriented art. However, by the eighties a marked shift was evident, spurred by changes within and without: on the one hand, native activism had helped to politicize the native artist, bringing questions of identity, both individual and collective, to the fore; on the other hand, a definitive shift from modernism to postmodernism, and with it the breaking down of institutional canons, an emphasis on pluralism, and an interest in exploring questions of difference, had weakened the ethnocentrism of the art establishment. The result was a dramatic increase in the number of exhibitions of contemporary First Nations art, organized from a variety of perspectives. For this reason it is harder to single out one or two as representative

while doing justice to the sense of a whole new discourse developing – new questions, new answers, and new relationships with the mainstream. Indeed, I shall refer to and cite from several, allowing these references to overlap in order to give an idea of the general contours of the landscape.

The first noticeable shift was in *who* was mounting the exhibitions. While the largest public institutions kept their distance, and museums and galleries with an established constituency and public for native art, such as the Heard Museum in Phoenix and the Philbrook Art Center in Norman, struggled gamely with the changes of the decade, other art institutions entered the field. Prime among these were the university art galleries and regional public galleries, less well funded and with less invested in the mainstream, and therefore more open to local initiatives. For example, the paradigm-shifting exhibition *New Work by a New Generation* at the Mackenzie Art Gallery in Regina was a co-operative project with the Saskatchewan Indian Federated College, held to mark the meeting of the World Assembly of First Nations there in 1982. The relatively small size of such galleries meant a concentration on thematically oriented shows, provisional gatherings remote from the totalizing approach of earlier exhibitions, which had surveyed millennia. It seemed no longer possible or desirable to represent a whole art movement, let alone a culture.

Equally important has been the changed response to the question of expertise. Where once the indispensable expert was the ethnologist or collector, the exhibitions of the eighties have most often been collaborations, with native individuals playing hybrid roles: administrator/historian (Tom Hill, Rick Hill), artist/critic (Jimmie Durham), artist/curator (Jaune Quick-to-See Smith, Gerald McMaster, Robert Houle), and artist/teacher/polemicist (Alfred Young Man). Of course, this has happened in part because it is contemporary, not historic, art that is the focus of these exhibitions. This also explains the extraordinary onrush of names where anonymity had been the rule: the new catalogues feature entries on artists rather than objects, biographies replace provenances, and artists' statements take the place of cultural data.

At issue also is the complex question of representation and self-definition – not far removed from the political issue of self-determination. The articulate presence of individuals able to pose and respond to the question, who shall speak for me?, is an essential step in addressing what Cornel West, writing of African-American cultural identity, has termed the "problematic of invisibility and namelessness,"[45] and what has for native peoples, until recently, been their mythic presence but real absence in contemporary consciousness. Now, through such exhibitions as *New Work by a New Generation* (Regina, 1982), *Contemporary Native American Art* (Stillwater, 1983), *Ni' Go Tlunh a Doh Ka* (We are always turning around on purpose, Old Westbury, Long

Island, 1986), *Beyond History* (Vancouver, 1989), *Our Land/Ourselves* (Albany, 1990), and others that propose new, multicultural perspectives, such as *The Decade Show* (New York City, 1990) and *Visions of Power: Contemporary Art by First Nations, Inuit and Japanese Canadians* (Toronto, 1991), a discourse is emerging in which First Nations individuals are telling it their way. A reading of these texts suggests some of the main themes.

Perhaps the most fundamental is that of reclaiming change and diversity as an integral aspect of native traditions, carried into the present. Thus, Robert Houle writes in 1982 of a new generation of artists whose work and experience straddle two cultures:

> To perceive the new generation of native artists as a symbol of revolt against existing conventions, or as a touchstone of tradition in search of new methods to express a new vision, is to reaffirm one of the most important aspects of native cultures, the capacity to harness revolutionary ideas into agents of change, revitalizing tradition.[46]

Jimmie Durham draws out the political significance of the artist's position in a similar statement:

> Traditions exist and are guarded by Indian communities. One of the most important of these is dynamicism. Constant change – adaptability, the inclusion of new ways and new material – is a tradition that our artists have particularly celebrated and have used to move and strengthen our societies.[47]

According to Durham, it is the driving motivation of the Indian aesthetic, seen in "the acts and perceptions of combining, of making constant connections on many levels," that gives the native artist's work its political edge in subverting and correcting the constant mythification of reality in a hybrid contemporary world.[48]

Of course, from the outside, change is often considered a sign of assimilation and loss of authenticity. No issue is more bitterly contested within the native art community. Here it has found an ally in postmodern theory, which has engaged in deconstructing the image of the unchanging *other* as a fictional construct of European identity formation. The classic example is Edward Said's critique of Orientalism's construction of static images instead of historical or personal narratives.[49] The theme of authenticity is taken up by George Longfish and Joan Randall in an argument against categorization in their essay, "Contradictions in Indian territory":

> From the artists' point of view . . . statements [about diversity] are logical reflections of Indian reality. The experiences of the artists as Indian people are as rich and varied as the Native American tribes and nations which remain on this continent. They approach

429

each other seeking to share their differences and to compare their similarities. . . . The assumption among them is that they are Indian; they do not concern themselves with having their art "look" Indian.[50]

They correctly observe that the issue is one that reflects the vested self-interest of the collector and the curator rather than the artist. Houle and Durham extend their refusal of compartmentalization, Houle in arguing for a "trans-cultural" modernism that can offer a critique of native culture without being severed from it;[51] Durham in refusing "the common assumption that an Indian artist deals only with the Indian world." He observes pointedly, "Once out, in New York City for example, we are expected to become deculturalized 'artists.' There is no similar expectation for the white artist."[52]

The question of identity that emerges out of such considerations is really not a single issue. If we think of it as a thing, it eludes us. "Identity is conjunctural, not essential," in historian James Clifford's words.[53] Not surprisingly, those who do address it usually resort to metaphors and discussions of strategies. The English critic Jean Fisher, in her introduction to *Ni' Go Tlunh a Doh Ka*, borrows the image of the

➡ **25.8 Rebecca Belmore, *Mawu-che-hitoowin: A Gathering of People for Any Purpose*, 1992, mixed media, stained floor, chairs, tape recorders, headsets, audiotape. Installation view in *Land Spirit Power: First Nations at the National Gallery of Canada*, Ottawa, 1992. Photograph courtesy of the National Gallery of Canada, Ottawa.**

Trickster, "whose seemingly polymorphous and uncentred persona is . . . adaptable to change and adversity", and who speaks "with a polyphonic voice characterized by ambiguity and paradox."[54] She points to strategies of ironic masquerade, of absurd juxtapositions and parody, strategies often identified with postmodernism, which we are as likely to find in works by Jimmie Durham or James Luna, Carl Beam or Lawrence Paul Yuxweluptun, as in those by Marcel Duchamp or Cindy Sherman.

Yet, although culture and tradition are not limiting conditions of identity, they provide signposts that are claimed by artists. In this catalogue, Durham states, "I've lived all of my adult life in voluntary exile from my own people, yet that can also be considered a Cherokee tradition," and explains, "We know the world through whatever specific cultural constructs we have. But 'Indians' of the Americas have a subtle colonial overlay to our self-definition which is almost impossible to separate out. Then, because we all still live under colonial conditions, we have a political responsibility to our own people." Jaune Quick-to-See Smith, curator of *Our Land/Ourselves*, writes that it is the land itself that spawns the stories and myths that keep identity intact.[55]

In *Visions of Power*, Alfred Young Man asks, "But isn't it important, after all is said and done, to recognize the historicity of these artists' life experiences?"[56] Repossessing history means telling the histories anew, and this is another crucial theme in the emerging discourse. Tom Hill, in *Beyond History*, and Rick Hill in *Our Land/Ourselves*, provide the institutional and political framework for a history of contemporary First Nations art in Canada and the United States. Alfred Young Man writes from personal experience of the struggles to establish Native American Studies programs in the United States and Canada, and to win acceptance from the academic establishment. Rick Hill is the director of the Institute of American Indian Art in Santa Fe, and Tom Hill directs the Woodland Cultural Centre on the Six Nations Reserve in Southern Ontario. Young Man is a professor of Native American Art at the University of Lethbridge in Alberta. These are histories written by the participants, and they partake of memory as well: they tell the stories of activism and collaboration, of initiatives that failed and of others that succeeded, providing vision and support for many artists, which may dispel forever the patronizing image of their work as coming from a privileged but passive creativity, existing outside of history.

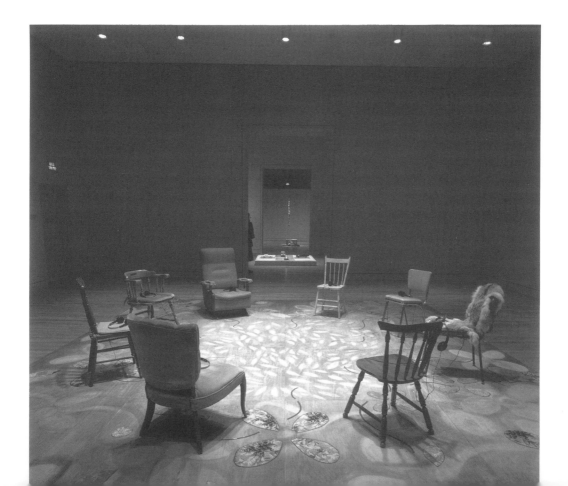

There may be a danger in this narrative of subsuming contradictions in an analysis that is too orderly, too optimistic. One of the most contradictory of the themes to emerge in the new discourse is that of sustaining cultural difference. Postmodernism has drawn welcome attention to the subject of difference and marginality, but it must be remembered that being marginal means being powerless and invisible. The real dilemma, then, is how to sustain cultural difference while contesting marginality. Some, like Rick Hill, view difference as a source of strength:

> Art for Indians is perhaps their last hope to retain their individuality in a country that promotes uniformity. Indians create art as an act of defiance to the attempt to subjugate Indians, as a protest to the attempt to assimilate Indians, and as an act of faith that somehow it is okay to be an Indian in the modern world. In fact, some Indian artists believe that it is preferable to be an Indian.[57]

But to attempt to win acceptance in the mainstream on this ground is fraught with difficulty. As Young Man asks regarding Robert Rauschenberg (rumored to be of native ancestry), "Would he have been as acceptable by the art establishment of the time if he [had] admitted that his Indian identity, culture and history was an indispensable element of his existence, and informed his statements, as do Carl Beam and Alex Janvier?"[58]

The problem is not easy to resolve. Therefore, as Jimmie Durham observes, "It would be impossible, and I think immoral, to attempt to discuss American Indian art sensibly without making the political realities central."[59] Cornel West, who would agree with Durham's enunciation of the moral and political core of the question of cultural difference, has suggested a possible strategy:

> The most desirable option for people of colour who promote the new cultural politics of difference is to be a critical organic catalyst. By this I mean a person who stays attuned to the best of what the mainstream has to offer – its paradigms, viewpoints, and methods – yet maintains a grounding in affirming and enabling subcultures of criticism.[60]

From my own point of view as a non-native curator in a national institution, I would like to borrow the limited (but not limiting), non-utopian model of a critical conversation amongst us, through which I might respond to and perhaps contribute to the emerging discourse. This essay is my effort to open a space for conversation, first, by demystifying the intellectual frameworks by which the National Gallery – and other, similarly comprehensive institutions such as the Museum of Modern Art and the Musée de l'Homme – simultaneously acknowledged and distanced First

432

Nations art in the past; and second, by listening to what has been said by native people and their allies in the present.

It seems to me that a politics of opposition is unduly limiting. Changes occur within institutions not because they are forced, as is often said, but as a result of a complex conjuncture of circumstances – discussions *and* paradigm shifts. Since 1985, the National Gallery has organized a major retrospective of the Inuit artist Pudlo Pudlat, and two smaller exhibitions of First Nations artists. The first, *Cross-Cultural Views*, in 1986, emphasized cultural mobility and political awareness, showing the work of native artists with that of other artists form the collection such as Jamelie Hassan and Hans Haacke, whose work may be viewed as a deconstruction of colonial power. The second, *Strengthening the Spirit*, held in 1991 on the occasion of the first in a series of conferences of indigenous peoples of the Americas, stressed· issues of identity, spiritual values, and history. *Land, Spirit, Power*, the first international exhibition of contemporary First Nations art at the National Gallery of Canada, follows in this spirit. It is a space and an occasion for dialogue.

NOTES

This essay was originally published in *Land, Spirit, Power: First Nations at the National Gallery of Canada*, Ottawa, National Gallery of Canada, 1992, pp. 16–41. It was written at a time of optimism about the likelihood of real constitutional change. However, the outcome of those constitutional negotiations, the proposed Charlottestown Accord, failed to be ratified by the provinces, and the future of its provisions touching the First Peoples, such as the implementation of self-government, is unclear.

1 Ruth B. Philips, "Indian art: Where do you put it?" *Muse*, 6:3 (Fall/Oct. 1988), p. 64.

2 William E. Taylor, Jr, "Some National Museum of Man thoughts on the curating of contemporary native art in the NMM and the National Gallery," 17 Oct. 1980, National Gallery of Canada administrative files. Taylor was Director, National Museum of Man, at that time.

3 Jean Blodgett, "Report on Indian and Inuit art at the National Gallery of Canada," 28 Oct. 1983. National Gallery of Canada administrative files. Blodgett has been chief curator of the McMichael Canadian Collection in Kleinburg, Ontario, since 1988.

4 The full statement reads:

> The Gallery's collecting activities in contemporary Canadian art represent the continuation of its historic commitment to collect work in all media – including painting, drawing, printmaking and sculpture – by living Canadian artists. The contemporary collection, therefore, builds on an extensive collection of historic and modern Canadian art, and aims to develop a collection of national significance that represents the state of artistic creation in Canada at the present time.
>
> Because of the vastness of the country and its geographic diversity, artistic activity has tended to flourish around a number of distinct regional centres on the West Coast, in the Prairies, the North, Ontario, Quebec and the Maritimes. The Gallery's collection

of contemporary art should recognize and reflect the regional variety of Canadian art. This policy should include the acquisition of representative examples of contemporary Inuit and Indian art, with the advice of curators from the Canadian Museum of Civilization.
(From "Collections policy and procedures," revised 1984 and 1990, National Gallery of Canada archives, p. 57)

5 Diana Nemiroff, "National Gallery collects contemporary works by artists of native ancestry," *Native Art Studies Association of Canada Newsletter*, 2:3 (Summer 1987), n. p.

6 Blodgett, "Report on Indian and Inuit art," p. 58.

7 Bruce Trigger, *Natives and Newcomers: Canada's "Heroic Age" Reconsidered*, Kingston and Montréal, McGill-Queen's University Press, 1985, pp. 6–7.

8 Carol Podedworny, "First Nations art and the Canadian mainstream," *C Magazine*, 31 (Fall 1991), p. 29.

9 Ibid., p. 32.

10 I am aware that the collecting and exhibiting of Indian artifacts began almost simultaneously with the first contacts between Europeans and native North Americans. A useful overview of pre-twentieth-century relations is found in Christian F. Feest, "From North America," in *"Primitivism" in 20th Century Art: Affinity of the Tribal and the Modern*, ed. William Rubin, New York, The Museum of Modern Art, 1984, pp. 85–95. My concern here is with the response by art institutions to cultural production viewed as art.

11 Several detailed studies and overviews of this subject exist and have provided invaluable assistance in shaping this inquiry. While I disagree with some of their conclusions, I am particularly indebted to Ann Morrison, "Canadian art and cultural appropriation: Emily Carr and the 1927 *Exhibition of Canadian West Coast Art – Native and Modern*," master's thesis, University of British Columbia, 1991: W. Jackson Rushing, "Marketing the affinity of the Primitive and the Modern: René d'Harnoncourt and *Indian Art of the United States*," in *The Early Years of Native American Art History: The Politics of Scholarship and Collecting*, ed. Janet Catherine Berlo, Seattle, University of Washington Press, 1992; and Lis Smidt Stainforth, "Did the spirit sing? An historical perspective on Canadian exhibitions of the Other," Master's thesis, Carleton University, 1990.

12 Eric Brown, "Introduction," in *Exhibition of Canadian West Coast Art: Native and Modern*, Ottawa, National Gallery of Canada, 1927, p. 2.

13 Brown, letter to J. Murray Gibbon, Canadian Pacific Railways, Montréal, 10 Oct. 1927, National Gallery of Canada archives.

14 Wassily Kandinsky, *Concerning the Spiritual in Art*, New York, Dover, 1977, p. 1. The first English translation of his book by Michael Sadlier was published as *The Art of Spiritual Harmony*, London, [publisher not known], 1914.

15 Stainforth, "Did the spirit sing?", p. 55.

16 Carr's pottery and rugs, also included in the exhibition, appear to be the exception, since they did make use of rather literal transpositions of indigenous motifs. However, Carr made these items for commercial sale and did not consider them an integral part of her art.

17 Marius Barbeau, "The Canadian Northwest," *American Magazine of Art*, 24:5 (May 1932), pp. 337–8.

18 Marius Barbeau, "West Coast Indian Art," in *Exhibition of Canadian West Coast Art*, p. 4.

19 Susan Hiller, ed., *The Myth of Primitivism: Perspectives on Art*, London and New York: Routledge, 1991, p. 283.

20 Brown, in *Exhibition of Canadian West Coast Art*, p. 2.

21 Morrison, "Canadian art and cultural appropriation," p. 24.

22 Brown, in *Exhibition of Canadian West Coast Art*, p. 2.

23 Marsden Hartley, quoted in Gail Levin, "American Art," in Rubin, ed., "*Primitivism*," p. 461.

24 Frederic H. Douglas and René d'Harnoncourt, *Indian Art of the United States*, New York, Museum of Modern Art, 1941, p. 10.

25 René d'Harnoncourt, "Living arts of the Indians," *Magazine of Art*, 34:2 (Feb. 1941), p. 72.

26 Ibid., p. 76.

27 W. Jackson Rushing, *Native American Art and the New York Avant-Garde: A History of Cultural Primitivism*, Austin, University of Texas Press, 1995, p. 108.

28 H.W. Janson, "Indian art of the United States," *Parnassus*, 13:3 (March 1941), p. 117.

29 Henry McBride, "The return of the Native," *Sun* [New York], 25 Jan. 1941, n. p.

30 Rushing, op. cit., p. 115.

31 See F. Maud Brown, *Breaking Barriers: Eric Brown and the National Gallery*, Ottawa, Society for Art Publications, 1964, for a detailed account of Brown's career.

32 Douglas and d'Harnoncourt, *Indian Art*, p. 12.

33 Edward Alden Jewell, "The Redman's culture," *New York Times*, 26 Jan. 1941, n. p.

34 Douglas and d'Harnoncourt, *Indian Art*, p. 11.

35 Hiller, ed., *The Myth of Primitivism*, p. 283.

36 Daniel Miller, "Primitive art and the necessity of primitivism to art," in ibid., p. 55.

37 Ibid., p. 52.

38 Ibid., p. 67.

39 Irene Baird, "Indian, Eskimo art convey a sense of magic," *Ottawa Journal*, 27 Aug. 1969, n. p.

40 Tim Creery, "Paris hails exhibition of Eskimo and Indian art 'Equal of great civilizations,'" *Ottawa Citizen*, 27 Sept. 1969, p. 35.

41 We might recall the recent French exhibition *Magiciens de la Terre* (Centre Georges Pompidou, Paris, 1989), which made this equation the explicit premise of an exhibition that ranged alongside established European and North American artists others from the Third World and the Fourth World (as the indigenous nations are sometimes known), joined in unity by this attractive but specious idea.

42 Christian Zervos, "Preface," in *Masterpieces of Indian and Eskimo Art from Canada*, Paris, Société des amis du Musée de l'Homme, 1969, n. p.

43 Marcel Evrard, "Introduction," in *Masterpieces of Indian and Eskimo Art from Canada*, n. p.

44 Miller "Primitive art," p. 54.

45 Cornel West, "The new cultural politics of difference," in Russell Ferguson, *et al.*, eds, *Out There: Marginalization and Contemporary Cultures*, New York and Cambridge, Mass., The New Museum of Contemporary Art and MIT Press, 1990, p. 27.

46 Robert Houle, "The emergence of a new aesthetic tradition," *New Work by a New Generation*, Regina, Mackenzie Art Gallery, 1982, p. 5.

47 Jimmie Durham, "Ni' Go Tlunh a Doh Ka," in *Ni' Go Tlunh a Doh Ka*, Old Westbury, Long Island, State University of New York College at Old Westbury, 1986, p. 1.

48 Ibid., p. 2.

49 Edward Said, *Orientalism*, New York, Pantheon Books, 1978.

50 George C. Longfish and Joan Randall, "Contradictions in Indian territory," *Contemporary Native American Art*, Stillwater, Oklahoma State University, 1983, n. p.

51 Houle, "Emergence of a new aesthetic tradition," p. 3.

52 Durham, "Ni' Go Tlunh A Doh Ka," p. 3.

53 James Clifford, *The Predicament of Culture*, Cambridge, Mass., and London, Harvard University Press, 1988, p. 11.

54 Jean Fisher, "Preface," in *Ni' Go Tlunh A Doh Ka*, p. v. Fisher has further elaborated on these ideas in her essay, "Unsettled accounts of Indians and others," in Hiller, pp. 292–313.

55 Jaune Quick-to-See Smith, *Our Land/Ourselves*, Albany, State University of New York, 1990, pp. vi–vii.

56 Alfred Young Man, "Towards a political history of native art (abridged)," in *Visions of Power*, Toronto, The Earth Spirit Festival, 1991, p. 29.

57 Rick Hill, "The rise of neo-native expression," in Smith, *Our Land/Ourselves*, p. 3.

58 Young Man, "Towards a political history of native art," p. 31.

59 Durham, "Ni' Go Tlunh A Doh Ka," p. 1.

60 West, "The new cultural politics of difference," p. 33.

IN AND OUT OF PLACE

Andrea Fraser

In 1980 Louise Lawler asked three art critics to collaborate with her on the production of a matchbook by submitting short texts to be printed on its cover. The critics – all of whom are involved in critical analysis not simply of works of art, but of the institutional apparatus in which they circulate – apparently thought matchbooks too vulgar a format for their texts. Perhaps resisting the impropriety of being presented by rather than presenting the artist, they opted to preserve their proper place of publication, their proper function. Consequently, this particular matchbook was never realized.

Produced for specific contexts, distributed in galleries and at cultural events, Lawler's matchbooks do not remain in their place of origin, but are continually placed, replaced, displaced. While only one aspect of her practice, they are

characteristic of much of her work. For Lawler consistently challenges the proprieties both of place (the divisions of artworld labor that assign artists, dealers and critics proper places and functions) and of objects (the ideological mechanisms which establish the authorship and ownership of art). Although she frequently collaborates with other artists, for Lawler artistic production is *always* a collective endeavor: it isn't simply artists who produce esthetic signification and value, but an often anonymous contingent of collectors, viewers, museum and gallery workers – and ultimately the cultural apparatus in which these positions are delineated.

I will generalize and say that Lawler operates primarily from three different yet interdependent positions within this apparatus: that of an artist who exhibits in galleries and museums; that of a publicist/museum-worker who produces the kind of material which usually supplements cultural objects and events; and that of an art-consultant/curator who arranges works by other artists (for example, her 1984 show at the Wadsworth Atheneum's Matrix gallery in Hartford, *A Selection of Objects from the Collections of the Wadsworth Atheneum, Sol LeWitt and Louise Lawler*).

For an artist to write reviews, curate exhibitions or run a gallery is a

➡ **26.1 Louise Lawler and Allan McCollum, *For Presentation and Display: Ideal Settings*, Diane Brown Gallery, New York, 1984. Photograph by Jon Abbott, courtesy of Metro Pictures, New York.**

contemporary artworld commonplace. But these occupations are usually regarded as secondary; the artist is identified primarily as a producer of a body of works, which other activities only supplement. By abdicating this privileged place of artistic identity, Lawler manages to escape institutional definitions of artistic activity as an autonomous esthetic exploration. Her objective is not so much to uncover hidden ideological agendas, but to disrupt the institutional boundaries which determine and separate the discrete identities of artist and art work from an apparatus which supposedly merely supplements them.

Lawler transforms the seemingly irrelevant plethora of supplements – captions which name, proper names which identify, invitations which advertise (to a select community), installation photos which document, catalogues which historicize, "arrangements" which position, critical texts which function in most of these capacities – into the objects of an art practice. Her use of these formats constitutes a double displacement; she brings the often invisible, marginal supports of art into the gallery and situates her own practice at the margins, in the production, elaboration and critique of the frame.

Engagement with the institutional determination and acculturation of art can be traced back to the historical avant-gardes – Duchamp, Dada and Surrealism on one hand, the Soviet avant-garde on the other. Lawler's work has a more immediate relationship, however, with the post-studio practices of the seventies, particularly the work of Michael Asher, Marcel Broodthaers, Daniel Buren and Hans Haacke. While very different, all these artists engage(d) in institutional critique, ranging from Asher's and Buren's situational constructions (or deconstructions) of architectural frameworks in galleries and museums, to Broodthaers's directorship of a fictional museum, to Haacke's documentation of high art's corporate affiliations.

But Lawler can also be differentiated from these artists, for rather than situate institutional power in a centralized building (such as a museum) or a powerful elite which can be named, she locates it instead in a systematized set of presentational procedures which name, situate, centralize. Unlike Asher's constructions of exhibition spaces within exhibition spaces, which critically contemplate the frame but continue to function within it as sculpture, Lawler's work is often conceived as a functional insert into a network of supports which is exterior to the gallery.[1] Unlike Broodthaers, Lawler doesn't occupy even fictional positions of institutional authority,

but works instead to dissipate all such concentrations of power. Unlike Haacke's, Lawler's relationship with corporate and market structures is one of ironic collaboration, simultaneously revealing the place of high art in a market economy *and* moving towards a repositioning of the artist within it.

In both her early installations and her later "arrangements" of pictures, Lawler selects and presents work by other artists as well as her own. Her main contribution to a 1978 group show at Artists Space was the installation of a painting of a race horse borrowed from the New York Racing Association. Placed high on windows in a wall dividing two galleries, the painting was flanked by two theatrical spotlights directed not at the painting but at the viewer, thereby interfering with the painting's visibility and, at night, projecting viewers' shadows onto the facade of the Citibank across the street (a Buren-like strategy of connecting the inside and outside of an exhibition space).

While her Artists Space installation is in many ways reminiscent of post-studio meditations on institutional context, on this occasion Lawler also dealt more productively with the frame, presenting the gallery rather than being passively presented by it. Instead of supplying the catalogue with the customary reproductions

440

➡ **26.2 Louise Lawler, *Living Room Corner Arranged by Mr. & Mrs. Barton Tremaine, NYC (Stevie Wonder)* (cropped for presentation in *Slides by night...*), 1984. Photograph courtesy of Metro Pictures, New York.**

of her work, she designed an Artist Space logo which was printed on the catalogue's cover and also distributed as a poster around lower Manhattan.

Two subsequent shows in Los Angeles accomplished a similar reversal of presentational positions. For a 1979 nine-person show in a loft in an abandoned department store, Lawler did another installation employing theatrical lights, again not directed at a picture she had painted of the exhibition's invitation – a gray, hard-edge Roman numeral nine in the New York School masking-tape tradition. Blue and pink gels and a tree-branch silhouette template on the lights emphasised the theatricality of the presentation. (A similar lighting scheme was used in a 1984 show at the Diane Brown gallery in New York, *For Presentation and Display: Ideal Settings*, done in collaboration with Allan McCollum. Bathing a hundred Hydrocal sculpture-bases in the idyllic atmosphere of corporate never-never land, the subdued but dramatic lighting indexed the commodity showcase.)

In her 1981 one-woman, one-evening show in Los Angeles, *Louise Lawler – Jancar/Kuhlenschmit, Jancar Kuhlenschmit Gallery*, Lawler presented the gallery more explicitly, spelling out its name on the wall in individual postcard-size photographs

of dramatically lit three-dimensional letters. She also directed the dealers to stand behind the reception desk (since they could not sit down in the tiny office) and show interested visitors other Lawler photographs contained in a small black box.

Lawler's literalization and reversal of presentational positions was also apparent in the first room of her 1982 exhibition at Metro Pictures in New York, where she presented an "arrangement" of works by gallery artists (Sherman, Simmons, Welling, Goldstein, Longo). Despite its somewhat unconventional hanging, Lawler's "arrangement" might have been mistaken for another anonymous group show of the Metro stable. But upon realizing (or remembering) that this was a "one-woman" show, viewers were confronted with an ambiguity of occupation, a shift in position which illuminated the role of the often unnamed "arrangers" in the exhibition and exchange of art. (Photographs documenting the "arrangement" of art in museums, homes and offices were exhibited in the gallery's main space.) Lawler's "arrangement" also ironically revealed the economic subtext of the Metro artists' esthetic of appropriation: her "arrangement" was for sale at the combined price of all the individual works plus 10 per cent for Lawler (the fee customarily charged by art consultants).

Because it continues to function within a traditional gallery context, the reversal Lawler's installations enact is primarily symbolic: the artist–institution relationship is contemplated, questioned, but remains intact. However, her matchbooks and invitations (like her Artist Space poster and catalogue cover) come closer to subverting mechanisms of institutional presentation and to constituting a counter-practice. Inasmuch as they do not depend upon an exhibition for distribution and do not even claim the status of art objects, in these works Lawler manages to resist the tendency of many contemporary artists to parody or criticize but nevertheless conform to the traditional position of artists in exchange relations.

One of Lawler's matchbooks was inspired by the media hype surrounding a 1982 lecture by Julian Schnabel in Los Angeles. Occupying the position of "publicist" unbeknownst to the lecture's sponsors Lawler printed matchbooks with the event's title and distributed them at the auditorium. Using a publicity tool against itself, she encapsulated the exaggerated spectacle of "An evening with Julian Schnabel" in a disposable souvenir.

For the 1983 *Borrowed Time* exhibition, a group show at Baskerville + Watson in

➡ **26.3 Louise Lawler, matchbook for the *Borrowed Time* exhibition at Baskerville + Watson, New York, 1983. Photograph by Louise Lawler, courtesy of Metro Pictures, New York.**

New York, Lawler produced a matchbook which advertised the show with a quote which emphasizes the relation of esthetic to economic value: "Every time I hear the word culture I take out my checkbook. – Jack Palance."[2] The immediate effect of such matchbooks is one of vulgarization: by employing a format usually used to promote restaurants and driving schools, Lawler amplifies polite art-market mechanisms into travesties of consumer culture.

Unlike matchbooks, which are made available to a general audience, invitations are distributed on the basis of mailing lists which consolidate a small art audience into an even smaller circle of cultural initiates for whose patronage a specific desire is expressed. The series of invitations to private, "salon-type" exhibitions Lawler organized with Sherrie Levine under the title *A Picture is No Substitute for Anything* (1981–2) called attention to this function, as did the 1981 event *Louise Lawler and Sherrie Levine invite you to the studio of Dimitri Merinoff . . .* (a Russian émigré figurative expressionist whose New York studio had been kept intact since his death). At times, however, Lawler displaces the kind of privileged reception which such private events imply; for example, in her invitation to a performance of *Swan Lake* by the New York City Ballet, the "readymade" spectacle Lawler appropriated

remained a thoroughly public event. (In the lower right-hand corner, where one would expect to read "RSVP," Lawler specified instead "Tickets to be purchased at the box office.")

Excerpts from a Letter to the Participating Artists by the Director of Documenta 7, R. H. Fuchs, Edited and Published by Louise Lawler (1982) situated the artist as invitee rather than inviter. Not invited to participate in *documenta 7*, Lawler reprinted the inflated, romantic, heroicizing rhetoric of the curator's letter to invited artists as tiny raised green type at the top of two sheets of stationery and an envelope, sold at Fashion Moda's art stand outside the galleries at Kassel. In Lawler's ironic commodification, the curatorial address was displaced (literally) to the margins, where it became little more than an institutional letterhead, an authorizing corporate-like logo disguised as esthetic rhetoric.

If Lawler's *documenta* stationery reduces high-art discourse to a supplement of institutions and the market, her gift certificate for the Leo Castelli gallery, "authorized" and exhibited there in a 1983 group show, reduces the art work itself to a similar status. Although it was printed in a limited edition (of 500), the certificate's value isn't contingent upon its singularity (or lack thereof) or the presence of the

artist's signature, but on the amount for which it is purchased and for which it could be used towards the purchase of a Warhol or a Rauschenberg. As Jean Baudrillard formulates in "The art auction," the value of an art object is produced not by the artist, but by the collector in his or her "sumptuary expenditure" or "economic sacrifice" for art. "Good investment" and "love of art" engage in mutual rationalization: wealth is legitimized in its dissipation for the sake of esthetic quality, while economic sacrifice pays homage to the transcendental value of high art.[3]

The collection and presentation of art has always been a display of social and economic standing before it is an exhibition of esthetic value. Lawler's photographs documenting *Arrangement of Pictures* in private, corporate and museum collections demonstrate the social uses to which art is put after it leaves the artist's studio. These "installation" photographs have been exhibited in galleries and museums, where the documentation of art objects is substituted for the objects themselves; they have also been published, both as independent photo-features and as subtly sardonic illustrations for critical texts.[4]

In Lawler's photographs of private collections, art is represented a simply one

444

➡ **26.4 Louise Lawler, "Gift Certificates are available," installed in *Photographs/Drawings*, group exhibition, Leo Castelli Gallery, New York, 1983. Photograph courtesy of Metro Pictures, New York.**

object among many in a chaos of accumulation; in the domestic interior, art – whether "tastefully" arranged or indifferently juxtaposed – is assimilated into a backdrop of decorative commodities. *Arranged by Mr and Mrs Burton Tremaine, New York*, 1984 is more than a picture of a picture hanging over the couch: Lawler includes the television set in front of a Robert Delaunay, next to a Lichtenstein sculpture head used as a lamp base on the coffee table. And in *Pollock and Tureen*, also 1984, the artist's last painting (or at least its bottom edge – which is all Lawler photographed) is little more than apocalyptic wallpaper behind an antique china dish.

Lawler's photographs of corporate collections document how art is used to express relative position in the corporate hierarchy: if large paintings and sculpture in the reception area establish a corporation's desired public image, in *Arranged by Donald Marron, Susan Brundage, Cheryl Bishop at Paine Webber, Inc.*, two Lichtenstein silkscreens establish the position of office workers (who are quite oblivious to the presence of "art"). As the Black, uniformed guard in *Longo, Stella, Hunt at Paine Webber Mitchell Hutchins* somehow seems part of the corporate collection, the artists' names in the title mimic the name of the Wall Street brokerage firm.

Even after art objects are withdrawn from exchange, the legacy of privileged expenditure is never severed from their pedigree.[5] In museums, the labels which supplement every object always begin with the author and end by citing its previous owner; in establishing art's value, these two genealogies are inseparable. Such informational labels are often the subject of Lawler's *Arrangements of Pictures* in museum collections, raising the question of whether institutional authority and an exclusive caste of collectors aren't actually the primary exhibits.

Establishing authorship, ownership, pedigree and, ultimately, value, such museum labels are the most conspicuous instance of the institutional exhibition of proper names. Yet even in these titles there is an ambiguity: Is the object "proper" to the artist or the collector? In the captions for her own photographs, Lawler extends this ambiguous poly-ownership to include an indefinite list of curators, art consultants, museum and office workers, etc. At the same time, she often withdraws or displaces her own name: for example, in a 1980 group show at Castelli Graphics, in which, as usual, artists' names were Lettraset on the wall next to their works, Lawler's own photograph of a text by another author was accompanied by the attribution "anonymous."

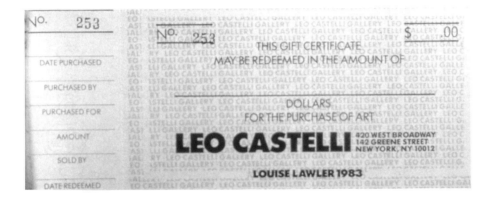

Lawler's work often involves an interference with the proper name. In her *Patriarchal Roll Call*, for example, she plays with artists' names, turning them into bird calls. Recorded in 1983, Lawler's bird calls are based only on *male* artists' names, calling attention to the fact that the proper name is always a patronymic (the name of the father); they also parody the viewer's desire to recognize, in a work of art, not a gesture or a style, but the name "itself," here disguised as a call of the wild.

Signifying the essential yet imaginary identity of a unified ego, the proper name establishes the subject as such, in language, under the law. Through the proper name, individuals are inscribed within power relations and come to identify with and be identified by positions therein. The conventional organization of art practices around a signature – everything which allows a work of art to be identified as a "Pollock" or a "Warhol," etc. – institutes the proper name as interior to the art object; thus, artists are locked in a structure of institutionalized subjectivity. And the institutional exhibition of proper names, designating the authors and owners of objects, defines that subjectivity in terms of consumption and ownership.

Because Lawler's work isn't reducible to a single theme, mode of production of place

➡ **26.5 Louise Lawler, *Painting of Announcement, without type*, installed in *Individual and Collaborative Work by 9 Artists*, Los Angeles, 1979. Photograph courtesy of Metro Pictures, New York.**

of functioning, it often seems anonymous, or at least difficult to identify without a caption. Her January 1985 slide show at Metro Pictures – *Slides by Night: Now That We Have Your Attention What Are We Going to Say?* – confronted the institutionally organized desire to recognize a unified subject in an artist's work. It also addressed the demands placed on production by the gallery's new space. Rather than exhibiting prints of her *Arrangements of Pictures* (as in her previous show at Metro), Lawler supplied the walls with the enormous images the gallery's vast space seems to require – but immaterial ones (slides) projected on the gallery's back wall and visible only after gallery hours from the street.

The program began with slot-machine signs – plums, oranges, cherries, apples, baseballs and bells – in random combinations of three until ... jackpot! The "payoffs" were pictures from a plaster-cast museum, copies of classical sculpture in various states of storage, decomposition, restoration (*Augustus of Primaporta* in a plastic bag). These images faded into one another in slow dissolves, finally giving way to another random exchange of one-arm-bandit signs and another jackpot – this time Lawler's own *Arrangements of Pictures* in homes, museums and corporate offices.

Thus, Lawler included her own production within the same structure of indifferent accumulation which her *Arrangements of Pictures* document, perhaps in order to refuse the audience what it is looking for in an artist's work – a lasting identity which seems to transcend (but which is actually constructed by) the arbitrary exchange and circulation of esthetic signs. The fact that Lawler included her own works does not mean that she has finally acquiesced to the market or passively accepted its mechanisms (and her own place within them). By representing her own photographs in slide form, she symbolically withdraws them from market exchange. Once again, her position is double: that of a producer of images, and that of one who actively organizes not simply their presentation, but perhaps a new chain, a counter-discourse in which they are only elements.

I began this essay with Lawler's unrealized "critical" matchbook in order to introduce, at the start, a certain self-consciousness about my own critical project of presenting the work of an artist who engages in a critique of institutional presentation. Lawler's practice implicates art criticism as well, especially monographic art criticism, which often functions retroactively to inscribe unruly

objects within an institutionally acceptable position, to recover from a heterogeneous practice a unified ego – the subject of a signature.

However, Lawler's work suggests a strategy of resistance, of functioning differently within an institution which reduces difference to a sign, ripe for consumption. As long as artists continue to subscribe to traditional modes of production and places of functioning – whether or not they engage in critique, appropriation or the uncovering of hidden agendas – esthetic signification will continue to be locked in an order of institutionalized subjectivity and legitimizing consumption. If Lawler manages to escape both marginalization and incorporation, it is because, whatever position she may occupy, she is always also somewhere/something else.

NOTES

This essay was originally published in *Art in America*, June 1985, pp. 122–9.

1 This remark applies primarily to Asher's work of the seventies (documented in

448

➡ **26.6 Louise Lawler,** *Announcement card,* **from** *Individual and Collaborative Work by 9 Artists,* **Los Angeles, 1979. Photograph courtesy of Metro Pictures, New York.**

Michael Asher, Writings 1973–1983 on Works 1969–1979. Halifax and Los Angeles, 1983). His more recent production, like Lawler's, treats the institution as a set of social relations (a notion that is only implicit in his earlier work) rather than as architecture. This shift may be a response to the expansion of the information industry and the service sector of the economy, which has resulted in a further ideological effacement of productive labor. If symbolic intervention in the conditions of material production is characteristic of modernist art, Lawler and Asher engage with the institutional services and informational mechanisms which position and define cultural production.

2 This statement originates with Nazi propagandist Joseph Goebbels, who said, "Every time I hear the word culture I reach for my gun." Palance read the line, rewritten by Godard, in the film *Contempt.*

3 Jean Baudrillard, "The art auction," in *For a Critique of the Political Economy of the Sign*, St Louis, 1981.

4 Lawler's photographs of Mondrians were juxtaposed with those of Sherrie Levine and published in *Wedge*, 1, under the title "A picture is no substitute for anything." A series of the *Arrangements of Pictures* appeared in *October*, 26. Lawler's photographs were also used to illustrate Douglas Crimp's "The art of exhibition," *October*, 30. Most recently, Lawler acted as photo-editor for the New Museum's anthology *Art After Modernism: Rethinking Representation*, a position which offered yet another format for her "work."

5 As Baudrillard writes, "We have seen that the true value of the painting is its

genealogical value (its 'birth': the signature and the aura of its successive transaction: its pedigree). Just as the cycle of successive gifts in primitive societies charges the object with more and more value, so the painting circulates from inheritor to inheritor as a title of nobility, being charged with prestige throughout its history" ("The art auction," pp. 120–1).

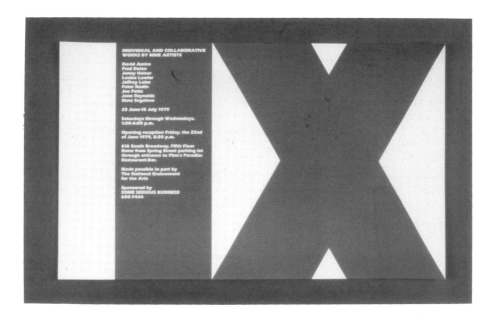

27

WHAT'S IMPORTANT ABOUT THE
HISTORY OF MODERN ART EXHIBITIONS?

Martha Ward

What's important to consider in writing a history of the modern art exhibition? As yet, we don't have anything like a comprehensive empirical history of this form, which has dominated the public presentation of art in the modern (post-1750) age. But even in advance of the research that would yield more information, it seems desirable to think about why and how such a history might be written.

It's not surprising that in the work that has already been done, contemporary critical concerns have played a major role. During the 1980s, when the history of exhibitions in my own field of nineteenth-century French art began to be written, much attention was given to universal exhibitions. These provided a proto-history for the blockblusters then so dominant in the artworld, seemingly so revelatory of

how exhibitions could turn into merely entertaining spectacles. Other research at this time on other sorts of exhibitions also tended to be event-oriented, concentrating on individual shows as nodal points in the social history of art. Politics, criticism, audience and painting could be shown to intersect more concretely in exhibitions than perhaps anywhere else. Interpreting a painting in view of the conditions and reception at its first showing came to be accorded a definitiveness that was not extended to any of the other situations – studio creation, auction purchase, domestic display – through which the meanings or values of nineteenth-century easel paintings might be said to have been realized. Exhibitions were also a focus in the 1980s for historians exploring the relations of art and capitalism through the workings of the market, so phenomenally on the rise during this decade. Whether operating with an all-inclusive revisionist agenda or one prizing instances of modernist resistance, these historians looked at exhibitions as promotional sites and at museums as holding out the promise of a (false) refuge from commodification.

Despite the progress of the past decade, I think that a broad understanding of the history of display and its effects still eludes us. We mostly have a patchwork of studies that feature one or another of the purposes served by various exhibitions. If

➡ **27.1 Pietro Antonio Martini, *Salon of 1787*, engraving. Courtesy of the Cabinet des Estampes, Bibliothèque Nationale, Paris.**

the goal is to be able to track the pervasive form of the exhibition and its impact across the modern period, then we need to attend to continuities and ruptures in habits that may not correspond directly to political, marketing or spectacularizing developments. We need to bring into view instead a more expansive, amorphous field, composed from the uneven or incomplete development of practices across this period. Customs of presentation changed but rarely dramatically and never pervasively. Below I pose four concerns around which we might begin to conceptualize the early history of the exhibition of modern art. My topics are not new in themselves. But my hope is that by highlighting the issues and stretching the questions across the breadth of more than a century, I can both expose what we don't know and demonstrate why we need to know more.

Before the outline of these concerns, one long proviso. Most of the examples I'll entertain come from the area that I know best, the mid-eighteenth through the early twentieth centuries in France, and involve temporary art exhibitions rather than museum collections. A more comprehensive account, extending to the present, would surely require some sort of periodization. Without attempting to reflect on these matters systematically, I'll note here that one way to characterize the period

from 1750 to 1914 in relation to our own is that it occurs prior to the articulation of any science or discourse of display. Despite the appearance during this period of the institutions that are now commonly taken to be synonymous with the creation of an autonomous space for art (museums, art societies, salons, galleries), it's nevertheless the case that art installation was not yet a subject for professional discussion, with a language of its own. Nor did the dealers, administrators, entrepreneurs or artists who mounted exhibitions often aim to create startlingly innovative displays of art and so to engineer new modes of visuality. Such things happened, to be sure. But it seems that they remained, by and large, much closer to the fabric of social life than in our own time of professional curators, exhibition designers and installation artists. Closer, too, than in the time of the 1920s when, as Yve-Alain Bois has claimed, self-consciousness about the effects of installation was such that Lissitsky could aim to exhibit an exhibition, to make a show that would be explicitly directed towards disrupting those visual habits (tactile and optical, temporal and spatial) that displays conventionally reinforced.[1] A range of developments in the early twentieth century – the beginnings of historicized museum installations, distinguishing among epochs in terms of modes of visuality, for instance; and the new American science of

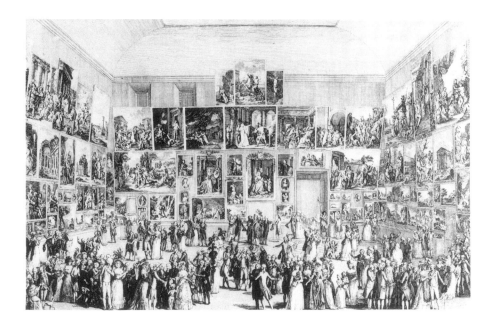

advertising, with its psychologizing of design in terms of attraction and attention – such developments as these brought about a new self-consciousness of how the relationship of viewer and object could or should be mediated through presentation. Before then, "exhibition installation" seems not to have existed, as such, as a subject.

We might accordingly wonder whether displays prior to this period should be pulled away from the dense historical fabric in which they are embedded and made into an historical subject in their own right. By the same token, however, we might question the logic according to which subjects come into focus for historical analysis only at times when they become arenas for innovation or are centered as discursive terms. This question of when installation or even exhibition begins to have a history of its own cannot be flushed out here, though I'll touch on it again shortly. It is clear from what's already been said, however, that shows prior to 1914 will necessarily require a differently textured account, one closer to a wide number of artistic and social practices, than many later exhibition designs would invite as an appropriate analysis.

➡ **27.2 Dining-room of Durand-Ruel, Paris, exact location unknown.**

ARTISTIC PUBLIC SPHERES?

The history that we're concerned with is one that can be taken to begin in the late seventeenth and eighteenth centuries with the exhibition of works for the "public." The most notable institution of such practice was the Paris Salon, first established on a regular basis in 1737 (fig. 27.1). Of course, paintings and sculpture had previously been displayed in a variety of fashions and for a variety of social groups, but what seems to turn the history of art's display into the history of its exhibition is precisely the intention to institutionalize the showing of art objects to this collectivity called the "public."

The seventeenth and eighteenth centuries were also when our modern usage of the word "exhibition" developed. Though not exclusively used for art, it did refer generally to showing publicly. According to the tenth and final definition of the word in the *Oxford English Dictionary*, a definition accompanied by a quotation from 1797, to exhibit means: "to show publicly for the purposes of amusement or instruction, or in a competition; to make a show of. . . ." Late seventeenth-century definitions of the French verb *exposer* similarly specify the act of putting something on public view; examples in 1690 included the exhibition of the sacred Host during

the Mass, and the exhibition of goods for sale in markets, but not yet, as in the next century, the exhibition of art in shows.[2]

The first dimension of the history of modern art exhibitions unfolds directly from these beginnings, and has to do with how exhibitions have exploited, denied or confounded the view that art, and the experience of art, properly belong to a public arena. As Thomas Crow has argued, the important and persistent tension here is between the notion of the experience of art as individual and private versus the very form of the exhibition itself which allowed for an artistic public sphere.[3]

The tensions between the public and the private, between the collective and the individual, evolved in what seems a quite ragged fashion over the course of the nineteenth century, ragged because of the uneven development of those various spheres – civic, commercial and social – that each came to have a stake in displaying art. Yet it's not hard to see that by the end of the century, with the maturation of the art market and of a consumer culture, the concept "exhibition" had quite lost any specificity it might once have had as a civic form or public arena. Consider that the dealer Durand-Ruel opened his apartment, hung with Impressionist paintings, as an exhibition for Paris tourists, and this, according to guide books, in 1900 (fig. 27.2).[4]

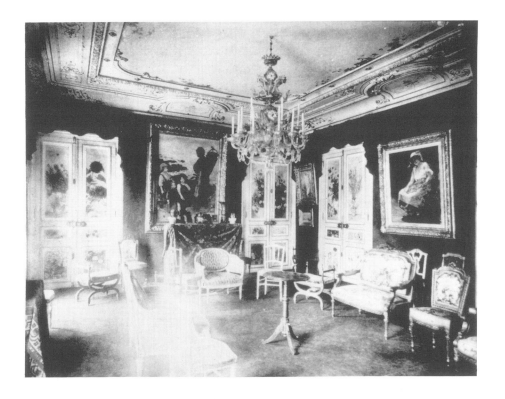

The dealer had obviously deemed that one of the best ways to show these works was to appeal to the domestic imagination, to mount an exhibition within a house, with the blinds drawn against the public life outside. As exhibitions transgressed that wall in bourgeois life between public and private, societal and domestic, becoming seemingly all pervasive yet also increasingly differentiated, what needs tracing are the consequences this had for the experience of art as a commercial, individual or critical engagement.

As a form, the temporary exhibition typically involved assessing unfamiliar objects in a provisional context. The exhibition form separated the sites of presentation and reception from those of production and often from those of use and ownership as well. It offered instead a unique field for comparative contextualization, one often claiming to make visible for its audience some more consequential or enduring entity than its own provisional nature and limited contents: for instance, at the Salon, the state of contemporary art in France; or at an artist's retrospective, the highpoints of a lifetime of painting. Criticism, the genre of writing that came into being alongside the public art exhibition in the eighteenth century, often operated precisely in this unstable domain of the temporary show and

➡ **27.3 *Révue comique*, 1880s, by Draner. Photograph courtesy of the Bibliothèque Nationale, Paris.**

its claims to significance and consequence. Yet forms of criticism, tied closely to the history of the press, and those of presentation did not necessarily evolve in tandem over the century, and their interrelationships are difficult to generalize. Consider, for instance, that when critics were invited in the 1870s to the new circle and society exhibitions that featured recent works by member artists, some professed discomfort at the prospect of reviewing the displayed pieces because the privacy of the setting seemed not to allow for the "public" discourse of criticism. Intimate exhibitions with intimate works seemed to call for a different sort of social exchange and evaluation, and it was not clear in these cases what the greater significance of the show and thus the purpose of criticism should be.[5] Moments such as these disclose the considerable tensions that occurred in the development of the modern art world over the appropriate role of criticism, over the proper functions and audiences for exhibitions, and over the desirability of shows being taken to signify something more than an occasion for looking at art.

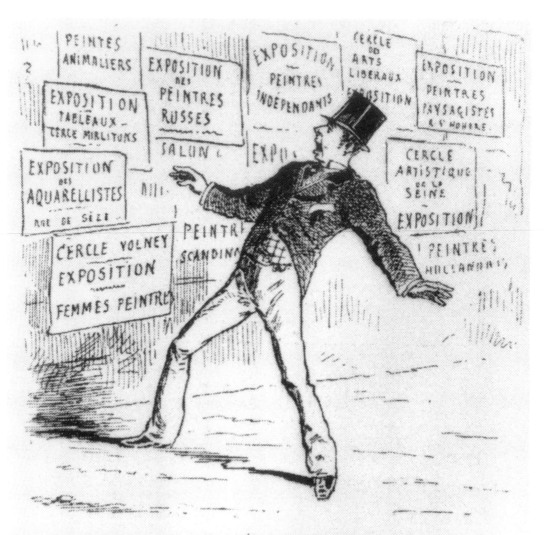

GIBOULÉE DE MARS
Pis que les concerts de carême!

EXHIBITION AS REPRESENTATION

Closely related to these issues is that of how exhibitions have functioned to represent some totality or entity greater than themselves. What interests me might, on one level, be described as a history of both the intuitive and explicit concepts around which art exhibitions have been organized and their contents selected, reviewed, promoted. Put otherwise, this is a history of the notions that have governed inclusion, exclusion and value.

Here the period we're considering is restlessly experimental. Two of its most innovative formats went on to become staples of twentieth-century modernism: (a) the monographic or retrospective show, in place by mid-century and quite common by 1900, and (b) the art-movement show, less common but already familiar by the 1890s.

Among the wide range of nineteenth-century exhibition types, others have only recently come back into their own. A once viable enterprise was the combination of thematic show and charitable/political cause as, for instance, in the exhibition mounted in support of the victims of the Greek War of Independence, held at the

➡ **27.4 Exhibition of painting at the Cercle de l'Union Artistique. Courtesy of the Cabinet des Estampes, Bibliothèque Nationale, Paris.**

Galerie Lebrun in 1826, where Delacroix displayed his *Greece on the Ruins of Missolonghi*. By the 1880s, as can be seen in a contemporary cartoon recently republished by Tamar Garb (fig. 27.3), there were specialized exhibitions in Paris that invited readings of their contents in terms of ethnic, national or gendered traits. Amid the signs for watercolorists, independent artists and animal painters in the cartoon there are announcements for exhibitions of women artists, Russian painters and Scandinavian ones.[6] Seen from this perspective, the culturally specific show appears not to be so much a post-modern creation as a modernist suppression.

We should not only chart the appearance (and disappearance) of such exhibition categories on a descriptive level, but try to figure how art exhibitions expressed the entities they were taken to evoke. How did one go about representing through exhibition an artist's career in 1885? Or an ethnic or national identity? What was the relationship between the assertion of a dominant term and readings of the show? Did visual presentations and critical texts each have their own modes of narrating or essentializing such matters? We might begin in this manner to bring the analysis of art exhibitions closer to the level of work that has been done on other types of displays. For it seems that nineteenth-century art exhibitions have not, as a lot, been

subject to anything like the sophisticated work that, say, Stephen Bann has done on how museums represented history and memory, or that Timothy Mitchell has done on how universal expositions represented colonial societies.[7]

Finally, it might be worthwhile to examine how and when exhibitions came to be portrayed as historical actors. In the period just before World War I, art exhibitions were promoted as events that would leave in their wakes transformed viewers and revolutionized artists. The Sonderbund exhibition in Cologne in 1912, the Post-impressionism shows in London in 1910 and 1912, the Armory Show in New York and Chicago in 1913, all were cast in the role of bringing modernism from foreign shores to their respective cities. Such representations of the exhibition's transformative power and historical mission were obviously related to the claims that had already been made for more than half a century on behalf of the progress embodied in universal exhibitions, but now these claims were accelerated for the distribution of modern art by an entrepreneurial avant-gardism. The precise examples are less important here, though, than the largely unexplored questions they raise, questions of how shows were seen to function in relation to everyday life and the roles they were accorded in promoting artistic and social developments.

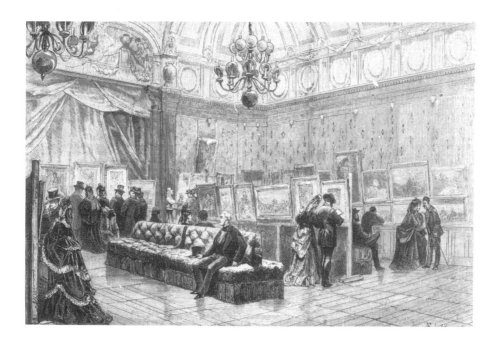

VIEWERS IN THE EXHIBITION'S IMAGE?

The third dimension of this history entails an analysis of spaces and installations, and of the experiences – both social and phenomenological – they prepared for the visitor. It asks how physical arrangements and methods of presentation sought to turn visitors into good viewers, and whether exhibitions could create through these means viewers in their own image.

Obviously here would be the place to describe those customs that guided art's display in the eighteenth and nineteenth centuries – such things as frames, wall colors, picture hangs, room sizes, sky lights and potted plants – all those things that seem rarely to have been described at the time and whose selection must have simply been guided by habit, good taste, common sense. These were arrangements that worked no doubt to suggest who was the socially appropriate viewer, what sort of environment art required, where one should stand, even how one should regard the works. Consider, for example, the emphases in this representation of a show put on by a Paris art circle in the 1860s (fig. 27.4) where the disposition of works on a single or double level in an intimate setting seems to invite close inspection, exemplified by

460

➡ **27.5 Honoré Daumier, "Don't you think, my dear, a person must be a bit touched to have her portrait done like that?", from *The Public at the Salon*, 1852.**

the actions of the standing and seated figures.

Here, too, would be the place to reckon with the changes that resulted in new desires and values in viewing. A surprising example of innovation that has recently come to light is Jacques-Louis David's use of mirrors in exhibitions, first in a Louvre apartment in 1799 where a mirror was placed at a distance from his *Sabine Women*, and again in a Paris apartment in 1824, where the mirror made his *Mars disarmed by Venus* seem, at first take, to be suspended in mid-air. Dramatizing viewing from near and far, inviting contrasts between surface inspection and disembodied illusionism, serving as a test of compositional coherence, the displays seem to have been designed to introduce a heightened consciousness of the stages of viewing itself.[8] Potentially more revealing for the history of display than these and other relatively isolated examples of innovation during this period, however, is the question of why installation was not more often called upon in such dramatic ways to enhance, enforce or multiply ways of seeing. What was it about painting that left it relatively unaffected in this age of dioramas, panoramas and other spectacular presentational strategies? Were measures of decorum appropriate for the exhibition site and audience made to dictate modes of visuality suitable for the art, or vice versa?

It's often a consequence of speaking of effects of display to assume a normative viewer and to speak as if visitors were all properly situated or instructed, all acted upon in such a way as to become identical to the presumed effect of the exhibition design. But we should also try to arrive at some estimation of those visitors who would not have known to see inside an exhibition custom or to detect an innovation and respond to it as such, those who continued to maintain their own ways of seeing inside the show. The vast majority of such instances are, of course, unretrievable for the history of spectatorship: the perceptions, acts or complaints of individuals who left no record.

Still, we do have vivid representations in caricatures and criticism of aberrant viewing. Consider, for instance, Daumier's print with the caption "A person must be a bit touched to have her portrait done like that" (fig. 27.5). A rough-featured woman looks at the statue before her as if it were a person, rather than apprehending it within the proper conventions: portraits are not nudes, and nudes, not portraits. Ignorant of the categories that separate art from life, the speaker cannot navigate the Salon properly. Moreover, to make the ignorance all the more complete, we assume that it's she, in the print's foreground, who speaks the caption and blunders over

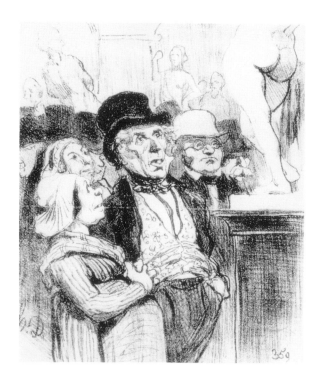

nudity rather than her male companion, close behind. Just as such representations expose the conventions of what is required for good viewing, so exhibitions now become the public tests of spectatorial competency. And in the caricatures, not "getting it" clearly tends to be a matter of class and gender.

In contrast to the caricatures' reduction of the exhibition to a normative "it" to be got, however, the arrangements and conventions of many nineteenth-century shows seem to have permitted and encouraged diverse types of observation. To judge from illustrations and criticism, for example, amateurs seem to have known how to judge works high on the wall of the Salon by exercising a combination of magnification and imagination that brought the *factures* of those works in for close inspection, thus allowing for appreciation as in the studio. Rather than positing a single notion of a good viewer based on the effects or categories of presentation, then, it's probably more productive to consider such shows as functioning complexly in relation to different types of visitors. On the one hand, they set up a field of possibilities, accommodating or soliciting a range of gazes; on the other, they provided for some a set of conventions against which class and gender could be foregrounded, and competency and its exclusions displayed.

IMPACT ON ARTISTIC PRODUCTION

462

We still need to work towards a fuller understanding of what might seem to be the best explored of these dimensions of the modern art show: how exhibition forms and demands have affected artistic production. In what ways did modern art internalize exhibition schedules, formats, modes of unity, of visuality and even of sociability into its own production? Monet's series are as clear an instance as one could imagine of an art that would be inconceivable without the one-person show or more specifically, the one-person/one-room show so popular in the 1890s. Similarly, according to David Cottington, Picasso's annual creation in the early twentieth century of a single large painting summarizing the state of his art was the carry-over of a Salon mode of production, even though most of these works, including the *Demoiselles d'Avignon*, were not intended for public presentation at all.[9] In addition to such direct connections which could readily be multiplied across the century, other more oblique relations have yet to be explored, having to do with how works may have been made to anticipate the less objective conditions of their own reception. Many of these conditions I've already touched upon, in discussing the public and private, commercial and critical dimensions of the modern exhibition and its claims to represent a significant entity greater than itself. Seen in its largest frame, interpreting how these developments have been exploited or denied by artists might amount to rewriting the history of modern art from the perspective of its anticipated reception.

I want to conclude on a more modest note by asking what might be the value of such a history for the way that we display modern art now.

One way to open up this question, at least regarding the exhibition of nineteenth-century materials, is to reflect on how museums used the history of display in the 1980s. Remember the National Gallery, Washington's recreation in 1981 of a Paris Salon for "Rodin Rediscovered"? Exhibitions about exhibition seemed to make for more adequately contextualized presentations of the works, even to overcome the great divide between the space of the museum and the history of the art. Thus, when Patricia Mainardi critiqued the installation of the Musée d'Orsay, she spoke in the name and defense of "history," arguing that the museum's contents should be arranged as they would have been in nineteenth-century shows. Mainardi took the situation of a work's initial exhibition to be its most meaningful (for her, its most overtly politicized) context and contended accordingly that the Orsay installation should restage the Salon's confrontations – Manet, say, versus the academic painters.[10]

If the goal of simulating nineteenth-century exhibitions was to allow the modern viewer to approximate how the art would have been experienced, what such experiments have tended to produce instead has been a distinctly twentieth-century form of spectacularization. In the nineteenth century, many display practices could still seem extensions of other conventions in social life, not a specialized installation that was itself to be foregrounded. If for this and a number of other, equally obvious reasons our experiences cannot be the same as nineteenth-century viewers', perhaps installation would better be conceived as a bridge from present to past.

An extensive history of exhibitions, one directed less at re-creating specific shows and more at establishing the general horizons of nineteenth-century practices, might be drawn upon for these ends. Rather than aiming to arrest the works and our perception of them at a supposedly conclusive juncture (in contrast to the multiply-situated and on-going histories of the objects themselves), it might be preferable to devise installations that acknowledge the temporal fluidity of the museum space. This is not a proposal in favor of ahistoricity, but rather of a different approach to how display might be historically informed. For as I hope to have suggested here, the exhibition of modern art is a far richer, more uneven, multivalent and consequential set of developments than we know how to trace or conceptualize now. Drawing out the broader issues that this history raises concerning the viewing, making and representing of modern art, both then and now, seems its best use.

For a conclusion, let's back up one step. Before positing any use for its materials, a study of this history might first and foremost provide some needed distance on the present, when exhibition and installation have become both a curatorial discipline

463

and an artistic medium. We're no doubt too close to this situation as it has developed over the past thirty years to grasp fully its historical significance. Comparison with the past two centuries may be our best and perhaps our only means of throwing into relief the peculiarities of our own practices, thus making them available for critical analysis.

NOTES

This essay is adapted from a talk I gave at the Bard Center for Curatorial Studies in March 1994. I have kept the flavor of an informal address but added examples and notes.

1 Yve-Alain Bois, "Exposition: esthétique de la distraction, espace de démonstration," *Les Cahiers du Musée national d'art moderne*, 29 (Autumn 1989), pp. 57–79.

2 *Dictionnaire universel d'Antoine Furetière*, Hague and Rotterdam, 1690; rpt. Paris, 1984.

3 Thomas E. Crow, *Painters and Public Life in Eighteenth-Century Paris*, New Haven, 1985. For later in the century, see Patricia Mainardi, *Art and Politics of the Second Empire: The Universal Expositions of 1855 and 1857*, New Haven, 1987, and idem, *The End of the Salon*, Cambridge, 1993.

4 Robert Jensen, *Marketing Modernism in Fin-de-Siècle Europe*, Princeton, 1994, pp. 59–60.

5 Martha Ward, "Impressionist installations and private exhibitions," *Art Bulletin*, 73 (Dec. 1991), p. 607.

6 For women's exhibitions at this time, see Tamar Garb, "Revising the revisionists," *Art Journal*, 48 (Spring 1989), pp. 62–70.

7 Stephen Bann, "The poetics of the museum: Lenoir and Du Sommerard," in his *The Clothing of Cleo*, Cambridge, 1984, pp. 77–92; and Timothy Mitchell, "The world as exhibition," *Society for Comparative Studies in Society and History*, 31 (1989), pp. 217–36.

8 David also used a mirror in the exhibition of the *Coronation of Napoleon*. For all three instances, see Dorothy Johnson, *Jacques-Louis David: Art in Metamorphosis*, Princeton, 1993, pp. 132–4, 270–1. For a different interpretation of the *Sabine Women*, see Ewa Lajer-Burcharth, "David's *Sabine Women*: body, gender and Republican culture under the Directory," *Art History*, 14 (1991), pp. 397–430.

9 David Cottington, "What the papers say: politics and ideology in Picasso's collages of 1912," *Art Journal*, 47 (Winter 1988), p. 353.

10 Patricia Mainardi, "Postmodern history at the Musée d'Orsay," *October*, 41 (Summer 1987), pp. 30–52.

SELECT BIBLIOGRAPHY
*Compiled by Reesa Greenberg with Sandy Nairne
and Bruce Ferguson*

Adams, Brooks, "Report from Chicago: the century revised," *Art in America*, 80:4 (1992), pp. 50–4.

Adorno, Theodor, "Valéry, Proust, Museums," in *Prisms*, London, Spearman, 1967.

Alloway, Lawrence, *The Venice Biennale, 1895–1968: From Salon to Goldfish Bowl*, London, Faber & Faber, 1969.

——— *Network: Art and the Complex Present*, Ann Arbor, Michigan, UMI Research Press, 1984.

Altshuler, Bruce, *The Avant-Garde in Exhibition: New Art in the 20th Century*, New York, Harry N. Abrams, 1994.

Ames, Michael, "Biculturism in exhibitions," *Museum Anthropology*, 15:2 (1991), pp. 7–15.

——— *Cannibal Tours and Glass Boxes: The Anthropology of Museums*, Vancouver, University of British Columbia Press, 1992.

Apple, Jacki, ed., *Alternatives in retrospect: an historical overview, 1969–1975*, New York, The New Museum, 1981, pp. 5–7.

Art and Confrontation; France and the arts in an age of change, trans. Nigel Foxell, London, Studio Vista, 1970.

"L'Art contemporain et le musée," *Les Cahiers du Musée national d'art moderne*, hors-série, 1989.

"Art galleries as alternative spaces", *Studio International*, 195: 990 (1980).

Bal, Mieke, "Telling, showing, showing off," *Critical Inquiry*, 18:3 (1992), pp. 556–94.

Bann, Stephen, "The imaginary exhibition," *Kunst & Museumjournaal*, 1:4 (1990), pp. 1–7.

———— "Poetics of the museum: Lenoir and Du Sommerard," in *The Clothing of Clio: A Study of the Representation of History in Nineteenth Century Britain and France*, Cambridge, Cambridge University Press, 1984.

Baranik, Rudolf, *et al.*, *an* anti-*catalog*, New York, The Catalog Committee, Inc., Artists Meeting for Cultural Change, 1977.

Barry, Judith, "Drive in or walk in museum," *Real Life*, 20 (1990), pp. 47–9.

Baselitz, George, "Vier Wande und Oberlicht. Oder besser: kein Bild an die Wand," *Kunstforum*, 34 (1979), pp. 162–4.

Baudrillard, Jean, "The Beaubourg-effect: implosion and deterrence," *October*, 20 (1982), pp. 3–13.

Bazin, Germain, *The Museum Age*, trans. Jane van Nuis Cahhill, New York, Universe Books, 1967.

Becker, Howard S., *Art Worlds*, Berkeley, University of California Press, 1982.

Benson, Susan P., Brier, Stephen, and Rosenzweig, Roy, eds, *Presenting the Past: Essays on History and the Public*, Philadelphia, Temple University Press, 1986.

Berger, John, "The historical function of the museum," in *The Moment of Cubism and Other Essays*, New York, Pantheon, 1969.

———— *Ways of Seeing*, London, BBC and Penguin, 1972.

Berger, M., "Are art museums racist?" *Art in America*, 78:9 (1990), pp. 68–75.

Berlinische Galerie and Museum für Moderne Kunst, Photographie, und Architektur, *Stationen der Moderne: Die bedeutenden Kunstausstellungen des 20. Jahrhunderts in Deutschland*, Berlin, Berlinische Galerie, 1988.

Blazwick, Iwona, "Psychogeographies," in *On taking a normal situation and retranslating it into overlapping and multiple readings of conditions past and present*, Antwerp, Museum van Hedendaagse Kunst Antwerpen, 1993.

Blottière, Sylvie, and Poinsot, Jean-Marc, *Sur Exposition: regards sur l'exposition d' art contemporain*, Rennes, Musée des Beaux-Arts, 1985.

Bois, Yves-Alain, "Exposition: esthetique de la distraction, espace de demonstation," *Cahiers du Musée national d'art moderne*, 29 (1989), pp. 57–79.

Bolton, Richard, "The modern spectator and the postmodern participant," *Photo Communiqué*, 8:2 (1986), pp. 34–45.

———— ed., *Culture Wars: Documents from the Recent Controversies in the Arts*, New York, New Press, 1992.

Bourdieu, Pierre, "The aristocracy of culture," *Media, Culture and Society*, 2:3 (1980), pp. 225–54.

———— and Darbel, Alain, *The Love of Art: European Art Museums and Their Public*, [1969], trans. Caroline Beattie and Nick Merriman, Cambridge, Polity Press, 1991.

Bozo, Dominique, "Le retour au musée," interview par Catherine Millet, *Art Press*, 62 (1982), pp. 4–6.

Brawne, Michael, *The Museum Interior: Temporary and Permanent Display Techniques*, New York, Architectural Book Publishing, 1982.

Brenato, Robyn, and Savitt, Mark, *112 Workshop/Greene Street*, New York, New York University Press, 1981.

Brock, Bazon, "Die Besucherschule des Bazon Brock," in *documenta 4*, Kassel, 1968.

Bronson, A. A., and Gale, Peggy, eds, *Museums by Artists*, Toronto, Art Metropole, 1983.

———— ed., *From Sea to Shining Sea*, Toronto, The Power Plant, 1987.

Broude, Norma, and Garrard, Mary D., eds, *The Power of Feminist Art*, New York, Harry N. Abrams, 1994.

Brummett, Barry, *Rhetorical Dimensions of Popular Culture*, Tuscaloosa, University of Alabama Press, 1991.

Bryson, Norman, "The gaze in the expanded field," in *Vision and Visuality*, ed. Hal Foster, Seattle, Bay Press, 1988.

Buchloch, Benjamin, "The Whole Earth Show," *Art in America*, 77:5 (1989), pp. 150–9.

Buren, Daniel, "The function of an exhibition," *Studio International*, 186:961 (1973), p. 216.

Burgbacher-Krupka, Ingrid, *Strukturen zeitgenossischer Kunst: Eine empirische Untersuchung zur Rezeption der Werke von Beuys, Darboven, Flavin, Long, Walthe*, Stuttgart, Ferdinand Enke Verlag, 1979.

Cauman, Samuel, *The Living Museum, Experiences of an Art Historian and Museum Director: Alexander Dorner*, New York, New York University Press, 1958.

Celant, Germano, *Ambiente/Arte dal Futurismo alla Body Art*, Venice, Alfieri Edizione D'Arte,1977.

Clifford, James, "On collecting art and culture," in *Out There: Marginalization and Contemporary Cultures*, New York, The New Museum of Contemporary Art, and Cambridge, Mass., MIT Press, 1990.

Conforti, Michael, "Hoving's legacy reconsidered," *Art in America*, 74:6 (1986), pp. 18–23.

Cooke, Lynne, "Exhibition tracking: the late 80's," in *Carnegie International 1988*, eds Sarah McFadden and Joan Simon, Pittsburgh, Carnegie Institute, 1988.

Coombes, Annie, "Museums and the formation of national and cultural identities," *Oxford Art Journal*, 11:2 (1988), pp. 57–68.

Cork, Richard, "Report from London: the artist's eye," *Art in America*, 69:2 (1981), pp. 42–55.

Corrin, Lisa, ed., *Mining the Museum: An Installation by Fred Wilson*, New York, The New Press, 1994.

———— and Sangster, Gary, "Culture *is* action," *Sculpture*, 13:2 (1994), pp. 30–5.

Crane, Diana, *The Transformation of the Avant-Garde*, Chicago, University of Chicago, 1987.

Crimp, Douglas, *On the Museum's Ruins*, Cambridge, Mass., MIT Press, 1993.

Crippa, Maria Antonietta, *Carlo Scarpa: Theory, Design, Projects*, Cambridge, Mass., MIT Press, 1984.

Crow, Thomas E., *Painters and Public Life in Eighteenth Century Paris*, New Haven and London, Yale University Press, 1985.

Csikszentmihalyi, Mihaly, and Robinson, Rick E., *The Art of Seeing*, Malibu, J. Paul Getty Museum and Getty Center for Education in the Arts, 1990.

Davallon, J., *Claquemurer pour ainsi dire tout l'univers: la mise en exposition*, Paris, Editions de Centre Pompidou-CCI, 1986.

Dechter, Joshua, "De-coding the museum," *Flash Art*, Nov.–Dec. 1990, pp. 140–2.

De Leeuw, Riet and Beer, Evelyn, eds, *L'Exposition imaginaire: The Art of Exhibiting in the Eighties*, 's-Gravenhage, SDU Rijksdienst Beeldende Kunst, 1989.

467

De Salvo, Donna, *Past Imperfect: A Museum Looks at Itself*, Southampton, New York, The Parrish Art Museum, 1993.

Devenish, David C "Labelling in museum display," *International Journal of Museum Management and Curatorship*, 9:1 (1990), pp. 63–72.

Dietcher, David, "Social aesthetics," in *Democracy: A Project by Group Material*, ed. Brian Wallis, Seattle, Bay Press, 1990.

Different Voices: A Social, Cultural, and Historical Framework for Change in the American Art Museum, New York, American Association of Art Museums, 1992.

"*documenta 7*: Ein Rundgang," *Kunstforum*, 53–4 (1982) (special issue), essays by Georg Jappe, Annelie Pohlen, Wolfgang Max Faust, pp. 7–8.

"*documenta 8*: Kunst auf dem Prüfstand," *Kunstforum*, 90 (1987) (special issue).

"Die *documenta* als Kunstwerk,", *Kunstforum*, 119 (1992) (special issue).

Drobnick, Jim, "Dia Art Foundation: a history of daring gestures as recollected by Heiner Friedrich and redirected by Charles Wright," *Parachute*, 54 (1989), pp. 15–21.

Duncan, Carol, *The Aesthetics of Power: Essays in Critical Art History*, Cambridge, Cambridge University Press, 1993.

——— and Wallach, Allan, "The museum of modern art as late capitalist ritual: an iconographic analysis," *Marxist Perspectives*, 1 (1978), pp. 28–51.

——— and Wallach, Allan, "The universal survey museum," *Art History*, 13:4 (1980), pp. 448–69.

Dunlop, Ian, *The Shock of the New: Seven Historic Exhibitions of Modern Art*, London, Weidenfield & Nicolson, 1972.

Eco, Umberto, "A theory of expositions," [1967], in *Travels in Hyperreality*, New York, Harcourt Brace Janovitch, 1986.

Elsen, Albert E, "Museum blockbusters: assessing the pros and cons," *Art in America*, 74:6 (1986), pp. 24–7.

"En revenant de l'expo," *Les Cahiers du Musée national d'art moderne*, 29 (1989) (special issue).

"Europa 79: Geschichte einer Ausstellung," *Kunstforum*, 36 (1979), pp. 16–22.

Ferguson, Bruce W, "International exhibitions: Parts One & Two," *Fuse*, 7:1 (1983), pp. 299–304; 7:2 (1983), pp. 322–6.

Foster, Hal, *Recodings: Art, Spectacle, Cultural Politics*, Seattle, Bay Press, 1985.

Fraser, Andrea, "Museum highlights: a gallery talk," *October*, 57 (1991), pp. 103–22.

——— "Two audioinstallations," in *Stellvertreter, Representatives, Rappresentanti: Austrian Contribution to the 45th Biennale of Venice, 1993*, Vienna, Der Kommisär und das Bundesministerium für Unterricht und Kunst, 1993.

Fry, Jacqueline, "Le musée dans quelques oeuvres récentes," *Parachute*, 24 (1981), pp. 33–45.

Gevers, Ine, ed., *Place, Position, Presentation, Public*, Maastricht, Jan van Eyck Akademie, 1993.

Gordon, Donald, *Modern Art Exhibitions 1900–1916*, vols 1 and 11, Munich, Prestel Verlag, 1974.

Goodes, Donald, "Qualified democratization: the museum audioguide," *Journal of Canadian Art History*, 14:2 (1992), pp. 50–72.

Goodman, Cynthia, "The art of revolutionary display techniques," in *Frederick Kiesler*, Whitney Museum of American Art, 1989, pp. 57–83.

Grasskamp,Walter, *Museumsgrunder and Museumssturmer: zur Socialgeschichte des kunstmuseums*, Munich, C.H. Beck, 1981.

Greenberg, Reesa, "The acoustic eye," *Parachute*, 46 (1987), pp. 106–8.

———— "MoMA and modernism: the frame game," *Parachute*, 42 (1986), pp. 21–31.

"Gurgles around the Guggenheim [Statements by Daniel Buren, Hans Haacke, Thomas Messer and Diane Waldman]," *Studio International*, 181:934 (1971), pp. 246–50.

Haacke, Hans, *Framing and Being Framed*, Halifax, Nova Scotia College of Art and Design, 1975.

———— *Unfinished Business*, New York, The New Museum of Contemporary Art, and Cambridge, Mass., MIT Press, 1986.

Hall, Margaret, *On Display*, London, Lund Humphries, 1987.

Haraway, Donna, "Teddy-bear patriarchy, taxidermy in the Garden of Eden, New York City, 1908–1936," in D. Haraway, *Primate Visions: Gender, Race and Nature in the World of Modern Science*, New York, Routledge, 1989.

Harley Jr, Ralph L, "Edward Steichen's modernist art-space," *History of Photography*, 14:1 (1990), pp. 1–22.

Haskell, Francis, *Past and Present in Art and Taste: Selected Essays*, New Haven, Yale University Press, 1987.

Heinich, Nathalie, *Harald Szeemann, un cas singulier. Entretien*, Caen, L'Echoppe, 1995.

Higonnet, Anne, "Museums: where there's a will . . .," *Art in America*, 77:5 (1987), pp. 65–75.

Hoet, Jan, "Museum piece: Jan Hoet on exhibiting art," *Artforum*, 25:10 (1987), pp. 2–4.

von Holst, Niels, "Bilderhängen – einst und jetzt," *Die Kunst und das Schöne Heim*, 52:6 (1954), pp. 208–10.

Holt, Elizabeth Gilmore, *The Triumph of Art for the Public, 1785–1848: The Emerging Role of Exhibitions and Critics*, Princeton, Princeton University Press, 1979.

Hooper-Greenhill, Eilean, ed., *Museums and the Shaping of Knowledge*, London and New York, Routledge, 1992.

Houle, Robert and Podedworny, Carol, eds, *Mandate Study, 1990–1993: An Investigation Surrounding the Exhibition, Collection and Interpretation of Contemporary Art by First Nations Artists*, Thunder Bay, Thunder Bay Art Gallery, 1994.

House, John, "Time's Cycles," *Art in America*, 80:10 (1992), pp. 126–35, 161.

Hulten, K.G. "Sandberg och Stedelijk Museum,' in *Stedelijk Museum, Amsterdam besöker Moderna Museet, Stockholm*, Stockholm, Moderna Museet, 1961, pp. 4–9.

Impey, Oliver, and McGregor, Andrew, *The Origins of Museums: The Cabinet of Curiosities in Sixteenth and Seventeeth Century Europe*, Oxford, Oxford University Press, 1985.

Inside the Art World: Conversations with Barbaralee Diamonstein, New York, Rizzoli, 1994.

Jacob, Mary Jane, "Places with a past: new site-specific art at Charleston's Spoleto Festival," in *Places with a Past*, New York, Rizzoli, 1991.

Johnson, Ken, "Forbidden sights," *Art in America*, 79:1 (1991), pp. 106–9.

Johnson, Leslie, "Installation: the invention of context,' in *Aurora Borealis*, Montréal, CIAC, 1985.

Kalinovska, Milena, "Exhibition as dialogue: The 'Other' Europe," in *Carnegie International 1988*, ed. Sarah McFadden and Joan Simon, Pittsburgh, Carnegie Institute, 1988, pp. 30–7.

Karp, Ivan, and Lavine, Steven D., eds, *Exhibiting Cultures: The Poetics and Politics of Museum Display*, Washington, D.C., Smithsonian Institution Press, 1988.

——, Lavine, Steven D., and Kreamer, Christine Mullen, eds, *Museums and Communities: The Politics of Public Culture*, Washington, D.C., Smithsonian Institution Press, 1992.

Kaufmann, Thomas de Costa, "Remarks on the collections of Rudolf II: the Kunstkammer as a form of representation," *Art Journal*, 38:1 (1978), pp. 22–8.

Kavanagh, Gaynor, ed., *Museum Languages: Objects and Texts*, Leicester, Leicester University Press, 1991.

Kluser, Bernd, and Hegewisch, Katherina, *Die Kunst der Austellung: Eine Dokumentationdreissig examplaischern Kunstausstellungen dieses Jahrhunderts*, Frankfurt, Insel Verlag, 1991.

Koch, Georg Freidrich, *Die Kunstaustellung: Ihr Geschicte von den Anfängen bis zum Ausgang des 18. Jahrhunderts*, Berlin, Walter de Gruyter, 1967.

Kolisynk, Anne, and Randolph, Jeanne, "Art vs. audience," *Vanguard*, 13:8 (1984), pp. 12–15.

Kosuth, Joseph, *The Play of the Unmentionable*, with an essay by David Freedberg, New York, The New Press, and London, Thames & Hudson, 1992.

Krauss, Rosalind, "The cultural logic of the late capitalist museum," *October*, 54 (1990), pp. 3–17.

Kreutzer, Maria, *"Plastische Kraft" und "Raum der Schrift": Uberleggugen zu den Kunstauffassungen von Joseph Beuys und Marcel Broodthaers*, Dusseldorf, Brennpunkt, 1987.

Kuspit, Donald, "Avant-Garde and audience," in D. Kuspit, *The New Subjectivism*, Ann Arbor, Michigan, UMI Research Press, 1988, p. 495.

—— "The magic kingdom of the museum," *Artforum*, 30:8 (1992), pp. 58–63.

Lamoureux, Johanne, "Exhibitionitis: a contemporary museum ailment," in *Theatergarden Bestarium: The Garden as Theater as Museum*, ed. Chris Dercon, Cambridge, Mass., MIT Press, 1990.

—— "The open window case: new displays for an old Western paradigm," in *Sylvia Kolbowski: XI Projects*, New York, Border Editions, 1992.

Landers, Timothy, McAllister, Jackie, Roberts, Catsou, Weil, Benjamin, and Wieczorek, Marek, *The Desire of the Museum*, New York, Whitney Museum of American Art, 1992.

Lavrijsen, Ria, ed., *Cultural Diversity in the Arts: Art, Art Policies and the Facelift of Europe*, Amsterdam, Royal Tropical Institute, 1992.

Lawler, Louise, "Arrangements of pictures," in *October: The First Decade 1976–86*, ed. Annette Michelson, Cambridge, Mass., MIT Press, 1988.

Leigh, Christian, "Questions," in *I am the Enunciator*, New York, Thread Waxing Space, 1993.

Leyten, Harrie, and Damen, Bibi, eds, *Art, Anthropology and the Modes of Re-presentation: Museums and Non-Western Art*, Amsterdam, Royal Tropical Institute, 1993.

Lippard, Lucy R., *Six Years: The Dematerialization of the Art Object*, New York, Praeger, 1973.

—— *GET THE MESSAGE? A Decade of Art for Social Change*, New York, E.P. Dutton, 1984.

Luckhurst, Kenneth, *The Story of Exhibitions*, London, Studio Publications, 1951.

Luke, Timothy W., *Shows of Force: Power, Politics, and Ideology in Art Exhibitions*, Durham and London, Duke University Press, 1993.

Lumley, Robert, ed., *The Museum Time-Machine: Putting Cultures on Display*, London, Routledge, 1988.

McClellan, Andrew, "The politics and aesthetics of display: museums in Paris, 1750–1800," *Art History*, 13 (1990), pp. 175–92.

McEvilley, Thomas, "On the art exhibition in history: the Carnegie International and the redefinition of the American self," in *Carnegie International 1988*, ed. Sarah McFadden and Joan Simon, Pittsburgh, Carnegie Institute, 1988, pp. 18–23.

———— "Marginalia: Thomas McEvilley on the global issue," *Artforum*, 28:7 (1990), pp. 19–21.

McManus, P.M., "Oh, yes, they do: how museum visitors read labels and interact with exhibit texts," *Curator*, 32 (1989), pp. 174–89.

Mai, Ekkehard, *Expositionen: Geschicte und Kritik des Ausstellungswesens*, Munich and Berlin, Deutscher Kunstverlag, 1986.

Malraux, André, *Museum Without Walls*, trans. Stuart Gilbert and Francis Price, London, Secker & Warburg, 1967.

"Manifester, exposer, monter," *Traverses*, 3 (1992) (special issue).

Marin, Louis, "L'Art d'exposer : notes de travail en vue d'un scenario," trans. Jeffrey Moore as "The art of exhibiting . . . notes for a film script," *Parachute*, 43 (1992), pp. 16–20, 57–9.

Mesquita, Ivo, *A Bienal de Sao Paulo, 1951–1991*, Sao Paulo, Ed. do Autor, 1995.

Michaud, Yves, *L'Artiste et les commissaires: quatre essais non pas sur l'art contemporain mais sur ceux qui s'en occupent*, Nîmes, Editions Jaqueline Chambon, 1989.

Morse, Margaret, "Judith Barry: the body in space," *Art in America*, 81:4 (1993), pp. 116–21.

"Mythos documenta. Ein Bilderbuch zur Kunstgeschichte," *Kunstforum*, 49 (1982) (special issue).

Nairne, Sandy, *State of the Art*, London, Chatto & Windus, 1987.

Nemiroff, Diana, "Pa-ral-lel," *Parallelogramme*, 9:1 (1983), pp. 16–19.

"L'oeuvre et son accrochage," *Cahiers du Musée national d'art moderne*, 17:18 (1986) (special issue).

O'Doherty, Brian, *Inside the White Cube: The Ideology of the Gallery Space*, Santa Monica, Lapis Press, 1986.

Parker, Rozsika, and Pollock, Griselda, ed., *Framing Feminism*, London, Pandora, 1987.

Peters, Philip, "The solitary work: impoverishment or perfect concentration?" *Kunst & Museumjournaal*, 13:5 (1986), pp. 1–5.

Petersen, Ad, "An audience research project in connection with '60 '80," in *'60/80: attitudes, concepts, images. Catalogue supplement*, Amsterdam, Stedelijk Museum, 1987.

Phillips, Christopher, "The judgement seat of photography," *October*, 22 (1987), pp. 27–63.

Phillips, David, "Recipe for an interactive art gallery," *International Journal of Museum Management and Curatorship*, 7:3 (1988), pp. 243–52.

Pindell, Howardina, "Art world racism: a documentation," *New Art Examiner*, 16:7 (1987), pp. 32–6.

Podedworny, Carol, "Indigena and land, spirit, power," *C magazine*, 36 (1987), pp. 54–7.

———— "On contemporary curatorial practice," *C Magazine*, 35 (1992), pp. 11–13.

Pohlen, A. (1983) "Harald Szeemann auf dem Weg zum 'Museum der Obsessionen,'" *Kunstforum*, 63–4 (1983), pp. 266–9.

Poinsot, Jean-Marc, "De nombreux objets colorés placés côté à côté pour former une rangée de nombreux objets colorés," *Artstudio*, 15 (1991), pp. 114–22.

———— "L'Art contemporain et le musée: la fabrique de l'histoire?" *Cahiers du Musée national d'art moderne*, 42 (1992), pp. 17–30.

Pointon, Marcia, ed., *Art Apart: Art Institutions and Ideology across England and North America*, Manchester, Manchester University Press, 1994.

Pontbriand, Chantal, "Skulptur in Munster: An Interview with Kaspar König," *Parachute*, 48 (1987), pp. 36–41.

Popper, Frank, *Art – Action and Participation*, London, Studio Vista, 1975.

Poppi, Cesare, "From the suburbs of the global village: afterthoughts on *Magiciens de la Terre*," *Third Text*, 14 (Spring 1991), pp. 85–96.

Preziosi, Donald, "Modernity again: the museum as trompe l'oeil," in *Deconstruction and the Visual Arts*, ed. Peter Brunette and David Wills, Cambridge, Cambridge University Press, 1987.

———— *Rethinking Art History: Meditation on a Coy Science*, New Haven, Yale University Press, 1990.

Price, Sally, *Primitive Art in Civilised Places*, Chicago, University of Chicago Press, 1990.

Rajchman, John, "The postmodern museum," *Art in America*, 73:10 (1985), pp. 110–17.

Rakatansky, Mark, "Spatial narratives," in *Strategies in Architectural Thinking*, ed. John Witeman, Cambridge, Mass., M.I.T. Press, 1992.

Ramirez, Mari Carmen, "Beyond 'the fantastic': framing identity in U.S. exhibitions of Latin American art," *Art Journal*, 51:4 (1992), pp. 60–8.

Rattemeyer, Volker, *Documenta: Trendmaker in internatzionalen Kunstbetrieb?*, Kassel, Standa,1984.

———— and Petzinger, Renate, "Pars pro toto: Die Geschicte am Beispiel des Treppenhauses des Fridericianums," *Kunstforum*, 90 (1987), pp. 334–57.

Raverty, Dennis, "Critical perspectives on *New Images of Man*," *Art Journal*, 53:4 (1994), pp. 62–4.

Reise Barbara, "A tail of two exhibitions: the aborted Hans Haacke and Robert Morris shows," *Studio International*, 182:935 (1971), pp. 30–7.

Roberts, Mary Nooter, *et al.*, *Exhibition-ism: Museums and African Art*, New York, Museum for African Art, 1994.

Rivière, Georges Henri, *et al.*, "Problems of the Museum of Contemporary Art in the West," *Museum*, 24:1 (1972) (special issue).

Rogoff, Irit, "Barricades into blockades: *documenta 8* and the spirit of 68," *Art History*, 12:2 (1989), pp. 240–6.

Rosler, Martha, "Lookers, buyers, dealers, and makers: thoughts on audience," in *Art After Modernism: Rethinking Representation*, New York, The New Museum of Contemporary Art, 1984.

Schneckenburger, Manfred, ed., *documenta: Idee und Institution – Tendenzen, Konzepte, Materialien*, Munich, Bruckmann, 1983.

Searing, Helen, "The Brillo box in the warehouse: museums of contemporary art and industrial conversions," in *The Andy Warhol Museum*, Stuttgart, Cantz Publishers, 1994.

Sherman, Daniel J., and Rogoff, Irit, eds, *Museum Culture: Histories, Discourses, Spectacles*, Minneapolis, University of Minnesota Press, 1994.

Siegelaub, Seth, in conversation with Harrison, Charles, "On exhibitions and the world at large," *Studio International*, 917 (1969), pp. 202–3.

Sischy, Ingrid, "A conversation with Pontus Hulten about the new Los Angeles Museum of Contemporary Art," *Artforum*, 20:4 (1981), pp. 67–70.

Spear, Richard, "Art history and the 'blockbuster exhibition,'" *Art Bulletin*, 68:3 (1986), pp. 358–9.

Stein, Judith E., "Sins of omission [Fred Wilson]," *Art in America*, 81:10 (1993), pp. 110–15.

"Still too many exhibitions [editorial]," *Burlington Magazine*, 130:1018 (1988), p. 3.

"Strategies d'exposition," *Blocnotes: art contemporain*, 1 (1992).

Szeemann, Harald, "Problems of the museum of contemporary art in the West: exchange of views of a group of experts," *Museum*, 24:1 (1972), pp. 5–32.

———— *Museum der Obsessionen*, Berlin, Merve Verlag, 1981.

"Talkshow der documenta," *Kunstforum* 21 (1977) (special issue).

Théberge, Pierre, "The Ydessa Hendeles Art Foundation: building a museum as a life process. An interview with Ydessa Hendeles," *Parachute*, 54 (1989), pp. 28–33.

Tillman, Lynne, "Dynasty reruns: treasure houses of Great Britain," *Art in America*, 74:6 (1986), pp. 35–7.

Tomassi, Noreen, Jacob, Mary Jane and Mesquita, Ivo, *American Visions/Visiones de las Américas: Artistic and Cultural Identity in the Western Hemisphere*, New York, ACA Books/Allworth Press, 1994.

Tomkins, Calvin, *Post- to Neo-: The Art World of the 1980s*, London and New York, Penguin, 1988.

———— "Profiles: a touch for the now [Walter Hopps]," *New Yorker*, 29 July 1991, pp. 33–57.

Tousley, Nancy, "History and real people," *Canadian Art*, 8:4 (1991), pp. 60–5.

Vergo, Peter, ed., *The New Museology*, London, Reaktion Books, 1989.

Véron, Eliséo, and Levasseur, Martine, *Ethnographie de l'exposition: l'espace, le corps et le sens*, Paris, Centre Georges Pompidou, 1989.

"Von hier aus: Dokumentation einer überflüssigen Austellung," *Kunstforum*, 75 (1984) (special issue).

Wallis, Brian, (1986) "Museum blockbusters: the art of big business," *Art in America*, 74:6 (1986), pp. 28–33.

Ward, Martha, "Impressionist installations and private exhibitions," *Art Bulletin*, 73:4 (1991), pp. 592–622.

Waterfield, Giles, "Picture hanging and gallery decoration," in *Palaces of Art: Art Galleries in Britain, 1790–1990*, London: Dulwich Picture Gallery, 1991.

Weil, Stephen E., *Rethinking the Museum*, Washington, D.C., Smithsonian Institution Press, 1990.

Zaugg, Remy, "Une Lettre," *Parachute*, 48 (1987), pp. 42–5.

INDEX

477

479

481

483

486